Designing
the Earth

Designing the Earth

The Human Impulse To Shape Nature

by David Bourdon

Harry N. Abrams, Inc., Publishers

Editor:
BEVERLY FAZIO HERTER

Designer:
MIKO McGINTY

Photo Editor:
UTA HOFFMANN

Library of Congress Cataloging-in-Publication Data
Bourdon, David.
 Designing the earth / the human impulse to shape nature /
 by David Bourdon.
 p. cm.
 Includes bibliographical references and index.
 ISBN 0–8109–3224–5 (hardcover)
 1. Earthwork. 2. Earth construction. 3. Earthworks (Art)
 I. Title.
 TA715.B65 1995
 709'.04—dc20 95–10639

PAGE 1: Pond-field terraces. The
Philippines. Photograph by Robert
Francis. *In order to grow rice,
a staple of their diet, Philippine
farmers often terrace hill- and
mountainsides to create sequences of
flat fields able to retain rainwater.*

PAGES 2–3: Westbury White Horse,
1778. Turf-cut chalk silhouette,
Wiltshire, England. Photograph
by Georg Gerster. *English country
gentlemen sometimes emblazoned
silhouettes of their favorite mounts
on hillsides. This equine treasure
stands near the ditches and ramparts
of an ancient hillfort.*

ENDPAPERS: *Qanats.* Hamadan
Province, Iran. Photograph by
Georg Gerster.

Printed and bound in Japan

Contents

Introduction

Getting an Education from the Ground Up

Although God created man from the face of the earth and lived to repent it, as the Book of Genesis maintains, humankind not only survived but proceeded to redesign much of the earth's original surface, seldom with any regrets. Adam and Eve's progeny were astonishingly resourceful in adapting the land to their needs, reconfiguring it to create shelters and work places. During the Stone Age, many homemakers developed their housekeeping skills in natural caves. If dissatisfied with their floor plan, all they had to do was hack away additional earth and rock to enlarge their living quarters. Where natural caves were in short supply, men and women excavated artificial versions, sometimes even carving their walls to create storage niches and blocky forms that functioned like built-in furniture.

Human beings have utilized earth and stone as basic building materials for most of their existence. Several millennia ago they learned to make mud-bricks and to stack them into dwellings and town walls; soon entire communities of mud-brick structures sprang up in several parts of the world. Sometimes, as in Anatolia and southwest Asia, successive layers of towns were piled one atop another to result in an artificial mound or "tell"—derived from the Arabic word for "hillock"—which, as it grew high enough to suggest a flat-topped mountain, offered inhabitants the advantages of being defensible against enemy warriors and flash floods.

As civilizations developed, people found new structural uses for earth and stone. Those who followed in Cain's footsteps—as tillers of the ground, that is—soon realized that they could increase their agricultural output by digging irrigation ditches to redirect river and lake water to their crops. To increase the extent of arable land, they terraced mountainsides, which helped to retain rainwater. They also learned to conserve water by constructing earthen dams.

To expedite trade and travel, people built roads, tunneled holes in mountains, and dug canals for their ships. They constructed earthen ramparts and excavated moats around their communities to keep out unwelcome visitors. They buried their dead under mounds of earth or laid them to rest in mountainside cavities which they carved out of "living rock" (a mass of stone that exists in its original geological setting.) In addition to reshaping the land for agricultural, commercial, and defensive uses, people in various parts of the world rearranged the landscape to create monuments that reflected their cosmological or religious views. A great many monks of the Buddhist, Christian, and Hindu faiths had at least one thing in common: an intense dedication to carving temples and churches out of living rock.

I learned at an early age that buildings could be constructed out of mud-bricks—not so very different from the mud pies I made in the backyard of my parents' house in the San Fernando Valley, north of Los Angeles. In the early 1940s my elementary-school teachers taught me about our region's historic adobe buildings, examples and remnants of which still remained, dating from "frontier days" when Alta California was under first Spanish, and then Mexican, rule. Some of the buildings were in ruinous condition, existing as little more than the lower courses of mud-brick walls. On Sundays I attended mass at Mission San Fernando, a vintage adobe-brick landmark that was part of the chain of missions that Junípero Serra, the Spanish Franciscan padre, founded in California in the late 18th century. Shortly after Mission San Fernando was completed in 1806, an earthquake clobbered it, but some of its rubbled remains could still be seen on the property. A second adobe structure was put up in 1818, and it was this one with its thick walls (which kept the interior impressively cool on even the hottest days) that entranced my youthful imagination. Adobe walls and red-tile roofs seemed to me as fundamental a part of the Southern California environment as the grove of orange trees I walked by on my way to elementary school.

Being aware that people could heap up mud structures to worship their gods, it did not altogether astonish me to learn later that some individuals wanted to reconfigure the surface of the earth for purely aesthetic pleasure. In the late 1960s, I became acquainted with a few artists who were venturing into large, open landscapes to create immovable, occasionally impermanent, pieces that were then known as "Earth art" or "Land art." Both terms are still in use but were later eclipsed by the more prevalent and awkward-sounding label, "site-specific art."

I became interested in Earth art in 1968 through Robert Smithson and Michael Heizer, who soon proved themselves to be masters of the "new" medium. Smithson, who was then 30 years old, had been exhibiting his drawings and sculptures in Manhattan galleries for several years. If he was among the gloomiest intellectuals I've ever met, he was also one of the most fascinating because of his relentlessly ruminative mind, which offered odd and original slants on a broad range of topics, from paleontology and the industrial wastelands of his native New Jersey to the imaginative fiction of Jorge Luis Borges. I listened raptly to his curious views during the course of many dinner conversations.

At Max's Kansas City, the New York art world's major watering hole, Smithson and I sometimes shared a table with Michael Heizer, a promising 23-year-old artist from California. Heizer virtually seethed with ambition but seemed conflicted about becoming enmeshed in the New York art world, insisting that he wanted to make large-scale outdoor works that galleries would be unable to accommodate. He had already constructed a group of impermanent sculptures in the Mojave Desert in California by digging geometric and sometimes trenchlike figures in the sunbaked soil. As I was then an assistant art editor at *Life*, I persuaded my superiors at the magazine to send a staff photographer to document Heizer's next desert outing. That journey resulted in Heizer's Nine Nevada Depressions, a set of linear loops, troughs, and zigzags carved out of the crusty surface of the earth with a pickax and shovel and collectively distributed over a desolate, 520-mile-long stretch of land. One of those Depressions, *Isolated Mass/Circumflex #2*, was a 120-foot-long, gracefully curved trench with a single loop in the center; dug out of the dessicated basin of Nevada's Massacre Dry Lake, it was best visible from the air. Now, more than a quarter of a century later, the piece still strikes me as one of the most significant artworks of 1968: its dimensionality seemed entirely horizontal ("below grade," even), and its existence was inseparable from its site. Two years later the Earth art movement definitively arrived with the completion of Heizer's *Double Negative* and Smithson's *Spiral Jetty*.

Earth art made me look at the world around myself with newly opened—and more critical—eyes. I could now focus my attention on the formal and functional characteristics of many seemingly commonplace earthworks and consider them in a larger design context. I found much to admire in the way that farmers terraced entire mountainsides to make them agriculturally viable. Even lowly drainage ditches, if they assumed an unexpected

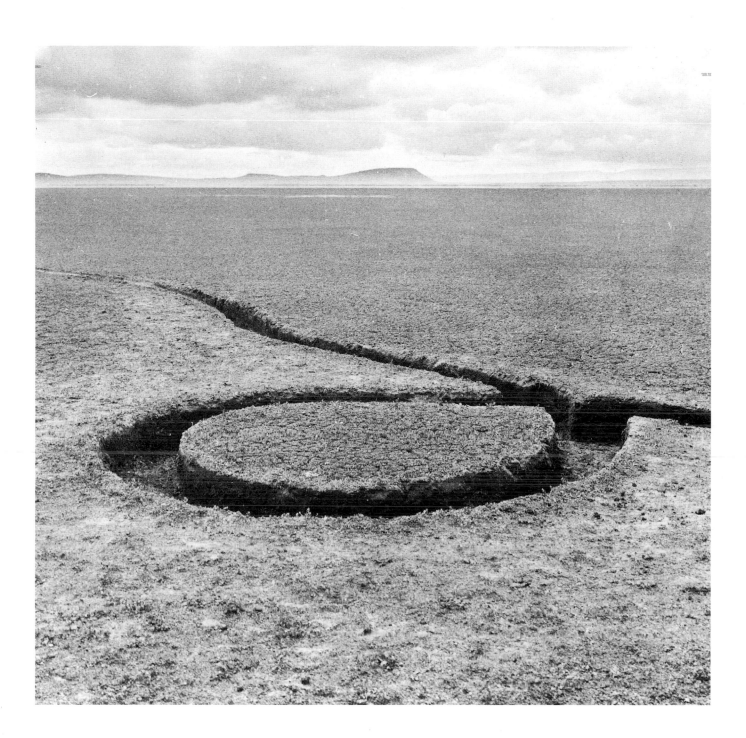

Michael Heizer. *Isolated Mass/
Circumflex (#2)*. 1968. Excavation
in playa surface, 120 x 12 x 1'.
Impermanent installation at
Massacre Dry Lake, Vya, Nevada.
Commissioned by Robert C. Scull.
Photograph by Michael Heizer.
*This was the ninth and last of a
series of Nevada Depressions that
Heizer carved out of desert basins
between June and September 1968.
The linear trench loops around a
circular segment of earth, which
constitutes the "isolated mass."*

configuration, suddenly became interesting. I developed an appreciation for earthen military fortifications, from ancient ramparts and medieval moats to 20th-century trenches and foxholes. Gradually, it dawned on me that this important heritage of design has been largely overlooked by history.

Why is it, I wondered, that people on different continents, usually unknown to each other, demonstrated similar ingenuity in reconfiguring their landscapes? Was it simply so obvious to farmers everywhere that they had to terrace their hillsides? Was it really self-evident that mourners should deposit their dead under mounds of earth or in rock-cut vaults? Was there something in their genetic makeup that inspired townspeople to construct earthen ramparts bordered by ditches to put their attackers at a disadvantage? What did the religious hope to achieve with their rock-cut churches and temples? Were they burrowing into the earth to get closer to their gods? Even a celebrated rock-cut artwork, such as the four presidential faces imposed on Mount Rushmore, is equivocal, existing as monumental portraiture in the form of landscape.

Most histories of art and architecture ignore the design of earthen structures, perhaps because the materials seem too humble, the designs too commonplace. The designers themselves are usually anonymous, and sometimes even the purpose of their structures is no longer apparent. Dating an ancient or even medieval earthwork is all but impossible unless the structure includes an artifact of organic origin that can be subjected to carbon 14 testing, the most useful means to assess the age of archaeological finds. (Carbon 14 is a radioactive isotope in the earth's upper atmosphere that leaves measurable traces on virtually all organic matter, from bones and antlers to straw and charcoal. When an organism dies, its residual carbon 14 content, which decays at a constant rate, enables scientists to determine the age of the once-living material.) The carbon 14 dating technique, devised by American chemist Willard F. Libby in the late 1940s, prompted radical revisions in the dating of Neolithic cultures, revealing, for instance, that the origin of farming in the Near East was about 3,000 years earlier than the previously accepted date of 4500 B.C.

If datability and functionality are frequently cryptic, durability is an altogether more universal problem. Mud-brick houses and churches were not designed to withstand the scrutiny of historians who came along many centuries—or even millennia—later. Earthen structures erode easily and tend to be swept away by winds and rains. Entire mud-brick communities have vanished from the face of the earth. Roads and canals that were heavily trafficked in ages past ultimately disappeared from sight, sometimes to be rediscovered in the 20th century through aerial photography.

Even as traces of ancient civilizations come to light, we must realize that much of humankind's history is forever lost to us. We can no more grope our way into the thinking of the native Americans who built earthen mounds throughout the Ohio River Valley more than 1,000 years ago than we can re-create the aggrandized feelings of nationalistic pride that led to Gutzon Borglum's carving of Mount Rushmore in the 1920s and 30s.

Today we can only speculate about some long-missing marvels, such as the famous hanging gardens of Babylon, one of the seven wonders of the ancient world. Classical historians attributed Babylon's hanging gardens to Sammu-ramat (whom the Greeks called Semiramis), queen to Shamshi-Adad V, the Assyrian king who ruled from 823 to 811 B.C. But present-day scholars are more inclined to think they were constructed by Nebuchadnezzar II (c. 605–562 B.C.), who sited them close to his palace for the pleasure of his wife, Amytis. The gardens apparently assumed the form of an artificial, terraced mountain, the terrace floors made of baked mud-brick to contain the earth in which trees and flowers were planted. Contemporary observers were astonished by the expertise of the hydraulic engineers who somehow contrived to lift the water mechanically to the topmost terrace. Sophisticated irrigation works existed, of course, throughout Mesopotamia, and Nebuchadnezzar certainly had the fiscal resources to open all faucets.

Under Nebuchadnezzar, Babylon became the greatest city of its time. During his reign, he constructed buildings whose architectural splendor is still renowned—a metropolis of

mud-brick buildings and walls. The royal buildings were constructed of fired bricks, lavishly decorated with glazed-brick friezes. Nebuchadnezzar was justifiably proud of the "great wall" he had built on the outskirts of the city so that, as he put it, "the evil and the wicked might not oppress Babylon." "Its moat I dug," he said, "and its inner moat-wall with mortar and brick I raised mountain-high. About the sides of Babylon great banks of earth I heaped up. . . ." Two sets of mud-brick fortification walls, each several yards thick, enclosed the city. Outside the walls, an outer moat, perhaps more than 100 yards wide, offered further protection, while within the walls, an inner moat, about 55 yards across, linked up with the river Euphrates, which flowed through the center of town.

Babylon was still a mighty city in 331 B.C., when Alexander the Great, fresh from his decisive victory over the Persians, led his army there. As the 25-year-old hero approached the massive mud-brick walls, Babylon's dignitaries flung open the city gates and came out to welcome him. The Macedonian soldiers enjoyed Babylon's hospitality for five boisterous weeks, while Alexander made himself at home in Nebuchadnezzar's 600-room palace and declared he would make the metropolis the eastern capital of his empire. Upon visiting the hanging gardens, he expressed his wish to add some Greek flora to the botanical collection that was already there. His wish was carried out, but most of the Greek transplants perished in the Mesopotamian heat. In time, the brick terraces, too, would come tumbling down. Today, however, even Babylon's ruins are impressive, covering more than 2,000 acres.

Now, more than two millennia after Babylon's heyday and despite the development of more sophisticated building materials, many architects, engineers, and designers continue to exploit the structural potentials of earth and living stone. Their designs for earthen dams, dikes, and artificial islands are often marvels of inventiveness. The laborers no longer carry baskets of soil, of course, because it is more efficient to rearrange the surface of the land with giant earthmoving machinery. Perhaps, like many of their antecedents, some of today's earthworks will become wondrous, if enigmatic, landmarks for future civilizations.

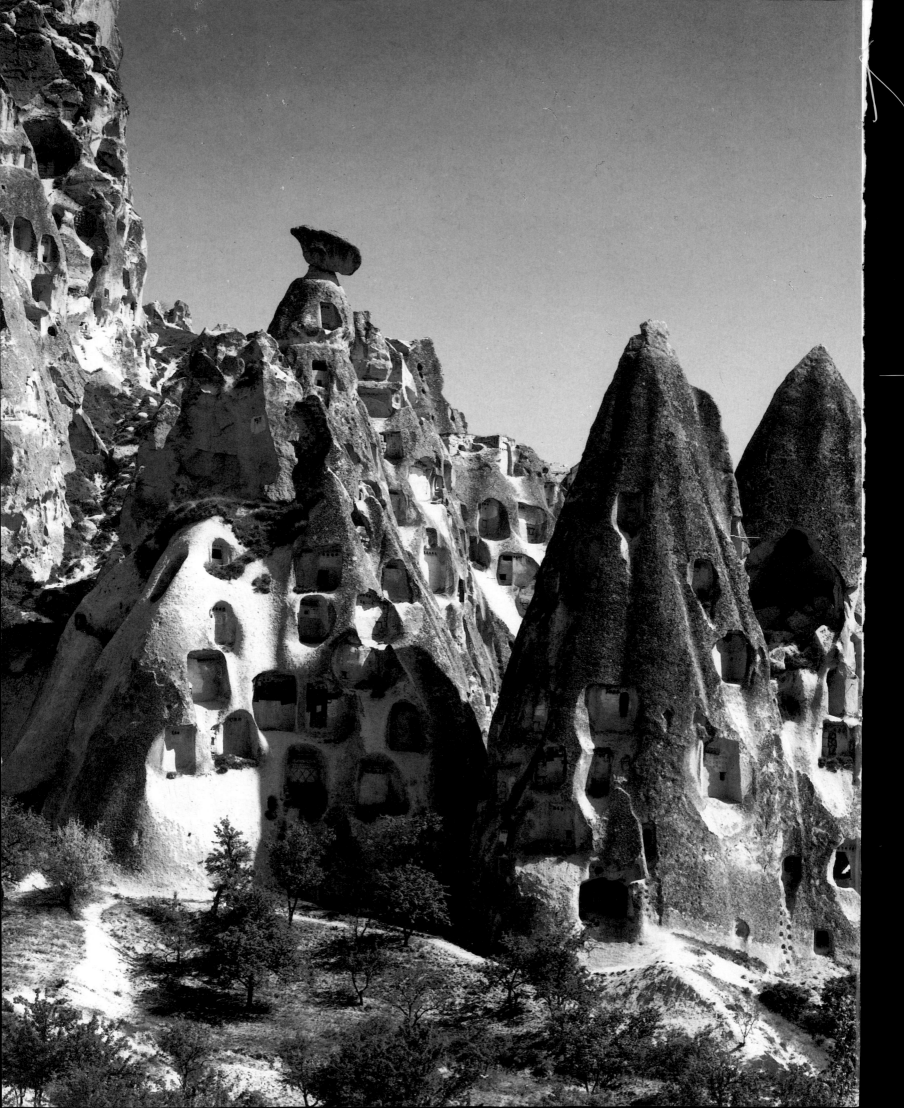

Shelter

Be It Ever So Humble

Natural caves and rockshelters provided many of our earliest ancestors with convenient and secure shelter—and probably prompted their first glimmering concept of architectural space. Initially transient by nature, our forefathers and foremothers seldom installed themselves in such cavernous quarters for very long, preferring to move on in pursuit of food. Eventually, in many parts of the world, groups of people settled down in riverside communities, where they typically built freestanding huts from the clayey mud that they gathered at the water's edge.

The ground surface of Earth is a wonderfully varied terrain that lends itself to numerous structural uses. Residents in the ancient Near East typically built their dwellings with mud-brick. Prehistoric peoples in China, Korea, and Japan often lived in semi-subterranean pit houses, which they roofed over with animal skins or plant materials. Reclusive individuals in Asia Minor carved domiciles out of volcanic rock. Viking immigrants to Iceland and prairie homesteaders in 19th-century Kansas made building blocks of turf from the ground. Earth, being readily available, has served as a building material for pueblos in New Mexico, clay houses in Mali, and adobe dwellings in Yemen. Many of these structures arouse the imaginations of today's householders, who long for a more natural and harmonious relationship to their surrounding terrain.

OPPOSITE: Cappadocian rock-cut dwellings, Üçhisar, Turkey. Photograph by Wim Swaan. As long as 2,000 years ago, settlers in Anatolia discovered they could carve multistoried living quarters in bizarre towers of volcanic rock.

Homo erectus, who originated some 1.6 million years ago in Kenya, exemplified a turning point in evolution because he was discernibly more human than ape. He appears to have been the first bipedal primate mammal to successfully emigrate from Africa, arriving in Asia about 1 million years ago and reaching Europe some 600,000 years later. On both continents, he and his companions were communal cave dwellers on a seasonal basis. In 1920 bone fragments of some 40 of these primitive humans were found in a hillside cave at Zhoukoudian, southwest of modern Beijing. (For decades the remains were popularly known as "Peking man.") Traces of ancient hearths and charred animal bones suggest that the Zhoukoudian cave dwellers had resided in the area some 350,000 to 400,000 years ago.

Like *Homo erectus*, *Homo neanderthalensis* ventured forth from Africa but headed primarily for Europe, where he established himself about 125,000 years ago. As Europe was then an extremely cold place, it is no wonder that Neanderthal man frequently made himself at home in caves and rockshelters. (He is named after Germany's Neander Valley, where limestone quarriers first found his remains, in a cave near Düsseldorf, in 1856.)

A related species of humankind, dubbed *Homo sapiens sapiens*, apparently arose in South Africa some 100,000 years ago and also made an outward migration, peopling the entire world. Like his forerunners, *Homo sapiens sapiens* sought refuge in caves and rockshelters. Those who lived in western Europe, particularly in southwestern France and northern Spain where caves and rockshelters were abundant, could be a finicky lot, making deliberate structural modifications of their otherwise natural quarters. At Cueva Morín and El Juyo in northern Spain, the people who occupied natural shelters about 10,000 years ago built walls to make their quarters more habitable. The residents of several caves in this part of the world paved their living rooms with cobblestones.

While early people in western Europe and eastern Asia often chose to live in caves, it is unlikely they stayed in them year-round. Instead, groups of *Homo sapiens sapiens* would have made seasonal journeys to follow their food supply, probably tracking the migratory paths of larger mammals. In mild weather they would have set up camps by rivers and streams, where they could fish and hunt. Their outdoor shelters were typically constructed of timber, thatch, and animal hides—all perishable materials and therefore underrepresented in archaeological findings. Cave dwellings, by contrast, tend to be overrepresented in archaeological literature because their bedrock so conveniently preserves evidence of prehistoric occupation.

THE BERINGIAN CONNECTION

Homo erectus and *Homo neanderthalensis* never set foot in the Americas—at least no verifiable trace of their existence has ever turned up there. But *Homo sapiens sapiens* migrated from Siberia to Alaska and brought his cave-dwelling habits with him. This migration could have occurred in stages during the tens of thousands of years prior to about 10,000 B.C. Beginning about 75,000 B.C., glaciation gradually lowered the sea level by hundreds of feet, converting what is now the ocean floor into a continuous land mass that physically connected Siberia to Alaska. (Even today, the Bering Strait is only about 55 miles wide and no deeper than 160 feet—and often frozen over in winter.)

From Alaska, the Asian immigrants fanned eastward and southward. At Bluefish Caves in the western Yukon, occupied 12,000 or so years ago, they left behind stone tools that had possibly been used in the pursuit of mammoths, bison, and caribou. At Utah's Danger Cave, some 50 miles southwest of Great Salt Lake, inhabited about 9000 B.C., residents abandoned thousands of artifacts, including stone points (the sharpened, wedge-shaped tips used in weaponry), milling stones, and bone tools, as well as fiber nets and baskets. In Mexico, in the valley of Oaxaca, bands of hunter-foragers, beginning in the mid-ninth millennium B.C., periodically occupied Guila Naquitz Cave.

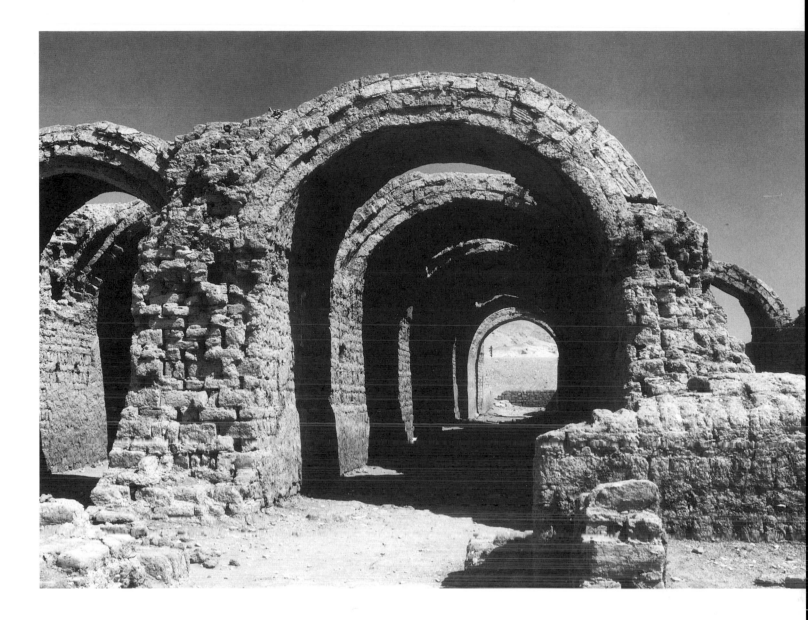

Mud-brick storehouses, c. 1260 B.C.
Luxor, Egypt. Photograph by Wim
Swaan. *Builders in ancient Egypt
packed Nile mud into molds and
utilized the resulting sun-dried
bricks to construct houses, palaces,
and town walls. These barrel-
vaulted structures were part of a
mortuary temple built for Ramses II.*

In South America the new arrivals found an ample array of caves awaiting their occupancy. The Guitarrero Cave, 8,500 feet above sea level in the Peruvian Andes, was occupied as early as 8000 B.C. In northwestern Brazil hunters took up residence in a rockshelter known as Toca do Boqueirao do Sitio da Pedra Furada by 6000 B.C., possibly thousands of years earlier. The migrants reached the end of the line—Tierra del Fuego, the archipelago off the southernmost tip of South America—by 9000 B.C. At Palli Aike Cave, in Patagonia, cremated skeletons of two adults and a child were found that appeared to date from the ninth millennium B.C. At Fell's Cave, also in Patagonia, carbon 14 dating established human occupancy between 9000 and 8700 B.C. On the basis of archaeological evidence, some experts conclude that it took less than a thousand years for people to migrate all the way from Beringia to Tierra del Fuego.[1]

THE MIDDLE EAST: PIT HOUSES AND MUD-BRICK DWELLINGS

In the ninth millennium B.C., people in Palestine and Syria excavated round pit houses, which they positioned in clusters to form villages. The circular holes they scooped out of the ground were only a few feet deep but sufficient to shelter them from the wind and dramatic changes in temperature. They could have assembled roofs from any combination of available materials, such as branches, thatch, and animal skins. During the sixth millennium B.C., builders in Syria constructed circular above-ground dwellings of tamped clay. A couple of thousand years earlier, in Jericho, one of the world's oldest cities, people were building round houses of mud-brick.

Several hundred miles north of Jericho, on the Anatolian peninsula, another thriving mud-brick metropolis, Çatal Hüyük, flourished from about 6500 B.C. to 5800 B.C. (The Turkish word *hüyük*, equivalent to the Arabic *tell*, is used to describe the massive multilayered mound of rubble that remains from successive mud-brick villages that were constructed on the same location over many generations.) This community covered 32 acres and held an estimated 5,000 to 6,000 people, who lived in a clustered arrangement of one-story flat-roofed houses that shared adjoining walls. The exterior walls of the outermost houses presented a continuous barrier, uninterrupted by doors or windows, a clever scheme for communal security that certainly must have discouraged unwelcome visitors. Residents entered their living quarters by ladders that extended through holes in the roof.

OPPOSITE: Detail of mud-brick facade, c. 625–560 B.C. Babylon, Iraq. Photograph by Roger-Viollet. *Some of Babylon's palace walls, as well as its famed Ishtar Gate, were embellished with molded brick reliefs representing bulls and dragons.*

Mud was the predominant construction material throughout much of the Middle East. Few materials are as adaptable as sun-dried mud-brick, which enables builders to easily alter or enlarge existing structures. In ancient Mesopotamia the region between the Euphrates and Tigris rivers was virtually devoid of stone and timber but was extremely rich in the alluvial sludge that spread from the lower courses of those two rivers. By 6000 B.C., villages of mud huts began springing up in the area. By 3500 B.C., many cities had emerged, including Ur (birthplace of Abraham), Uruk, Lagash, and Nippur. Mesopotamian mud-brick architecture probably attained its apotheosis in sixth-century B.C. Babylon (about 50 miles south of present-day Baghdad) under the administration of Nebuchadnezzar II.

Palestinian pit houses had a troglodytic counterpart in the Negev desert region of southern Israel, where archaeologists uncovered evidence of an underground settlement apparently dating from 3000 B.C. Its makers had provided the subterranean community with a maze of winding tunnels that led to large rooms and storage areas. The below-grade setting undoubtedly provided occupants with relief from the torrid heat.

As for ancient Egyptian architecture, most historians tend to focus only on its famous stone monuments. While the Egyptians reserved their precious limestone for the construction of pyramids and other imposing structures, they relied on down-to-earth mud-brick for their relatively mundane buildings, including palaces, houses, storehouses, and the walls that surrounded temple precincts and towns. Nurtured by the annual flooding of the Nile, which fertilized adjoining fields, the Egyptians took additional advantage of the river by making mud-bricks, which they shaped in molds and then left to dry in the sun.

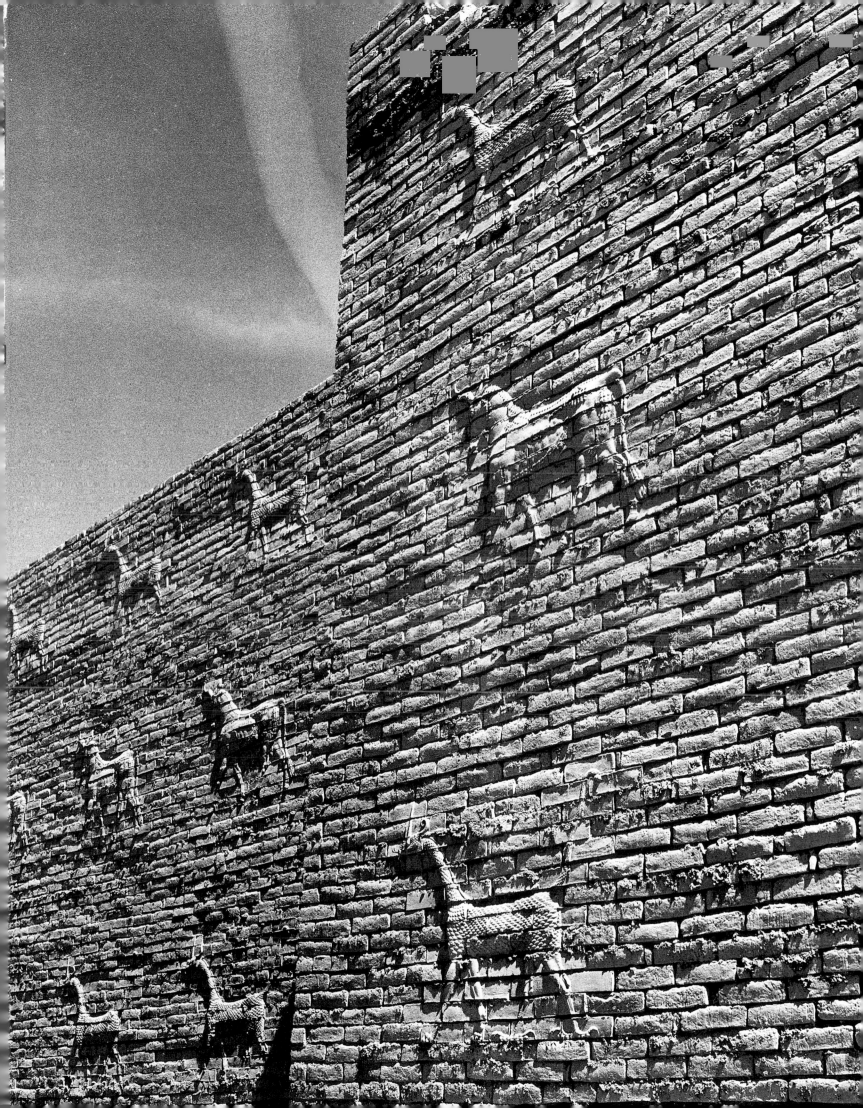

RIGHT: Mohenjo-Daro, c. 2400–1700 B.C. Sindh Province, Pakistan. Photograph by Douglas Waugh. *Once home to more than 30,000 inhabitants, this enigmatic city in the Indus River Valley contained many two-storied houses of kiln-fired mud-brick.*

BELOW: Subterranean village. Henan Province, China. Photograph by Wulf-Diether Graf zu Castell, c. 1920. Deutsches Museum, Munich. *Underground housing in China dates back to about 5000 B.C. These dwellings are shielded from high winds and harsh temperatures.*

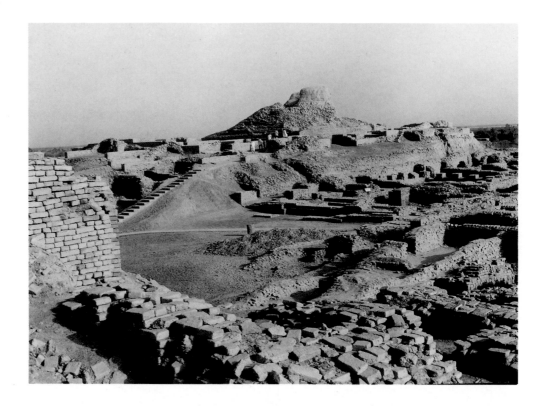

Mud-brick housing appeared in the Indus River Valley toward the end of the third millennium B.C. The remnants of two large mud-brick cities, Mohenjo-Daro and Harappa, were rediscovered there in the 1920s. Mohenjo-Daro was sited in what is now southern Pakistan, and Harappa was built some 400 miles to the north, in the Pakistani Punjab. Both cities apparently flourished between 2400 and 1700 B.C., although neither is mentioned in any surviving records. Each settlement may have held 30,000 to 40,000 inhabitants.

Mohenjo-Daro and Harappa contained spacious two-storied houses constructed of kiln-fired bricks, the manufacture of which would have consumed tremendous quantities of fuel. The dwellings were outfitted with bathrooms and drains. In the poorer districts smaller mud-brick dwellings consisted of only two rooms. The larger houses were generally laid out around an inner courtyard, which may have had overhanging wooden balconies on the second floor. None of the dwellings had windows that opened onto public places. Streets were straight, based on a regular grid plan, and impressively large—up to 12 yards wide.

Both cities were fortified. Mohenjo-Daro's citadel was situated on an artificial mound, about 40 feet high and composed of plain mud, as well as both sun-dried and kiln-fired mud-brick. Walls and towers presumably deterred enemy attacks, while massive embankments were perhaps intended to protect the mound against floods. Not the least of many mysteries generated by Mohenjo-Daro and Harappa is why the cities became depopulated. Some experts, noting that the course of the Indus River was not fixed, speculate that floods periodically and perhaps permanently ravaged both cities.

In ancient China building techniques were considerably less sophisticated than those of the Indus Valley. Many early residents lived in pit-house villages, one of the earliest being Pan-p'o, dating from about 5000 B.C., recently "unearthed" near the city of Xi'an in Shanxi Province. Round pit houses, probably occupied by single families, were 10 to 15 feet in diameter and as deep as nine feet below ground level. All the semi-subterranean buildings had timber supports for steeply pitched thatched roofs. The settlement contained about 100 houses and was surrounded by a ditch and earthen bank. At a nearby site, another early settlement, Chiang-chai, consisted of houses arranged in roughly concentric circles and facing the center of the village. The houses were built on low mounds of packed earth, with their floors sunk below ground level. Homebuilders plastered floors and interior walls with clay and straw, and set roof-supporting posts on stone bases. This community too was surrounded by a ditch.[2]

Near Anyang, which lies north of the Yellow River in Henan Province, archaeologists uncovered a village, Hsiao-t'un, consisting of 47 pit houses and apparently dating from the third millennium B.C. Each house had a large semi-subterranean living space with straight walls, as well as several smaller storage pits surrounding it. Wooden posts, set on large, centrally positioned stones, probably supported wattle-and-daub roofs.[3] (Wattle and daub, a construction technique widely used over the millennia, typically involves a framework of plant materials, such as branches, reeds, and twigs, plastered with clay.) At the same location, excavators also found remnants of 53 rammed-earth foundations for above-ground structures. Most of the foundations were square or rectangular; the longest was nearly 91 yards in length and over 15 yards wide. The long-vanished buildings are thought to have been palaces or temples, not only because of their uncommonly large size but because of their sacrificial burials—more than 600 human victims associated with just one structure.[4]

During Shang-dynasty China, which lasted from about 1766 to 1027 B.C., both house walls and city walls were typically constructed of rammed earth, following a standardized technique that would remain in use for centuries to come. Builders placed a framework of wooden planks on either side of the new wall, poured in several inches of dry soil, tightly compacted the earth with heavy pounding tools, then moved the wooden forms to repeat the process at a higher level. Large stones or bronze castings were inset in the earthen foun-

dations to provide a solid base for wooden pillars that held up the roof. A well-made building typically had plastered earthen walls, wooden pillars and cross beams, and a roof that may have been composed of any blend of thatch, rushes, grass, and bamboo.

The Shang state enveloped hundreds of walled towns, traces of which are particularly prevalent in Henan province. At Anyang, a dynastic capital, several palatial buildings, some possibly two stories, were erected on massive pounded-earth terraces that sometimes were more than a yard high. An early Shang city lies largely buried under the present-day metropolis of Zhengzhou, the capital of Henan Province. Discovered in 1955, its tamped-earth city wall was roughly square in plan, with sides that measured approximately 1,800 and 2,000 yards in length.[5]

Pit houses dug out of a soft and loamy soil, known as loess, became a traditional form of dwelling for millions of Chinese in the northern provinces of Gansu, Shaanxi, Shanxi, and Henan. Loess in this part of China is a silty, yellowish earth, originating on the Mongolian plateau and blown southward by cold winds. Over the centuries it piled up in thick deposits, attaining heights from about 100 to more than 300 feet. Less dense than clay and less porous than sand, loess could be carved into underground dwellings with vertical walls. Farmers lived in "downstairs" dwellings, shielded from high winds and harsh temperatures, while cultivating "upstairs" fields. Sunken courtyards provided natural light and ventilation. Loess, however, is not the most rigid of building materials. In 1920 an earthquake in Gansu Province smothered entire villages, burying nearly 250,000 people.

People in Neolithic Korea and Japan also lived in pit houses. In the early 1970s, near the Han River in South Korea, excavators found 20 pit-house foundations, mostly round or rounded-off squares in plan. Dwellings were 12 to 19 feet in diameter and set about two feet deep into the ground. Walls were apparently constructed in tepee fashion, with slanted poles set at the four "corners" of the pit and covered with reeds. Each home had a central hearth made of river stones. In Japan some 7,500 years ago, people lived in pit houses with upright posts and thatched roofs. Settlements of between three and 10 such dwellings, each probably housing a single family, were usually located close to lakes, rivers, or the sea. By partly sinking the houses into the earth, builders were able to construct relatively large houses that, had they been entirely above ground, would have required substantial timbers.

THE AMERICAS: PIT HOUSES, EARTHEN LODGES, PLATFORM MOUNDS

As in Asia, pit houses were a favored mode of dwelling on the opposite side of the Pacific Ocean. As early as 4000 B.C., bands of "native" Americans, living along the lower Snake River in what is now the northwestern United States, spent their winters in pit-house villages. (Some of their later houses, dating to about 500 B.C., were surprisingly large, with diameters of 20 to 40 feet.) In Surprise Valley, in northeastern California, archaeologists have excavated pit-house villages that date from between 4000 and 3000 B.C.

By about 2100 B.C., in southern Oregon, the ancestors of Klamath Indians lived in large semi-subterranean earthen lodges. In the summertime they partially dismantled the dwellings and moved to brush shelters while their earthen quarters aired and dried out. Their neighbors, the Modocs, whose territory included part of southern Oregon and northern California, lived in similar lodges.

The building techniques would remain essentially unchanged for centuries to come. In British Columbia the ancestors of the Plateau tribes (Shuswap, Thompson, and Okanagan) also lived in semi-subterranean dwellings, excavated to a depth of about six feet and measuring about 13 feet in diameter. Their makers laid poles across the pits and covered them with layers of grass and earth. The tribes spent the winter months in villages of between five and 10 earthen lodges, situated in the sheltered canyons of the Columbia and Fraser rivers.

Far to the south, below the tropical shoreline of the Gulf of Mexico, where the modern states of Veracruz and Tabasco border each other, a robust civilization with the organization and manpower to create large-scale public earthworks arose during the first two mil-

lennia B.C. The Olmec people, as they are known, developed a sophisticated and complex civilization that flourished from about 1200 to 600 B.C. Olmec culture centered on several sites, the four most important being San Lorenzo, La Venta, Laguna de los Cerros, and Tres Zapotes. Most of them lie inland in a sort of arc that parallels the Bay of Campeche.

The builders of San Lorenzo situated their settlement on a natural plateau, to which they added thousands of cubic yards of earth to create a flat-topped platform. The Olmec diligently graded their terrain by hand. When they finished, the plateau rose more than 150 feet above the surrounding river basin and extended about three-quarters of a mile in length from north to south; the top 25 feet of the mesa-like platform were completely artificial, composed of clay, sand, and rock.

The Olmec used their immense, artificially enlarged platform as a foundation for hundreds of smaller earthen mounds, which served as the bases for temples, courts, and houses. Some mounds were pyramid-like in form and separated by plazas. The platform also held several stone monuments, including the colossal carved-basalt heads, five to 10 feet high, for which the Olmec are famous. The people of San Lorenzo also constructed an ambitious water system, devising 20 or more artificial ponds and an elaborate stone drainage system. But their luck seems to have run out about 900 B.C. Perhaps soil depletion caused the residents, who depended on maize cultivation, to abandon their laboriously constructed plateau.

Some of San Lorenzo's inhabitants may have moved to La Venta, which flourished between about 800 and 400 B.C. Nearly 50 miles northeast of San Lorenzo, La Venta was situated on a small island in a region of slow-moving rivers and estuaries. This Olmec center also featured an ambitious complex of earthen mounds and platforms, laid out in near-perfect symmetry on a north-south axis. Many of them probably served as the foundation for buildings constructed in more perishable materials, such as wood and thatch. The island complex was dominated by a 110-foot-high Great Pyramid, the largest of its time in Mexico.

La Venta's preeminence among Olmec centers was perhaps assumed by Tres Zapotes, which prospered between about 500 B.C. and A.D. 1. This community and another major Olmec settlement, Laguna de los Cerros, remain largely unexplored. The latter center had about a hundred earthen mounds, including conical, ridged, and pyramid-like forms, many of them still discernible today, lying enigmatically beneath a unifying mantle of green pasture.

On the opposite side of the Gulf of Mexico, an obscure culture of mound-building people, contemporary with the Olmec, came to power in what is now northeastern Louisiana. They are known mainly by their settlement at Poverty Point, situated along the Bayou Maçon near the town of Epps. The prehistoric community was probably built between 1500 and 700 B.C., but is named after a 19th-century plantation that later shared the site.

The most striking aspect of Poverty Point's design was its series of six concentrically aligned earthen ridges that collectively formed a nested "C," with its large semicircular open space facing the water. The ridges were three to four yards high, about 27 yards wide, and spaced some 50 yards apart. The outermost ridge had a diameter of about 1,400 yards. The earthen embankments are believed to have functioned as platforms for dwellings.

Because Poverty Point was contemporaneous with the Olmec center at San Lorenzo, many scholars have investigated possible connections between the two cultures. Although both mound-building communities had relatively easy access to the Gulf Coast and conceivably could have been linked by canoe trade, no evidence of any direct connection exists. Poverty Point's concentric ridges have no counterparts in Mesoamerica. Moreover, the agricultural and trading practices of the two cultures appear to have virtually nothing in common.[6]

Unlike the Poverty Point people, the Zapotecs, based in southern Mexico's valley of Oaxaca, did trade with the Olmec and shared some of their cultural characteristics. The Zapotec civilization, which prospered from about 400 B.C. to A.D. 800, was based at Monte

ABOVE: Plan of Poverty Point, c. 1500–700 B.C. Northeastern Louisiana. Drawing by William Morgan. *A little known Native American society constructed this settlement, situated on a bluff overlooking a bayou. The six concentrically aligned earthen embankments possibly served as platforms for dwellings. In this ground plan, oriented with north to the top, each square of the grid represents a 200 x 200-meter space.*

OVERLEAF: Laguna de los Cerros, c. 1200–600 B.C. Veracruz State, Mexico. Photograph by Kenneth Garrett. *The inhabitants of this Olmec settlement, located south of the Bay of Campeche, constructed nearly 100 earthen mounds. One of the largest faces a 260-foot-long plaza, flanked by earthen ridges.*

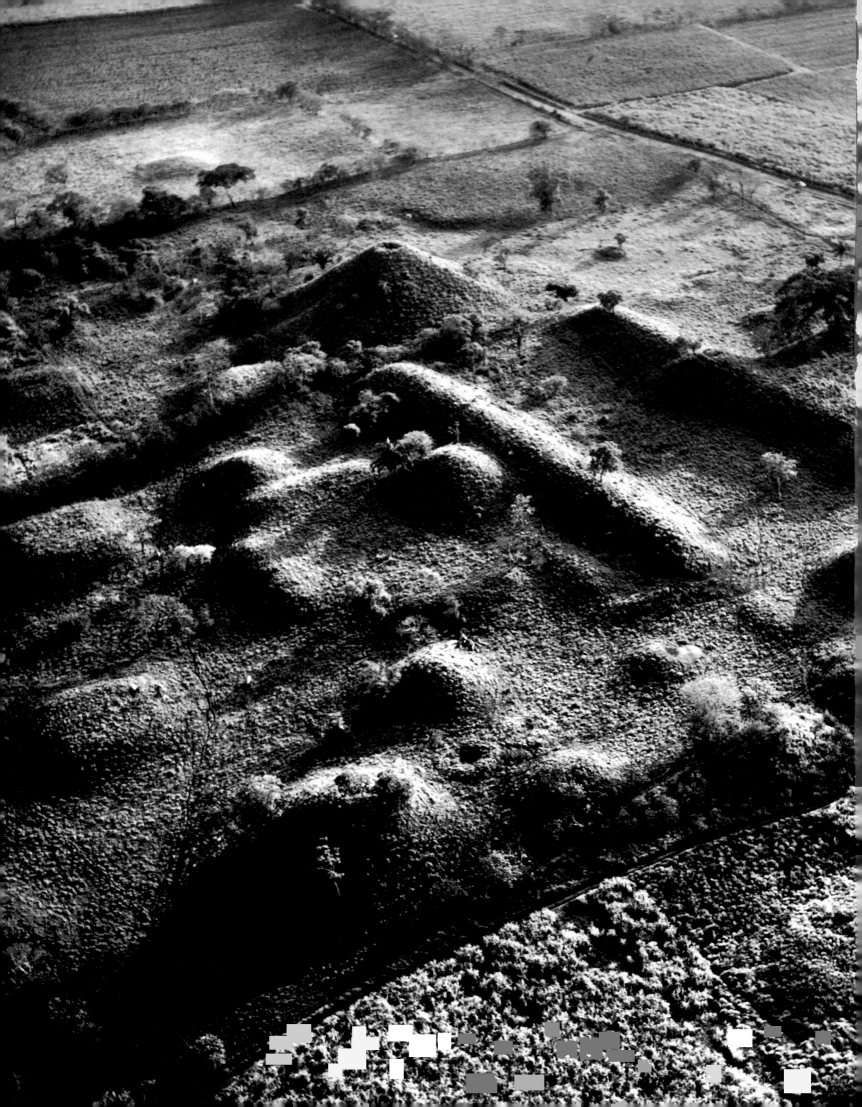

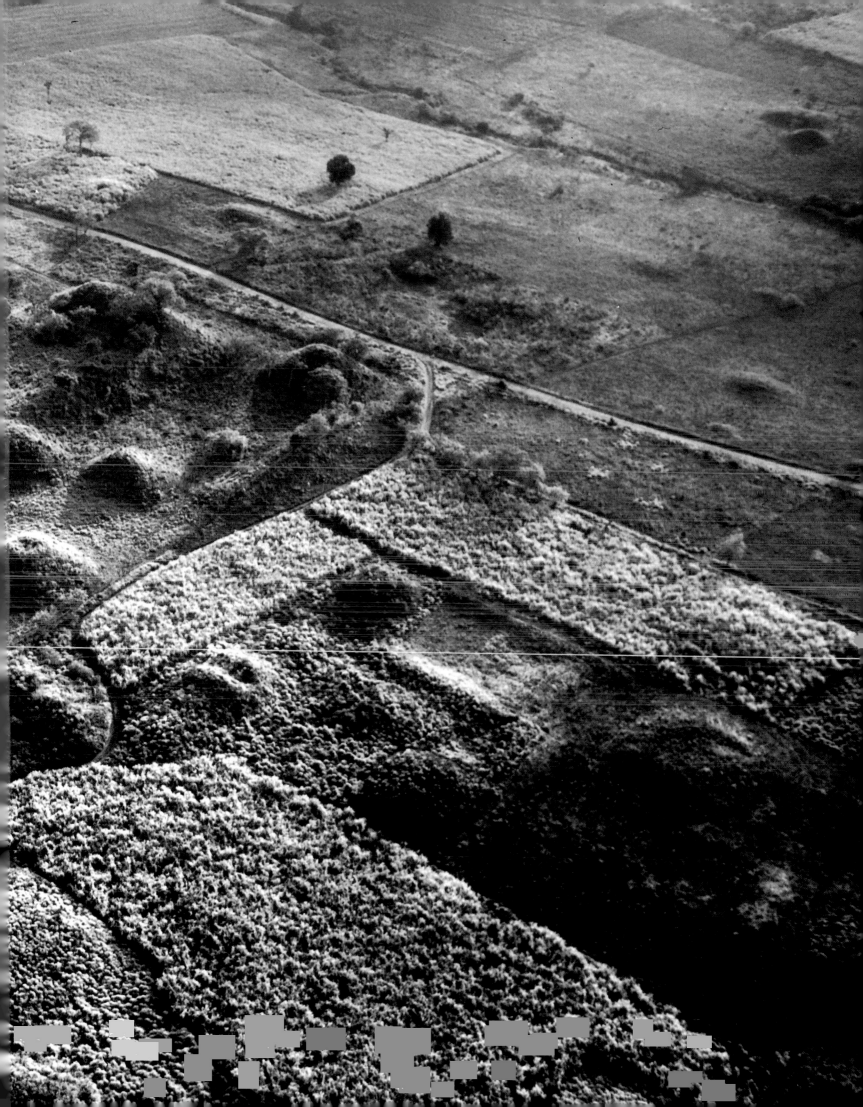

Albán, perched atop a steep 1,200-foot-high bluff. Zapotec planners sliced off the top of their mountain to create a flat surface, upon which they built a large complex of stone temples, pyramids, and palaces, separated by majestic plazas. The terracing was accomplished over nearly a millennium, but the bulk of the work is believed to have been done between 200 B.C. and A.D. 100. As Monte Albán's population swelled to 25,000 between A.D. 300 and 750, the people, needing additional space for their houses and other buildings, spilled over onto neighboring hillsides, carving up the slopes to form more than 2,000 terraces.[7]

ASIA MINOR: CAPPADOCIA'S ROCK-CUT DWELLINGS

Along the Aegean and Mediterranean coasts of Asia Minor, mud-brick housing became increasingly prevalent during the first millennium B.C. Homebuilders in ancient Smyrna (now Izmir), Tarsus, and other towns constructed mostly small, one-room dwellings on stone foundations. Farther inland, on the Anatolian plateau, where mud was scarce, a far more dramatic type of lodging prevailed. There, in a bleak region known as Cappadocia, people gouged living quarters out of bizarrely shaped rocks (see page 12).

Cappadocia, southeast of Ankara, is noteworthy for its weird and seemingly inhospitable landscape with clusters of tall rocks that suggest grotesquely disfigured cones or stalagmites. The southern edge of the territory is lined by a chain of volcanoes, which, some 50 million years ago, spewed layers of lava, cinders, and ash onto the surrounding terrain, blanketing a 20-mile-long stretch of land with a volcanic rock known as tuff (not to be confused with tufa, a calcareous rock formed by spring or river deposits). Over the millennia, wind, rain, and snow created huge fissures in the stone, eroding it into a multitude of conical towers, many of them rising between 30 and 100 feet in height.

By 400 B.C. (possibly earlier), settlers in the region began discovering they could carve shelters in the surrealistic-looking rocks. Cappadocia became a province of the Roman Empire in A.D. 17, but its out-of-the-way location necessitated a week-long journey from the main imperial trade routes. That remoteness from governmental authorities is precisely what made the desolate place so attractive to early Christians.

For more than a thousand years, Christian inhabitants excavated living quarters, chapels, and entire monasteries with refectories in the eccentric rock formations. In some cases they created multistoried dwellings with rooms ingeniously connected by labyrinthian passageways, sometimes so narrow that their occupants had to wriggle up or down narrow shafts or crawl through barely negotiable tunnels. When residents needed furniture, they carved it directly out of the stone, crafting built-in tables, benches, and beds.

Cappadocia's inhabitants tunneled underground as deep as 265 feet to create extensive labyrinthian settlements. Two multistoried "cities," established in the second century and occupied as late as the 13th century, were connected by a tunnel nearly six miles long. One of the cities could reportedly accommodate several thousand people on its seven levels.

The secretive residents typically situated the entrances to their dwellings on the "rear" face of a rock, away from main pathways where passersby might notice them. Many homes had a single place of entry, high above ground level, accessible only by a rope ladder that occupants could pull in after themselves. Where exterior rock-cut steps or footholds existed, they were typically steep, narrow, and unobtrusive. Most of Cappadocia's rock-cut churches date from about 900 to 1070, a period of protracted peace when emboldened inhabitants carved some of their more elaborate facades.[8]

IRISH RATHS AND CRANNOGS, VIKING TURF DWELLINGS

Homebuilders in medieval western Europe ordinarily had access to dense timber forests, so they seldom chose to gouge shelters out of stone. Nevertheless, many Frenchmen in the Middle Ages chose to hang their hats in austere dwellings that they carved out of living rock at Les Baux, nearly 20 miles east of Arles, in Provence. In Matera, a hilltop town in the

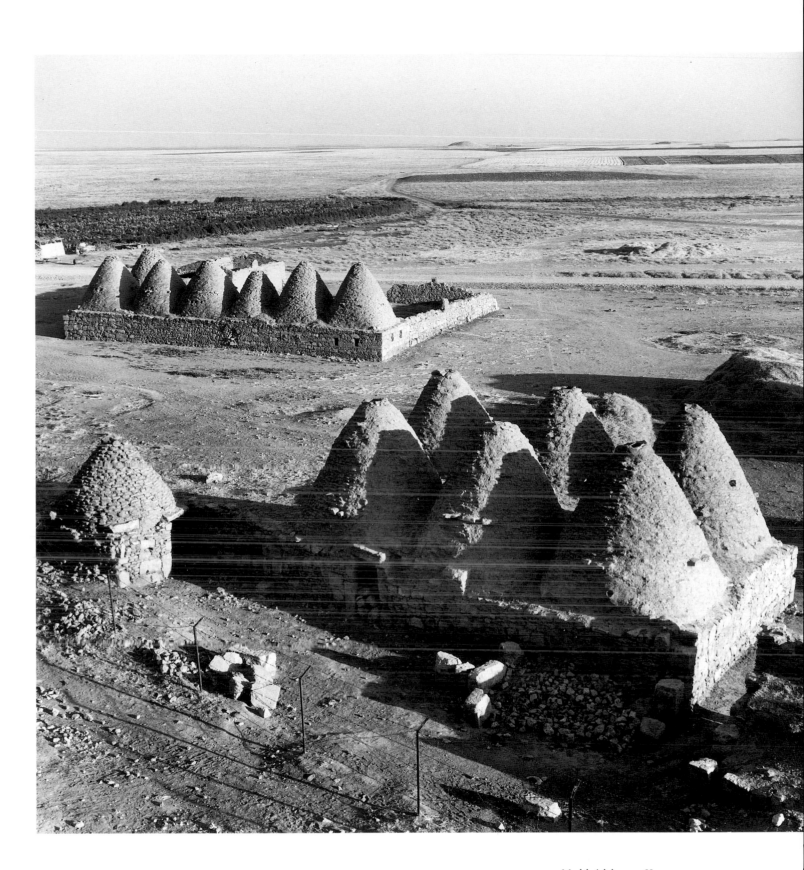

Mud-brick houses. Harran,
Anatolia, Turkey. Photograph by
Roger-Viollet.

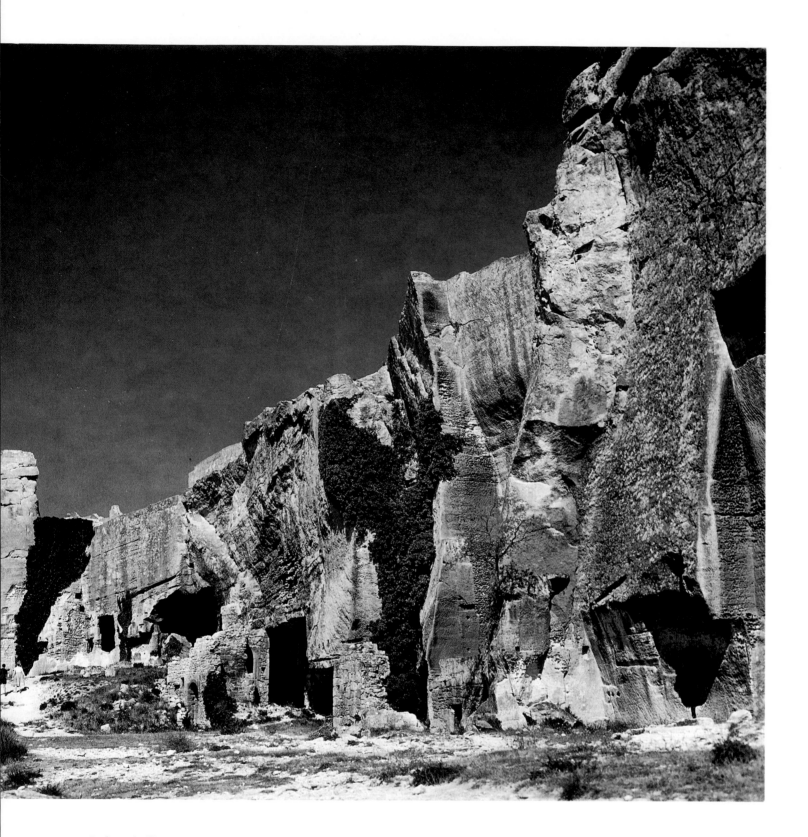

Rock-cut dwellings. Les Baux,
Provence, France. Photograph by
Roger-Viollet. *During the Middle
Ages, ascetic individuals in quest of
solitude and a solid roof over their
heads excavated living quarters and
sanctuaries in the rugged rocks.*

mountainous Basilicata region of southern Italy, homebuilders first began excavating living quarters out of steep, rocky slopes thousands of years ago. Benedictine monks colonized the area in the sixth century, carving their retreats and chapels in the tufaceous terrain for the next several hundred years. Their presence attracted other reclusive and not-so-reclusive types who left behind a total of nearly 3,000 stone-cut shelters.

Resourceful inhabitants of the ancient and medieval British Isles constructed three rather peculiar types of earth shelters whose obsolescent forms are reflected in their now-obscure names—souterrains, raths, and crannogs. Souterrains (from the French *sous terrain*, meaning "under ground") were subterranean chambers constructed by the native Celts during the Roman occupation. They typically consist of an excavated passageway that leads underground into a long gallery that sometimes branches into lateral rooms. The walls were lined with stone masonry, corbeled at the top to form a ceiling. Many souterrains had hearths. While they probably were not permanent habitations, they may have been useful to agrarian people who wanted to keep an eye on their crops or herds at particular times of year.

In medieval Ireland thousands of wary farmers protected their farmsteads, and often their livestock as well, by constructing raths, which were usually circular earthen embankments similar to the ramparts around hillforts. Most of them were built between the fifth and 11th centuries, although some seem to date from as early as 300 B.C. Farmers typically positioned their thatched wooden dwellings within earthen rings that were 100 to 150 feet in diameter. Raths smaller than 50 feet in diameter may have proved useful as cattle compounds. Serious rath-builders constructed several concentric earthen rings with outer ditches. Lisnagade Rath, in Northern Ireland, is the largest, measuring 370 feet in diameter.

Another distinctive type of Irish real estate is the crannog, an artificial fortified island constructed in a lake or marsh. Crannogs are part of a defensive tradition that goes as far back as 600 B.C. and continued through the Middle Ages. Their durability must have been impressive, because attacks on them were still being recorded in the 16th century. Clea Lakes Crannog, 20 miles southeast of Belfast, was a circular "island" constructed 200 yards from shore and apparently occupied as far back as the first century A.D. A 1956 excavation revealed that its foundations consisted of boulders and earth piled on the clay bottom of the shallow lake.[9]

The Irish had good reason to be defensive, especially from the 830s on, when Viking brigands began making almost annual raids on the island, where they made Dublin their regional capital. In their forested homelands in Scandinavia, the Vikings had been able to construct homes out of timber. But as they sought new lands to the north and west of the British Isles, they came upon bleak, treeless islands, where necessity inspired them to build shelters out of turf, constructing massive walls, up to six feet thick, on stone foundations.

A major stepping stone in the Vikings' trans-Atlantic migration was Iceland, mainly settled between 870 and 930. They established farms on which the primary building was a long, two-roomed turf dwelling. They later developed more elaborate buildings with several smaller rooms. In 1939 excavators cleared away a mantle of ash from an early 12th-century volcanic eruption to uncover the remnants of a turf farmstead at Stöng, on the southwestern portion of the island. While preserving the remains of the Stöng farm, scholars used its plan and many of its structural details as the basis for a full-scale reconstruction.[10]

The most renowned of the Icelandic Norsemen is the chieftain and seaman known as Eric the Red, a relative latecomer to the island who settled there in about 950. Unfortunately, Eric got caught up in personal problems (feud, manslaughter) that resulted in a three-year banishment. Therefore, in about 982, he sailed away from Iceland in search of a western land that one of his countrymen had spotted earlier. Eventually, he returned to Iceland with promising accounts of "Groenland," or Green Land, a name chosen with the shrewdness of a realtor trying to lure prospective settlers. Those who reached the new "emerald" island founded two main colonies, situated some 400 miles apart on the southwestern coast,

around Julianehab Bay and Godthab Fjord. They became known, respectively, as the Eastern and Western settlements. As Greenland has no forests, Viking settlers once again had to build their farmsteads of turf and stones.

Within a generation, Greenlanders could have boasted of Christianity's westernmost church. Eric the Red's son, Leif Ericsson, converted to Christianity and succeeded in converting his father's wife, Thjodhild, who had a turf-walled church built at the family farm at Brattahlid in about 1001. A framework of timber (probably imported) supported a turf-carpeted roof. (When archaeologists excavated Brattahlid, they discovered the remains of Thjodhild's small turf church a short distance from the main homestead.)[11]

From their bases in Greenland, Norse adventurers sailed westward across Davis Strait to explore the coast of Baffin Island. Continuing southward, they scouted the coastal regions of northeastern North America. Subsequent expeditions resulted in a short-lived colony that the Norse called Vinland, a region reputed to have fertile land, access to good fishing, and mild winters. In the early 1960s, archaeologists announced their discovery of Vinland on the northern tip of Newfoundland island, at a site now known as L'Anse-aux-Meadows. The archaeologists excavated the ruins of a settlement that had had an estimated population of 100, finding evidence of three groups of turf-built structures, each set of buildings possibly built and used by successive expeditions. The largest structure, 60 by 45 feet, contained a typically Norse great hall with a hearth in the middle. Some of the houses had stone fireplaces and ember pits, which are small square stone holes where coals were kept alive at night. Radiocarbon analyses of charcoal indicated the site had been occupied in about 1000. The experts are virtually unanimous in declaring L'Anse-aux-Meadows the only indisputable Norse site in North America.

The Vinland colony endured only a few years, but the Viking adventure in Greenland lasted five centuries. Eventually, however, the seafarers and farmers were unable to cope with all the hardships and setbacks that confronted them, including dwindling trade, deteriorating climate, and sporadic conflict with hostile natives, Arctic ancestors of the Inuit who competed with them in whaling and seal-hunting. By the middle of the 14th century, the Vikings abandoned the Western Settlement, and about 150 years later they gave up on the Eastern Settlement. By 1500, the Viking colonies were deserted, their residents having died out or sailed back to Iceland or Scandinavia.[12]

MISSISSIPPIAN MOUND BUILDERS, SOUTHWESTERN PUEBLO DWELLERS

If the Vikings had penetrated the North American continent to the Mississippi River, they would have encountered a race of Native Americans whose vast and imposing settlements featured enormous, geometrized earthen mounds arrayed around the edges of large rectangular plazas. Between about A.D. 800 and 1500, Native Americans of the so-called Mississippian culture established some of their most impressive communities in the upper Mississippi and Ohio valleys. They also created settlements in the lower Mississippi Valley, where the Poverty Point people had flourished more than a thousand years earlier. Many of their communities were D-shaped in plan, the straight side facing the river or stream and the curved side forming a moated enclosure. Within their watery boundaries, communities were often fenced in by a palisade of upright logs, situated atop an earthen embankment.

The Mississippian mound-builders were evidently tireless movers of soil, all of which had to be laboriously carried in baskets to the sites where they built their huge earthen platforms, which resemble truncated pyramids and cones, on top of which they placed their temples, council houses, charnel houses, chieftains' dwellings, and other structures. A hierarchy of chiefs, priests, and clan heads probably planned and designed the settlements, situating the major buildings on platform mounds in the center of town. The temples may have been constructed of timber and the dwellings were perhaps composed of some combination of wood, animal skins, and wattle-and-daub. All probably had overhanging thatched roofs. The platforms obviously provided protection against overflowing waters that may

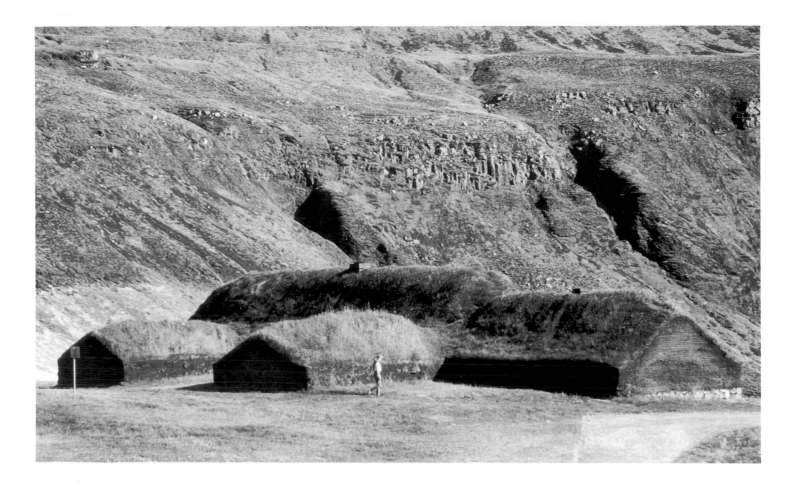

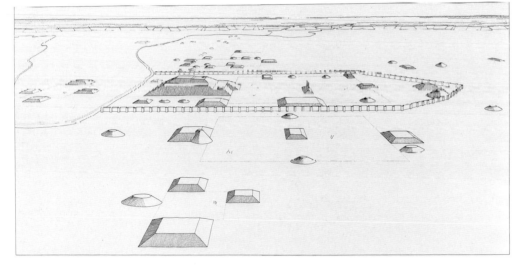

ABOVE: Viking turf farmhouse, late
11th century. Stöng, Thjórsárdalur,
Iceland. Photograph by Rafn
Hafnfjörö. *Lacking timber, Viking
migrants in Iceland constructed turf
farmhouses on stone foundations. In
1939, excavators uncovered the rem-
nants of a Viking turf farmhouse at
Stöng and used its plan as the basis
for this full-scale reconstruction.*

LEFT: Cahokia, c. 1050–1250.
Collinsville, Illinois. Perspective
drawing by William Morgan.
*Founded about A.D. 600 by
members of the Mississippian cul-
ture, Cahokia's 200-acre central
area contained 17 earthworks, some
of which functioned as platform
mounds for temples and houses.*

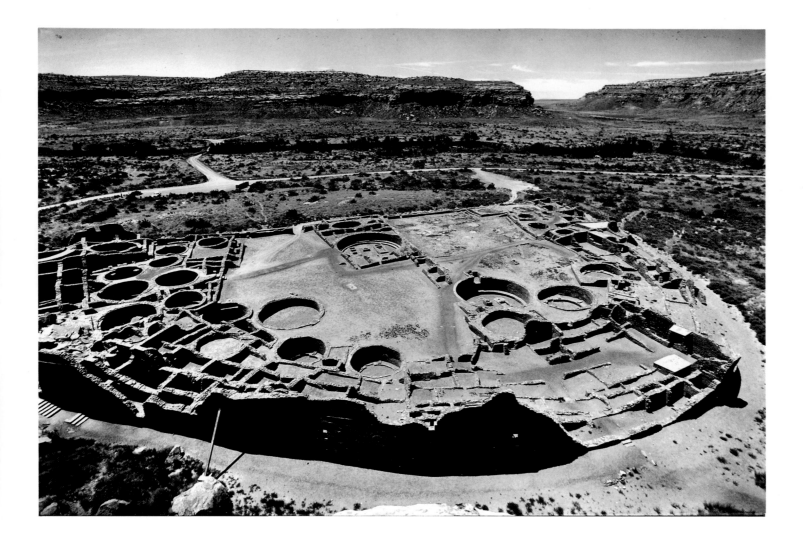

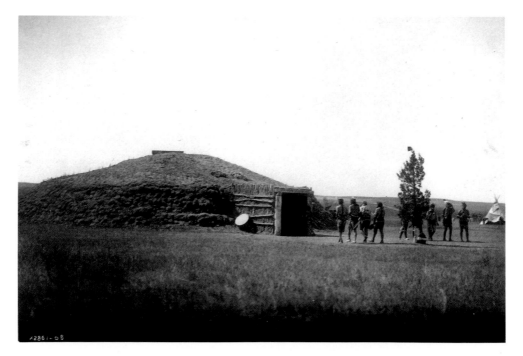

have followed heavy rainfalls or river risings. The higher the platform, the more eminent (presumably) were its religious and civil tenants. The formal similarities between Mississippian platform mounds and those of Mesoamerican cultures are unmistakable, but not a shred of evidence exists to establish any direct link between their civilizations.

The largest city of the Mississippian culture was Cahokia, much of which now lies under East St. Louis, Illinois. Founded in about A.D. 600, Cahokia was sited several miles south of the confluences where the Illinois and Missouri rivers flow into the Mississippi River, putting the city in an excellent position for trade and transportation. In its heyday, between 1050 and 1250, Cahokia was the largest town north of central Mexico and may have had approximately 120 mounds within an area of five or more square miles. (Today, about 80 of them are preserved in Cahokia Mounds State Park, which offers the largest concentration of surviving mounds anywhere in the United States.) The 200-acre central area of the city contained 17 earthworks and was surrounded on three sides by a defensive wall of upright logs and bordered on its fourth side by Cahokia Creek. The great majority of Cahokia's mounds were positioned outside the palisaded center city. Cahokia's mounds were geometrized forms, including flat-topped cones and pyramids as well as multistoried structures. As many as 10,000 people lived in the settlement.

Cahokia's centerpiece, Monks Mound, was an immense truncated pyramid with four platform levels, rising some 100 feet high, measuring 1,037 by 790 feet at the base and covering 16 acres. Built between 900 and 1200, it remains one of the largest earthworks ever constructed in the Americas, greater in volume than the biggest mounds at Poverty Point or La Venta. The imposing wooden temple that once crowned its topmost terrace must have been the focal point for the entire city.

Cahokia's glory days dimmed after 1250, when the city began sliding into an irreversible decline that eventually left it depopulated, a pattern that was mirrored in many contemporary communities throughout the eastern United States. By the time Europeans reached the banks of the Illinois and upper Mississippi rivers, the Mississippian culture had virtually vanished.

Of the many mound-building settlements in the lower Mississippi Valley, one—Troyville, at Jonesville, Louisiana—is noteworthy because its largest mound rose nearly 80 feet high, making it the second-highest earthen structure in the eastern United States. Amassed between A.D. 800 and 1500, it assumed the form of a two-tiered truncated pyramid with a conical mound set on its top terrace. The 51-acre site also had four artificial ponds, linked by navigable canals to the Black River, which formed one of the settlement's boundaries. The ponds probably had their origin as borrow pits, excavated to supply fill for the mounds.

Nearly 300 miles northeast of Troyville, near Tuscaloosa, Alabama, a settlement known as Moundville became a distant second in size to Cahokia, covering a comparatively modest 300 acres. Situated on a bluff of the Black Warrior River, Moundville flourished between 1200 and 1500. The community constructed a group of 20 rectangular and square platform mounds, most of which were 13 to 16 feet high and deployed around the perimeter of an 80-acre plaza. A 21-foot-high temple mound, measuring 268 by 350 feet at the base, accessorized with a single ramp, occupied an off-center position within the plaza. An even larger temple mound, rising 55 feet high, was positioned on the northern side of the plaza, nearer the river. The community's elite members, a small hereditary group, lived in dwellings built on top of the platform mounds overlooking the central plaza. Commoners lived in villages outside the town's wooden palisade. Like Troyville, Moundville had artificial ponds, three of them, situated near the edges of the main plaza. From the numerous fish hooks found on the bottom of the ponds, it appears they were used to stock fish, a convenient source of food for the estimated population of 3,000.[13]

Mississippian culture may have evolved into some of the tribal societies that survived into historical times. Both the Natchez and the Tunica tribes, whose heartlands were in the lower Mississippi Valley, continued the tradition of building earthen platform mounds, as witnessed by French explorers in the 17th century.

OPPOSITE, ABOVE: Pueblo Bonito, early 10th–late 11th century. Chaco Canyon, northwestern New Mexico. Photograph by Walter Rawlings. *The Anasazi built this multistoried pueblo, the largest multiple dwelling of its time in the Southwest. The walls had cores of earthen fill but were faced with sandstone masonry and plastered with mud.*

OPPOSITE, BELOW: Medicine lodge, Arikara Buffalo Society. Photograph by Edward S. Curtis, 1908. National Anthropological Archives, National Museum of Natural History, Smithsonian Institution, Washington, D.C. *The Arikara (sometimes referred to as "Northern Pawnee") were Plains Indians who lived in multifamily earthen lodges along the upper Missouri River. Timber poles supported domed roofs of willow sticks, woven grass mats, and sod.*

West of the Mississippi Valley, between the 15th and 18th centuries, several tribes of Plains Indians lived in circular earthen multifamily lodges in settlements that were sometimes fortified by dry moats and stockades. In the summertime the mounds' contours became less distinct under a shaggy mantle of grass. The Mandan Indians, who lived along the upper Missouri River, built circular, timber-framed earthen lodges that could accommodate five or six families. They made their domed roofs by laying sod over woven grass mats that covered a framework of sticks. The occupants partitioned the interior into family units by suspending willow mats and animal skins from the ceiling. The Pawnee, a tribe of hunter-farmers whose territory extended across Kansas and Nebraska, also built round, domed earthen lodges, but with a kind of vestibule, consisting of a semi-underground corridor. Inside, they dug deeper into the central part of the floor, leaving a ledge along the walls to serve as sleeping areas.

In the southwestern United States, earth shelters appeared first (as early as the second century B.C.) as primitive pit houses and later (in the 10th century A.D.) as multistoried communal dwellings, known as pueblos. Much of this homebuilding activity occurred in the so-called Four Corners area, where Arizona, New Mexico, Utah, and Colorado meet. By about A.D. 300, the Anasazi people occupied parts of New Mexico and Arizona, living in pit houses that they roofed over with branches and mud. By about 700, they moved into above-ground multifamily pueblos, which they constructed of sandstone masonry or mud, but they retained some of their pit houses for use as kivas. (For more on kivas, see Chapter 5.)

As many pueblos were constructed primarily of stone masonry, they do not technically belong within the scope of this text, which concentrates primarily on forms structured out of earth or carved from living stone. But, perhaps inconsistently, we may consider some pueblos here because their walls were often assembled from a combination of earthly materials—a core of earth fill, for instance, faced by sandstone masonry and finally plastered with a coat of mud. Pueblos are typically multistoried, flat-roofed structures with sometimes hundreds of rooms. Some of the earliest pueblos, dating between 700 and 900, were semicircular or D-shaped in plan. In later versions, beginning about 1100, the rooms on upper floors were clustered in an arc around a large semicircular plaza. Some settlements contained several hundred contiguous rooms, arranged in tiers around the central plaza and rising to four or five stories at the rear. If built in adobe, the mud mixture was applied in layers and allowed to dry before the next layer was added. Even when built with thin, flat slabs of sandstone, both external and internal walls were usually plastered and whitewashed with fine light-colored clay.

The most extensive clustering of Anasazi settlements occurred at Chaco Canyon, in northwestern New Mexico. Along some 12 miles of its narrow and virtually barren valley, Chaco Canyon contains the ruins of more than a dozen pueblos, including eight that were built within the canyon and four more on nearby mesas.

The largest of the Chaco Canyon settlements was Pueblo Bonito, built mainly in the 10th and 11th centuries A.D. The complex covers only three acres yet held between 650 and 800 rooms for a population that may have exceeded 1,200. Pueblo Bonito, D-shaped in plan, measures some 500 feet across, probably making it the largest structure of its time in the Southwest. Its walls had rubble cores, which the Anasazi meticulously faced with sandstone masonry before finally covering them with layers of mud plaster.

Another important Anasazi settlement existed at Mesa Verde, in southwestern Colorado. The Anasazi first appeared there about A.D. 600, living in villages of pit houses. About a century later, they were occupying multifamily dwellings, with about eight rooms on average, atop the mesa, where they grew corn, beans, and squash. Traces of their fields and farming terraces can still be discerned on the mesa. Then, by the mid-12th century, perhaps in response to enemy raids, many Anasazi groups relocated to protected, more defensible dwellings within natural caves and rockshelters that mark the upper walls of the steep canyons that slice through the mesa. One of the largest and most dramatically sited of these

OPPOSITE: Cliff Palace, c. 1150–1260. Mesa Verde, southwestern Colorado. Photograph by Wim Swaan. *Seeking a more protected environment, some Anasazi retreated to a natural rockshelter in a steep canyon wall. They modified the large cleft in the rock by building a multistoried stone pueblo with about 220 rooms.*

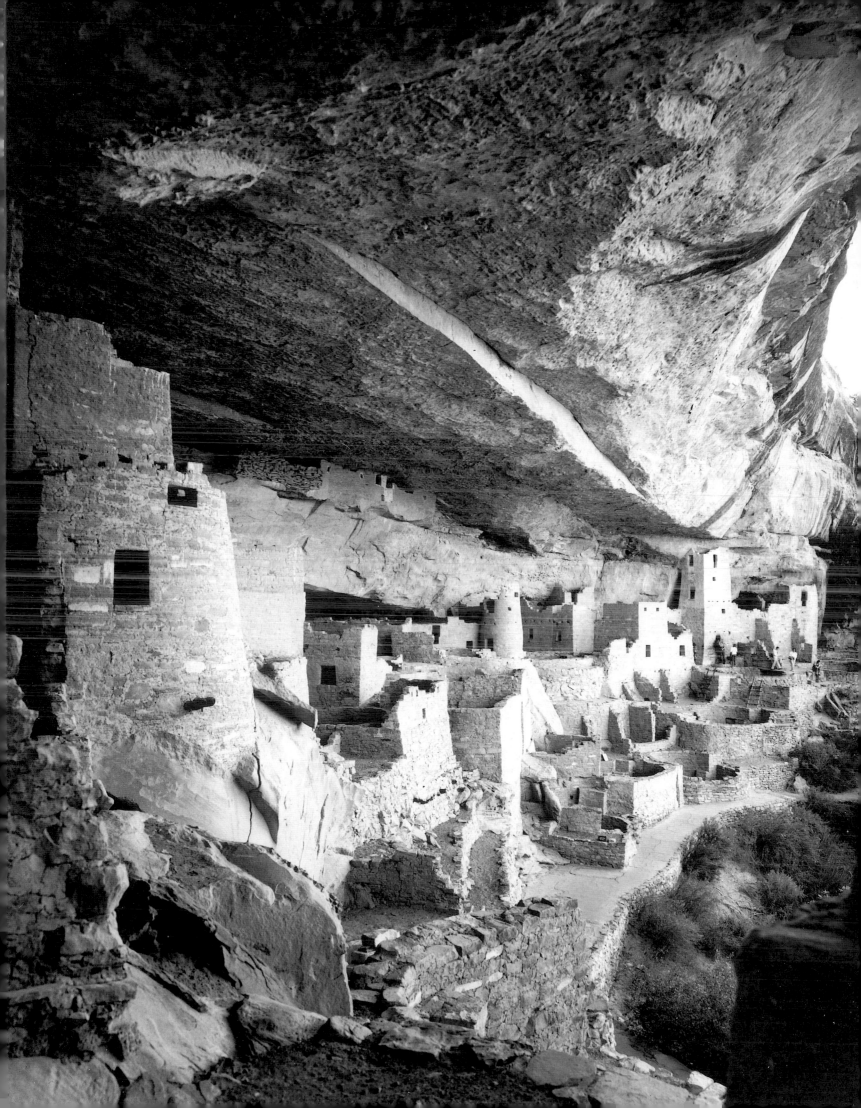

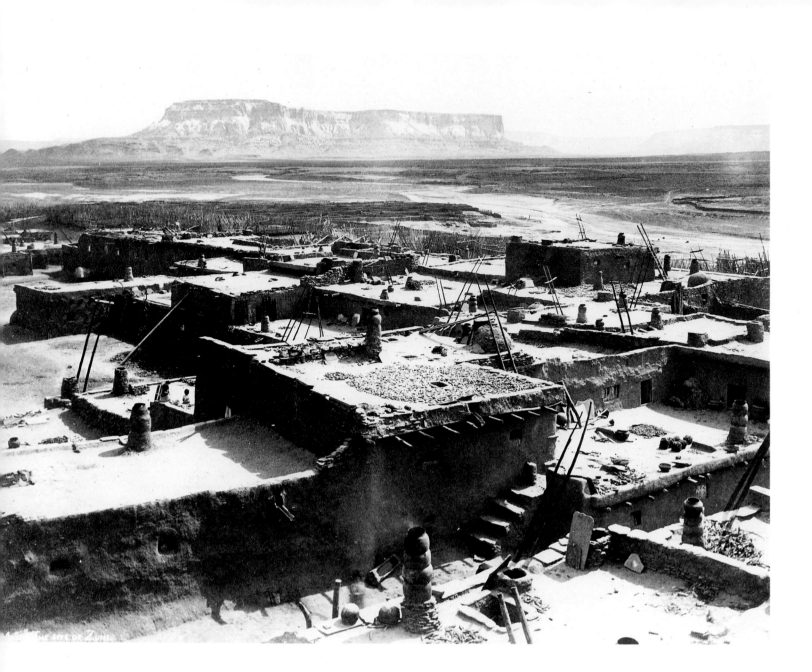

Zuni pueblo. McKinley County,
New Mexico. Photograph by
Hillers, 1879. National Anthropo-
logical Archives, National Museum
of Natural History, Smithsonian
Institution, Washington, D.C.
Timber joists, which protrude
through adobe walls, support flat
roofs, which are composed of dead
branches and pressed earth.

stone pueblos is Cliff Palace, which had some 220 rooms. Anasazi masons concentrated their building activity in Mesa Verde's canyons until the middle of the 13th century.

South of Anasazi territory, adobe functioned as the major building material for other tribes, including those who constructed Casa Grande in southern Arizona, and, confusingly, the similarly named Casas Grandes in northern Mexico. The Arizona site features a four-story-high adobe complex, known as the Great House, built between 1100 and 1300 in Hohokam territory, but not necessarily by people of the Hohokam culture. Its walls, built up in layers of puddled adobe, are massive at the base and tapered as they rise to the top.

By contrast, Mexico's Casas Grandes was a 40-some-acre metropolis of mud architecture, situated in the Chihuahua Desert nearly 120 miles south of the New Mexican border and 390 miles south of Pueblo Bonito. The city suddenly effloresced in the mid-11th century and endured into the 13th century. Its estimated population of more than 2,200 people occupied more than 1,000 rooms in adobe housing complexes that rose five and six stories tall. Even now, in ruins, many of the walls are four stories. Casas Grandes was evidently the center of an immense trading network that extended from Mogollon and Anasazi territory to the north, the Gulf of California to the west, and central Mexico. The city had lively marketplaces, broad plazas, ball courts, and stone-lined channels for water supply and drainage. By the mid-14th century, however, Casas Grandes, like the Anasazi pueblos to its north, was a ghost town, its narrow alleyways traversed only by gusts of dry air.

When Spanish explorers and missionaries ventured into the American Southwest in the mid-16th century, they encountered the Zuni and other native peoples living in adobe dwellings in compact communities atop mesas and along cliffsides. They promptly dubbed them *Pueblo* Indians, "pueblo" being the Spanish word for village.

In contrast to the construction techniques of the Pueblo Indians, who built housing by slathering on successive layers of mud, the Spaniards introduced a more sophisticated process—adobe *brick*. They taught the tribesmen to pour a muddy mixture of clay, sand, straw, and water into wooden frames, which were left outdoors under the desert sun until the molded bricks had completely dried out. The Spaniards had learned the adobe-brick technique from the Moors, who, centuries earlier, had brought it to Spain from the shores of North Africa. "Adobe," a word so strongly identified with Spanish-type architecture in the American Southwest, derives, in fact, from the Arabic *at-tub*, which in turn derives from the Coptic *tōbe*, for brick.

AFRICA: TUNISIA'S UNDERGROUND SETTLEMENTS, MALI'S MUD HOUSES

The virtues of sun-dried mud-brick, a traditional building material since ancient Egyptian times, were recognized all across North Africa. Egypt's Coptic population, Morocco's Muslims, and many other North Africans prized mud masonry for its capacity to alleviate the intense daytime heat, while retaining enough solar warmth to lessen the drop in temperature after sundown. But in particularly torrid places, some groups passed up the advantages of mud-brick, preferring to dwell underground.

Saharan temperatures inspired Berber tribesmen in southern Tunisia to cut through layers of sandstone at ground level in order to excavate underground settlements. A population of 5,000 to 6,000 Berbers once lived in this fashion in the town of Matmata, on an inlet of the Mediterranean. Most of the dwellings at Matmata were constructed around a central courtyard, which provided rooms with access to light, while shielding most of them from the full blaze of the desert sun. Residents could modify indoor temperatures by hanging moistened screens in the rooms, using rainwater that they had collected in cisterns.

Less than 200 miles to the southeast of Matmata, Libyan Berbers also lived in underground dwelling complexes, which typically accommodated four families, each occupying several rooms along one side of a square courtyard. The courtyards were often surprisingly large and deep—about 20 to 25 feet below grade. Steeply inclined corridors led

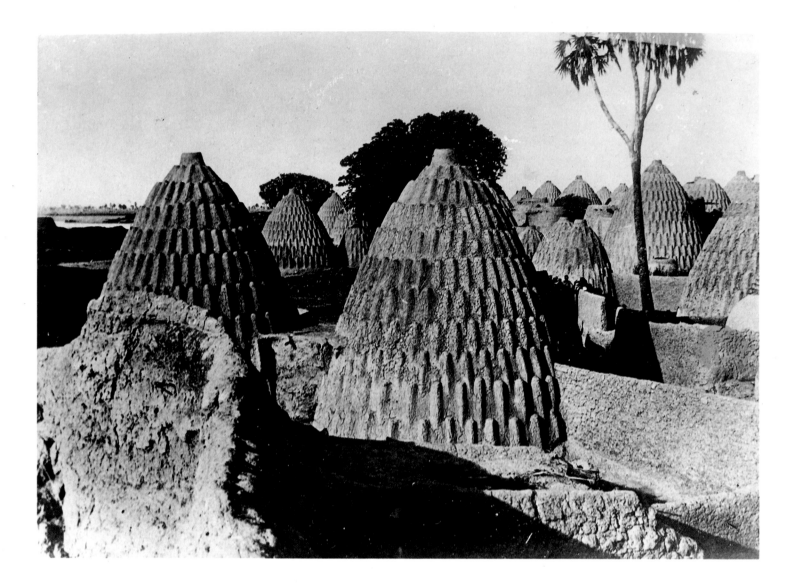

Clay-covered huts. Chad. Photo-
graph by Roger-Viollet. *A single
family typically occupied several
huts, individually outfitted for wives,
kitchen, storage, and animals.*

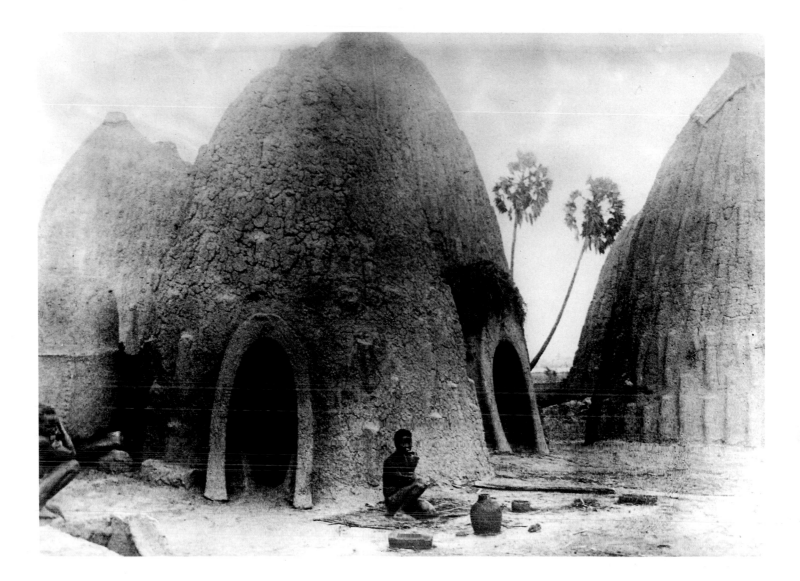

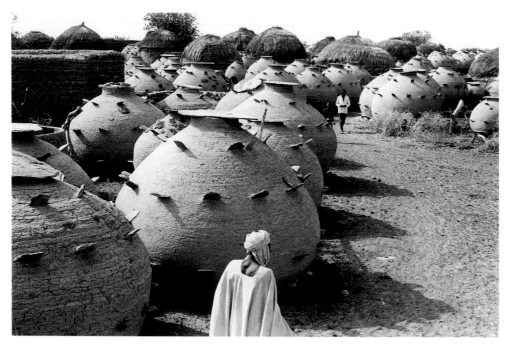

ABOVE: Clay-covered huts and granaries. Mousgoun, Chad. Photograph by Roger-Viollet, 1906.

LEFT: Clay granaries and houses. Labbezanga, Mali. Photograph by Georg Gerster. *The Niger River provides tribespeople in West Africa with an ample supply of clay, which they often model into strikingly designed structures. Amphora-shaped granaries hold millet and rice and are just wide enough at their lidded tops to admit a person. The projecting stone fragments serve as footholds. Clay houses with thatched roofs appear in the background.*

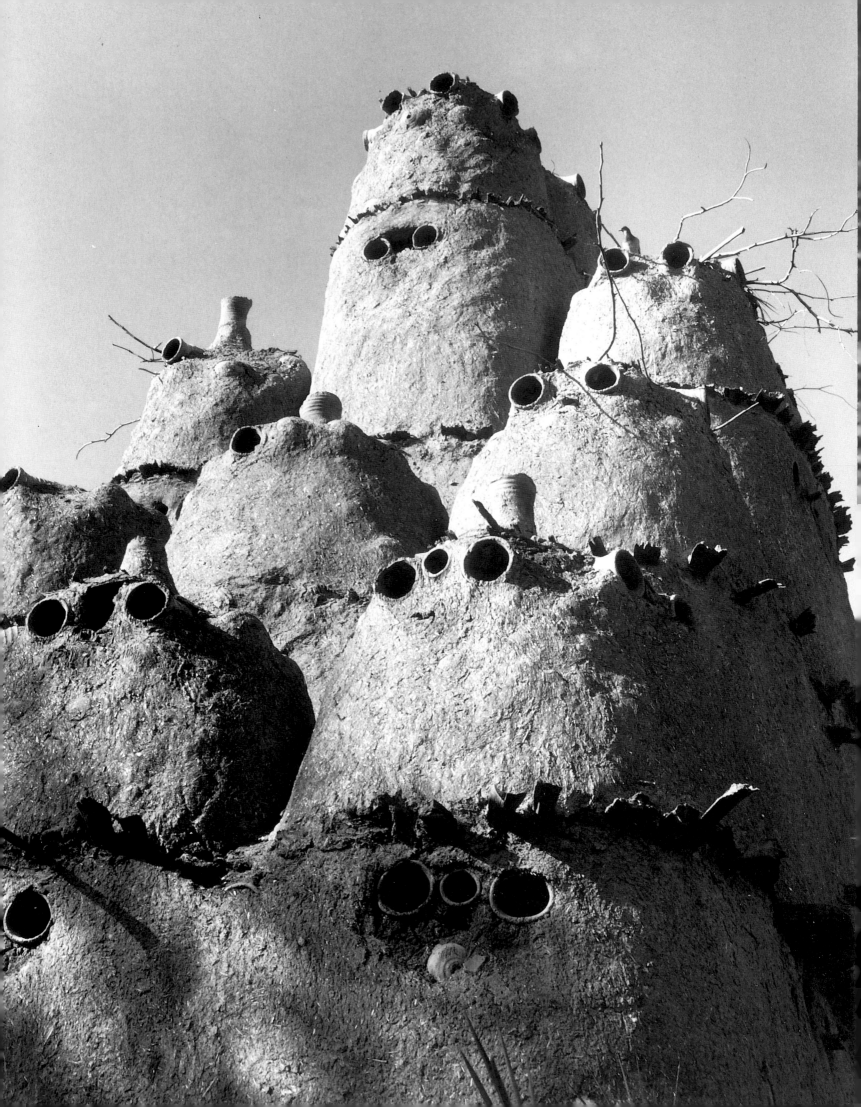

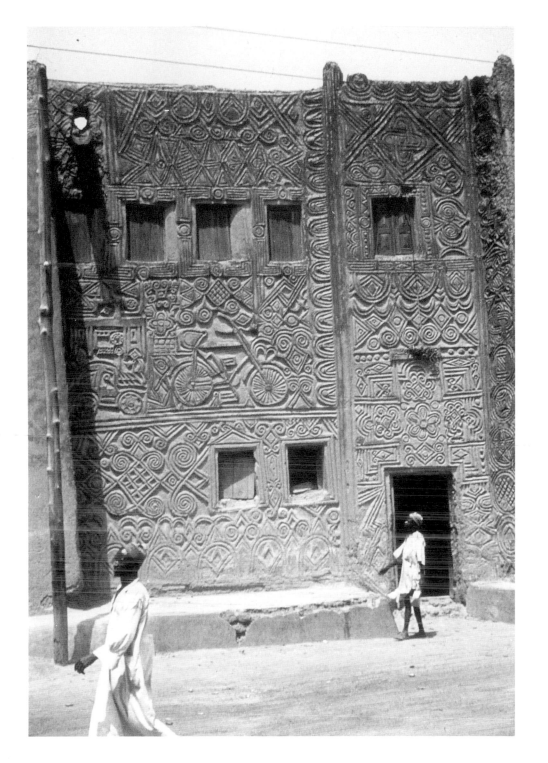

LEFT: Clay house facade. Zaria, Nigeria. Photograph by Frank Willett, c. 1971. *The Hausa people of northern Nigeria embellish the facades of their clay houses with abstract patterns, modeled in low relief. The owner of this house incorporated a couple of vehicular status symbols.*

OPPOSITE: Clay dovecote. Egypt. Photograph by Wim Swaan. *Domesticated pigeons nest and breed in multiturreted mud castles throughout much of Egypt, where they are kept for food and fertilizer.*

from the upper level down to the rooms that had been hollowed out of rock.

In West Africa tribesmen traditionally model private dwellings out of clay, often creating structures with a striking sculptural presence. This is particularly true in Mali, a relatively fertile nation where many lakes and rivers, including the great meandering Niger, provide an abundant source of rich clay. An ancient tell at Djenné, situated on the Bani River, indicates nearly two millennia of occupation from about the third century B.C. By the 13th century A.D., Djenné was a renowned agricultural and market center, where merchants from North Africa could trade in gold, slaves, and salt, and in the 17th century it became a center of Muslim culture.

In both Djenné and Timbuktu, the "twin cities" of the Niger basin, people traditionally lived in rectangular mud-brick or clay houses. Residents typically buried sacred stones and other offerings below the four corners of the house, as well as beneath the central pillar and the jambs of the front door. The facade was invariably symmetrical, with a centered door and a decorated panel above it. A set of pilasters flanked the entrance and often paraded across the entire facade, tapering to rounded conical points above the roof line.

Elsewhere in Mali, the Dogon, an agricultural people, live in clay dwellings, with entrances that lead into a central living room, which in turn provides access to side chambers and a circular kitchen. They construct conical thatched roofs, but also favor flat roofs that consist of a framework of wooden beams, covered with an initial layer of leaves and branches and then by an upper layer of clay. The Dogon built some of their most impressive settlements along rocky slopes near the base of the soaring cliffs at Bandiagara, where the natural configuration of overhanging rocks provides shelter for their clay granaries, which resemble spectacularly elongated stalagmites. (Thousands of years ago, the Dogon lived in rock-cut cliffside homes. Some still do.)

Throughout West Africa, wherever mud architecture is prevalent, housing can be extraordinarily sensual, modeled with the skill and subtlety of a handcrafted ceramic vase. The malleability of clay makes it an ideal substance for homebuilders who want to embellish walls with decorative reliefs. In northern Nigeria, the Hausa people traditionally decorate the outer walls of their flat-roofed clay houses with low-relief abstract ornamentation that, in some cases, incorporates thoroughly modern motifs, such as automobiles and bicycles. In southwestern Nigeria, the Yoruba people—whose sacred city, Ife, flourished between the 13th and 15th centuries—construct their rectangular, mud-walled houses around courtyards that they pave with sherds and pebbles to create intricate geometric patterns. In the nation of Benin, immediately to the west of Nigeria, high-ranking chiefs customarily build mud houses with exterior walls that are horizontally fluted.

UNFIRED EARTH: COB, PISÉ, ADOBE

Historians of earthen architecture are often careful to distinguish between "raw" and "cooked" earth. Both originate in the layered matter beneath organic topsoil, but vary in their essential composition as well as their suitability for particular kinds of construction. "Cooked" earth—known as *terre cuite* in French, *terra cotta* in Italian—requires a sandy clay that is transformed by firing into a firm and rigid material. By contrast, "raw" earth, or *terre crue* in French, is a composite material, often a clayey soil mixed with aggregate rock (sand, gravel, small stones) and sometimes vegetable matter (straw, twigs), all of which bind together as the earth dries and hardens. A builder's choice typically depends upon the type of soil that is most readily and freely available. Some regions may offer a sandy clay of wonderful purity, for instance, but yield no firewood or other fuel with which to fire it.

In England many farmhouses and other rural buildings were traditionally constructed of cob, a mixture of unfired clay (or marl, as clayey soil is sometimes called when it contains chalk or carbonate of lime), gravel, and straw. Cob was particularly useful for building thick walls—and surprisingly durable if it was set on a good stone foundation and protected by a roof with substantial eaves. Cob, however drab, was generally considered a more

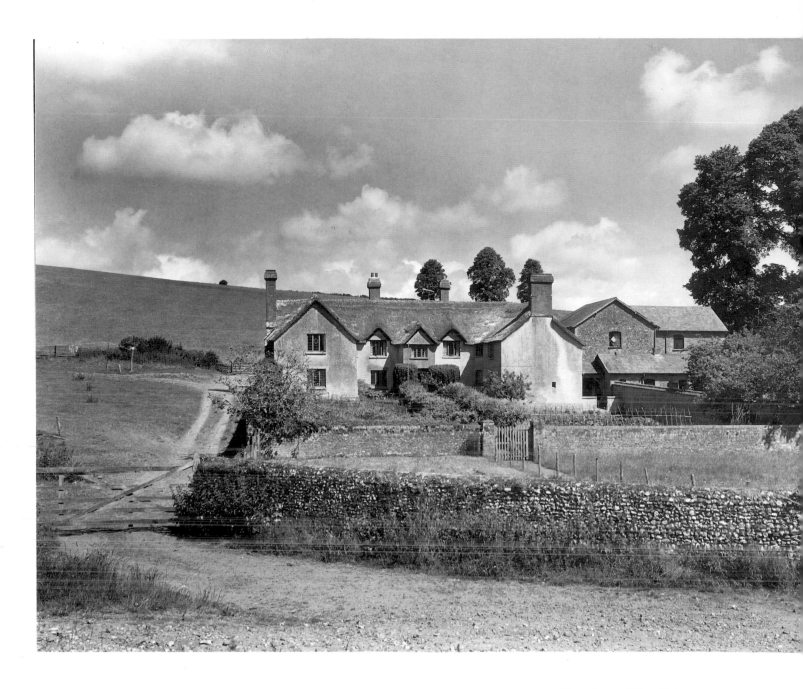

Manor house of Hayes Barton,
16th century. Devon, England.
Photograph by A. F. Kersting. *Many
houses and farm buildings in rural
England were constructed of cob, a
mixture of unfired clayey soil, gravel,
and straw. Sir Walter Raleigh was
born in this cob house in 1552.*

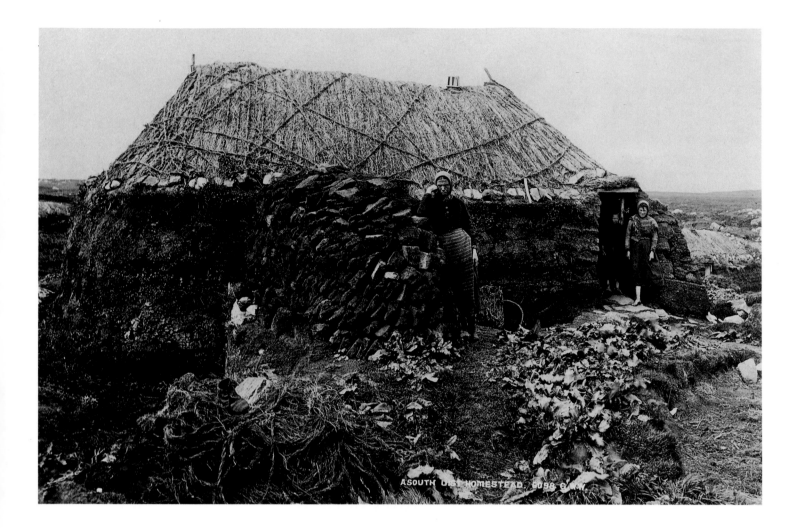

ABOVE: Cottage, late 19th century. South Uist, Outer Hebrides, Scotland. *Agrarian people in poorer regions of Scotland built rustic sod dwellings with thatched roofs. The pile of peat constitutes this home's fuel supply.*

RIGHT: The J. C. Cram family sod house. Loup County, Nebraska. Photograph by Solomon D. Butcher, 1886. Collection, Nebraska State Historical Society, Lincoln. *Because the Great Plains lacked timber, 19th-century settlers like the Crams constructed sod-brick homes. Roofs were typically overlaid with dried grass, clay, and thin slabs of turf.*

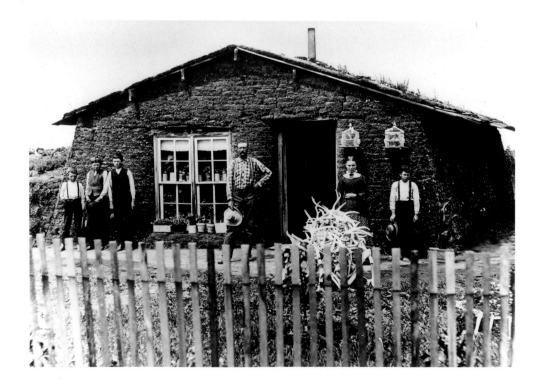

civilized building material than sod, which constituted the homes of agrarian people in the poorer regions of Scotland and Ireland throughout the 19th and early 20th centuries.

A French equivalent to cob is *pisé*, a form of construction popular in and around the city of Lyon and other parts of the country from the 16th century until the beginning of World War I. *Pisé* is a clay soil, very sandy and mixed with gravel, used in a slightly moist state (about 10 percent water). In constructing a wall, builders pour the *pisé* between lateral wood frames and compress it with a tamping tool. As soon as the earth hardens, they transfer the boards to a new position and repeat the process. (The technique is similar to the rammed-earth construction that the ancient Chinese employed in building their palaces and temples.) After drying, *pisé* walls are strong and durable, capable of lasting for centuries. Both the bourgeoisie and the lower classes utilized *pisé* in many types of structures, including homes, barns, churches, factories, city halls, and schools.

The father of modern French earthen architecture is François Cointeraux (1740–1830), a Lyon-born advocate of *terre crue* who was also an entrepreneur, pedagogue, and social reformer. Presenting himself as a "*professeur d'architecture rurale*," he designed *pisé* farmsteads and urban buildings, as well as schools and factories. In 1790, amid the chaos of the French Revolution, he founded the École d'Architecture Rurale in Paris. He disseminated his ideas by writing more than 50 works, many of which were translated and widely published. Almost coinciding with Cointeraux's death, in 1830, a German architect named Wimpf designed a Neoclassical eight-story high *pisé* building for Weilburg, Germany. A technical tour de force for its time, it still holds the record for Europe's tallest earthen building.

Pisé and cob were relatively refined construction techniques compared to a mode of building that became commonplace in the American Midwest during the second half of the 19th century. Land was cheap and, in some cases, free, provided that homesteaders constructed a permanent dwelling and cultivated the land within a specified amount of time. Because the plains were essentially treeless, settlers—like the Norsemen in Iceland and Greenland some 800 years earlier—built their dwellings with blocks of turf. The state of Nebraska became particularly noted for its sod-brick homes, or "soddies," a prevalent form of housing between 1860 and 1910. Residents archly referred to sod bricks as "Nebraska marble."

To make a sod house, settlers plowed the ground into long strips, usually 12 to 14 inches wide, which they then cleaved into blocks of two to three feet in length. An average house required about an acre of sod. They constructed walls by aligning the blocks lengthwise, the grass side facing down. Each course of a wall was normally two sod-blocks in thickness, with the slabs of turf staggered or laid at right angles to one another to minimize the gaps between. When the stack attained the level of the window sills, builders inserted a wooden sash, often no more than an open-ended plank box, and continued building the wall on either side. Because heavy sod walls settled six to eight inches during the first year or so, builders had to make structural allowances for the walls over their windows and doors, where the lighter load resulted in subsiding of only two or three inches. To allow for the variation in settling and to prevent window sashes and door frames from becoming jammed or even crushed, they raised the wall about eight inches above both sides of the sash or frame, then set a log or plank across the top, stuffing the gap in between with rags, paper, or grass. As walls settled around the windows and doors, this added material was harmlessly compacted.

The soddies' interior walls were often plastered with clay and whitewashed, and sometimes covered with store-bought wallpaper. Some homemakers reportedly kept their dirt floors looking spick-and-span by sprinkling them with salt, which mixed with the earth to form a hard crust.

Sod houses offered excellent insulation, being cool in summer and warm in winter. But many also had a major disadvantage—leaky roofs. The most popular type of roof consisted of a wooden framework, overlaid with dried grass, clay, and thin slabs of turf, with the

grass side facing up. If it rained for days at a time, a roof could become so waterlogged that homemakers had to cook with lids on their skillets to prevent mud from falling into the food. In the worst instances, over-saturated roofs caved in, pinning the occupants under a pile of muck.

Many old-time Nebraskans cherished sod homes for their coziness and economy. (Seen in today's perspective, the houses were strikingly fuel-efficient.) But, as railroad companies laid track across the prairies in the late 1860s and 70s, once-remote homesteaders had relatively easy access to milled lumber, window glass, and other building supplies, so sod houses began to disappear. The wood-frame houses that replaced them were roomier and airier, but also inadequately insulated and more expensive to heat.

Westward trekkers with an artistic bent discovered New Mexico in the late 19th century, preparing the way for a new round of appreciation for the territory's adobe architecture. During the 1920s, pueblo imagery figured in the paintings of many notable artists, both resident and visiting, including Joseph Henry Sharp, John Marin, John Sloan, Ernest L. Blumenschein, Victor Higgins, and Raymond Jonson. Their art helped persuade state and local planners to preserve vintage adobe buildings and to encourage new construction in traditional style.

Georgia O'Keeffe was one artist who immediately responded to the region's adobe buildings: their sensuous surfaces and soft contours seemed made to order for her paintings. In 1945 she bought a ruin of an adobe house in Abiquiu, New Mexico. Most of the house dated to the early 19th century. One of its attractions for her was a spacious patio alongside a lengthy adobe wall that was interrupted by a seemingly enigmatic door; the setting subsequently turned up in some of her most famous paintings. During a four-year-long renovation, O'Keeffe had new adobe bricks produced right on the property, made in the traditional way and incorporating the very earth that surrounded the derelict house. "I wanted to make it my house but I'll tell you the dirt resists you," O'Keeffe said, reflecting on the arduous process. "It is very hard to make the earth your own."[14]

Halfway around the globe, on the southern edge of the Arabian peninsula, the people of Yemen convert their arid earth into sometimes amazing buildings. Most of them appear to be adobe-brick structures, while others are assembled in techniques similar to *pisé* and cob. San'a, the nation's capital, contains a great many multistoried earthen buildings, often with arched windows and filigrees that are outlined in white. Another Yemeni municipality, Shibām, has some 500 similar buildings. Many of them rise seven to 10 stories, making it the city with the world's tallest buildings constructed of unfired earth.

MODERN EARTH-SHELTERED AND ADOBE ARCHITECTURE

Few American architects were as astute about their building sites as Frank Lloyd Wright (1867–1959), who was born near the northern edge of the Great Plains, in Wisconsin, in a decade when the Midwestern prairies were dotted with sod houses and dugouts. His turn-of-the-century house designs possess an "earth-pressing" or "ground-hugging" quality and demonstrate a harmonious relationship to their settings.

Later on, Wright designed several houses that were to be edged—and insulated—by sloping banks of earth, known as berms, that obscure the lower half of the exterior walls. His project for Cooperative Homesteads (1941–45), in Detroit, involved berms that were to surround virtually the entire house, except for the entrance. One of Wright's most prophetic designs for a bermed dwelling is the "second" Herbert Jacobs house (1943–48), in Middleton, Wisconsin. The architect himself called it Solar Hemicycle, probably because its rooms fitted within an arc-shaped or semicircular band, whose concave side faces south. Viewed from the convex north side, the two-story stone-masonry residence appears to arise from a natural hill, pierced by a walkway that leads to a ground-floor entrance. The north, or "rear," side of the house is bermed with earth all the way up to the windows of the second-level sleeping area. The south, or concave, side of the house consists mainly of glass,

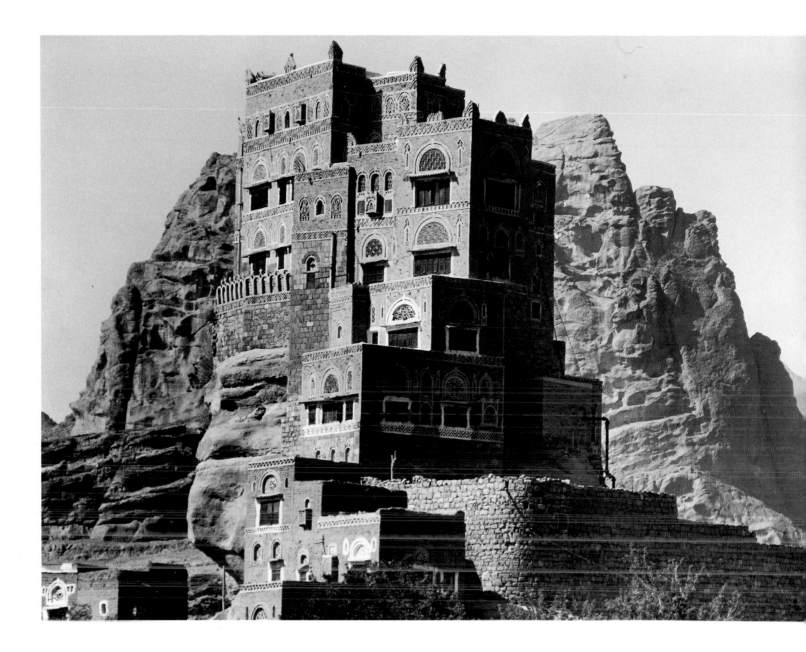

Imam's palace. North Yemen.
Photograph by Georg Gerster.
This Arabian republic contains most
of the world's tallest buildings con-
structed of unfired earth. Many of
them, like this Muslim leader's
palace, are ornamented with elabo-
rate filigrees.

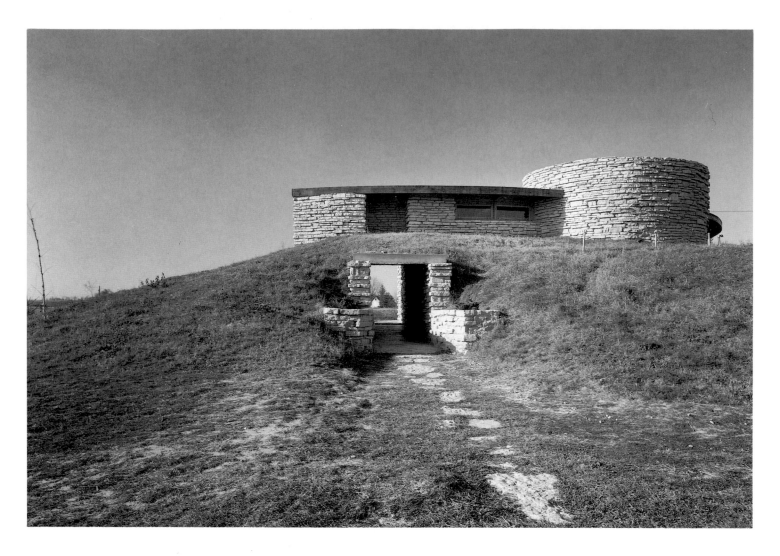

ABOVE: Frank Lloyd Wright. The "second" Herbert Jacobs House, 1943–48. Middleton, Wisconsin. Photograph by Ezra Stoller. *The north side of Wright's earth-sheltered dwelling has berms that reach almost to the second-story windows. The sunny south side of the house is largely glass-walled.*

RIGHT: Philip Johnson. Geier House, 1965. Cincinnati, Ohio. Photograph by Ezra Stoller. *The house appears to mysteriously subside into the ground. Massive berms flank the entrance, and the roof is covered with 15 inches of earth.*

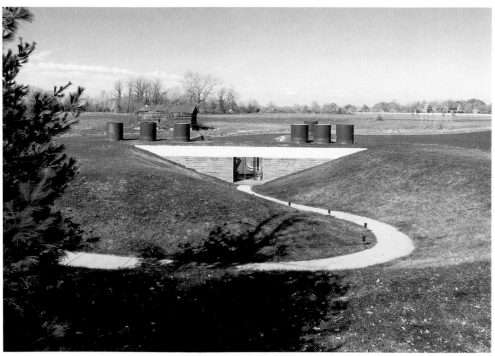

which admits ample light into the major living areas. Wright's concept of siting a dwelling so that it faces the sun and turns its back to the cold is not significantly different in principle from many prehistoric residences, such as New Mexico's Pueblo Bonito.

Another architect who has made extraordinary use of berms is Philip Johnson (b. 1906). His designs are particularly startling, because he had been, for decades, one of the most influential advocates of International Style architecture—exemplified by austerely elegant high-rise slabs of steel and glass. Johnson subsequently became a kind of maverick, going against International Style orthodoxy by designing two noteworthy earth-sheltered buildings.

One of Johnson's novel forays into subsurface design is a private art gallery (1965) situated on his New Canaan, Connecticut, property, which houses his extensive collection of contemporary paintings. To avoid marring the landscape views from his house, he sank the exhibition space into a nearby piece of ground, which now looks like a grassy knoll. On one side of the knoll, an inclined walkway leads downward between vertical walls to a simple door, which opens into the subterranean gallery. Anyone familiar with ancient Greek architecture will instantly recognize the similarity between Johnson's gallery, with its hill-like exterior and corridor-like entrance, and the Mycenaean underground tomb known as the Treasury of Atreus (see Chapter 4).

Johnson designed another earth-sheltered project, the Geier House (also 1965), in a Cincinnati suburb. Again, he wanted to preserve as much as possible of the unobstructed landscape, in this case a field beside a lake. Johnson ensconced the 4,000-square-foot house along the shore, with two wings flanking a rectangular pool that is actually a small bay of the lake. The lake and pool are connected via a narrow waterway, flanked by large conical mounds of earth that rise to the roofline, resembling naturally contoured banks and shielding much of the house from view. From the landward side, the house has berms that angle outward from the paved walkway to the outer corners of the reinforced concrete roof, which is covered with 15 inches of earth, maintaining the illusion of a house that has mysteriously subsided into the ground.

Although the Geier and Jacobs houses were wedged into the earth for aesthetic reasons, their designs began to look especially prophetic after the prolonged energy crisis of 1973. Seeking a more effective use of natural resources, conservation-minded architects, planners, and homebuilders began to ponder the energy-efficiency of earth-sheltered dwellings, which generally require less fuel than comparable above-ground structures because they maintain more stable temperatures. They arrived early at a consensus that a sloped site, facing south, offers the ideal setting for an earth-covered structure. The rear and side walls are typically bermed with earth and the roof is covered with 18 or more inches of soil, which join seamlessly with the ground to the rear.

Among architects who excel at designing earth-sheltered dwellings, William Morgan (b. 1930) has devised boldly bermed exteriors for several of his most striking projects. The Jacksonville, Florida, architect, who admits to being inspired by Native American platform mounds, is the author of an important study of such earthworks, *Prehistoric Architecture in the Eastern United States* (1980), which assembles a considerable amount of information on 82 sites dating from 2220 B.C. to A.D. 1500. Morgan's widely acclaimed two-unit Dune House (1974) in Atlantic Beach, Florida, suggests a large bivalve seashell that has buried itself in the sand. In order to maximize his use of the beachfront lot, he recessed the twin living units (each 750 square feet) into the sand dune and then restored the site to its original contours. The subsurface structure consists of sensuously contoured concrete vaults, covered by 22 or more inches of earth. According to the architect, the pressure of the surrounding soil actually helps strengthen the thin-walled concrete shells. From the street side, one enters each unit on the upper level, a partial loft with a bedroom and bath. The beach is accessible from the lower-level terrace through an ovoid opening. The twin egg-shaped entrances look somewhat Pop when they are cast in shadow, suggesting a pair of giant sunglasses propped against the grassy dune.

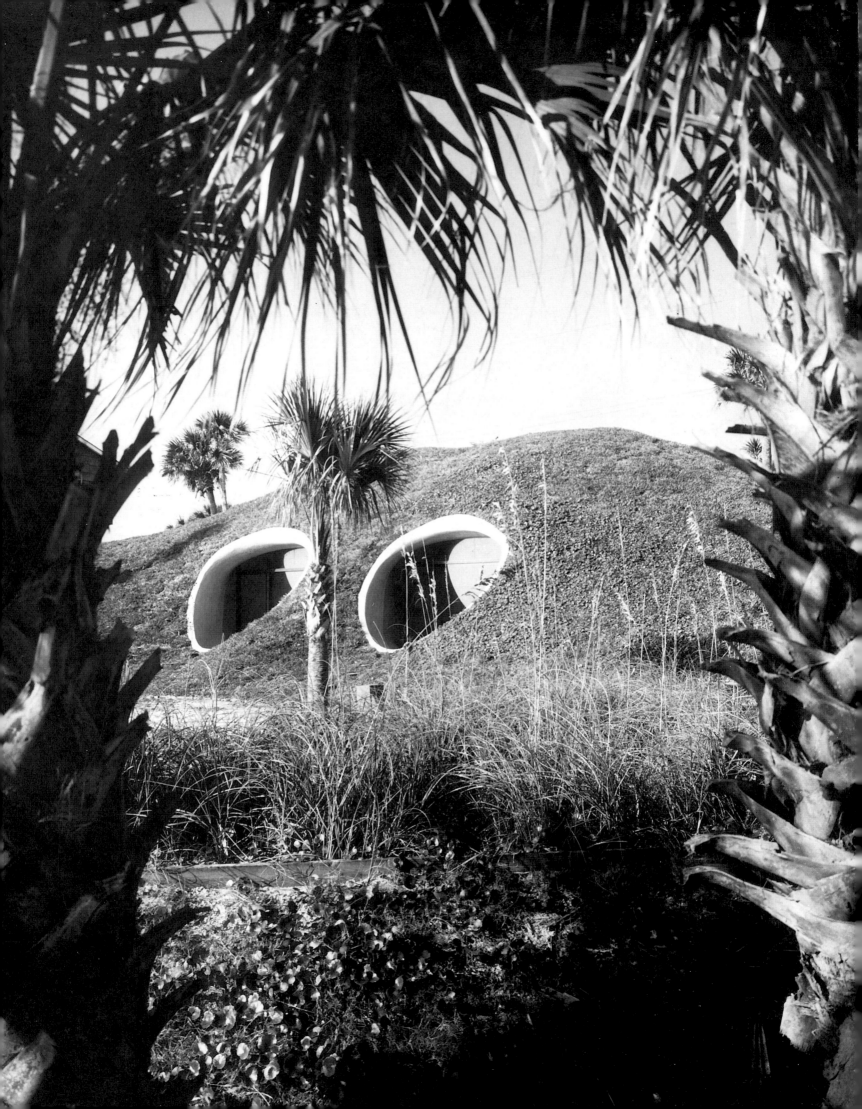

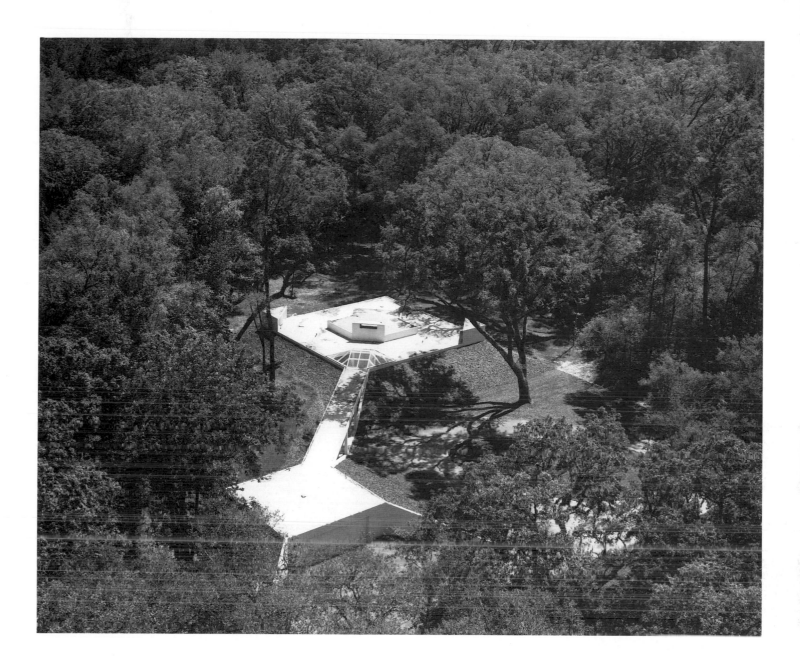

ABOVE: William Morgan. Forest House, 1977–79. Gainesville, Florida. Photograph by Bob Brown. *Morgan set two truncated pyramids on a diagonal axis and linked them with a covered walkway. The smaller structure is a garage; the residence has, at its far end, a windowed living room.*

OPPOSITE: William Morgan. Dune House, 1974. Atlantic Beach, Florida. Photograph by Alexandre Georges. *Morgan's two-unit beach-front dwelling is nestled into a grassy dune. Each apartment's terrace has access to the beach through an ovoid portal.*

RIGHT: Emilio Ambasz. *House for Leo Castelli.* 1980. Model in acrylic, styrene, and paint. Courtesy Emilio Ambasz. *A three-foot layer of earth melds the house with its terrain. On the far side, earth berms support a pair of tall solar panels.*

BELOW: Antoine Predock. La Luz townhouses, 1967–74. Albuquerque, New Mexico. Photograph by Cradoc Bagshaw. *The ground-hugging character of pueblos influenced Predock's elegant design for a development of 100 adobe townhouses, each with its own enclosed yard. Massive exterior walls ward off torrid sun and desert winds.*

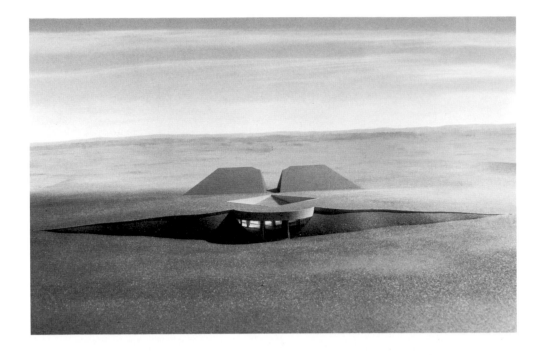

Taking a cue from archaic platform mounds, Morgan went on to design Forest House (1977–79) in Gainesville, Florida, an elegantly conceived structure composed of two truncated pyramids with massive sloping earth walls. The larger pyramid constitutes the dwelling, while the smaller one contains a garage. Both buildings are set on a diagonal axis for greater dynamism and are linked, corner to corner, by a covered walkway, or portico. Before reaching the front door of the house, one passes through a hexagonal skylighted area, planted with tropical foliage. Inside the residence, at the opposite corner, the living room has a floor-to-ceiling window, flanked by tall glass doors, that overlooks a forest glade. Beyond the glass wall, a wooden deck and swimming pool enhance the feeling of being close to nature, while conforming to the geometric scheme. The pool area is enclosed with insect screening, installed in a canted plane, that extends and fulfills the pyramidal form of the residence's surrounding berm.

In addition to berm-sheltered housing, the 1970s and 80s witnessed an energy-conscious boomlet in adobe construction, particularly in the American Southwest. New Mexico's arid landscape once again became a hotbed of earthen housing. Much of it was created by dirt-poor do-it-yourselfers but, more surprisingly, wealthy newcomers to the state also wanted adobe homes—and had the pocketbooks to indulge their sensual appetites for luxurious villas. Affluent clients for custom-made adobe villas sought out architects such as William Lumpkins of Santa Fe and Antoine Predock of Albuquerque.

In the realm of luxury adobe, however, Frank Lloyd Wright merits a posthumous place of honor. In 1942 he designed a spectacular adobe residence with curved sides and pointed ends, whose overall plan resembles a canoe. He named the project Pottery House. In 1985 more than a quarter of a century after Wright's death, a Santa Fe businessman built Pottery House and put it on the market the following year for $2.2 million. Adobe could never again be regarded as merely a poor man's material.

However glamorous it becomes, adobe—and other forms of "raw" earth construction—may still offer the best solution for housing the needy and the homeless, particularly in Third World countries that face a housing crisis. Earthen dwellings that use a minimum of industrially fabricated materials possibly constitute the most feasible and economic response to the situation, making efficient use of available local resources while avoiding the cost of imported materials and technology. With the planet's human population spiraling ever higher, impoverished people in chronically poor nations may have few other choices than to construct their own dwellings out of earthen materials.

It appears, therefore, that *Homo sapiens sapiens*, after 100,000 years or so on the scene, is about to complete a full circle in the housing cycle. In an endless quest for attractive, comfortable, economic, and secure homesites, these experienced house-hunters are newly attracted to earth-sheltered and adobe dwellings, the contemporary architectural equivalents of natural caves and mud-brick huts.

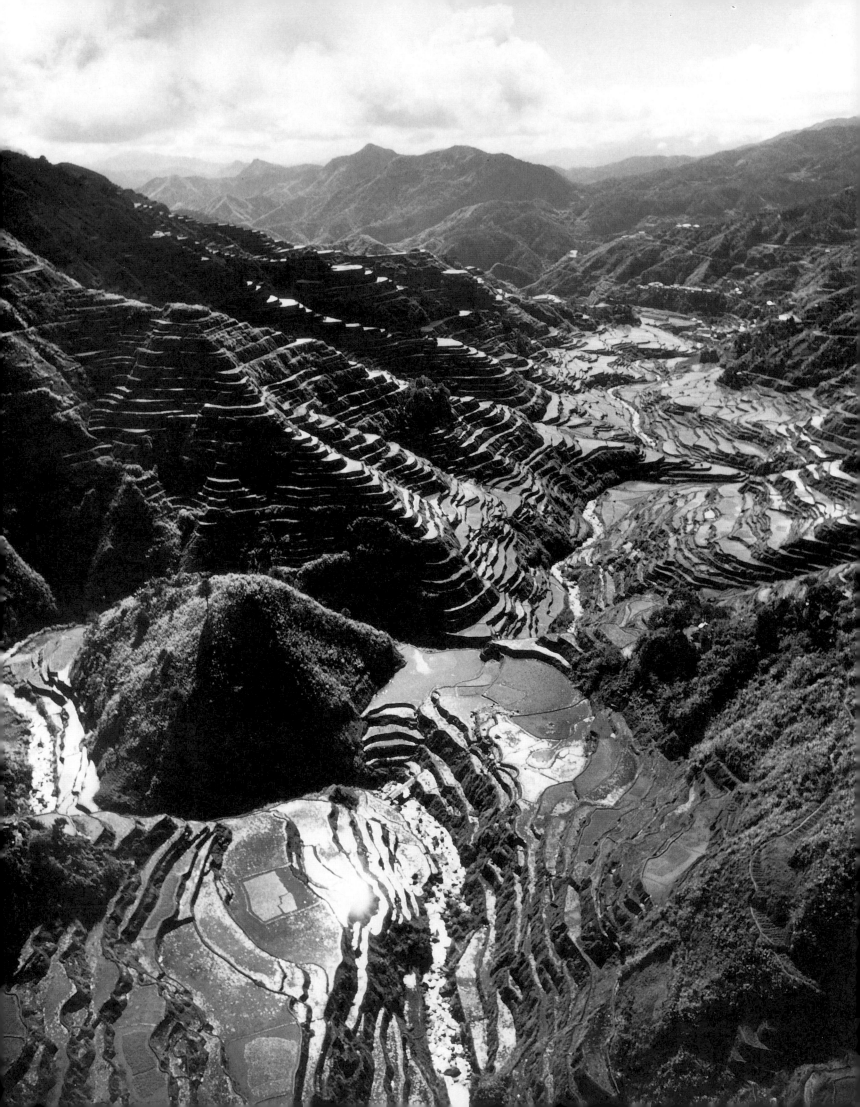

Commerce

Modifying the Land to Make a Living

As prehistoric tribes settled into stationary communities, their members reshaped the land around them to meet their immediate needs and to make their lives more productive. The persistent demand for potable water prompted many settlers to establish their villages near rivers, which helps explain why several of the earliest civilizations arose in river valleys.

Once people park themselves by a river, the first thing they want to do is to divert its water to irrigate their cropland or to control its flow so that it doesn't wash away their homes. To achieve these water-management aims, settlers readily reconfigure the surface of the earth to construct irrigation canals, cisterns, reservoirs, dikes, and dams. Those folk who choose to live in the mountains also manipulate the terrain, often by terracing hillsides to create stair-stepped sequences of flat, cultivatable fields that will retain rainwater.

When prehistoric tillers of the soil achieved an agricultural surplus that exceeded their domestic needs, they were ready to trade. Commerce led in turn to travel, which necessitated transportation routes. By the third millennium B.C., resourceful individuals, recognizing that one of the most efficient ways to move people and goods from one place to another is to gouge out the earth between two bodies of water, developed navigable canals. To facilitate overland transportation, early engineers constructed roads, tunnels, and causeways. Through trade, markets were created for valuable materials that were mined from the earth, such as flint, copper, gold, and diamonds.

OPPOSITE: Pond-field terraces. The Philippines. Photograph by Ted Spiegel. *Generations of Philippine farm families labored to construct terraced pond-fields that cascade down entire mountainsides, all shaped with nothing more sophisticated than hand-held tools. Each steeply tiered field has its own spillway, drainage conduit, and stone retaining wall.*

IRRIGATION: CANALIZED RIVERS, TERRACED MOUNTAINSIDES

The origins of agriculture are "rooted" so deeply in the prehistoric past that it is unlikely anyone will ever discover the world's earliest irrigation ditch, which probably silted up many millennia ago. By the sixth millennium B.C., people in several parts of the Middle East were developing water-management strategies. Traces of irrigation canals dating from about 6000 B.C. have turned up in the foothills of the Zagros Mountains in Iran. Evidence of other canals dating from about 4000 B.C. was discovered near Mandali, Iraq, in 1968. In 1974 archaeologists located stone-faced earthen dams, dating from about 3200 B.C., at Jawa, Jordan.

Mesopotamian civilizations owed their very existence to the presence of two great rivers—the Euphrates and Tigris. Both streams originate in eastern Turkey, the Euphrates flowing circuitously through Syria and then into Iraq, where it joins up with the shorter but more turbulent Tigris, eventually to flow into the Persian Gulf. The southern Mesopotamian plain was interlaced with a dense tracery of watercourses, merging into an extensive delta of reed-filled swamps that teemed with fish and wildlife. Human settlers flocked to the Edenic region, but they were periodically swept away by raging floods that destroyed villages.

At a very early stage, Mesopotamian people realized an important truth: if they could devise ways to control the floods and channel river and swamp water into their agricultural fields, they would make more effective use of the land. The inhabitants of neighboring villages often cooperated in the construction of networks of irrigation ditches and canals. Their joint efforts encouraged an equitable distribution of water, as well as a fair share of labor in the maintenance of irrigation systems. Mud-banked canals easily fell into disrepair and constantly needed to be dredged of silt and cleared of weeds.

During the third millennium B.C., regional leaders initiated the construction of more extensive networks of canals. It was obviously in the interest of developing city-states to consolidate their prosperity by controlling the integrity of irrigation systems within their territory. Inevitably, some settlements expanded at the expense of their rivals.[1]

Legend, sometimes backed up by archaeological evidence, credits several Mesopotamian kings with impressive waterworks. Entemena, who ruled the prosperous city-state of Lagash, built a major canal that ran from the Tigris to the Euphrates in the early third millennium B.C. A couple of thousand years later, Babylonian leaders became zealous canal-builders who turned their realm into one of the ancient world's richest granaries. Babylon's Assyrian nemesis, Sennacherib, who reigned from about 705 to 681 B.C., was perhaps the most accomplished of the royal waterworks planners, having constructed many canals and aqueducts to satisfy the personal and commercial thirsts of his subjects at Nineveh.

Around the beginning of the seventh century B.C., Sennacherib supposedly authorized an ingenious underground aqueduct, or *qanat,* designed to carry water from a mountain river to the city of Arbil, in what is now northern Iraq. A *qanat*—the word is Arabic—is essentially a sloped, underground tunnel, sometimes of great length and depth, that takes advantage of gravity to channel a continuous flow of groundwater from its higher end, usually in or near the mountains, to the lower and drier plains. At the tunnel's lower terminal, the water is apportioned through a network of irrigation channels. To construct a *qanat,* its makers dig a line of vertical shafts along the course of the channel, then join the bottoms of the shafts by a continuous tunnel. If the *qanat* is very deep, maintenance shafts may be dug at a slant from the surface to the tunnel. The *qanat*'s advantage over above-ground aqueducts is that it loses relatively little water through evaporation.

No one really knows who invented *qanats.* Some historians believe that Sennacherib's father, Sargon II, encountered the irrigation system, not yet known in the Assyrian empire, during an invasion of Persia in 714 B.C. From Persia, the idea of underground aqueducts could easily have spread to distant regions of central Asia. Thousands of *qanats* are in use

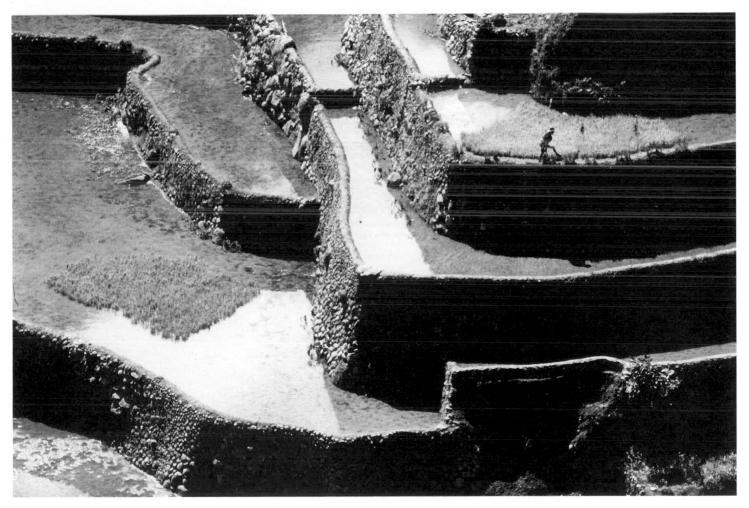

ABOVE: Pond-field terraces. The Philippines. Photograph by Robert Francis.

Terraced fields, late 12th–13th
century (photographed 1960).
Mere, Wiltshire, England. *These
hills were subtly modulated with
terraces during the Middle Ages,
when a population boom sparked a
demand for new agricultural land.*

today in present-day Iran and neighboring Pakistan. Intriguingly, Persia's early *qanats* anticipated counterparts in seventh-century A.D. Peru and present-day Xinjiang in north-western China.

The ancient Near East had a third major artery that pumped life into its surrounding territory—the Nile. Egyptian farmers depended on the river's seasonal floods to irrigate and fertilize (with rich silt) their fields. The country's irrigation canals, which date at least as far back as 3000 B.C., enabled farmers to inundate large tracts during the Nile's periods of high water. A grid of dikes segmented the land to be flooded into a series of smaller areas. After the individual plots filled with water, the farmers closed up the dikes and impounded the water for a month or so until the ground was thoroughly soaked. Then they allowed the surplus water to drain off into the canals.

It makes sense for farmers in broad river valleys to excavate irrigation canals and construct earthen dikes, but those types of structures are impractical or useless in the highlands. Consequently, for many agriculturists in hilly terrain, the conventional solution has been to carve mountainsides into terraced fields. Rainwater, instead of running down the mountainside, collects on the flat surfaces and has time to seep down to plant roots before excess water spills down from one terrace to the next. The practice of terracing apparently developed independently in ancient civilizations on several continents; it was a commonplace procedure in Hellenistic Greece, medieval England, Song-dynasty China, and Inca-era Peru and is still widely employed today in many parts of the world.

In Europe, in the Tuscan region of the Italian peninsula, the resourceful Etruscans were creating skillful hydraulic systems by the fifth century B.C. The Etruscans were outstanding engineers who put their tunneling skills to use in boring subterranean channels in order to divert rivers and drain lakes so that they could reclaim land needed for agriculture. Much of their southern territory consisted geologically of tufa (a porous rock formed as a deposit from springs or streams), which is relatively soft and easily tunneled. The Etruscans exploited this tufaceous material to develop an extensive network of tunnels that channeled surplus water off the land and therefore prevented soil erosion.[2]

The Etruscan city of Veii, on the northern side of the river Tiber, developed a sophisticated water system that enhanced its agricultural output during the fifth century B.C. Veii conserved its water supply in rock-cut cisterns that were fed by a number of excavated shafts. In addition, the citizenry created the extraordinary Ponte Sodo by enlarging a natural tunnel through a massive outcrop that had often caused a Tiber tributary to flood. The people of Veii deepened the channel, extending it through the rock for more than 200 feet and thereby preventing future flooding. Veii expanded its water-control system for miles around the town, transforming what had been a low-lying, waterlogged area into fertile land. The city constructed many rock-cut drainage channels, some nearly two miles long, to carry streams underground. Like Mesopotamian *qanats*, Veii's underground drainage channels had vertical shafts every 100 feet or so that enabled maintenance men to keep the conduits clear.[3] Unfortunately, Veii's superb hydrological know-how and underground tunnel system also led to the city's doom (see Chapter 3).

Farmers in China traditionally made extensive use of mountain terracing. Until the territorial expansion of the Tang dynasty (618–907), most of the Chinese population was concentrated in the north, where agricultural terracing may have played a relatively insignificant role. During the Song dynasty (960–1279), however, the south became more densely populated. At the same time, rice—grown in wet fields—was becoming an increasingly important element in the national diet. Farmers needed an abundant and regular water supply, so Song officials authorized numerous irrigation-control systems, as well as dams and dikes. Making use of virtually every parcel of land, farmers began terracing mountainsides.

In the deserts of Xinjiang Uygur Autonomous Region (also known as Chinese Turkistan), in the northwestern part of the nation, water conservancy is crucial. Modern farmers and hydraulic engineers have created green oases in an area of scanty rainfall

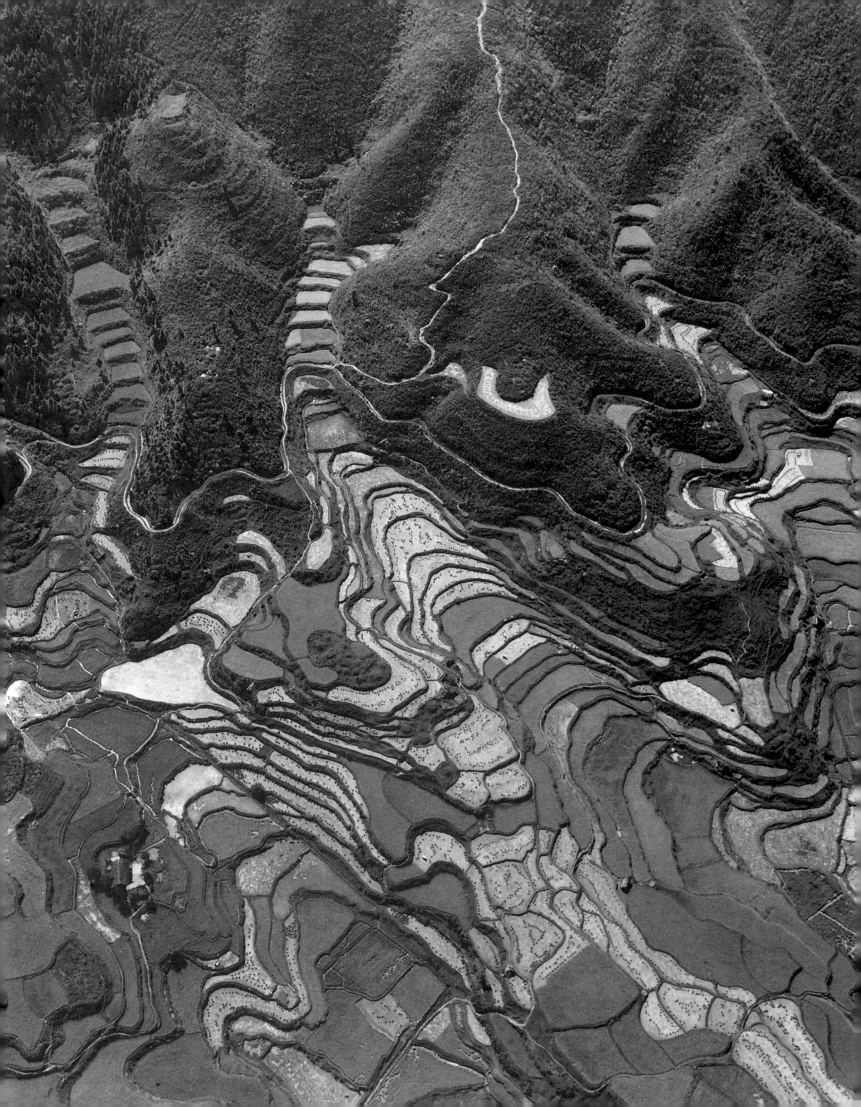

by channeling water from melted snow and ice into *qanat*-like subterranean aqueducts. Xinjiang farmers receive much of their water through these underground aqueducts, which are punctuated on the ground surface by a system of vertical shafts, resembling long rows of manhole-size openings, which make the channels accessible to maintenance workers.[4]

In the Americas, native farmers—who presumably had no connection with Mesopotamian *qanat*-diggers or Chinese rice-growers—also sculpted the earth to create irrigation systems and terraced fields. Some Mesoamerican cultures, especially those based in Mexico and Peru, were extremely resourceful at managing water, practicing irrigation, terracing, and floodwater farming wherever local conditions permitted.

The Maya constructed terraced fields in much of the hilly country they occupied in the southern lowlands of Mexico's Yucatán Peninsula and northern Guatemala. (They built their homes on top of rectangular earthen mounds to escape summer floods.) In the lowlands, they practiced slash-and-burn cultivation, a process in which farmers cleared portions of the jungle and burned the brushwood and vegetation to create small fields, called milpas.

For decades, some historians assumed that milpa farming was the sole system of Maya agriculture. In the early 1970s, however, aerial surveys revealed evidence of raised planting beds, mostly dating from between A.D. 250 and 700, alerting archaeologists to the fact that the Maya had also practiced this form of agriculture. The Maya favored swampy terrain for their raised fields because they also needed an extensive network of irrigation canals. They grew their crops on rectangular planting beds, deployed in a grid and rising a few feet above the irrigation canals that flowed in between. Each year the farmers dredged the muddy bottoms of the canals and used the soil to fertilize and replenish the beds.

This form of raised-field or "floating garden" cultivation is known in Mexico as *chinampa* agriculture. Large-scale *chinampa* agriculture, involving the rearrangement of millions of tons of muddy earth, indicates an efficiently organized labor system. *Chinampa* agriculture may account for the rise of city-states, such as Tikal, in northern Guatemala, where the population, at its height, in about 700, is estimated to have ranged between 20,000 and 80,000.[5]

Maya civilization deteriorated in the southern lowlands during the late eighth and early ninth centuries, perhaps due to one or more catastrophes, including (or combining) crop failure, deforestation, overpopulation, and disease. Some experts believe the Maya population outgrew terracing and raised-field cultivation and resorted to extensive slash-and-burn forest clearing that degraded the soil to their own ruination.

In central Mexico, the Aztecs also practiced *chinampa* agriculture, which helped feed a population of more than 200,000 at the time of the Spaniards' arrival.[6] The Aztecs founded their twin towns of Tenochtitlan and Tlatelolco on swampy islands near the southwestern shore of Lake Texcoco during the first half of the 14th century. At the time, the lake filled a substantial part of the Valley of Mexico: it was about 35 miles long from north to south. By the mid-15th century, Aztec rulers had initiated several large-scale water-control and construction projects. One of those schemes, launched by Itzcoatl toward the end of his reign, was a causeway that linked Tenochtitlan to towns on the shore of Lake Xochimilco, which lay a couple of miles to the south. His successor, Montezuma I (1400–1469), was a great believer in public works: he built a 10-mile-long dike across Lake Texcoco, which provided flood control; constructed an aqueduct that channeled fresh water to Tenochtitlan from springs at Chapultepec, in the north; and excavated a large canal that led to Tlatelolco's market area. Montezuma's dike, built across a narrow neck of Lake Texcoco, not only provided defense against rainy-season floods but also prevented the saltier waters of the eastern part of the lake from polluting its western third, which the Aztecs had filled with fresh water piped in from Chapultepec by their aqueduct. By 1500, Tenochtitlan covered about five square miles. But it dominated a territory of about 125,000 square miles and a population of as many as 10 million.[7]

Tenochtitlan gave off the illusion that it floated on water. The central city was sliced into

portions by a network of canals and linked to nearby suburbs by several causeways. The Spaniards, who arrived in 1519, compared the Aztec capital to Venice, because the city's main "roads" were in fact canals, amply filled with the lively traffic of canoes. (Like the Maya, the Aztecs possessed no wheeled vehicles or draft animals, so all goods had to be transported on their backs or in boats.) The canals not only facilitated transportation but also served as drainage ditches, reducing the water content of the swampland around the original islands to the point where it could be farmed.

Along the southern edges of the city, farmers built an extensive network of *chinampas*, composting the rectangular, raised garden plots with the rich silt they dredged from the lake and canals. The floating vegetable beds created in the course of the Aztecs' ongoing drainage and land-reclamation projects were composed of woven-grass mats, covered with a layer of lake-bottom mud. They were highly productive: one acre could reportedly provide enough food for six to eight people.[8] If this estimate is correct, it follows that 200,000 mouths would have required tens of thousands of acres of *chinampas*. Is it any wonder that virtually all of Lake Xochimilco became covered with soil-bearing rafts?

Ancient codices from pre-Hispanic days show that the Indians sometimes rowed entire fields from one place to another. Eventually, however, the plant roots took hold in the shallow waters of the lake and the *chinampas* became fixed in place.

In 1989, Mexican officials made a major effort to rescue Xochimilco's canals. They built a new sewage treatment plant, expanded another, and cleared more than 100 miles of canals of the waterlilies that clogged them. Adjoining land was restored, and thousands of new trees were planted to stabilize the soil. They enlarged and deepened Lake Huetzalín, which covers about 120 acres, and created a small new lake. Both hold treated waste water, which, although not potable, is apparently clean enough to support *chinampa* cultivation. The area currently exists as an educational park, including a re-created area of *chinampas*, where hundreds of peasants are allowed to earn their livelihoods. The canals are the heart of present-day Xochimilco, where farmers can still go about their business in long, flat-bottomed boats, called *trajineras*, which they load with mud to replenish their fields.[9]

Down in South America, in the rain-drenched coastal mountains of northeastern Colombia, the Tairona Indians practiced mountain terracing in settlements that survived from about A.D. 1000 to the arrival of the conquistadors in the 16th century. The name of one major town is lost to history, so archaeologists call it Buritaca 200, a reference to the Buritaca River that flows nearly 3,400 feet below. The densely populated town, founded in the 14th century, once stood at the junction of trade routes from Colombia to Central America, Venezuela, and Ecuador.

To create flat fields for their corn, beans, peppers, and other crops, Tairona farmers modified their mountainous topography by constructing terraces that fanned out like circular lily-pads. The terraces were protected from erosion by stone walls and drainage gutters that were laid around their peripheries. Walkways connected the terraced fields to the main roads. The people built their houses on similarly shaped stone-faced platforms.

Buritaca 200's isolated location postponed its fatal confrontation with the conquistadors, who eventually penetrated the settlement in 1630. Over the decades, a thick layer of earth gradually mantled the remains of the city and the jungle moved in to reclaim it. For some 300 years, Buritaca 200 was literally lost, until a grave robber happened upon it in 1975.

In Peru, three cultures—the Mochica, the Nazca, and the Chimú—coped with the aridity of coastal regions by constructing skillfully designed irrigation canals and aqueducts. The Mochica people, who flourished from about A.D. 200 to 700, controlled only a strip of desert coastline, some 250 miles in length. To make their territory habitable, they dug extensive networks of canals that irrigated their fields and brought water to their villages; some of their aqueducts were lined with adobe bricks. They channeled much of their water from rivers that spilled out of the Andes, enabling them to cultivate about 100,000 acres of otherwise arid coastal valleys. It appears, however, that the Mochica were eventually done

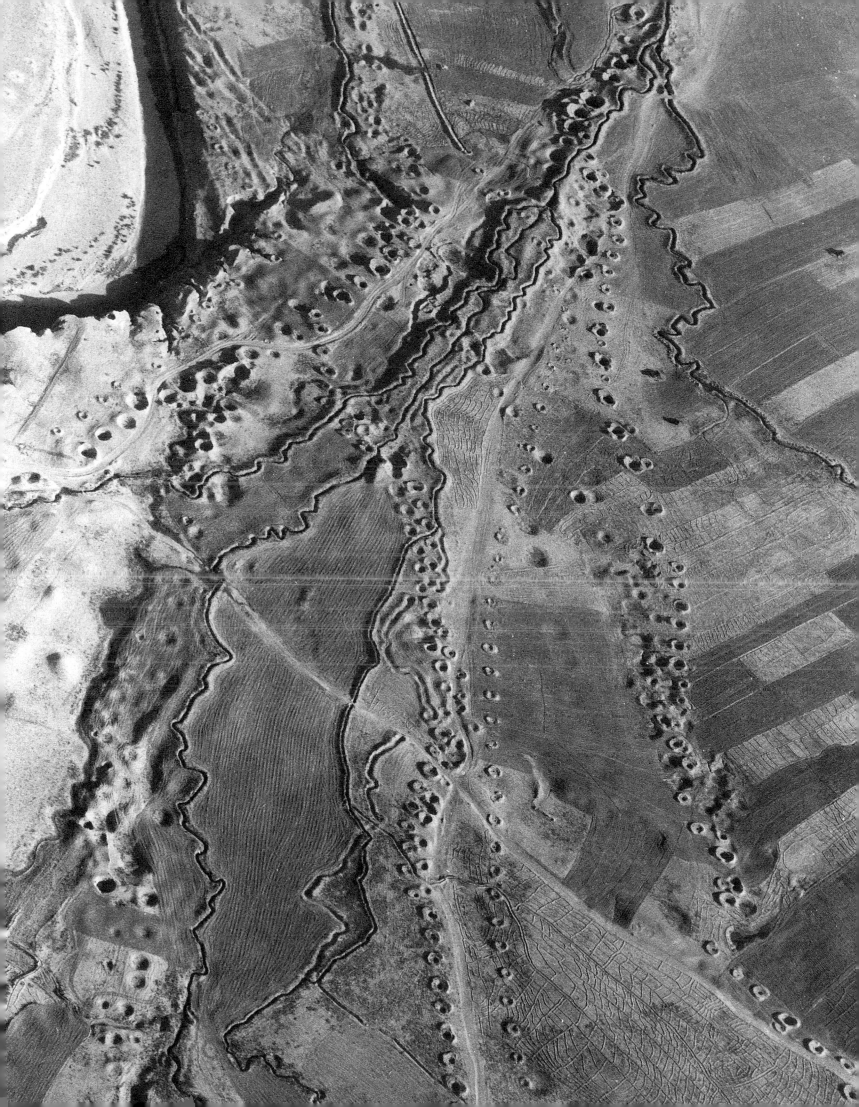

in by a series of natural catastrophes, probably including earthquakes and decade-long droughts.[10]

The Nazca people prevailed along the southern coast, where inadequate water was one of the most serious problems confronting farmers. Even in good years, the Nazca River flows for only a few months. Perhaps as early as A.D. 600, the Nazca people devised a system of underground aqueducts—similar to *qanats*—that took advantage of the sloping water table of the Nazca Valley to channel water to where it was needed. Some of these aqueducts started near hillsides and paralleled the river and its tributaries. Every 100 yards or so, the people constructed stone-lined shafts, providing them with physical access to the aqueducts below, so that they could periodically enter them and clear them of mud.[11]

The Chimú civilization established its capital at Chan Chan, on the northern edge of the Moche Valley, about A.D. 800. Chimú rulers embarked on massive projects to rebuild and extend the irrigation systems that were already present in the valley. Their water-management ambitions led them to create an inter-valley canal system that linked together several major rivers.

Chimú leaders initiated an ambitious and extraordinary hydraulic engineering project: the 50-mile-long La Cumbre canal, designed to deliver water from the Chicama River Valley, in the north, to the Moche Valley. Some archaeologists speculate that La Cumbre may have been under construction for two centuries. The canal passed through difficult terrain that included a variety of obstacles, from rocky foothills to sand dunes. In places, the builders had to amass huge earthen embankments, nearly 70 feet high, to support a stone aqueduct. Only the northern half was successfully completed. Despite the vast amount of effort expended upon La Cumbre, it never delivered a single drop of water to Chan Chan. A tectonic shift, the result of an earthquake, may have doomed the project, causing Chimú's water engineers to abandon it.[12]

In contrast to the Chimú, Nazca, and Mochica societies, the Inca empire, which peaked in the late 15th century, owed its success to its resourcefulness in cultivating high-altitude terrain in the Andes. Its enormous domain extended some 2,700 miles, from the southern edge of Colombia through the highlands and coastal regions of Ecuador and Peru to central Chile. The Incas optimized their agricultural production in mountainous terrain by creating tiered fields, notably in the region around Cuzco, their capital, and in the Colca Valley, in southern Peru. In an environment marked by steep and irregular topography, stepped terraces provided level spaces for crops, as well as for dwellings and ceremonial structures. The terraces were flanked by stone retaining walls, which reduced soil erosion, and equipped with stone-lined drainage systems.

The remains of centuries-old stepped terraces are still found throughout the Andean region. Some of them are even renowned, such as the circular terraces of Moray, an Inca adaptation of natural declivities in the highlands of southern Peru. There, three sets of concentrically ringed terraces and one horseshoe-shaped set of terraces nestle so enigmatically in the landscape that they could almost pass for meteor-impacted amphitheaters.

NAVIGATION CANALS: TRANSPORTATIONAL SHORTCUTS

Because farmers in the ancient Levant could easily pole small boats from rivers into irrigation canals and vice versa, aspiring traders and merchants required only a diminutive leap of the imagination before they conceived larger canals whose primary purpose would be navigation. Southern Mesopotamia was laced with navigable canals perhaps by the early third millennium B.C. Still, no one then could have foreseen the day, some 5,000 years later, when artificial canals, or waterways that combine natural rivers with canalized links, would crisscross entire continents.

Terrestrial exploration, technological know-how, a surplus of trade goods, and a dream—all had to fall into place before anyone could make a hydraulic statement that would significantly change the face of the earth. Many generations of Old and Middle

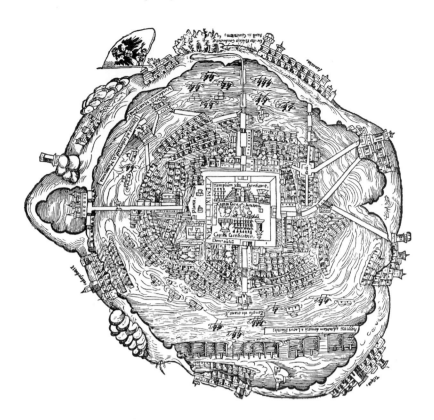

LEFT: Map of Tenochtitlan, 16th century. Collection Seymour I. Schwartz. *The Aztecs founded their capital on swampy islands in Lake Texcoco; a network of canals wove through the city to facilitate canoe traffic. Tenochtitlan impressed the conquistadors, who arrived in 1519, as a city that floated on water. Whatever remains of the Aztec capital now lies buried under Mexico City.*

BELOW: La Cumbre aqueduct-canal, 13th–14th century. Between Chicama and Moche, La Libertad Department, Peru. Photograph by Evan Hadingham. *For nearly 200 years the Chimú people labored on a 50-mile-long intervalley aqueduct-canal with huge earthen embankments, designed to channel water to their capital, Chan Chan. The unfinished project was abandoned during the 15th century.*

PREVIOUS PAGES: Inca agricultural
terraces, c. 15th century. Moray,
Cuzco Department, Peru.
Photograph by Marilyn Bridges,
1989. *Inca fields were terraced,
flanked by stone retaining walls, and
equipped with stone-lined drainage
systems. Moray's extraordinary ter-
racing—three sets of concentric
amphitheater-like cavities and one
horseshoe-shaped set—may be
adaptations of natural sinkholes in
the underlying limestone.*

Kingdom Egyptians, for instance, must have remarked on the narrow bridge of land that separated the Mediterranean from the Red Sea, observing how on occasion the flooding in the Nile delta nearly brought the two bodies of water into contact. Moreover, the flat, sandy isthmus contained its own bodies of water, specifically Lake Timsah and, to its south, a group of briny lagoons, known as the Great Bitter Lakes. More than one pharaoh must have ruminated about constructing a canal that would intersect these bodies of water and connect the Nile to the Red Sea, thereby opening up markets in Arabia and the Horn of Africa.

About 600 B.C., Necho II, a pharaoh of the 26th Dynasty who reigned from 610 to 594 B.C., finally realized this aspiration. He initiated a navigable canal that linked an eastern branch of the lower Nile to the northern part of the Bitter Lakes, then continued eastward to provide access to the Gulf of Suez, which flows into the Red Sea. The canal's surviving remains suggest that it was about 60 miles long, 50 yards wide, and about 16 feet deep.[13] According to Herodotus, the fifth-century B.C. Greek historian, the breadth of the canal, when later completed by the Persians, was large enough to allow two triremes (large galleys with three banks of oarsmen) to be rowed abreast, while the length of the waterway required a four-day journey. Herodotus maintained that the construction of the canal cost the lives of 120,000 Egyptians and that Necho did not complete the project in deference to an oracle who warned that "barbarians" (foreigners) would turn it to their advantage, a prophecy that held more than a grain of truth.[14]

In 520 B.C. the Persian king, Darius I (521–486 B.C.), invaded and conquered Egypt, per-ceived the canal as a useful shortcut to the Red Sea and the Persian Gulf, and commanded that the project be resumed. Although the canal was completed at this time, it proved to be difficult to maintain, being almost continually clogged by drifting sand and rising silt. Ptolemy II (c. 308–246 B.C.), one of Egypt's Macedonian kings, made a valiant effort to restore it. During the second century A.D., when the country was under Roman rule, the emperors Trajan and Hadrian also had the canal cleaned out and repaired. When the Arabs conquered Egypt in the seventh century A.D., they, too, tried to revive the canal—but silt was once again the victor.

In the northern Mediterranean, another potential shortcut that appealed to rulers in the ancient world was a navigable canal across the Isthmus of Corinth, in Greece. The moun-tainous isthmus, which joins the Peloponnesian peninsula to the rest of mainland Greece, is some 20 miles long and, in places, only about four miles wide, but it constituted a formi-dable barrier for sailors who wanted to travel between the Ionian and Aegean seas, forcing them to make a nearly 200-mile-long voyage around the complicated southern shore of Peloponnesus.

After the Roman conquest of Greece, Nero in A.D. 66 decided to build a canal across the Isthmus of Corinth, despite warnings by Roman engineers that it would result in a dangerous current. He himself took the first swing with a digging implement and carried off the first basketful of dirt. His soldiers went on to excavate more than 500,000 cubic yards of earth, making cuts that were up to 98 feet deep and more than 163 feet wide. After Nero's suicide in A.D. 68, the Romans abandoned the project. The cuts were still visible some 1,800 years later.[15]

In China, the origins of canal building have been traced as far back as the sixth century B.C. The country's longest canal, an 1,100-mile-long waterway that extends from Luoyang, in Henan Province, to Hangzhou, in Zhejiang Province, is known to Westerners as the Grand Canal and to the Chinese as Da Yunhe, or the Great Transport River. The Grand Canal was principally built by the Sui dynasty (A.D. 581–618) emperors, who incorporated earlier waterways and canalized rivers in order to link the Yellow River in the north with the Yangtze River in the south. Chinese leaders conscripted 10 million laborers to construct the canal, which facilitated the transportation of goods and also accelerated the convoying of armies. As a result, much of the economic wealth of the fertile southern region was diverted to the north to support the government's administrative and military needs. By the end of

the Sui dynasty, the Grand Canal was probably the longest artificial waterway in the world.

The Grand Canal fell into disrepair between the 10th and 13th centuries, a state of affairs that can be partly blamed on the Yellow River. While the river brings water from Tibet that nurtures northern agriculture, it also carries an extraordinarily heavy amount of silt (which accounts for its name), and the sedimentation causes sandbars that impede navigation.

Under Kublai Khan, the Mongol emperor who ruled China in the 13th century, the Grand Canal was rebuilt and further extended to serve his capital, at Beijing. The skill and scale of Chinese water projects of that period was witnessed by Marco Polo, the Venetian merchant who followed the Silk Route into Kublai Khan's China in about 1275. Polo's travels during his extended stay in China took him to the "noble and magnificent city" of Hangzhou, south of Shanghai on a deeply indented bay of the East China Sea. Being Venetian, he took particular note of the canals. The city was situated, he said, between a fresh, clear lake and a river of great magnitude, and numerous canals, both large and small, ran through every quarter of the city, carrying sewage to the lake and ultimately to the ocean. A wide moat, issuing from the same river and continuing for about 40 miles, enclosed the city.[16]

The Ming emperor Chengzu (also known as Yung-lo) also established his capital at Beijing, in 1421. He reconstructed the once-again silted-up Grand Canal in order to supply the city and the northern frontier with grain and textiles from the more productive Yangtze River region. Despite periodic restorations, however, the Grand Canal continued to deteriorate. It is currently of little use for long-distance traffic: silting, poor maintenance, and competition from railroads have seriously undermined its importance.

Unlike the Yellow River, the Yangtze is navigable all the way to the Pacific, with many tributaries contributing to an extensive transportation network. Large vessels on the Yangtze were traditionally towed upstream by scores, sometimes hundreds, of "trackers," laborers who were harnessed together like teams of sled dogs as they filed along a riverbank and exerted the combined power of their muscles and ropes to haul the boats against a powerful current. In its more turbulent upper course, the river flows through treacherous steep-walled gorges, where narrow tow paths had been laboriously gouged out of the rocky cliffs. Who knows how many generations of laborers chiseled their lives away in carving these narrow channels? Depending upon the amount of water in the gorge, the relative position of the rock-cut pathways could vary from one to 60 feet above the surface of the river.[17]

In Europe, the golden age of canal-building spanned the 17th and 18th centuries. Holland, being crisscrossed with navigation canals in the 17th century, was the site of Europe's first mass-transit system. Dutch waterways and towpaths, called *trekvaarten*, enabled ships to ferry passengers on both intracity and intercity runs. *Trekvaarten* were built in fairly straight lines from city to city, often with a small embankment on one side to protect against flooding. The narrow vessels averaged about 40 feet in length and were capable of carrying 24 to 30 passengers at standard, year-round fares. The trips were regularly scheduled, following a timetable, and departures were punctual, signaled by the ringing of a bell.[18]

Even more than many other Dutch cities, Amsterdam owed its economic development to its incessant control of water. In plan, the city's network of canals resembles a spiderweb, a meticulously spun grid of about 40 concentric and radial waterways, most of them flanked by tree-lined streets and crossed by some 400 bridges. As the land was so flat and the groundwater so close to the surface throughout the Low Countries, the Dutch, through determined hand labor, had to amass earthen foundation mounds and drive timber piles into the ground in order to construct their buildings.[19]

Amsterdammers continued to construct inland waterways into modern times: in 1876 Amsterdam linked itself to the North Sea via the Noordzeekanaal (or North Sea Canal), and in 1953 the city gained more direct access to northwest Germany with the completion of the Amsterdam-Rhine Canal.

RIGHT: Rock-cut towing path. Yangtze Gorges, Hubei Province, China. Photograph by Russ Kinne. *In the turbulent Three Gorges section of the Yangtze, tourists now replace "trackers," harnessed laborers who traditionally pulled vessels upstream by ropes as they filed along a narrow tow path.*

BELOW: The Corinth Canal, 1882–93. Isthmus of Corinth, Greece. Photograph by Roger Wood. *The four-mile-long canal severs the slender strip of land that connects the Peloponnesus to central Greece, providing a shortcut between the Aegean and Adriatic seas.*

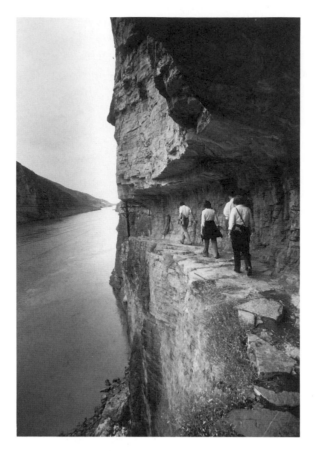

Intensive canalization in France accelerated the flow of trade and thereby contributed to the country's economic development in the 17th and 18th centuries. In 1642 the Canal de Briare provided a north-south connection between the Seine and Loire rivers, eliminating the need for overland transport between them. The 150-mile-long Canal du Midi, built between 1666 and 1681, cuts across the southwestern corner of France, linking the Mediterranean via the Garonne River to the Atlantic. (Initially conceived to carry oceangoing vessels, the Midi canal now accommodates only barges.) The Canal du Rhône au Rhin, begun late in the 18th century, facilitated travel between the Mediterranean and northern Europe.

In England, during the second half of the 18th century, canals were built to link virtually every major navigable river. The Duke of Bridgewater, inspired by his tour of the Canal du Midi, sparked England's canal craze by building, in the 1760s, an artificial waterway that linked his collieries in Worsley with Manchester. Coal and the canals that carried it helped fuel the Industrial Revolution. By the end of the century, Britain had an extensive water-transportation network that surpassed those of most continental countries.

Across the Atlantic, canalmania swept through regions of North America in the early 19th century, when industrialists and politicians determined to link the Great Lakes with eastern markets. Of the five lakes, the only one that presented a natural passage to the Atlantic Ocean was Lake Ontario, whose waters drained into the Saint Lawrence River, which flowed past Montreal on its way to the sea. The problem was that navigators could not get past the Lachine Rapids at Montreal. (Montreal's *raison d'être* was that early French settlers could not proceed upstream.) Between 1821 and 1825, Canadians constructed the Lachine Canal, which bypassed the rapids, thereby facilitating shipping all the way from the shores of Lake Ontario—and the city of Toronto—to the Atlantic.

In 1825 New York State opened the Erie Canal, a 350-mile-long waterway that connected Lake Erie, via the city of Buffalo, to Albany; from there, boats could voyage down the Hudson River to New York City and the Atlantic. The Erie Canal was an instant success, enabling industries in several lakeside cities—including Detroit (Michigan), Cleveland (Ohio), and Erie (Pennsylvania)—to float their commodities to the East Coast. Natural waterways already existed among Lake Erie, Lake Huron, and Lake Michigan, bringing Milwaukee (Wisconsin) and Chicago (Illinois) to the network of inland cities that could engage in long-distance shipping.

Only two of the Great Lakes, Ontario and Superior, remained to be incorporated in the expanding navigational network. In 1828 the Oswego Canal, in northern New York, joined the Erie Canal to Lake Ontario. In 1829 Canadian navvies excavated a canal in the bar of land that separated Lake Ontario from Lake Erie. (It was later replaced by the 27-mile-long Welland Canal.) Waterborne commerce became so intensive that only 10 years after the Erie Canal's inauguration, its main channel had to be enlarged—to 70 feet wide and seven feet deep.[20]

Finally, Lake Superior, the most westerly of the Great Lakes, was linked to Lake Huron by the two Sault Sainte Marie Canals, also known as the Soo Canals. The U.S.-built Soo Canal, constructed between 1853 and 1855 by the state of Michigan (and reconstructed since then), is 80 feet wide and slightly more than one and a half miles long. The Canadian-built Soo, which opened in 1895, is 60 feet wide and slightly less than one and a half miles long.

As the dimensions of ships changed, inland waterways had to be redesigned to accommodate them. The Erie Canal was closed down in 1917, to be replaced the following year by the New York State Barge Canal. In 1959 the Saint Lawrence Seaway opened to great fanfare, bringing large oceangoing vessels through its 2,342-mile-long system of rivers, lakes, canals, and locks into central North America as far west as Duluth, Minnesota.

Among 19th-century canals, the most widely acclaimed and perennially important is the Suez Canal, which fulfilled the ancient Egyptian dream of linking the Mediterranean to the Red Sea. The waterway became a reality through the creative vision of Ferdinand Marie de Lesseps (1805–1894), a French diplomat who had served as consul at Cairo in the 1830s.

In contrast to Necho II, whose canal had taken a mainly west-east route from the Nile, Lesseps chose to make a north-south cut from Port Said, on the Mediterranean, to the city of Suez on the Gulf of Suez. But like Necho, Lesseps linked his artificial waterway to existing lakes, so that only half of the overall length of the canal had to be excavated. Consequently, the northern section of the canal runs in a fairly straight line from Port Said to Lake Timsah. A second excavation connects Lake Timsah to the Bitter Lakes, and a final cutting leads to the Gulf of Suez. The canal was slightly more than 100 miles in length, 26 feet deep, and 72 feet wide at the bottom (since deepened to 40 feet and widened to 179 feet).[21] Because the Red Sea was only marginally higher than the Mediterranean, construction workers were able to dredge a relatively simple, trenchlike canal, unimpeded by locks and thereby capable of accommodating vessels as large as present-day oil tankers.

The Suez Canal opened with triumphant celebrations in 1869, only 10 years after the first spadeful of dirt had been turned. It dramatically shortened ocean travel between London and Bombay by some 4,400 miles, revived marine trade in the eastern Mediterranean, and bolstered Egypt's importance as a commercial passageway between Europe and the Middle and Far East. Today about 15 percent of all international shipping passes through the canal.[22]

After the success of the Suez Canal, no isthmus in the world was safe from scheming entrepreneurs and engineering geniuses intent upon excavating watery paths to glory. Istvan Türr, a Hungarian businessman with a military background, negotiated a deal with the king of Greece to cut a canal across the Isthmus of Corinth. Where Nero had failed, Greek borers and dynamiters succeeded in creating a shortcut between the Aegean and Adriatic seas. In August 1893 the Greek king officially opened the canal, which was about four miles long. "With its towering and almost vertical rock walls," writes international canals chronicler Charles Hadfield, "it is perhaps the most spectacular canal ever built."[23] Passage through the canal after midnight, with the ship's lights playing eerily over the rocky walls, is exceptionally dramatic.

Prior to his involvement with the Corinth Canal, Istvan Türr had designs on the Isthmus of Panama. In 1875 he organized a French syndicate to acquire a canal concession from Colombia, which then had sovereignty over Panama. After winning the concession in 1878, the syndicate sold its rights to a French company headed by none other than Ferdinand Marie de Lesseps, who planned to build a sea-level canal across the isthmus. The digging began in 1881, but a medley of troubles forced the company into bankruptcy eight years later.[24]

The last of the great 19th-century waterways to be constructed was the Kiel Canal, in northern Germany, which connects the North and Baltic seas by severing the neck of the Jutland peninsula (technically separating mainland Denmark from the continent). Also known as the Kaiser Wilhelm Canal, the 61-mile-long sea-level waterway was built between 1887 and 1895. It expedited commercial shipping between the Elbe estuary, on the North Sea, and the port city of Kiel, on the Baltic side—and also facilitated movement of the German navy.

Overseas, in the United States, President Theodore Roosevelt was keeping a wary eye on the German navy—not hard to do in 1902, when the Kaiser's mariners were blockading and shelling Venezuelan seaports in an effort to collect on defaulted loans. German bellicosity spurred the Roosevelt administration's efforts to negotiate an agreement with Colombia, giving the United States the rights to build a canal across a strip of leased land in Panama. The principal parties signed the Hay-Herrán Treaty in 1903, but the Colombian congress balked at ratifying it, hoping to squeeze more money out of the "Yankee imperialists." Panamanians revolted, a U.S. warship rushed to the scene to deter Colombian troops from quelling the insurrection, and Roosevelt immediately recognized the new republic of Panama. American engineers and contractors went to work on the Panama Canal the following year.

In contrast to a flat sea-level channel, such as Suez, the Panama Canal, in elevation, brings to mind a stair-stepped bridge of water. It has six double locks, which raise incoming

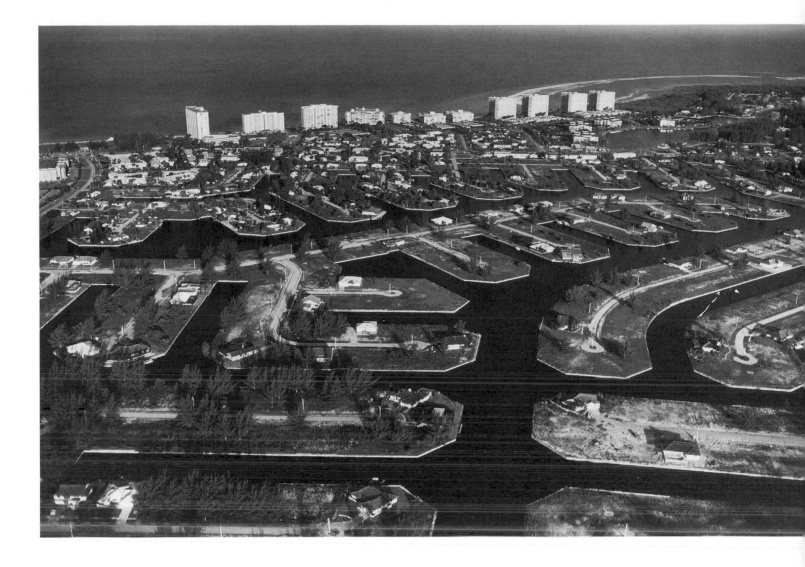

Marco Island. South of Naples,
Florida. Photograph by Cameron
Davidson. *Navigation channels
are as important as streets in this
luxury resort development on South
Florida's Gulf Coast.*

vessels from the Caribbean Sea a total of 85 feet to Gatun Lake, a large body of fresh water on the northern half of the isthmus. Each of the Gatun Locks is 1,000 feet long by 110 feet wide, and has a minimum depth of 40 feet. After Pacific-bound ships cross the lake, they pass through the Gaillard Cut (once known as the Culebra Cut, or "the Ditch"), an eight-mile channel, 270 feet deep with a bottom width of 500 feet, that winds through the continental divide at the Canal's center. Before reaching the Pacific, ships pass two smaller sets of locks.

The Panama Canal, which opened in August 1914, is only 40 miles long from sea to sea, a welcome shortcut for any voyager who wants to avoid the 7,800-mile trip around the southern tip of South America. People making their first crossing are often startled to discover that the Pacific terminus is actually 27 miles east of the Caribbean terminus. This is because the canal runs south and south-east from Colón, on the Atlantic side, to the Bay of Panama, at Balboa on the Pacific side. Although its locks are not large enough to accommodate present-day supertankers, it is still the world's busiest big ship canal.

The naval battles of World War I prompted Americans to develop inland waterways that would protect ships from the hazards of seagoing travel. The Intracoastal Waterway, authorized by Congress in 1919, now extends for some 3,000 miles, from Boston to Key West on the Atlantic route, and from Apalachee Bay, in northwest Florida, to Brownsville, Texas, on the Gulf of Mexico route. Many canals—some new, some dating to the 1820s and 1830s (such as the Delaware & Raritan and the Chesapeake & Delaware)—were linked to existing rivers, bays, and sounds to create a semi-natural, semi-artificial waterway that provides sheltered passage for both commercial and leisure boats.

Skippers can now circulate around the eastern half of the United States without ever setting foot on land. The Atlantic route of the Intracoastal Waterway leads, via the Hudson River and the New York State Barge Canal to the Great Lakes; from Lake Michigan, the Illinois Waterway leads to the Mississippi River, which flows into the Gulf of Mexico.

Among the outstanding barge routes in present-day Europe is the 2,175-mile-long Rhine-Main-Danube Canal, which connects hundreds of inland ports to both the North and Black seas. Its conception can be traced to Charlemagne, the king of the Franks who in A.D. 793 attempted to link the headwaters of the Rhine and Danube rivers, separated by some 5,500 yards. He set a great many laborers to work digging a connecting trench, but the scheme was abandoned after only one season. A portion of Charlemagne's project, the Fossa Carolina, is still visible, near the village of Graben, Germany, and it is now clear that his eight-foot-deep trench would not have been nearly deep enough to accommodate the difference in elevation between the two rivers.

But Charlemagne's dream lived on in the minds of other men, to be realized 12 centuries later. Opened in September, 1992, the canal links the Main River, a tributary of the Rhine (which empties into the North Sea), to the Danube, which flows into the Black Sea. In contrast to many canals that cut in a ruthless straight line across the land, some sections of the Rhine-Main-Danube canal were given a natural-looking winding route. One stretch, running through the Altmühl Naturpark in Bavaria, has subsidiary areas of still water to provide habitat for birds and other wildlife.[26]

ROADS AND TUNNELS: ACCELERATING TRADE AND TRAVEL

A considerable number of people must have passed through West Sudan in 15,000 B.C. in order to have left the tracks that a U.S. space shuttle discovered in 1982. But at what junction in time and place did prehistoric pedestrians turn away from habitually followed paths and tracks to construct a road? By the fifth century B.C., the Persian empire was building roadways that extended from its capital to outlying provinces, while, in Italy, the Etruscans were applying their engineering skills to construct roads that wound sinuously down their hillsides to the valley floors. The Etruscans linked their settlements by a network of roads that often involved ambitious excavations through massive formations of rock.

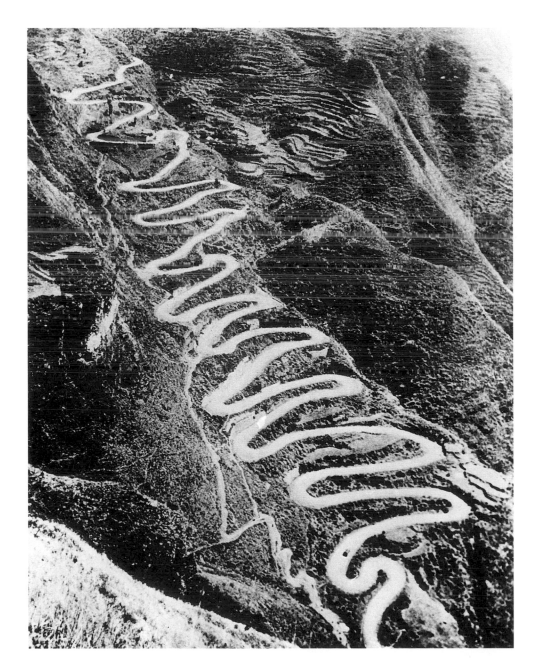

ABOVE LEFT: Etruscan road-cutting, c. 7th–6th century B.C. Near Pitigliano, Italy. Photograph by Piero Malvisi. *The Etruscans linked their settlements by skillfully engineered roads that occasionally involved industrious excavations. This road was cut in the territory of Vulci, an Etruscan city that lay to the south.*

LEFT: The Burma Road, 1938. Lashio, Myanmar, to Kunming, Yunnan Province, China. *After Japanese forces invaded China in 1937, the Chinese responded by rapidly building the Burma Road to transport war supplies from a rail-head in neighboring Burma (now Myanmar) to the Chinese city of Kunming. The unpaved road meandered across 700 miles of exceptionally rugged mountain country and constituted a vital lifeline to China until 1942, when the Japanese also overran Burma.*

An elaborate road system helped unify early imperial China. The first emperor, Qin Shi Huangdi, who reigned from 246 to 210 B.C., was a prodigious builder, now renowned mainly for constructing a substantial portion of the Great Wall (see Chapter 3). His immense road-building projects facilitated travel all across the empire. About 212 B.C., according to historian Ssu-ma Ch'ien (writing nearly a century later), the emperor commissioned a long, intercity road that required its builders to level hills and fill valleys in order to make it straight.[27] The Qin empire's road-building method involved a roadbed of ordinary soil, covered by a top layer—convex to shed water—of rammed earth, tamped with metal ramming tools. Qin highways were about 50 feet wide and planted every 30 feet with firs for shade and beauty. The people who lived near the imperial highways were assigned the responsibility for their upkeep.[28]

As the Pre-Columbian peoples in the Americas lacked not only wheeled vehicles but also suitable domestic animals that might have been harnessed to them, we might imagine they had little need for efficiently designed highways; their roads, however, were often surprisingly well engineered. In Mexico's low-lying rainforests the Maya constructed causeways, or elevated roadways, to run across swampy ground or bodies of water. In eastern Yucatán, a 62-mile-long causeway, possibly built in the ninth or 10th century A.D., linked the settlements of Cobá and Yaxuná. At the western edge of El Mirador, in Guatemala, which prospered from about 150 B.C. to A.D. 150, the remains of three causeways suggest that its 80,000 inhabitants exercised control over virtually anything entering or leaving the city. Near El Mirador, aerial photographs have revealed an extensive network of causeways traceable to other Maya sites several miles away.

The pueblos at Chaco Canyon, in northwestern New Mexico, were connected to one another by unpaved pedestrian roads, probably laid out between A.D. 800 and 1000. They were cut only a few inches deep into the soil and often edged by shallow banks or low stone walls. Aerial photographs and satellite imagery over the past two decades have uncovered a network of more than 400 miles of roadways that linked Chaco to more than 30 outlying settlements. Chaco's highways were as wide as 40 feet and ran in straight lines for up to 60 miles. The roads sometimes contained stairways—no problem for a civilization that had neither draft animals nor wheeled vehicles.

In 15th-century Peru, the Inca developed an impressive system of roads and highways that extended 19,000 or more miles over some of the craggiest terrain on earth and contributed to its speedy ascendancy over rival cultures. Inca roads reached into Ecuador, Bolivia, Chile, and Argentina. Two parallel north-south routes, a highland course across the Andes and a coastal highway, ran the length of the empire. A secondary network of roads and paths linked the pair of north-south highways to one another, to Cuzco, and to many smaller settlements and administrative centers.

Inca road-planners preferred straight routes: several sections of the coastal highway ran for 25 miles or more with scarcely any deviation. Sometimes a road passed directly over rocky hills rather than curving around them;[29] other times, as a conquistador observed of an Inca road somewhere between Cuzco and Quito, Ecuador, it occasionally sliced through living rock: "Through some places it went through flat and paved; it was excavated into precipices and cut through rock in the mountains; it passed with walls along rivers, and had steps and resting spots in the snows. In all places it was clean and swept free of refuse, with lodgings, storehouses, Sun temples, and posts along the route."[30] Inca administrators could send messages via relay runners from Cuzco to Santiago, Chile—a distance of nearly 1,700 miles—in less than two weeks.

Despite extremely distant termini, however, pedestrian roadways seldom go very far in promoting a thriving nationwide economy. Consequently, it is hardly surprising that the Industrial Revolution coincided with a more efficient mode of transportation. Long-distance trade and travel suddenly accelerated in the 1830s as a new type of roadway with parallel rails began to span entire continents. But, before rails and ties could be laid, the ground had to be prepared, frequently by grading and banking. In many parts of the world,

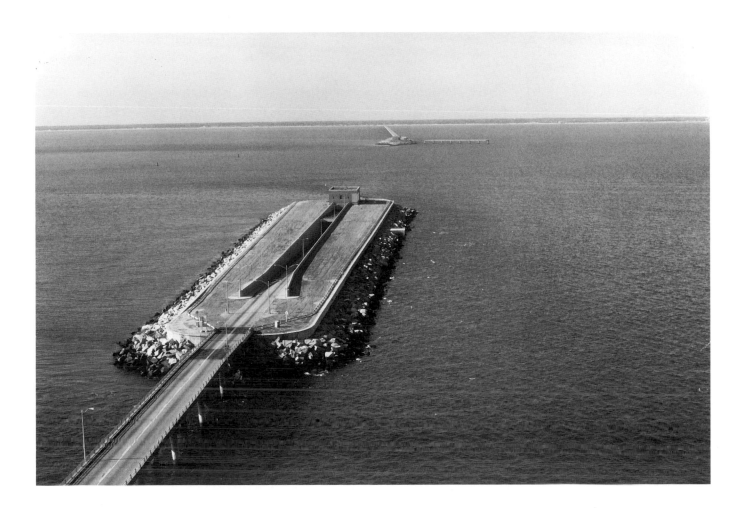

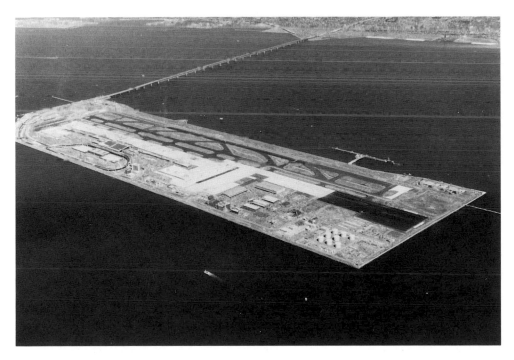

ABOVE: Artificial islands of the Chesapeake Bay Bridge-Tunnel, 1964. Between Cape Charles and Norfolk, Virginia. *The 18-mile-long engineering marvel extends across the mouth of Chesapeake Bay in eastern Virginia. Low trestle bridges lead to artificial islands, where the roadway plunges into a mile long tunnel to leave space for shipping channels.*

LEFT: Kansai International Airport, 1991–94. Osaka, Japan. *The airport occupies a 1,300-acre artificial island in Osaka Bay. The government sited the single-runway airport offshore so that it could operate 24 hours a day.*

engineers sited the rails on artificial ridges of earth that resemble barrows, berms, and causeways, designed to keep the track level and above floodwater. Throughout much of the Great Plains, earth-elevated tracks are often the highest piece of terrain on the horizon.

No terrain—even Alpine—seemed to daunt 19th-century railway engineers. The use of compressed-air rock drills and high explosives enabled them to tunnel through hard-rock mountains. Between 1857 and 1871, construction crews accomplished a spectacular piece of engineering, the eight-and-a-half-mile-long Fréjus Tunnel, a rock-cut passageway for trains crossing the Alpine border between Mondane, France, and Bardonecchia, Italy. Tunnel construction had proceeded at a very slow pace for the first four years, until compressed-air drilling machines were installed in 1861. When the two ends of the tunnel finally met in the middle, they were less than a foot off vertically and about a foot and a half off horizontally.

Emboldened by the success of the Fréjus Tunnel, Swiss officials and engineers initiated an equally audacious project, the nine-and-a-quarter-mile-long Saint Gotthard Railway Tunnel, which runs through Alpine mountains to facilitate traffic between northern and southern Switzerland. Its makers utilized dynamite, water-turbine-powered air compressors, and railborne rock drills. Constructed between 1872 and 1882, the tunnel was achieved at a high cost in terms of human misery: 310 men died on the project and 877 were incapacitated.[31]

Within the next century, the Swiss Alps were crisscrossed with dozens of road and rail tunnels. One of the longest is the 10-mile-long Saint Gotthard Road Tunnel, which opened to traffic in 1980; it runs from Goschenen to Airolo and shortened travel time between Zurich and the southern canton of Ticino by more than an hour. (In anticipation of increased trade in a unified Europe, Swiss officials are planning two additional trans-Alpine railway tunnels. One of them will run 31 miles through the Saint Gotthard massif, passing beneath the two earlier tunnels.)

Technological advances in tunneling passageways for underground trains led inevitably to that gleaming hallmark of advanced civilization—the subway. By the early 1900s, many of the world's great cities were excavating under themselves to create extensive rapid transit systems. London was the first (1863), followed by Boston (1898), Paris (1900), Berlin (1902), and New York (1904).

Two underwater railway tunnels on opposite sides of the globe attracted widespread attention in recent decades. The earlier project, begun in 1964 and largely completed by 1985, is Japan's 33-and-a-half-mile-long Seikan Rail Tunnel, bored more than 300 feet below the sea bed (or nearly 800 feet below the surface of the water) in the Tsugaru Strait, between the islands of Honshu and Hokkaido. The Seikan tube is more than twice the length of the previous "world's longest railway tunnel," also in Japan, and still claims that title, despite close competition from the more recently built "Chunnel."

Although the notion of tunneling under the English Channel had perennially tickled the imaginations of engineers in both England and France, the Chunnel did not become a reality until the 1990s. The 31-mile-long rail tunnel, situated 300 feet below the surface of the English Channel, links Folkestone, England, with Sangatte (near Calais), France—and cuts travel time to 35 minutes. It actually consists of three tunnels, two for passenger and cargo trains and a third, in the center, to service the other two. About the time the tunnel was holed through—on May 22, 1991—the engineers realized they had to devise a way to cool the tunnels for the safety of both passengers and equipment. The speed of the trains, traveling at 100 miles an hour, creates pressure and air friction that cause the temperature to rise as high as 130 degrees Fahrenheit. The solution was to install four refrigerator units, or "chillers," on each side of the channel. The French units were built on land, but the chillers on the British side had to be constructed on an artificial island below the cliffs of Dover.[32] The Chunnel opened in 1994.

Although it is neither road nor tunnel, Japan's new Kansai International Airport may be noted here because it combines a form of transportation with an extravagant earthwork—an artificial 1,300-acre island in Osaka Bay. (Osaka, the nation's "second city," is 300 miles

southwest of Tokyo.) The government decided to site the airport offshore, so that it could be kept open 24 hours a day without annoying (or uprooting) any of Osaka's citizenry. In order to construct the island in 60 feet of water, its builders had to excavate and move more than 6 trillion cubic feet of earth. The government also had to build a two-and-a-quarter-mile-long bridge to convey people to the island, which is surrounded by six and half miles of seawall.

Unfortunately, the island began to sink almost immediately and builders had to augment it with an additional 11-foot layer of earth. As construction costs soared, the government decided to hold expenditures down by building only a single runway. It is perhaps the most expensive runway in the world.[33] It may also become one of the most easily and frequently bottlenecked, and in the event of a major earthquake or tsunami, certainly the most terrifying.

MINING: CARVING THE EARTH FOR PROFIT

Mining is fundamentally different from other commercial endeavors to transform the face of the earth for gain. When farmers terrace fields or dig irrigation ditches, they are behaving as husbandmen of the soil, preserving its fertility for future generations. Builders of shipping canals, roads, and tunnels are generally forgiven their immense gashes in earth and rock because their projects clearly have long-term benefits for trade and travel. Miners, by contrast, are often viewed as sordid plunderers of the earth's resources. Few would deny that society has a need for mining's products—including copper, tin, gold, sulfur, coal, diamonds, and uranium. But the valuable commodities extracted from quarries and mines can never be replenished. Mines are generally incapable of making prolonged contributions to civilization because of their predictable pattern—from exploitation to depletion and abandonment.

Ancient civilizations, including those of Egypt and Rome, trimmed their mining costs by employing slave labor. Diodorus Siculus, a Sicilian-born Greek historian who lived in the first century B.C., detailed some of the horrors of Nubian gold mines, where war captives and anyone found guilty of some crime were chained and put to work "unceasingly by day and throughout the entire night." The physically strongest laborers cut tunnels through the stone, using iron hammers to break the quartz rock and working "not in a straight line but wherever the seam of gleaming rock may lead."[34] Because they labored in unending darkness, the workers carried lamps, bound to their foreheads. Boys were assigned the task of gathering up the rocks and carrying them out into the open, where women and old men pounded and ground them to flourlike consistency.

Two millennia later, man's persistent avarice for gold erupted anew in 19th-century North America, with tens of thousands of unruly prospectors rushing headlong toward remote areas such as Sutter's Mill, near Sacramento, California (1848); Bingham, Utah (1860s); the Black Hills of South Dakota (1870s); and the Canadian Yukon (1890s). Bingham had been a quiet Mormon settlement before gold was found there. The Dakota Territory had been Sioux country before General George Custer's 1874 expedition discovered gold in the Black Hills, attracting prospectors to that region. In Lead, South Dakota, the Homestake Mine, operating continuously since 1877, became the largest, deepest (about 50 underground levels), and most productive (more than $1 billion) gold mine in North America. One of the most famous boom towns is Dawson City in Canada's Yukon Territory, where alluvial gold was discovered in the Klondike River area in 1896, sparking the gold rush of 1897–98. Yesteryear's nugget hunters wielded hand tools, such as picks and pans, which did not cause massive scarification. By contrast, today's mining companies in the Yukon employ huge floating dredges to extract ever-diminishing gold deposits, leaving monumental gashes in the earth.

Although gold put Bingham on the map, its most valuable asset turned out to be its copper. The Bingham Canyon Mine, operated for decades by Kennecott Copper (now a

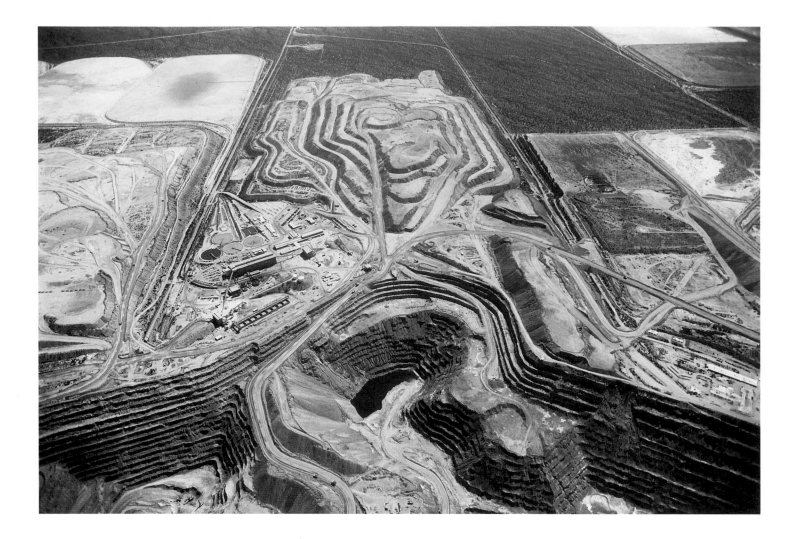

ABOVE: San Xavier open-pit copper mine, 20th century. Southwest of Tucson, Arizona. Photograph by Jim Work.

RIGHT: Chuquicamata copper mine, c. 1915 to the present. Chuquicamata, Chile. Photograph by Sybil Sassoon. *One of the world's largest open-pit copper mines, the Chuquicamata is sited some 10,000 feet high on the slopes of the Andes.*

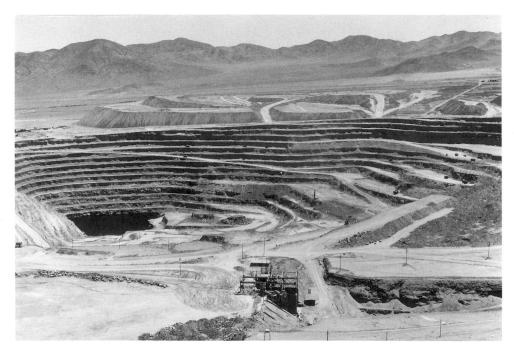

ABOVE LEFT: Gold-dredged field, 20th century. Near Dawson City, Yukon Territory, Canada. Photograph by Georg Gerster. *Dawson became a boom town during the gold rush of 1897–98. Where yesteryear's nugget hunters wielded hand tools, such as picks and pans, today's mining companies employ huge floating dredges that leave a voluminous trail of systematically churned tailings.*

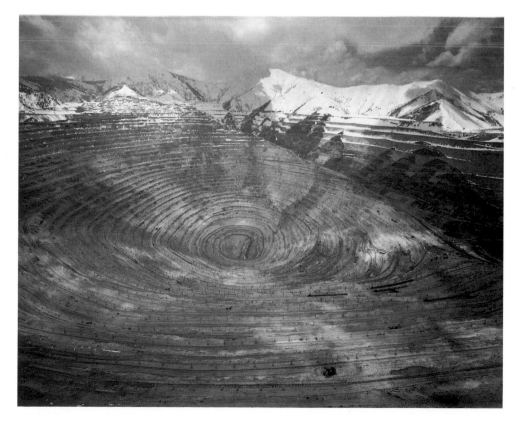

LEFT: Bingham Canyon open-pit copper mine, 20th century. Bingham Canyon, Utah. Photograph by Charles Rotkin. *The Bingham Canyon Mine, one of the world's most productive copper mines, is nearly two and a half miles across and half a mile deep. Its concentric tiers are up to 50 feet high and 120 feet wide.*

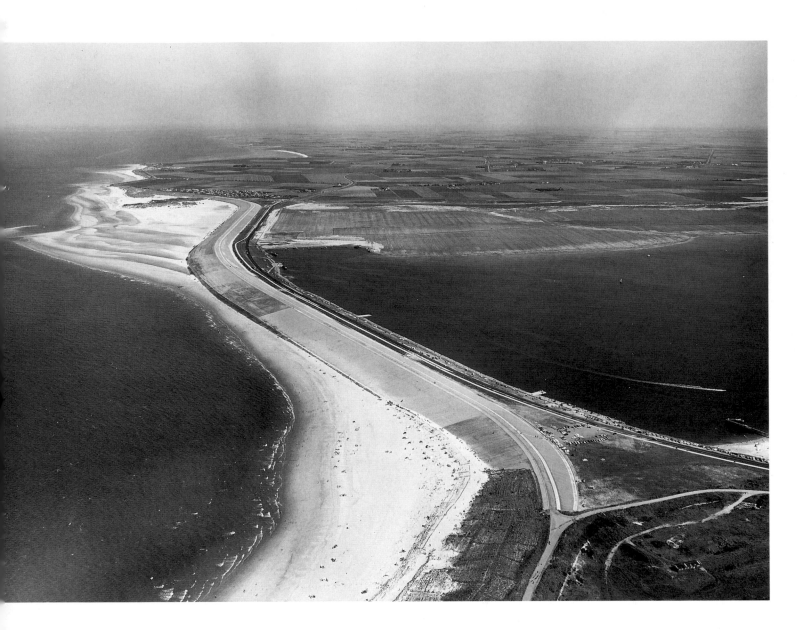

Veersche Gat dike, 1962–64.
Walcheren and Noord Beveland
islands, The Netherlands. *The dike
is composed of rock and sand-fill
and rises 44 feet above sea level. One
and three-quarter miles in length, it
was constructed between two islands
to close off the Schelde estuary.*

division of the RTZ Corporation), became one of the world's most productive copper mines and one of the largest open-pit mines of any kind—nearly two and a half miles across and half a mile deep. Since 1904, more than 5 billion tons of materials have been removed and processed to yield 14 million tons of crude copper. Bingham Canyon Mine's South American counterpart is the Chuquicamata open-pit copper mine in northern Chile, about 10,000 feet up the western slopes of the Andes, operated since 1915.

Elsewhere from Australia to Angola, hardy men subject themselves to harsh or primitive conditions as they pursue sudden wealth by digging for covetable minerals. In South Australia, miners congregate in Coober Pedy, a town near one of the world's richest opal fields. Government policy prevents large mining firms from extracting the iridescent mineral, so lone fortune-hunters from all over the world converge there to pick at the earth for the opals, both fiery and white, for which the region is noted. Thousands of miners live in underground homes, dugouts carved out of the terrain. Few of the dugouts display any architectural distinction, but many have surprised their occupants with added attractions: in remodeling their premises, the miners occasionally unearth precious opals.

In Angola, perhaps as many as 50,000 fortune seekers have descended upon the Cuango River area, where they live and work amid dangerous and degrading conditions while they prospect for diamonds. Diamond mining is one of Angola's oldest industries, dating from 1912, when deposits were first discovered in the Cuango River valley. As the African drought dried up rivers, alluvial diamond deposits in riverbeds and riverbanks became more accessible. By 1992, the Cuango, once a 100-mile-long stream, had become a dry riverbed, a bleak sight to everyone but the unending flow of diamond hunters.

De Beers Consolidated Mines, Ltd., headquartered in Kimberley, South Africa, is the largest and most powerful company in the world diamond trade. De Beers mines diamonds in several provinces of South Africa, as well as in neighboring Namibia and Botswana. Along the coast of Namibia, the company's earthmoving equipment displaces tens of millions of cubic yards of sand and gravel from bedrock each year, using some of it to maintain a 115-foot-high seawall.[35] To obtain a single gram (or five-carat) diamond, miners often have to process 40 tons of ore.

DAMS AND DIKES: MANAGING WATER RESOURCES

One of the most effective ways to manage water is to construct earthen embankments, such as dams and dikes. Dams are barriers built to retain needed water (for drinking, irrigation, improved waterway navigation, hydroelectric power, and so on). Dikes, or levees, are barriers built to keep out unwelcome water. Both types of structures have proved useful for thousands of years and continue to be built.

Few nations in history have managed their water resources more prudently than the Netherlands, a country so low and flat that much of it lies below the high-tide level of the North Sea. The Dutch had to make do with a coastal region that was predominantly wetlands, with marshes, tidal flats, dunes, and shallow lakes. About 1,000 years ago, the people began building earthen dikes to keep various bodies of water within bounds. They increased their cultivable land by continually diking and draining patches of swampy terrain. Their land-reclamation efforts accelerated in the 15th century, when they began to employ windmill-driven pumps to draw off the water.

Eventually, the Netherlands succeeded in reclaiming more than a quarter of its land from below sea level, maintaining it with an extensive network of dikes and canals. One of the nation's most ambitious projects was the drainage of the Zuider Zee, a shallow, 80-mile-long inlet of the North Sea. The Zuider Zee had once been a lake but was "appropriated" by the North Sea during a great flood of the 13th century. Between 1920 and 1932, the Dutch split the Zuider Zee in two with a barrier dam, creating an inner body of water, the IJsselmeer (much of which has been reclaimed for farmland and urban expansion), and an outer body of water, the Waddenzee. In the early 1960s, the Dutch constructed the Veersche

Gat, a rock- and sand-fill dike between Walcheren and Noord Beveland islands that closes off the Schelde estuary. Although its length is less than two miles, it is one of the highest dikes in the Netherlands—44 feet above sea level.

But Holland's land reclamation has been achieved at a stiff environmental cost. The extreme manipulation of land and water has created havoc with water tables and polluted aquifers. It has also contributed to eradicating native plant and animal species. In the country's higher regions, pumping has lowered water tables by as much as two feet, while, in the lowlands, the land is sinking by as much as two feet as the soil compresses after being pumped dry. The soil itself has become dangerously acidified through overuse of insecticides, manure, and chemical fertilizers.

In 1990 the Dutch government initiated an ambitious plan to halt the overall deterioration of the landscape. It is buying up tens of thousands of acres and aims eventually to return some 600,000 acres—almost 10 percent of present farmland—to forest, wetlands, and lakes. Dutch officials now argue that it makes economic sense to return less viable lowlands to nature. In the lowlands south of Amsterdam, which are 18 feet below sea level, the earth will be deliberately flooded so that it may revert to marshland and lakes. In the uplands, a formerly constricted branch of the Rhine will be set free to curve at will. The government bought up nearly 50 farms in one area and flooded them to join two lakes into one larger one. Elsewhere, it acquired 15,000 acres of farmland and set them aside to revert to wetlands, which hopefully may become a breeding ground for storks, geese, cranes, and other birds.[36]

Israel is similarly attempting to restore wetland in a northern region that it ruinously drained in the 1950s. Back then, when its citizens clamored for new farmland, the government triumphantly dug a network of canals to drain the Hula lake and marsh, north of the Sea of Galilee, thereby "reclaiming" some 15,000 acres of supposedly fertile land. The problem was that the peat soil from the bottom of the marsh dried out, decomposed, released pollutants, and even caught fire in underground conflagrations caused by spontaneous combustion. Most of the resulting wasteland was unfit for cultivation. Government planners now want to bulldoze a new lake bottom and reflood 1,500 acres in anticipation that a somewhat restored wetland will raise the depleted water table under adjacent farmland. To accomplish this, they will draw water from the Jordan River, which used to meander through the Hula marsh—before being diverted in order to drain the swamp.[37]

Dams, too, are being subjected to critical reappraisal. Since the 1970s, environmentalists have been pointing out that dams disrupt the temperatures and nutrient systems on which organisms depend. Dams trap nutrients and prevent them from flowing downstream, and both the impoundment and release of dam water alter downstream temperatures, making the water either too warm or too cold and thereby dispatching entire populations of insects vital to the riverine food chain.

One of the worst offenders is the Aswan High Dam, completed in 1971, an earth- and rock-fill dam (with a clay and cement core) that produces much of Egypt's electric power while also controlling the annual flooding of the Nile. The 375-foot-high dam created an enormous artificial lake (Lake Nasser) that displaced 90,000 people and destroyed many archaeological treasures. But the Nile now deposits its organic nutriments on the bottom of the lake, which is silting up, instead of carrying them to the agricultural lands of Lower Egypt. As a result, the soil downstream does not get naturally replenished and farmers must increasingly rely on artificial fertilizer. The reduction of organic nutriments in the Nile has also contributed to the elimination of some fisheries in the eastern Mediterranean. Moreover, as Lake Nasser's water lies still under Egypt's blazing sun, more than a quarter of it evaporates.[38]

Excessive silting may also be a problem in what promises to be one of the world's largest dams—the Three Gorges Dam, being built by the Chinese government on the Yangtze River. Authorized in 1992, the 607-foot-high Three Gorges Dam will produce electric power and reduce the risk of flood by creating a huge lake. It will also displace 1.2 million people

from the 375-mile-long area that is to be flooded. The dam will not only destroy entire villages but also annihilate nearby forests and wildlife habitats. Because the Yangtze carries more than 5 million tons of sediment each year, opponents of the dam charge that most of the silt will fall to the bottom of the reservoir, gradually turning the lake into an unnavigable mud puddle.

In Mesopotamia's Edenic past, when early civilizations first discovered they could alter and dominate natural watercourses, people soon learned that those who control a region's water necessarily determine the destiny of its populace. That lesson is being learned harshly by the Madan, Arabs who dwell in the marshes of southern Iraq, below the confluence of the Euphrates and Tigris rivers. The Madan live on artificial isles, constructed on an armature of reeds that over the years increase in bulk as buffalo dung, household garbage, and mud accumulate. The Madan sustain themselves by tending to their water buffalo and by fishing. They maneuver their long canoes adroitly through secluded reed-bordered streams and lagoons, never getting lost in waters that outsiders find virtually unnavigable. Because the marshes offer a good hideout, the region has traditionally attracted political dissidents.

As a consequence of the Persian Gulf war, thousands of southern Iraq's Shiite Muslims, as well as many Iraqi army deserters, fled to the Madan marshland; the Madan are Shiites, too. In 1992, the Iraqi government responded by draining the region, constructing dikes, dams, and canals to cut off the tributaries that sustain the marsh. After drying up more than half of the 6,000 square miles of wetlands, the government sent in infantry and armored personnel carriers to attack, shell, and burn the villages. In destroying the marshland, the government virtually annihilated the Madan's way of life, making it all but impossible for the people to grow rice or harvest fish.[39]

All Iraqis are likely to discover in coming decades that their once-abundant river water will become an increasingly rare and precious resource. Turkey, their neighbor to the northwest, is building a series of 22 dams that will contain the headwaters of both the Euphrates and Tigris rivers. By 1994 the first three dams were either fully operative or nearing completion. All are part of the Turkish government's Southeastern Anatolia Project, intended to revitalize six arid provinces by making them cultivable, while generating hydroelectric power.

Turkey's new dams may create problems for both Iraq and Syria. Syria currently draws on the Euphrates for irrigation and hydroelectric power, while Iraq relies on both the Euphrates and the Tigris for the same purposes. As Turkey's southern provinces turn green with fields of wheat and barley, Iraqis and Syrians with a reduced share of the rivers may have to become accustomed to parched riverbanks that are less conducive to human habitation than those of a few thousand years ago.

OVERLEAF: Island village. Southern Iraq. Photograph by Georg Gerster. *For centuries the Madan people dwelt in reed huts on islands constructed of reeds, mud, and buffalo dung in the marshes south of Al'Amarah, near the confluence of the Euphrates and Tigris rivers.*

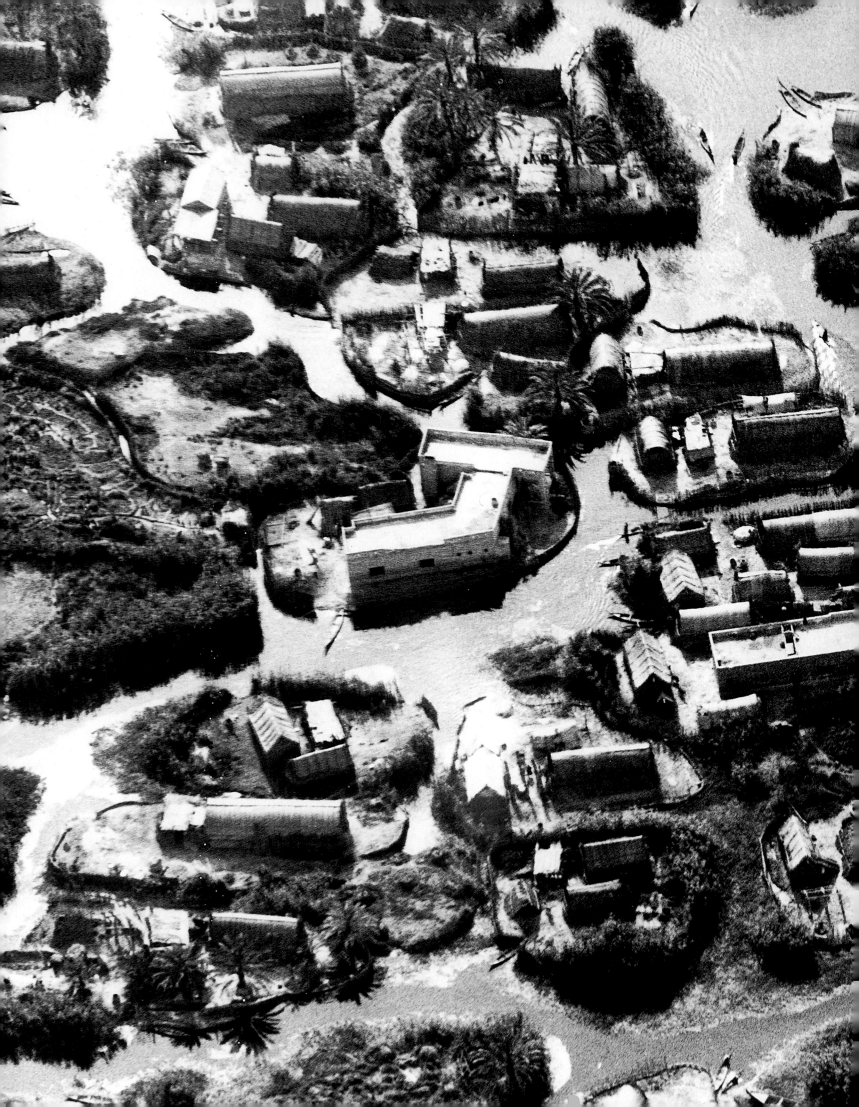

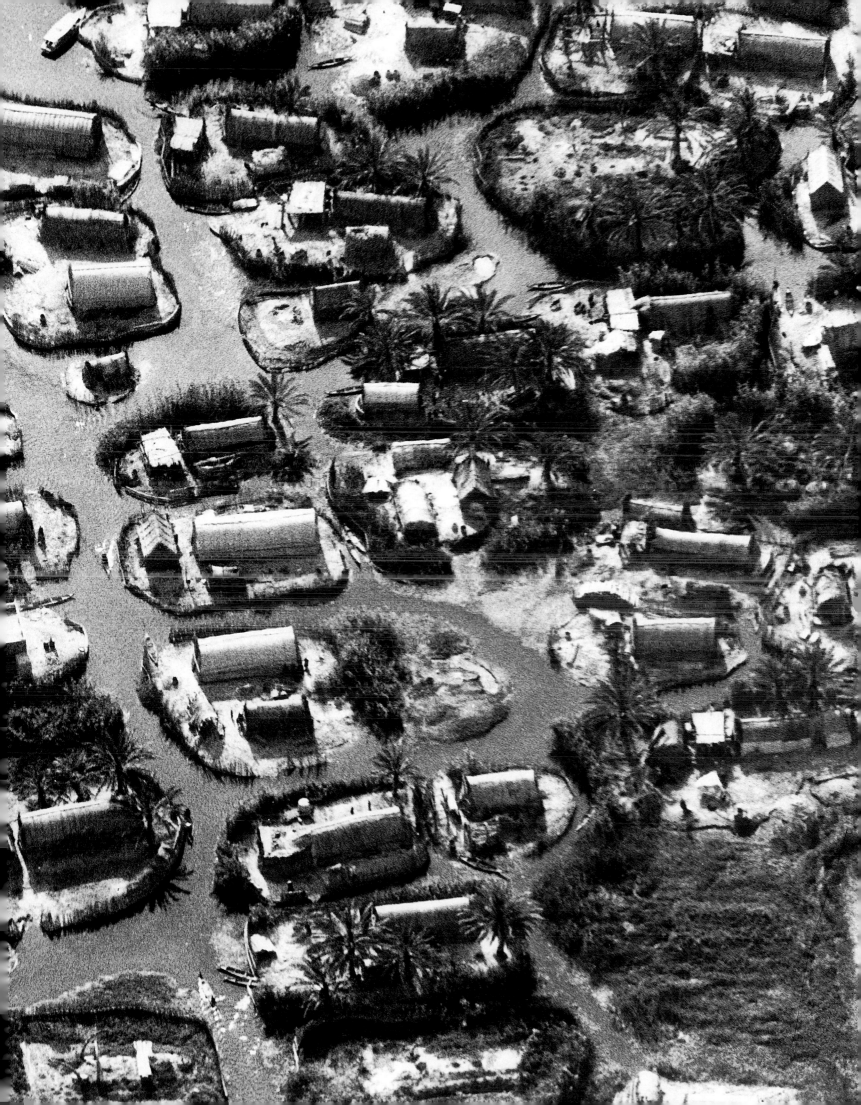

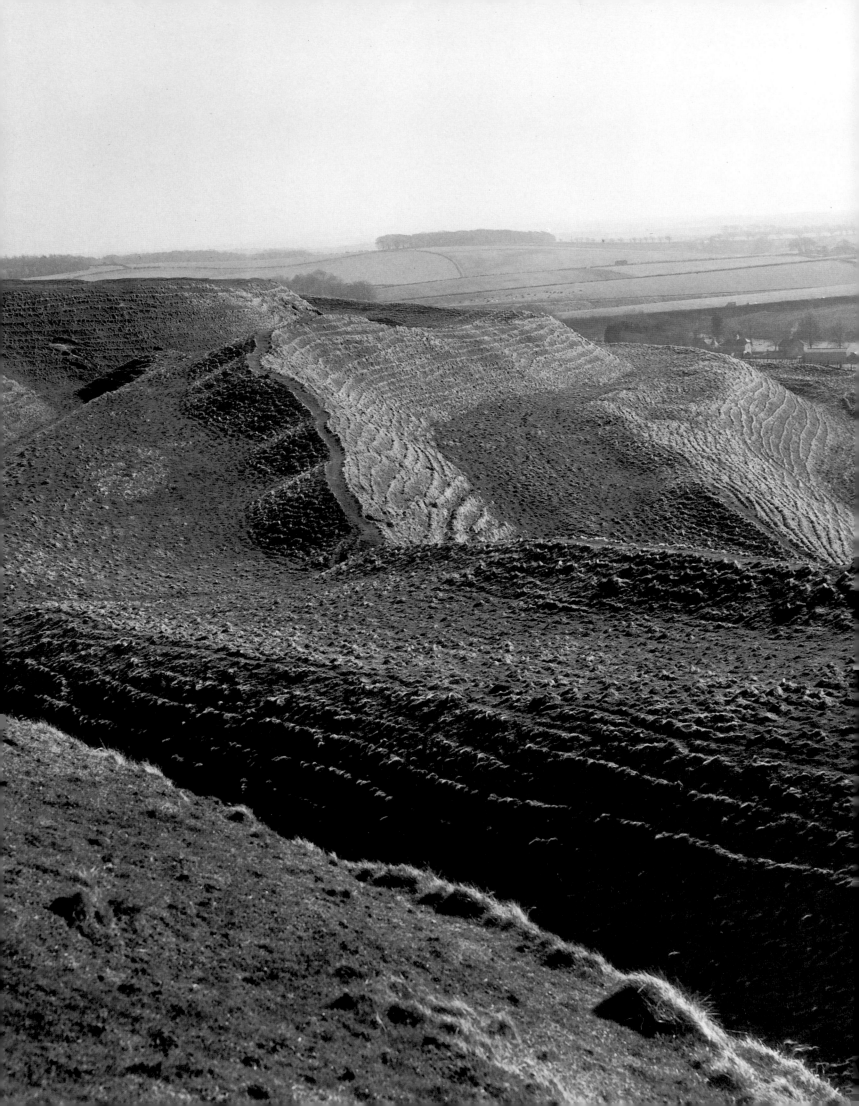

Defense

From Ramparts and Moats to Trenches and Foxholes

*Strife is as old as the human race. By the end of the Stone Age, orga-
nized warfare was commonplace among rival tribes who invaded
each other's seasonal hunting grounds. Many of the earliest settled
societies often discovered—too late—that they could not survive
without defensive fortifications. Besieged prehistoric communities in
southern England learned to cope with invasion by retreating in
times of peril to hillforts that they had previously encircled with
concentric rings of ramparts and ditches, designed to put their ene-
mies at a tactical disadvantage. In the ancient world, many cities
sought to protect themselves with stone walls or defensive earth-
works. Their attackers responded with earthworks of their own: they
amassed earthen siege ramps to get over the wall and excavated
tunnels to go under it. Castle-dwellers in the medieval world dis-
tanced themselves from unwelcome intruders by living atop steep
artificial mounds of earth, surrounded by deep moats. Some of their
kings discouraged invading populations by building immense
earthen dikes that extended for miles. In the 20th century, soldiers
endeavor to find shelter and survival in trenches, foxholes, and
bunkers. Despite all the sophisticated weaponry of mass destruction,
the earth still provides an available refuge.*

OPPOSITE: Maiden Castle, c. 350
B.C. Near Dorchester, Dorset,
England. Photograph by Lesley
Burridge. *The combined height of
ditches and ramparts was designed
to put invaders at a disadvantage.*

As early as the eighth millennium B.C., fortified settlements began to appear around much of the eastern end of the Mediterranean. When people built solid walls or ramparts around their villages, they could more easily protect their stored reserves of food and more safely work the land outside the walls.

Jericho, situated west of the river Jordan some five miles northwest of the Dead Sea, is the world's oldest known "city" (c. 8000 B.C.)—and perhaps the first to devise massive fortifications. It began as an oasis settlement in a semi-desert valley, making an early transition from hunting and food-gathering camp to agricultural community, where the people cultivated wheat and barley on the mud flats. By 7000 B.C., Jericho grew to a nearly 10-acre mud-brick village with 2,000 to 3,000 inhabitants who had become wary of attackers. They surrounded their town with a massive stone wall that was 10 feet thick. Inside the wall, they constructed a single tower that was 28 feet high and 33 feet in diameter, equipped with an internal stairway; it served as a lookout and as an elevated platform for Jerichoan archers. At the outside base of the wall, the inhabitants excavated a dry moat that was 30 feet wide and 10 feet deep, a large enough channel to deter all but the most venturesome enemies.

As the centuries rolled by, Jericho's inhabitants repeatedly rebuilt their dwellings and city walls, each settlement creating a new stratum atop the rubble of previous ones. Altogether, the multilayered ruins of the successive townships add up to a 65-foot-high tell. But Jericho's walls did not save the city from violent destruction several times—and several centuries—before Joshua led the Israelites there (between about 1400 and 1250 B.C.).[1] Long before the miraculous conquest described in the Hebrew Bible, Jericho pioneered three of the main features of defensive fortifications—wall, tower, and moat. They were all in place some 9,000 years ago, and they remained the standard ingredients of fortified strongholds until the introduction of gunpowder in the 14th century.[2]

In Anatolia, about 5400 B.C., the residents of Hacilar II enclosed their settlement with a mud-brick fortification wall between five and 10 feet thick with mud-brick towers on stone foundations. Obviously, the thicker the wall, the better, but the principal requirement of a defensive wall was height, setting the besieged above and out of reach of the attackers. The top of the wall had to permit the defenders to move freely and to wield their weapons without difficulty. Inhabitants often equipped their settlements with arsenals of spears, bows, slings, maces, axes, and daggers. The sling was a favored weapon all over the Mediterranean; it could discharge deadly rock missiles over a range of about 200 yards.

Central Anatolia served as the homeland for the combative Hittites, whose empire thrived from about 1650 B.C. to about 1200 B.C., enabling their armies and war chariots to dominate Syria and even to invade Egypt. The Hittites established their capital at Hattusha (or Hattusas), near Boğhazköy (about 100 miles east of present-day Ankara). The towering site, a high trapezoidal plateau, was a natural stronghold with steep cliffs on the north and east sides. Because it offered such good security, other tribal peoples had occupied it as early as the third millennium B.C. The Hittites constructed their palace atop a rocky crest near the cliffs. To accommodate additional buildings along other edges of the site, they extended the plateau by creating stone terraces. But their most ingenious structure was the fortification they built along the west and south sides.

The Hittites first amassed a huge earthen rampart, 80 yards thick at its base and narrowing as it rose to present a glacis, or slope, to the outside. (One advantage of a curved glacis was that it made it more difficult for enemies to approach with battering rams and scaling ladders. Glacis were typically faced in places with dressed stone; when defenders dropped stones from above, they bounced off the glacis at unexpected angles, causing disarray among the attackers.) Upon this rampart, builders constructed a double wall of dressed stone masonry, filling the space between with rubble. Atop this stone wall, they built a mud-brick wall, probably crowned by battlements. This tall, intimidating structure

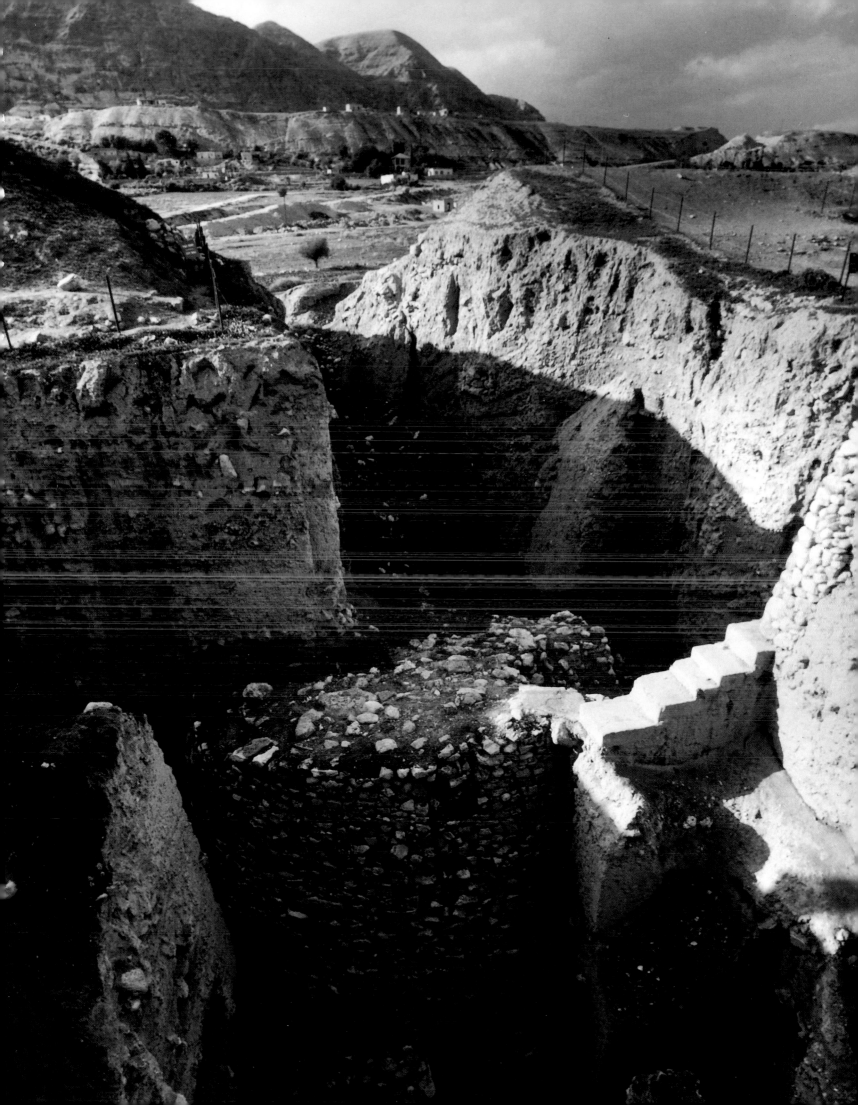

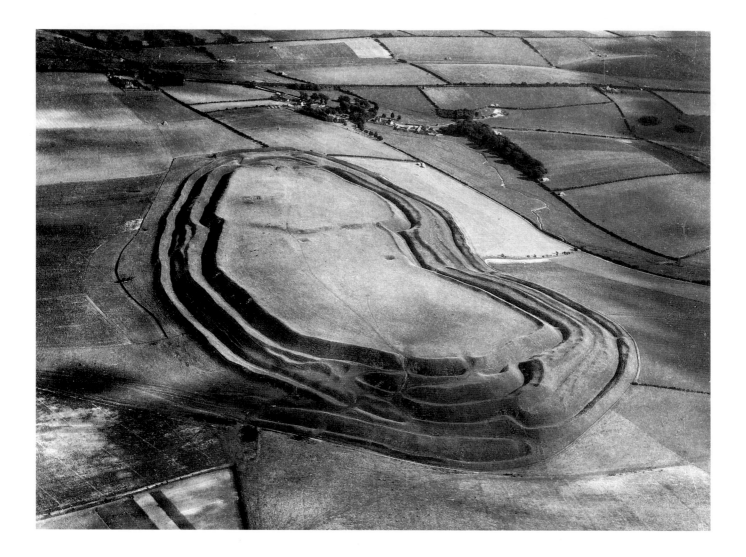

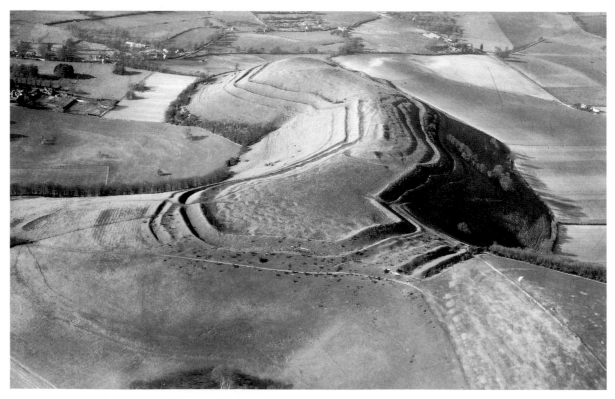

extended across the terrain for more than three miles, securely girdling the once-vulnerable sides of the plateau.[3]

A standard component of Hittite defenses was a tunnel that ran under the city wall, connecting the settlement's center with the outside. The tunnels probably functioned as sally ports for sorties. The one at Hattusha was corbeled and 90 yards long.

Throughout much of ancient Europe, villagers entrenched themselves behind ditches, ramparts, and stockades. In Britain people particularly favored ditch-encircled camps, intended to be entered only by a single causeway, and hillforts, which were also surrounded by ditches. In some locations traces of causewayed camps and hillforts occupy the same hilltop site, although they were constructed more than 1,000 years apart. The causewayed camps, typically circular in form, are both earlier and rarer (about 20 have been identified), and most are situated in southern and eastern England. They are usually surrounded by one or more concentric ditches, enclosing an area from three to seven acres. The causeway provided the only planned access into the camp, and the entrances were often safeguarded by an obstacle, such as a boulder or tree trunk. If attackers attempted to enter via the causeway, they found themselves funneled into an easily defended opening.

Briar Hill, in Northampton, appears to be England's oldest causewayed camp, dating from about 4400 B.C. It was rediscovered through aerial photography in 1972. Another ancient causewayed camp, Windmill Hill, in Wiltshire, was in almost constant use from about 3250 to 2000 B.C. Its name derives from the so-called Windmill Hill people, Neolithic colonist-farmers, who migrated from the Continent to southern England around 4000 B.C. The area enclosed by the outermost ditch covered about 21 acres, making it the largest of Britain's extant causewayed camps. Its makers dug three concentric rings of ditches and threw the earth inward to make an internal embankment that parallels each ditch. The outermost ditch was the deepest (seven feet) and the innermost was the shallowest (three feet).

People probably did not live year round in causewayed camps; more likely, the inhabitants of the surrounding area retreated to them in times of conflict to mount a common defense. The camps may also have functioned as ritual sites at certain times of year. Considerable quantities of both human and animal bones have been recovered from the ditches, leading some experts to see signs of feasting, others to construe a mortuary significance (the people exposing corpses of loved ones around the edge of the enclosure.)

Hillforts are more numerous than causewayed camps: traces of nearly 1,500 of them exist in southern England. Most were built after 1000 B.C., becoming almost commonplace by 400 B.C., and they continued to be made until A.D. 750. The forts generally occupied an area of 10 to 20 acres and consisted of several concentric rings of banked earth and ditches. Hillfort design was basically intended to accentuate the existing difficulties of the terrain. By relocating to hilltop positions in times of peril, people could monitor the approach of unwelcome intruders and prepare to repel assailants.

In its simplest form, the hillfort consists of an outer ditch and an inner bank, composed of the earth thrown inward from the ditch. The people who built them employed primitive tools: discarded antlers of red deer functioned as picks, and shoulder blades of large, probably domestic, animals served as shovels. Wicker baskets were used to carry the earth. In some cases a palisade of stakes crowned the embankment, considerably increasing the fort's defensive capabilities. The approach to the entrance was sometimes channeled by banks and ditches so that attackers had to expose their unshielded right sides to the sling-stones and javelins of the defenders.

Many hillforts, like causewayed camps, were essentially rallying places, defensible refuges to which a rural population could flee in times of danger. But some yield traces of numerous dwellings, which suggest that defensive earthworks were integral to the village they contained.

Two of the largest hillforts are Maiden Castle and Hambledon Hill, both in Dorset (and both overlapping earlier causewayed camps). The older of the two, dating to about

OPPOSITE, ABOVE: Maiden Castle, c. 350 B.C. Near Dorchester, Dorset, England. *This hilltop refuge acquired its present configuration of triple ditches and earthen ramparts over several centuries. During the first century A.D. Roman forces stormed the ramparts and massacred the inhabitants.*

OPPOSITE, BELOW: Hambledon Hill, c. 3500 B.C. Dorset, England. *Hambledon Hill's two main ramparts accentuate the existing challenges of the terrain, causing would-be attackers to weary themselves in climbing to the top*

3500 B.C., is Hambledon Hill, whose two main ramparts enclose 31 acres. By contrast, Maiden Castle, built around 350 B.C., covers some 160 acres and includes a triple ditch and rampart system. The first embankment there enclosed 16 acres; the site was enlarged in a second phase, c. 250 B.C., and eventually covered almost 50 acres. Its outer ditch was 16 feet wide and more than six feet deep. It served numerous peoples over the centuries, including a tribe of Bretons who were fleeing Julius Caesar in 56 B.C. Archaeologists discovered an arsenal of 54,000 sling-stones at Maiden Castle, indicating that its occupants took their defense very seriously indeed.

The crucial role of a well-dug defense is still acknowledged in the English language by the phrase "last-ditch effort." William III, who ruled in the late 17th century, evoked a millennium or so of British courage when he said: "There is one certain means by which I can be sure never to see my country's ruin: I will die in the last ditch."[4]

MILITARY CAMPAIGNS IN THE ANCIENT WORLD

In besieging a city, there were three basic ways to get past a city wall: go over it, through it, or under it. The Assyrians, who conquered virtually all of the ancient Near East between 900 and 612 B.C., typically employed all these tactics simultaneously, utilizing scaling ladders, battering rams, and tunneling tools. They built earthen ramps outside city walls and, after reaching a sufficiently high level, positioned ladders that enabled them to go over the top. They mounted battering rams on wheeled siege towers that could be moved directly against the wall. From the siege towers, archers picked off defenders atop the city walls, providing cover for the soldiers below who were intent on breaking the wall with their battering ram. Meanwhile, other Assyrian soldiers tunneled under the walls until the subsiding earth caused a breach in them.

Under Sennacherib (see Chapter 2), the Assyrians ruled Babylon through a series of puppet kings. But the treacherous Babylonians seized one of them and handed him over to enemy forces in Elam. Sennacherib, enraged, initiated fierce campaigns against both the Elamites and the Babylonians. As a result, in 689 B.C., he demolished Babylon, knocking down its mud-brick temples and diverting the river Euphrates to flood the city squares. "The wall and outer wall, temples and gods, temple towers of brick and earth, as many as there were, I razed and dumped them into the Arahtu Canal," he gloated. "Through the midst of that city I dug canals, I flooded its site with water, and the very foundations thereof I destroyed. . . . That in days to come the site of that city, and its temples and gods, might not be remembered, I completely blotted it out with floods of water and made it like a meadow."[5]

But Babylon rose again on an even more lavish scale. Under its sixth-century Chaldean king, Nebuchadnezzar, the Babylonian capital achieved architectural eminence. According to Herodotus, writing in the following century, the square city was "surrounded by a broad deep moat full of water, and within the moat there is a wall 50 cubits wide and 200 high." The earth that was shoveled out to make the moat was formed into bricks, which were baked in ovens. Workmen then laid the bricks to revet each side of the moat, using hot bitumen for mortar. They subsequently built a wall, so enormous—in Herodotus's account—that its top held two rows of "one-roomed buildings facing inwards with enough space between for a four-horse chariot to pass."[6]

Military leaders on the Italian peninsula were also heaving earth around, usually for defensive purposes. The Etruscans typically established their cities on naturally fortified sites and made use of ditch and mound defenses. Poggio Buco, which prospered from the seventh century B.C. into the first half of the sixth century, occupied a hill that overlooked and controlled a strategic juncture of three streams that protected the settlement on its western, eastern, and northern fronts. The city's acropolis, on the south side of the hill, was isolated by a ditch and mound, believed to be the oldest known defensive earthwork in the Etruscan homeland.[7]

Farther south, Rome was also taking its fortifications seriously. The emerging city initially had consisted of small villages on the Palatine hill and neighboring knolls with groups of thatched huts clustered together in defensible positions. By the seventh century B.C., the hilltop villages acquired more elaborately constructed fortifications in the form of terraces, ramparts, and ditches.

Because of its increasing population, Rome needed to expand territorially, preferably into more fertile terrain, and the wealthy Etruscan city of Veii was the nearest and most tempting target, positioned about 10 miles away, on the opposite side of the river Tiber. The people of Veii attempted to augment their natural defenses by cutting back the cliffs on which the city stood, making the approach more precipitous. They also erected an earthen rampart along the periphery. The Romans besieged Veii during the last part of the fifth century B.C., and the campaign lasted perhaps a decade. Ironically, according to legend, the Etruscans' superb engineering brought about Veii's downfall. Roman soldiers penetrated one of the Etruscans' drainage tunnels, which enabled them to pass beneath Veii's citadel. Roman sappers then cut a shaft below the floor of the Temple of Juno. Just as a priest was about to predict the outcome of the war by examining the entrails of a sacrificed animal, the Romans burst through the floor, seized the entrails, and claimed victory. For more than a century afterward, Roman armies would routinely defeat Etruscan forces until the last stronghold, Volsini, was vanquished in 280 B.C. By then, every spoonful of Etruscan soil had fallen under Rome's expanding shadow.

As early as 378 B.C. the Roman state was able to organize the building of a massive city wall, more than six miles long, parts of which still survive. The wall was made, ironically, of squared stone blocks from the Grotta Oscura quarries in the territory of Veii.

Perhaps no military leader was so resourceful at constructing earthworks to storm walled cities as Alexander the Great (356–323 B.C.), the Macedonian king whose martial skills were among the wonders of the ancient world. He utilized moles, or causeways, as well as sapping and siege ramp tactics to conquer intransigent opponents. He is famous for the length of his march (25,000 miles), trekking eastward from Macedonia to prevail over much of the earth, from Asia Minor and Egypt to northern India.

In 332 B.C. Alexander employed earthworks to besiege and conquer two important cities: Tyre, the ancient capital of Phoenicia along the coast of Lebanon, and Gaza, a major caravan station in Palestine. Tyre, a great port for international trading voyages, was situated on an island with a circumference of nearly three miles and walls up to 150 feet high, separated from the mainland by half a mile of sea. Alexander needed Tyre on his side because of its eminent position for shipping and communication. He attempted to negotiate with the city's elders, but the Tyrians demonstrated their disdain by hurling his messengers from the top of the city walls to their deaths. Alexander, infuriated, resolved to storm the city.

Without ships at his disposal, Alexander commanded his troops to build a mole across the water, linking the mainland to the island. To obtain construction materials, he had his army demolish the stone buildings of Old Tyre, on the mainland, and cut timber from Lebanon's forests. The troops scooped up mud from the shallows and used it as binding matter to fasten the stonework in place. Yard by yard the mole extended toward the island.

Alexander's men constructed two 150-foot-high towers at the end of a 200-foot-wide mole, equipped with catapults to hurl missiles against the city and her ships. In July, after a seven-month siege, the towers, complete with drawbridges, were beside the city walls. The Tyrians utilized all the standard devices of defensive siege warfare, including red-hot sand and boiling oil, which they poured onto Alexander's men. But Alexander's army breached the walls and took the city. The vengeful Macedonians, angered by the stubborn resistance of the Tyrians, massacred more than 8,000 of the island's inhabitants and took some 30,000 (mostly women and children) into slavery. On Alexander's orders, 2,000 more Tyrians were crucified along the shore.[8] (Alexander's mole is still extant today, considerably

widened by two millennia of drifting sand and now crisscrossed by asphalt roads.)

After conquering Tyre, Alexander continued his campaign southward to Gaza, another strategically important city. Gaza was amply fortified and garrisoned by mercenaries, but its most formidable defense was the sheer height of its tell. When Alexander commanded his troops to reassemble the siege machinery that had been shipped from Tyre, his engineers objected that the city was "too high to take by force." In that case, Alexander replied, the ground level would have to be raised to meet it. He ordered his men to construct an earthen mound along the south wall of the city. Despite summer heat, the troops heaped up a huge mound in only two months; it reportedly rose 250 feet in height and measured 400 feet in width. While some soldiers constructed the earthwork, sappers dug tunnels beneath the city walls to undermine them, often an effective method against cities set on a tell. Alexander's catapults and siege-towers were hauled to the top of the mound, within striking distance of Gaza's walls, which, being simultaneously undermined by the sappers' tunnels, soon ruptured, enabling the Macedonians to pour in. Gaza's population was ferociously punished for its resistance: every man was killed and every woman and child was taken into slavery. Not one of its former residents remained as Alexander proceeded to Egypt.[9]

Alexander's reputation for harsh treatment of his opponents may have preceded him to Egypt because, there, he was welcomed heartily and, according to some reports, was even crowned as pharaoh at Memphis.

Early in 331 B.C., Alexander sailed from Memphis to the mouth of the Nile, explored its outlets, and at the delta's western edge founded Alexandria, the first of many cities that he created and named after himself. He even marked out the ground plan for the new city.

Alexander led his army all the way to the Beas River in northern India before deciding reluctantly to turn back. His men were on the brink of mutiny. To put a good face on his retreat, he declared that he was fulfilling the will of the gods. Still, another three arduous years passed before he and his exhausted troops made their way back to Babylon in 323 B.C. There he came down with a debilitating (and controversial) ailment, possibly a malarial fever, and died, just short of his 33rd birthday.

ANCIENT CHINA: THE BEGINNINGS OF THE GREAT WALL

If Alexander the Great had continued his march into China, he would have encountered a multitude of city walls, typically made of rammed earth and sometimes faced with stone. The very first consideration in ancient Chinese town planning was the design of the fortification walls. As early as the third millennium B.C., settlements of the Lung-shan people (a Neolithic culture of c. 2500–1800 B.C.) were often protected by ramparts of beaten earth or mud-brick. During the Shang dynasty (c. 1766–c. 1122 B.C.), the city of Zhengzhou, in Honan Province, had a pounded-earth city wall, nearly four and a half miles long, that was about 30 feet high and 65 feet wide.

During the eighth century B.C., some 200 feudal territories existed in China, but fewer than 20 individual states survived by 500 B.C. During the Warring States period (403–221 B.C.), several kingdoms, including Chu, Qin, Wei, Yan, Zhao, and Zin, independently constructed numerous walls, reflecting their mutual mistrust. City walls were frequently 65 feet wide at the base and nearly 50 feet high.

A tamped-earth method was used to build the walls. This entailed erecting planks on both sides of the wall. Then, a stratum of earth was poured into the space between and tightly pounded a few inches at a time, layer by layer, with a heavy pounder.

The warring kingdoms feared not only each other but also the dreaded nomads to the north. Farmers in northern China were periodically harassed by tribes of these herdsmen, who seized crops, livestock, and even people. The most notorious of these "barbarians" were the Xiongnu (Hsiung Nu). (Some historians detect an ancestral link between them and the Huns.) As early as 300 B.C., raids by nomadic tribes along the northern frontier

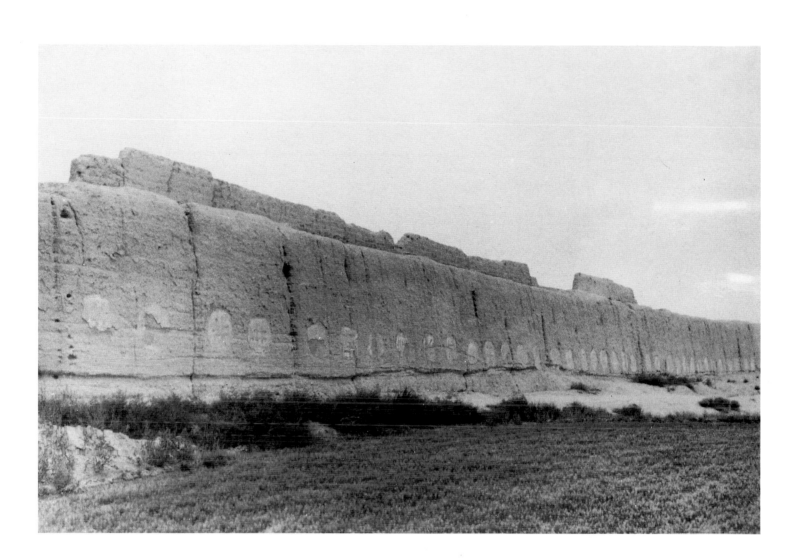

ABOVE: The Great Wall, rammed-earth section. Ming dynasty. Yongning County, Gansu Province, China. *As early as 300 B.C., the Qin kingdom constructed a defensive wall near the Yellow River to keep out nomadic herdsmen from the north. Approximately 600 miles of the Great Wall in Gansu Province was constructed of rammed earth. This segment is about 26 feet high.*

LEFT: Illustration of tamped-earth wall-building technique. *These Chinese builders are constructing a house with earthen walls. Having placed planks on both sides of the planned wall, they pour in a few inches of earth and compact it with a heavy pounder. They repeat the process until they reach the desired height. Similar methods were used to construct the Great Wall.*

prompted the Qin state to build a long defensive wall near the Yellow River. Not surprisingly, the walls constructed as barriers against the Xiongnu came to be perceived as dividing lines between a settled agricultural civilization (China) and nomadic barbarism (the northern steppes).

At the end of the Warring States period, the Qin king emerged triumphant: he unified the various kingdoms and proclaimed himself the first emperor of China, titled Qin Shi Huangdi, the same ruler who initiated the imperial highways (see Chapter 2). The empire's most urgent task, he decided, was to extend existing defensive walls that would act as a buffer between the Chinese and their undesirable nomadic neighbors. He essentially consolidated the existing northern walls of the Zin, Zhao, and Yan kingdoms and created the basis for a united defense against the barbarians. Because he established a larger and more comprehensive defensive wall than ever before in China, Qin Shi Huangdi is often acclaimed for building the entire Great Wall of China. But, while he deserves a great deal of credit, he does not merit all of it. Though one of the most formidable builders in Chinese history, he could not have foreseen how the wall would continue to grow segment by segment for more than 1,500 years.

Qin Shi Huangdi assigned one of his most important generals, Meng Tian, the task of consolidating the walls. He also sent along his eldest son, Fu Su, to assist. Meng Tian took control of the area south of the Yellow River and proceeded to construct a new wall that complemented the terrain and made advantageous use of natural obstacles. He relegated the old Qin wall to a secondary position, building the new one farther north. Some 300,000 people were conscripted to labor on the project.

The emperor died in 210 B.C., enabling his grand counselor, Li Si, and his prime minister, Zhao Gao, to engage in a treacherous piece of mischief. They suppressed news of the emperor's death and attempted to save their careers and spheres of influence by forging an edict that ordered both General Meng Tian and Prince Fu Su to commit suicide on account of conspiracy. "What crime have I before heaven?" Meng Tian responded. But, being a good soldier, he did as he was instructed, first writing, "Indeed I have a crime for which to die. Beginning at Lintao, and extending east of the Liao river, I have made ramparts and ditches over more than 10,000 *li* [a *li* is approximately equivalent to 630 yards or one-third of a mile], and in that distance it is impossible that I have not cut through the veins of the earth. This is my crime." Prince Fu Su also did away with himself, making it possible for the late ruler's incompetent second son, Hu Hai, to inherit the empire. By the spring of 206 B.C., the short-lived Qin dynasty was terminated.

Rulers of the Han dynasty, which succeeded the Qin state, continued construction of the Great Wall. From the first century B.C. through the first century A.D., the Great Wall not only functioned as a military defense but also played an economic role in the development of the so-called Silk Route. By extending the Great Wall westward, the Han government protected the trading caravans that set out from Xi'an (Chang'an), in Shaanxi Province, to Dunhuang, in Gansu Province. A large part of the wall that passes through Gansu is made of rammed earth; remnants of it still survive.

Because of several variables, including workers' skills, available materials, and terrain, the Great Wall differs considerably in construction and dimensions from one area to another. Growing by segments and snaking its way across the north, it would not achieve its fullest extent until the 17th century.

THE ROMAN EMPIRE: FROM MASADA TO HADRIAN'S WALL

By the first century A.D., Roman armies occupied virtually the entire rim of the Mediterranean, from Spain and Gaul to North Africa and the Near East. Pickaxes were as important as swords in enabling the Romans to conquer and secure new territories. Part of every Roman soldier's gear was a tool bag containing—in addition to a pickax—a saw, a chain, and a hook, as well as rope and stakes for constructing entrenchments. He also carried a

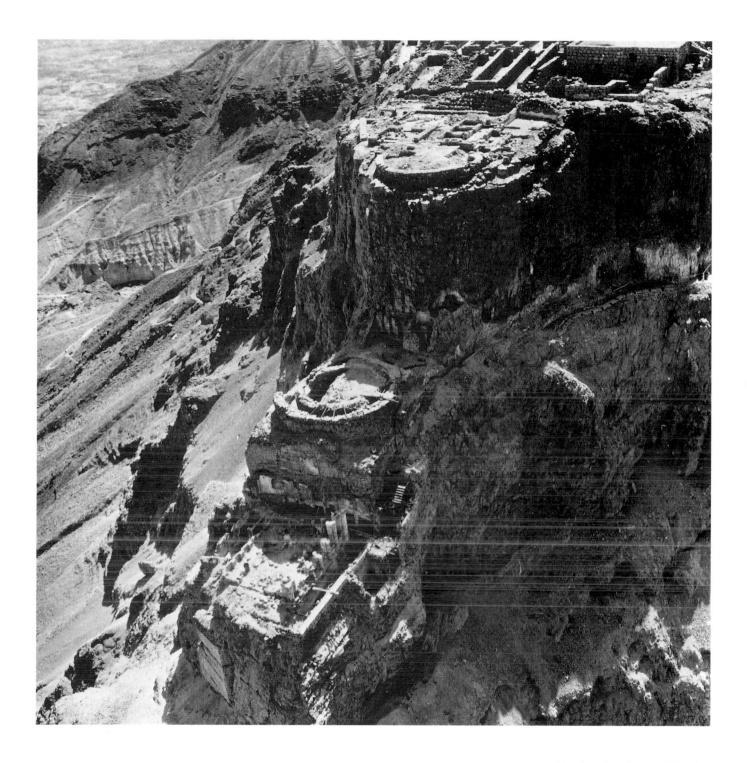

Masada, palace-fortress of Herod, 36–30 B.C. Masada, Israel. *Herod built a luxurious three-tiered palace atop Masada, a steep, flat-topped mountain at the edge of the Judean desert. About a century later, nearly 1,000 militant Jews, known as Zealots, defied Roman rule and sought refuge on the mountaintop, which they used as a base for raids against the imperial army.*

wicker basket for moving earth. The soldiers, or legionaries, quarried building materials, dug canals and drainage ditches, and constructed roads.[10]

Rome maintained authority over its territories through a comprehensive network of roads that linked it to all parts of the empire, from western Europe to Asia Minor and Syria. Within their African province alone, which extended from the Nile basin to Morocco, the Romans constructed some 10,000 miles of road. The imperial roads are renowned for the accuracy of their surveying and the skill of their engineering. Their exacting design enabled commanders to calculate precisely the amount of time needed to travel from one place to another; a march from Rome to Cologne, for example, took 67 days.[11] The legionaries customarily constructed paved roads with multiple layers of sand, gravel, and large and small stones. The roads ran with impressive directness through open country and kept to high ground in uneven terrain.

In building their camps, the Roman legionaries typically chose sites on strategic plateaus at river junctions. They always adapted the ground to the form of the camp, no matter how much digging this entailed. Rectangular in shape, the camps covered 50 or 60 acres and were capable of holding 6,000 men. They were surrounded by a rampart or palisade, initially constructed of turf and timber and later made more durable in stone. The rampart was surrounded on the outer side by a ditch.[12]

Vegetius, a Roman military historian in the fourth century A.D., described the legionaries' methods in constructing camps. "If danger is not too pressing, turves [blocks of turf] are dug from the earth all round, and from them a kind of wall is built, three feet high above the ground, in such a way that there is the ditch in front from which the turves have been cut; and then an emergency ditch is dug, nine feet wide and seven deep." But, if the army anticipated a more threatening enemy force, it fortified the circuit of the camp with "a full-scale ditch," 12 feet wide and nine feet deep. "Above this," Vegetius wrote, "placing supports on both sides, a mound is raised to a height of four feet, by using the earth from the ditch. At this stage the defenses are 13 feet high and 12 feet wide."[13]

Judea, before it became a Roman province, was one of the empire's "client kingdoms." Two of Caesar's most loyal followers, Mark Antony and Octavian (later known as Caesar Augustus), helped Herod the Great become king of Judea, a throne he held from 37 to 4 B.C. Herod initiated nearly two dozen major building projects within his realm. He also built an entire city, Maritima Caesaria (which he dedicated to his patron, Caesar Augustus), on what is now the Israeli coast, as well as various palaces, fortresses, and a new temple in Jerusalem. Herod built or rebuilt royal residences set on top of easily defended mountains and outfitted them with splendid living quarters and with ample cisterns and storerooms to withstand long sieges. His mountaintop palace-fortresses offered luxurious living with swimming pools, gardens, and Roman-style baths.

Between 36 and 30 B.C., Herod created an ambitious palace-fortress atop Masada, a dramatically steep, flat-topped rock at the eastern edge of the Judean desert with a sheer drop of more than 1,300 feet to the desert floor below. The top of the mountain is roughly rhomboidal in shape, with its narrowest angle in the north. The site measures some 1,900 feet from north to south and 650 feet from east to west. According to Flavius Josephus, a Jewish historian who was born in Jerusalem about A.D. 37, Herod chose the site for two reasons. The first involved his apprehension that a Jewish uprising might depose him; the second was his fear that Cleopatra would persuade her lover, Mark Antony—Herod's one-time sponsor—to bestow the kingdom of Judea upon her. Fortunately for Herod, Antony refused to grant her wish. Just in case, Herod prepared Masada as a refuge.

Upon Masada, Herod built two palaces, equipped with heated baths. Of the two, the elegant three-level "hanging villa" on the mountaintop's northernmost edge is the more compelling. It appears to cling to an aerie-like reconfigured "corner" of the mountain, its tiered terraces descending the steep scarp. Herod's engineers, before they could erect anything on the lowest and narrowest terrace, had to fashion a massive buttressing wall, up to

OPPOSITE: Herodion, 22–15 B.C. Several miles south of Jerusalem. Photograph by Georg Gerster. *Herod remodeled a natural hill to construct this sumptuous palace-fortress. He banked earth and stone fill around the sides of the hill to create a stylized mound in the form of a truncated cone. A long, winding flight of steps provided the only access to the top, where four semicircular towers were deployed around a central courtyard.*

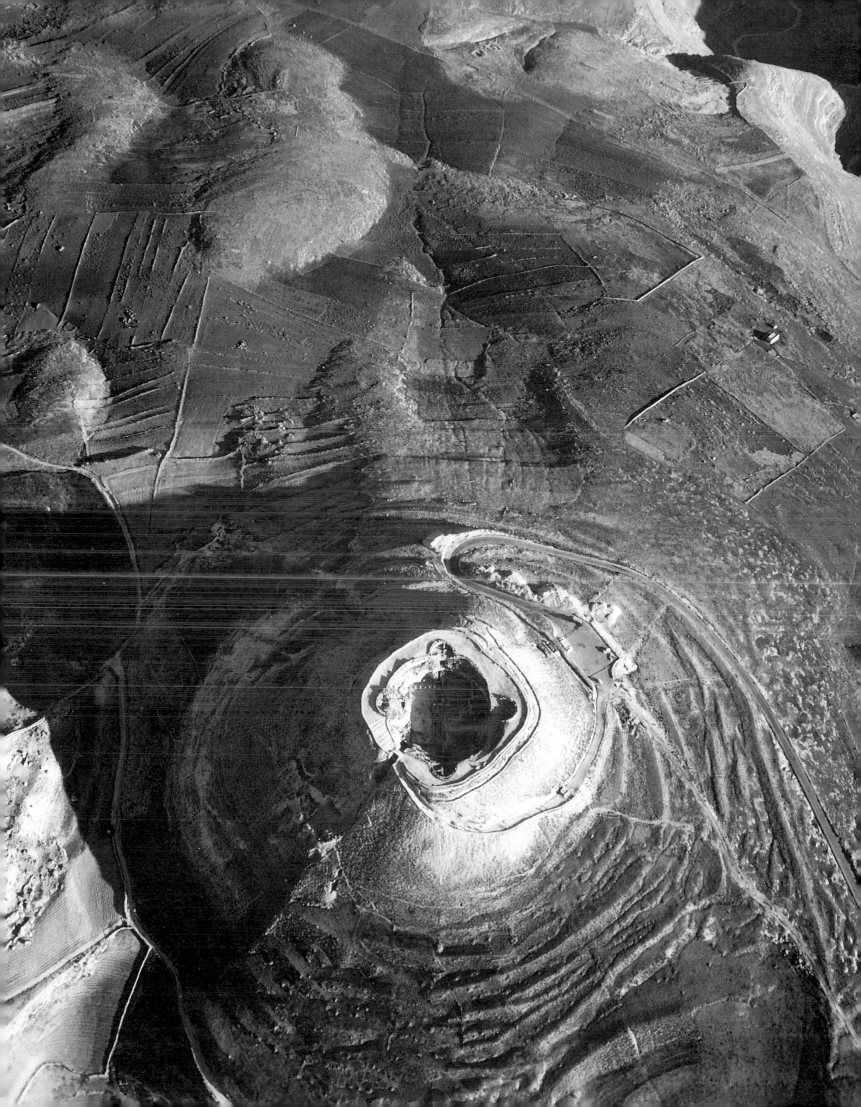

80 feet high, to support a largely artificial platform that seems to perch precariously over the abyss below. The buttressing wall obviously required of its builders extraordinary engineering skill. The terraces were connected by staircases that were partly rock-cut and partly constructed.

Although Masada had no natural water supply, it did have two wadis (dry river beds), which, while parched most of the year, swiftly filled with rushing water when it rained. Herod's engineers constructed channels to conduct water from the wadis into vast underground cisterns, carved from living rock.

In another part of his kingdom, about eight miles from Jerusalem, Herod constructed a sumptuous mountaintop fortress known as the Herodion. Between 22 and 15 B.C., he remodeled a natural hill and banked a mass of earth and stone fill along the top to create an artificial conical shape. A long flight of some 200 steps provided the only access to the circular structure on top, which is about 68 yards in diameter. Four semicircular towers bordered the open circle. The eastern tower may have held the royal apartments.[14]

As it turned out, Herod never had to defend any of his palace-fortresses. He survived into his late 60s—some say increasingly deluded, depraved, and violent—before being laid to rest in his palace in Bethlehem. Ironically, in A.D. 66, 70 years after his death, Masada became a refuge for Jews revolting against Roman rule.

Nero, who became emperor at age 17 and ruled from A.D. 54 to 68, appointed one of his generals, Titus Flavius Vespasianus (the future emperor Vespasian), to suppress the Jewish rebellion. Vespasian, then in his late 50s, was a seasoned warrior who had been a commander in the Roman invasion of Britain in A.D. 43. Now, in Judea, he readily led his army against the Jewish rebels—at least until A.D. 69, when he became emperor. His son, Titus, a legionary commander, continued the assault on Jerusalem and, following a siege, conquered it in A.D. 70.

But the rebellion in Judea had not yet reached its final conclusion. A faction of militant Jews, known as Zealots, took refuge at Masada, using it as their base for raids against the Romans. In A.D. 72 Flavius Silva, the Roman procurator of Judea, set out to crush this last outpost of resistance. He and his legionaries marched on Masada, accompanied by thousands of Jewish prisoners of war. Flavius Silva commanded his troops to build an earthen rampart around the base of Masada and established eight camps at key points along the base of the rock to assure that no Zealots escaped. The Zealots, led by Eleazar ben Yair, prepared for a long siege.

The Romans began their assault by constructing an enormous siege ramp, piling earth on top of a natural ridge of rock until the head of the ramp was only 150 feet below the citadel. There, they built a 75-foot-high stone platform and on top of that they placed a 90-foot-high, iron-plated siege tower with a battering ram. From the relative safety of their iron tower, the Romans catapulted grapefruit-sized stone balls at the Zealots, who fought back with bows and arrows. Finally, the Romans' battering ram breached the stone wall. Within, they found a second wall of wood and earth, which they managed to set on fire. As darkness cloaked the site on the evening of April 15, A.D. 73, the Romans returned to their camp, confident they would take Masada the following morning.

During the course of the night, the Zealot men, fully expecting to be annihilated or, perhaps worse, enslaved by the Romans, decided they would rather die by their own hands. They resolved that each man would dispatch his own family. After they carried out that action, they gathered all their material possessions and set them on fire to assure that the Romans would find nothing of value. Then the men wrote their names on pieces of broken pottery and cast lots to decide which 10 of them would dispatch the others. The 10 remaining individuals cast lots again to determine who would kill the other nine. Finally, the last man impaled himself on his sword.

When the Roman soldiers climbed through the breach in the still-burning walls on the following day, they were astonished to find 960 dead bodies. They might never have known what happened had it not been for seven survivors, two women and five children, who

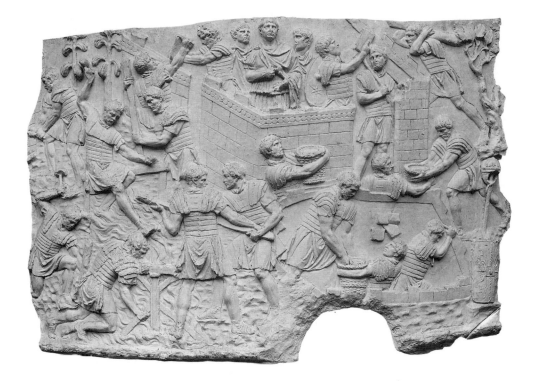

Trajan's Column (detail of lower portion), A.D. 106–13. Trajan's Forum, Rome. *The entire shaft of the 125-foot-high marble column is covered by a spiraling relief sculpture that constitutes a visual narrative of Trajan's campaigns against the Dacians. This detail shows the legionaries setting up a typical Roman camp: while some soldiers excavate a double ditch and carry away baskets of earth, others construct ramparts with squared pieces of turf. Trajan, at top, oversees the activity.*

Hadrian's Wall, c. A.D. 122–28. Near Cawfields, England. *The Roman army secured its position in Britain by building a wall that ran in an east-west direction all across northern England. Most of the 73-mile-long wall was composed of stone, but some 30 miles of the western portion was initially constructed in blocks of turf.*

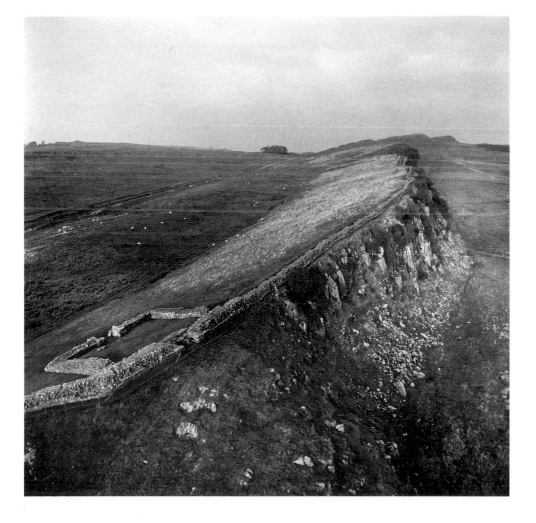

crawled out of their hiding place to tell an extraordinary story, recorded by Josephus in his *History of the Jewish War* (c. 77–78).

Nearly two millennia later, Masada's siege ramp is still in place, scarcely disturbed by passing time. The mountaintop site is now a symbol of Jewish resistance and has become a crucial rallying point for present-day Israelis, who vow, "Masada shall not fall again."

Around the time that the legionaries were putting down the Jewish revolt in the east, the Roman Empire was battling on its western front to secure its territories in Britain. There, the Romans were experiencing difficulties in establishing a permanent line of defense in an area that is now between northern England and southern Scotland. Almost as fast as the soldiers built turf-and-timber forts, the fierce clans in Scotland destroyed them in raids that forced the Romans to withdraw.

In A.D. 122 Emperor Hadrian arrived in England as part of an extensive tour to personally examine the military frontiers of the Roman world. Considering the frequency of tribal uprisings in Britain and the many attacks on Roman garrisons, Hadrian either initiated or endorsed the proposal to build a wall across the island to deter raids by tribesmen in Scotland. Like China's Great Wall, Hadrian's Wall was meant to be a permanent frontier barrier, protecting the "civilized" population in the south from the "barbarians" to the north.

Hadrian's Wall, built between A.D. 122 and perhaps A.D. 128, runs in an east-west direction, crossing the island at a fairly narrow point where both coasts are indented by estuaries. Its eastern end was at Wallsend, at the mouth of the river Tyne, which flows into the North Sea; its western terminus was at Bowness, on the south shore of the Firth of Solway, which leads into the Irish Sea. Where the wall traversed higher ground, as it did for much of its central section, strategic use was made of its elevation to permit long-range views northward. Most of the 73-mile-long wall was composed of stone and measured 15 to 20 feet high and up to 10 feet thick. But some 30 miles of the western portion was initially constructed in blocks of turf (for lack of suitable building stone) laid in courses, and that section may have been only 12 feet high.[15]

At regular intervals Hadrian's Wall had small forts abutting its southern side. They averaged about 60 feet square and most of them had gateways that led through the wall to the north. These fortifications were obviously designed to control all traffic crossing from one side of the wall to the other. The wall also had a series of watchtowers and possibly a parapet sentry walk.[16]

On the northern side of the wall, the legionaries dug a ditch that must have discouraged at least some trespassers: it was 27 feet wide and 10 feet deep. But not all the unfriendly natives were on the Scottish side of the wall. The Romans had to cover their backsides as well. Consequently, they dug a broad, flat-bottomed ditch, 20 feet wide and 10 feet deep, which served to restrict access to the wall from the south. This earthwork defense, known today as the *vallum*, follows the entire length of the wall, usually close by but occasionally as far away as half a mile. A few causeways crossed the *vallum* to expedite authorized traffic to and from the forts.[17]

In A.D. 139 the legionaries pushed the frontier farther north, between the Firth of Forth on Scotland's east coast and the Firth of Clyde on the west coast. There they constructed a new barrier, the Antonine Wall, named for Hadrian's successor, Antoninus Pius, who reigned from A.D. 138 to 161. The Romans displayed an outstanding command of regional geography in their choice of an exceptionally narrow site, less than 35 miles across, between two firths, or estuaries, that make deep indentations into the coastline. This wall was built entirely of blocks of turf. Troops from three legions constructed 37 miles of wall, laying the turves in courses on top of a 14-foot-wide stone or cobble foundation. The Antonine Wall was 10 feet high and topped by a six-foot-wide wooden walkway. The wall was paralleled on its north side by additional earthwork defenses, including a ditch that was 40 feet wide and 12 feet deep. Nineteen forts, spaced at two-mile intervals, also contributed to the Romans' security.[18]

Toward the end of Antoninus Pius's reign, however, things began going badly for the legionaries in Britain. It appears that tribal pressures along the northern frontier were just too severe, forcing the Romans to retreat to Hadrian's Wall. By A.D. 180, they abandoned the Antonine Wall altogether. At some point during these troubled decades, the Romans restored Hadrian's Wall and replaced its turf section with stone.

The Romans had a fractious time in Britain for the next couple of centuries. By the mid-fourth century, they were being assaulted by Picts and other tribesmen from the north, as well as by Saxons and Franks who were arriving by the shipload along the eastern coast. Even before Hadrian's Wall was finally evacuated, possibly between 401 and 410, many legionaries had deserted and near-total chaos prevailed.

Things were no better at home. The Visigoths had been harassing northern Italy since 401, and in 408 they presented themselves outside the walls of Rome, where they were temporarily bought off. But they returned in 410, and this time Roman traitors flung open the gates, enabling the Visigoths to sack the city.

MEDIEVAL EUROPE: OFFA'S DIKE, VIKING RAMPARTS

Earthwork fortifications played an important role throughout Europe during the Middle Ages. According to Gregory of Tours, a sixth-century Frankish historian, the Thuringians, who were based in central Germany, employed deceitful ditches to repel the troops of Thierry I, the Frankish king of Austrasia. "They dug a series of ditches in the field where the battle would be fought," he wrote. "Then they covered these holes over with turves and made them level again with the rest of the grass. When the battle began many of the Frankish cavalry rushed headlong into these ditches and there is no doubt that they were greatly impeded by them."[19]

In Britain royal combatants sometimes seemed to emulate the Hadrianic and Antonine walls, to judge by the proliferation of their linear earthen fortifications. The most ambitious of them is Offa's Dike, built in the late eighth century and named for the powerful king of Mercia who asserted his overlordship across most of England by the time of his death in 796. Offa's Dike runs in a roughly north-south direction "from sea to sea," from the Dee estuary, which flows into the Irish Sea in the north, to the mouth of the river Wye, which pours via the Bristol Channel into the Celtic Sea to the south. The 176-mile-long earthen dike rises as high as 30 feet and is paralleled by a ditch that descends as low as 12 feet. It effectively defined the boundary between Offa's kingdom to the east and Wales to the west. It also functioned as a cultural barrier between the Anglo-Saxons on one side and the Celtic Welsh on the other. Offa, having raided Wales, apparently intended the dike as a defensive work, built to discourage Welsh counterattacks.

Several other British earthworks assume similar ridge-and-ditch configurations, which suggests a defensive role. Traces of several dikes still exist in Cambridgeshire, including the formidable Devil's Dike and the smaller Fleam Dike, which could have been constructed almost any time between the late Roman era and the end of the Anglo-Saxon kingdoms. The dikes constituted an excellent defense against cavalry attack, providing they were steep enough to upset the horses and cause their riders to topple into the ditches where they could be picked off by weapons hurled from above.

Although the British islands had absorbed many invading armies over the years, a new menace appeared toward the end of the eighth century—seafaring plunderers from Norway and Denmark, who became known to history as Vikings. In response to the seaborne invasions, Offa and his continental counterpart, Charlemagne, both organized coastal defenses in the 790s.

In 835 a Danish raid on Kent inaugurated a series of almost annual attacks that would span the next three decades and finally end with the invasion of a full-scale army. After 886, virtually all of northeastern England became known as the Danelaw, meaning it was under Danish law.

RIGHT: Rutupiae, 1st–3rd century A.D. Richborough, Kent, England. *Invading Roman forces established a beachhead at this site, which they called Rutupiae, in A.D. 43. In the late third century the Romans constructed one of their stone-walled Saxon Shore forts on the site to ward off Saxon pirates and raiders. The concentric ditches evidently date from that period.*

BELOW RIGHT: Offa's Dike, late 700s. Border between England and Wales. *The largest defensive earthen fortification in medieval England was the 176-mile-long Offa's Dike, named for the king of Mercia. The dike rises as high as 30 feet and runs in a north-south direction, separating Offa's kingdom from Celtic Wales.*

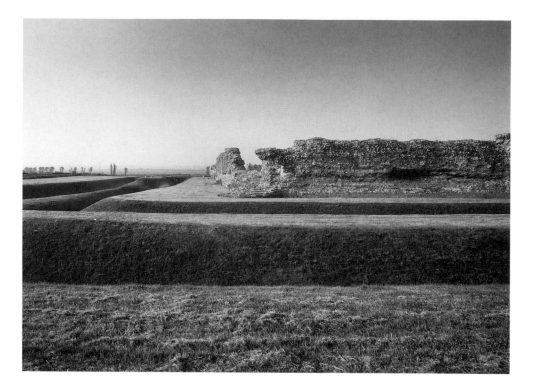

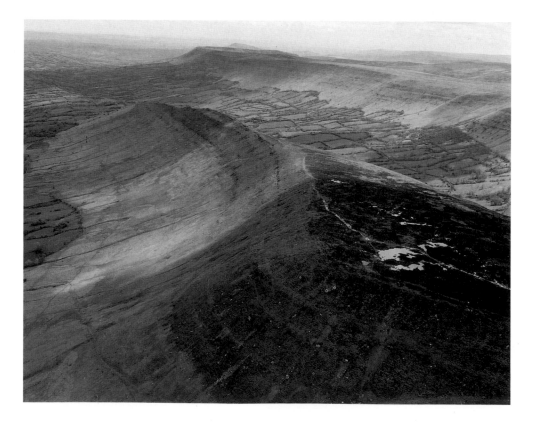

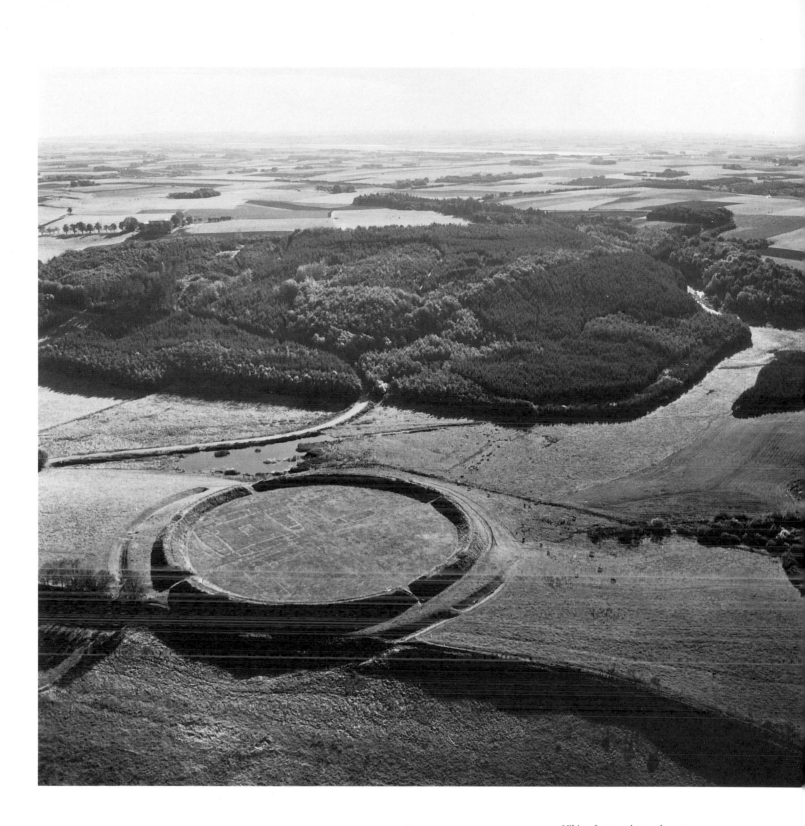

Viking fortress, late 10th century. Fyrkat, Denmark. Photograph by Ted Spiegel. *This circular fortress had four gateways and two axial streets. The enclosure was divided into quadrants, each with buildings deployed around the four sides of a square courtyard. Its earthen rampart has been reconstructed.*

Conventional earthworks did not hinder the Vikings, whose success depended on their naval prowess. They could maneuver their long ships in exceptionally shallow water, which enabled them to enter estuaries and stealthily travel upriver to raid inland villages. The opportunistic Vikings were especially rapacious in northern Europe, because that was where the best booty and tribute could be found. They regularly infiltrated the Seine and the Loire to make life in western France such a misery that the French eventually abandoned the downstream portions of both rivers.[20]

The Vikings were resourceful builders of defensive earthworks in their homelands. Denmark is particularly rich in earthen fortifications. At Hedeby, strategically located at the base of the Jutland peninsula, the Danes built a market town and manufacturing center that was apparently one of Europe's largest settlements during the ninth and 10th centuries. Its port provided direct access to the Baltic Sea, and its success as a mercantile center attracted Arabian, Jewish, Slavic, and probably English merchants and traders. An immense semicircular earthen rampart, possibly built in the late 10th century, enclosed a settlement area of about 60 acres and ran down to the water's edge, continuing as a curved jetty into a sheltered harbor. Within the rampart, the settlement contained merchants' and craftsmen's plots with reed-thatched dwellings, storehouses, and workshops.

Midway in Hedeby's defensive arc, another earthen rampart ran in a straight line westward, connecting with a complex of defensive earthworks known as the Danevirke, which formed a barrier across the neck of the Jutland peninsula. The earliest phase of the Danevirke apparently dates from about 737. At the beginning of the ninth century, the Danes banked additional earth and reinforced it with timber to create a barrier that was several miles long. An 808 date for the Danevirke is cited in annals that report that Danish King Godfred "decided to fortify the border of his kingdom against Saxony with a rampart," intersected by "a single gate through which wagons and horsemen would be able to leave and enter."[21] The Danevirke apparently protected the kingdom from southern invaders and cattle rustlers, while offering security to legitimate travelers, who could avoid a lengthy coastal journey around Jutland by traversing the short distance overland on the "safe" side of the barrier.

A Swedish counterpart to Hedeby existed at Birka, on the island of Björkö in Mälar Lake. Established at the beginning of the ninth century, the town of Birka was an important trading center that relied heavily on trade with the east. A semicircular earthen rampart once enclosed the town of some 30 acres, linking it to a hillfort on its southern edge. Birka apparently faded away by the mid-11th century. Only part of its curved rampart, which ran down to the water's edge, remains. Hedeby also went into an irreversible decline, never recovering from being set afire by Norway's Harald the Hard-ruler just before 1050 or being raided by the Slavs in 1066. By the end of the 11th century, it was completely abandoned.[22]

Tenth-century Danish royalty probably commissioned the construction of four noteworthy circular fortresses, each with a turf rampart and an external ditch. Some historians assign them a date between 950 and 1000 and attribute them to either Harald Bluetooth or his son, Swein. Two of the fortresses were built on the mainland and one each on the islands of Sjaelland and Fyn. All followed the same basic plan and were sited near important routes. The ramparts had four gateways and timber-paved streets. Of the four fortresses, the most recently excavated and most fully known is that at Fyrkat, on the mainland. Its rampart, which has been reconstructed, is 394 feet in diameter (on its internal side) and 11 feet high. The accompanying ditch is 23 feet wide and six and a half feet deep. The fortress at Trelleborg, on the west coast of Sjaelland (Denmark's largest island), was much larger: its earthwork ring was 16 feet high and 561 feet in diameter.[23]

CASTLES: *MOTTES AND MOATS*

In the ninth century, as widespread anarchy accelerated the collapse of the Frankish empire, fortresses sprang up in many European principalities. The burgs were typically

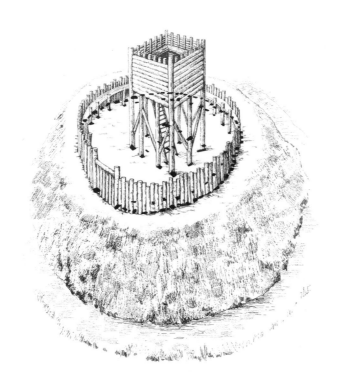

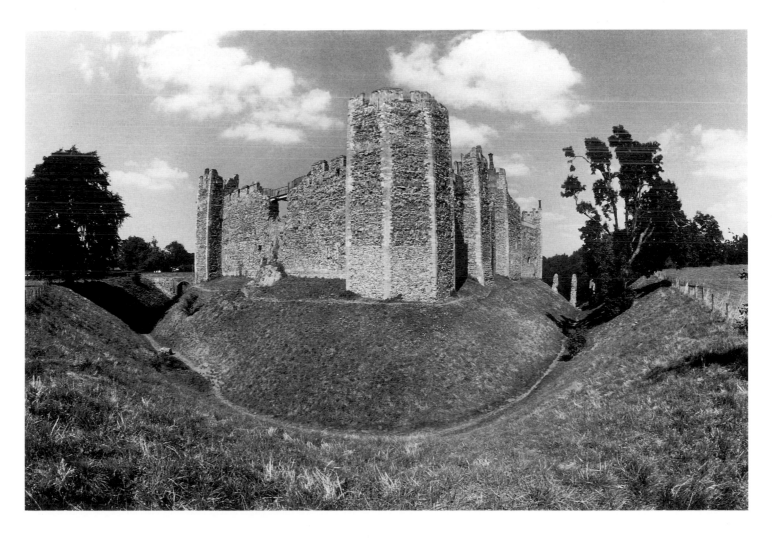

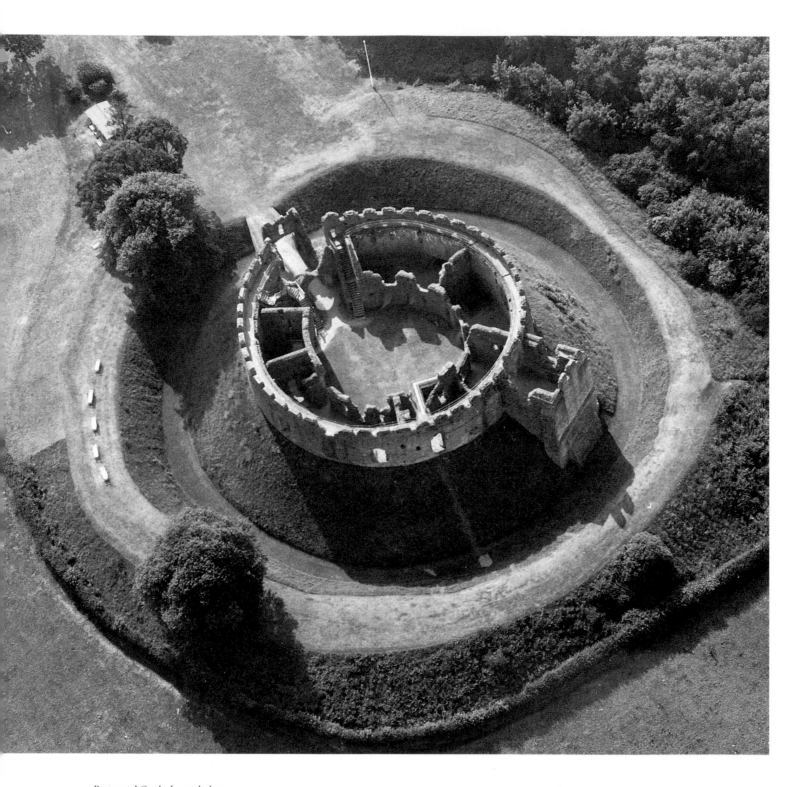

Restormel Castle, late 11th–late
12th century. Cornwall, England.
Photograph by Georg Gerster.
Normans probably initiated con-
struction of this castle. Earth from
the 30-foot-deep moat was used to
create the mound. The structure had
already deteriorated by Elizabethan
times but is still striking for its com-
pact design and solid eight-foot-
thick stone walls.

circular, walled enclosures, surrounded by a wide trench. The private fortress, or castle, symbolized a new ordering of society, now splintered into armed factions.

By the beginning of the 10th century, castle-building was becoming a major trend among the aristocracy. Many medieval castles were built on naturally defensible sites, often a high and isolated hilltop. But if a nobleman lacked that particular type of terrain on his property, the next-best thing was to construct an artificial hill, a high mound of earth, often a flat-topped cone in shape, that is known to the English as a *motte* (French for "mound"). If an "average" *motte* existed, its base diameter could be anywhere from 98 to 196 feet, while its diameter on top ranged from about 33 to 65 feet. Its height generally ran between 16 and 32 feet. (The form and dimensions of the *motte* were obviously determined by the nature of the terrain. Sometimes, a lucky landowner could incorporate an existing knoll and simply flatten its top.) The summit of the *motte* was usually fortified by a wooden palisade, which had towers at intervals. Within the palisade was a citadel, or keep, sometimes surrounded by a deep ditch.

The ditch that encircled the base of the *motte* was usually filled with water and became known as a moat, an English misnomer for *motte*. The French call a moat a *fosse*, while the Italians call it a *fosso*.

Another classic component of the feudal castle is the bailey, designating the outer, usually lower, court that surrounds the castle mound and is often encircled by a second ditch. The "motte-and-bailey" castle flourished in 11th- and 12th-century western Europe.

The boom in English castle-building is often credited to the Normans, following their famous conquest of 1066. But prior to that date, the Anglo-Saxons had found it necessary to defend themselves, usually against repeated Viking attacks, and had augmented their earthwork fortification skills. Manors in Lincolnshire and Northamptonshire had been enclosed by substantial earthen banks. Evidence of ramparts and ditches dating from 1000 to 1020 suggests that numerous houses and manors were fortified in several different areas of pre-Conquest England.[24]

Mottes also loomed on the horizon of 12th-century Flanders, where an eyewitness left this account: "It is the custom of all the richest and most noble men of this region . . . to construct, piling up the earth, a *motte* as high as they are able, digging all around it a ditch as wide and deep as possible, and fortifying it on the outer side of its enclosure with a palisade of planks solidly joined together in the form of a wall. They furnish the circuit with as many towers as possible and on the inside, they build in the center a house or rather a fortress which dominates everything else."[25]

By the beginning of the 13th century, fortress-dwellers typically considered a normal defensive ditch to be between 24 and 36 feet deep and 39 to 60 feet wide. The ditches might be dry or filled with water. Either way, serious besiegers necessarily had to fill at least a portion of the ditch with whatever materials were at hand (including wood, stone, or earth), preparing a causeway of sorts in order to maneuver their siege-engines against the wall.

Between 1275 and 1325, moated dwellings became almost commonplace in parts of England and Flanders. Some skeptical historians have been inclined to interpret medieval moats as status symbols. But the new class of affluent peasant landholders that emerged about 1300 probably perceived itself to be particularly vulnerable to attack. For the first time in their lives, many commoners enjoyed a prosperity that enabled them to possess objects of material value. With so many alternative ways to display one's pretension, it seems extraordinary that anyone would have gone to the trouble of excavating a large ditch for mere show.

Europeans brought their castle-building prowess to the Holy Land. Between 1240 and 1243 the crusading Templars—an order of monastic knights who functioned as the "sword arm" of Roman Catholicism—built their citadel, Saphet, atop an extinct volcano, 2,780 feet high. Like the Herodion, it required an impressive adaptation of an existing mountaintop. The outer set of walls was 72 feet high, and the interior walls were 93 feet high; in between was an immense moat, 50 feet deep and 43 feet wide.[26]

OVERLEAF: Mud-brick citadel, c. late 16th–early 17th century. Bam, southern Iran. Photograph by Georg Gerster. *Although its origins can be traced as far back as the 10th century the present-day fortress was largely constructed by the Safavid dynasty. Its excellent preservation is due in great part to Farah Diba, the former queen of Iran and a trained architect.*

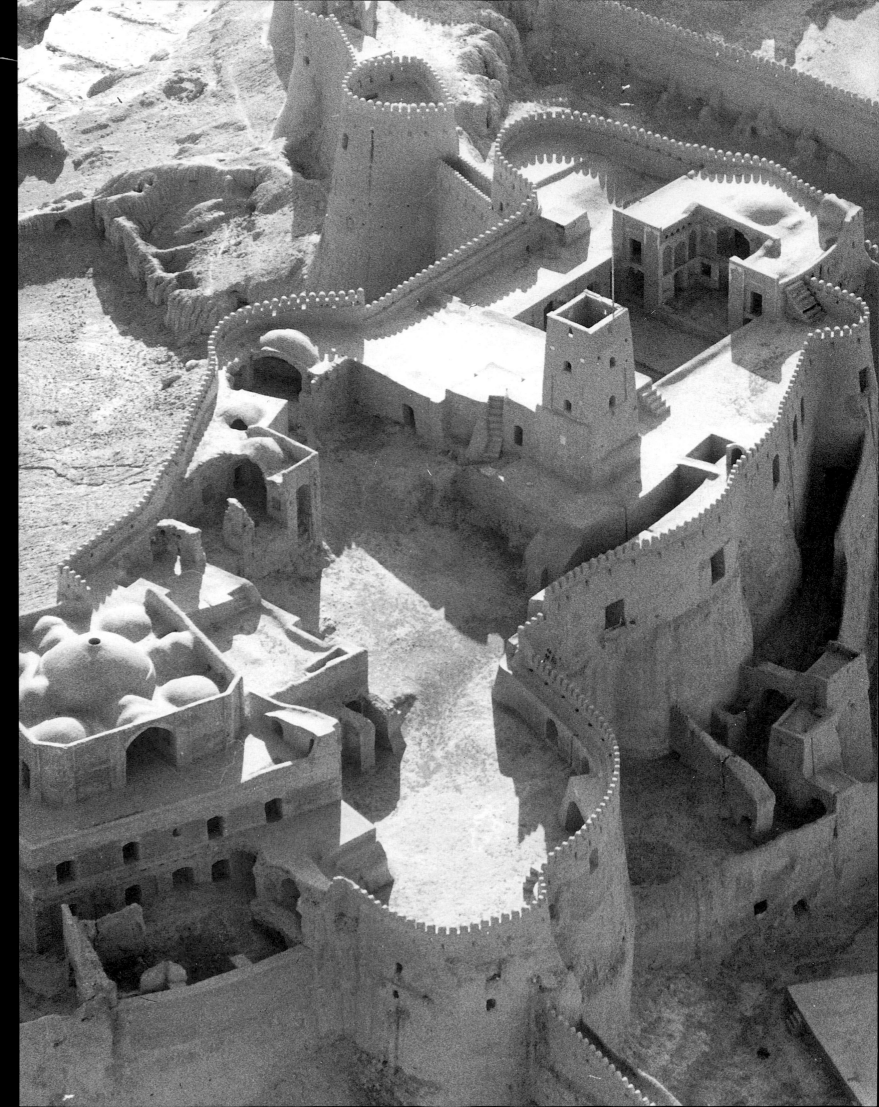

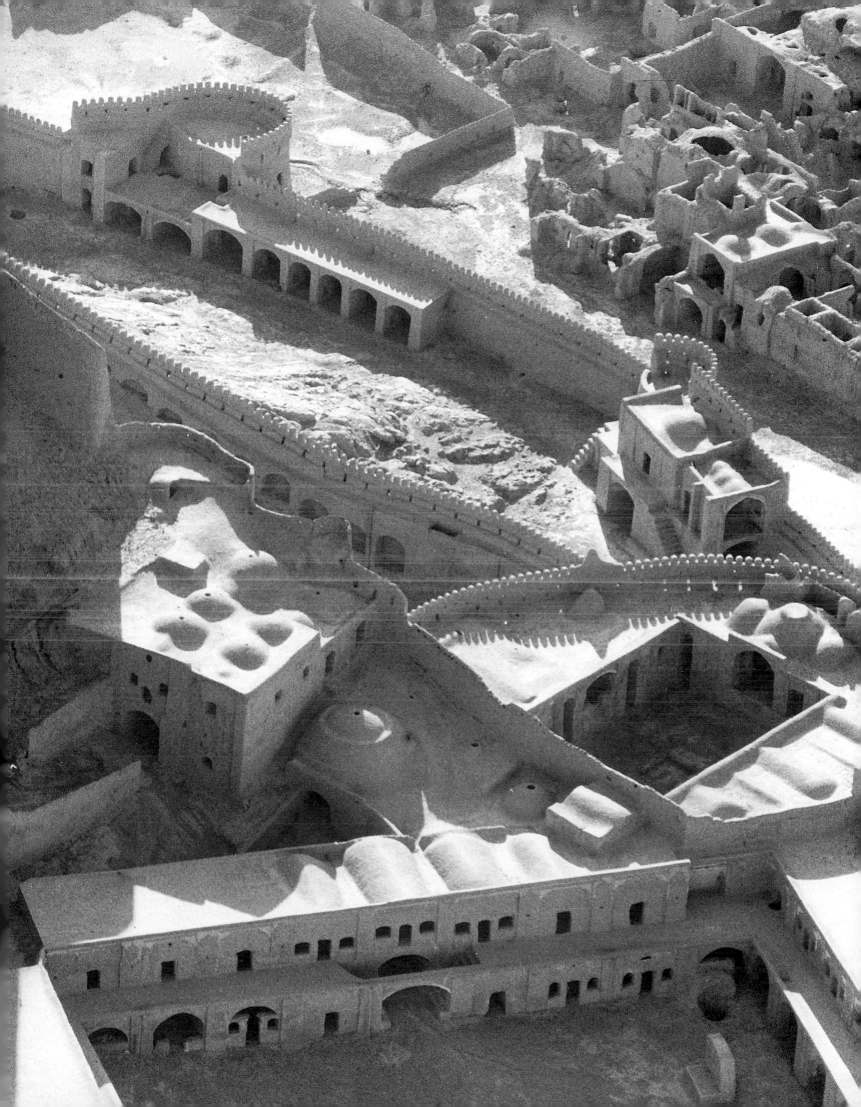

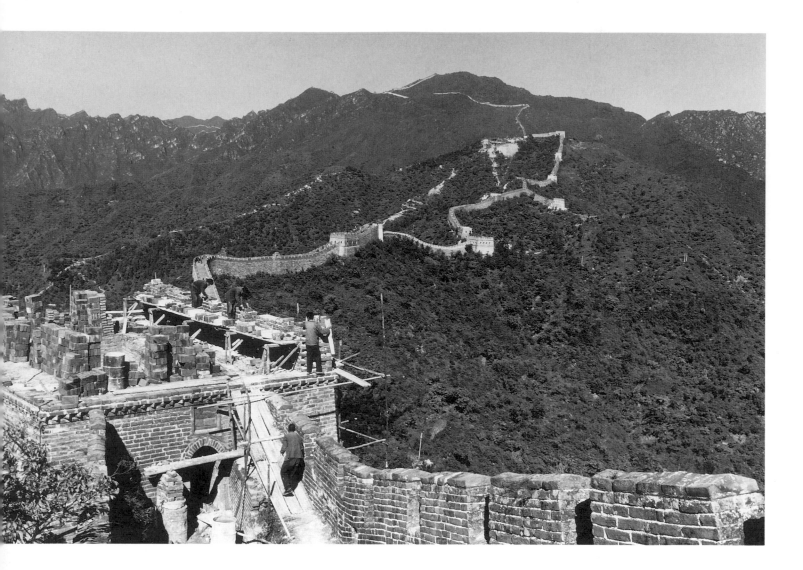

Workers repairing the Great
Wall of China. North of Beijing.
Photograph by Georg Gerster.
From the 14th through the 16th cen-
tury, Ming-dynasty emperors made
the Great Wall a top priority and
continued to build new sections of it.
Many of the Ming segments had an
earthen core but were faced with
bricks that were fired in on-site kilns.
In recent decades the government
has demonstrated its commitment to
preserving the Great Wall.

The 13th century was an extraordinary era for armed conflict on a massive scale. While European Crusaders clashed with Arab Muslims over control of the Holy Land, Mongolian warriors overran northern China, sweeping across the countryside like pestilential scythes. Despite more than a millennium of wall-building, the Chinese could not prevent the dreaded barbarians from ravaging their homeland. Under the leadership of Genghis Khan, the Mongols captured Beijing in 1215, made it their administrative center, and subjected the native population to what many people consider the most discouraging period in Chinese history. Even after Genghis Khan died in 1227, the Mongols continued to expand their oppression until, by the end of the century, his grandson Kublai Khan (1216–1294) had conquered the remainder of China. Kublai Khan founded the Yüan dynasty, a Mongolian lineage that lasted until 1368. Needless to say, the Yüan rulers did not contribute to the building of the Great Wall, which, after all, had been intended to keep them out.

But Yüan officers encountered resistance from the south, where a Buddhist monk named Zhu Yuanzhang (or Chu Yüan-chang, later known as Hung-wu) led a group of rebels in the capture of Nanjing in 1356. Establishing himself as an independent warlord, he went on to become the first Ming emperor, ruling from 1368 to 1398. During his 30-year reign, he not only drove the Mongols out of northern China but also gained control of Inner Mongolia. He made the Great Wall a top priority and, year after year, sent troops to the north to build new fortifications.

Zhu Yuanzhang's son Chengzu (Yung-lo) moved his capital from Nanjing to Beijing in 1421, possibly because it offered a better vantage point from which to keep a wary eye on the northern territories. Like his father, he continued the construction of the Great Wall. In the 16th century, the Ming dynasty added the section between Beijing and the sea, contributing greatly to the impressive monument that the world knows today.

Between 1450 and 1540, Ming garrisons constructed a wall of pounded earth along China's western border, south of the Ordos Desert. They followed the traditional Chinese building technique, temporarily affixing posts or boards on both sides of the wall and tamping layer after layer of earth in between. Wherever possible, the wall-builders incorporated natural obstacles into their defensive system; at some locations, for instance, they carved into mountainsides below crags to make them steeper.[27] Many Ming walls, however, were built of stone, which was quarried in the mountains, or bricks, which were generally fired in kilns erected on the spot.

The most majestic section of the Great Wall is the 400-mile stretch that extends eastward from Beijing, along the high ridges of the Yanshan Mountains, to Shanhaiguan, on the gulf of Bo Hai, an arm of the Yellow Sea. A portion of the wall that winds over Mount Badaling, northwest of Beijing, is particularly well preserved and is usually the one shown to foreign visitors. The Badaling segment of the wall averages 22 to 26 feet in height and is about 16 feet wide on top.[28] Elsewhere, the wall ranges in height from 15 to 39 feet.

The exact length and route of the Great Wall are still, astonishingly, a matter of uncertainty. Earlier estimates of its length ranged from 1,500 to 4,000 miles. Some experts now think the wall extends 2,150 miles, with an additional 1,780 miles of branches and spurs.

Ming leaders were still adding to the wall when the dynasty fell in 1644, the year that invading Manchu captured Beijing. As the Manchu exercised territorial control on both sides of the wall, its defensive value was virtually nil.

By the time Japanese troops invaded China's northern provinces in the 1930s, the Great Wall had long outlived its usefulness as an effective barrier. During the tragic years of the Cultural Revolution, which began in 1966, dozens, some say hundreds, of miles of the Great Wall were deliberately destroyed, its stones and bricks being pilfered for use in road, reservoir, and building construction. A portion of the wall was dynamited in 1979 to make way for a dam. Since the 1980s, however, the People's Republic has made serious efforts to survey and preserve the wall, and to promote scholarly research on it.

OVERLEAF: Chimú citadel, c. 1200. Paramonga, Peru. Photograph by Georg Gerster. *The shape and location of this multiterraced hilltop structure, located in the Forteleza Valley north of Lima, suggest a fortress. But the enigmatic adobe structure could just as well have been a temple.*

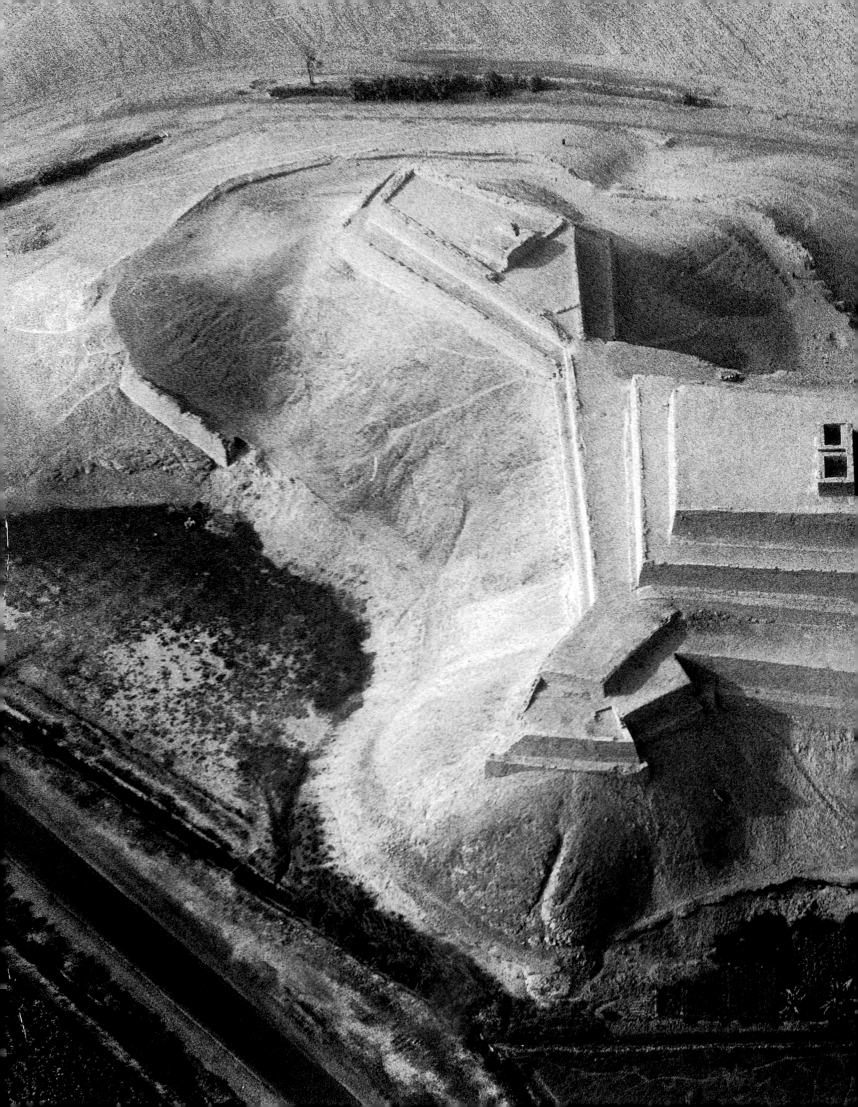

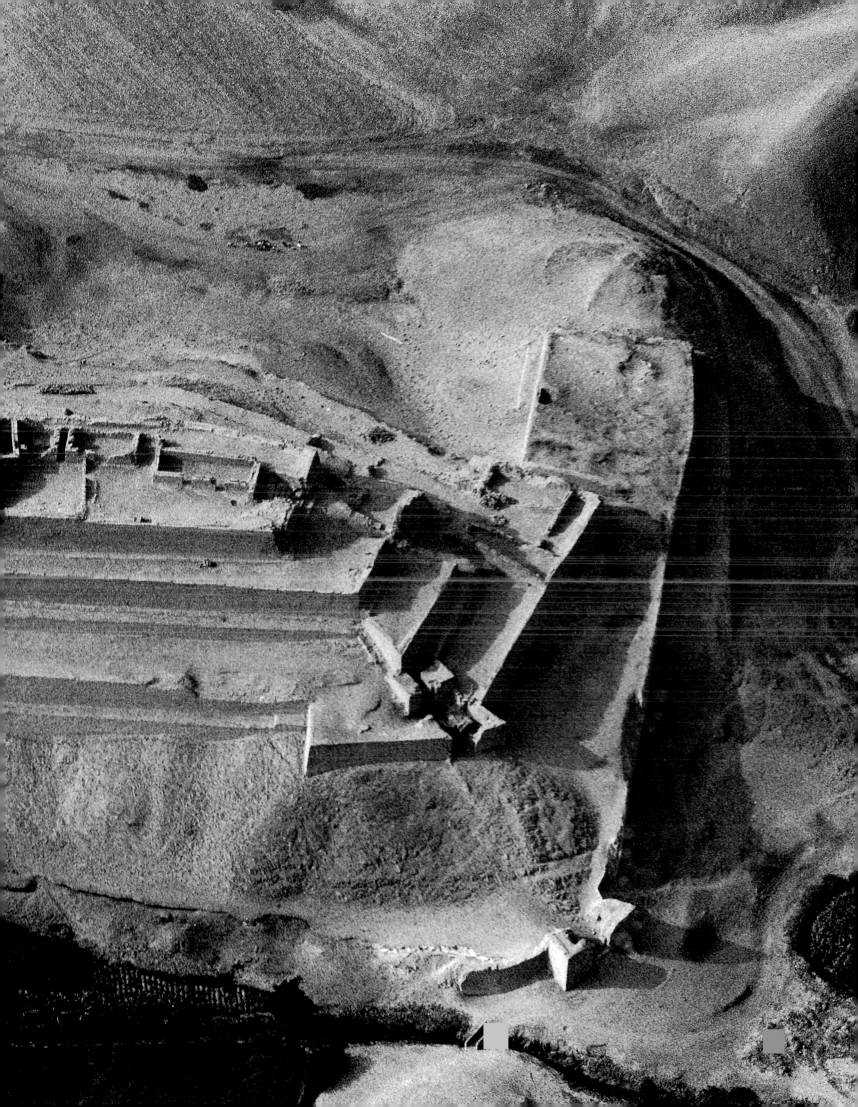

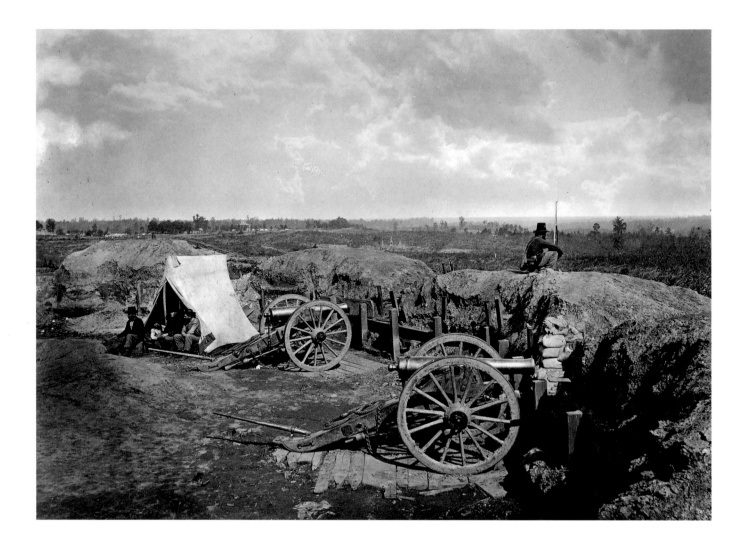

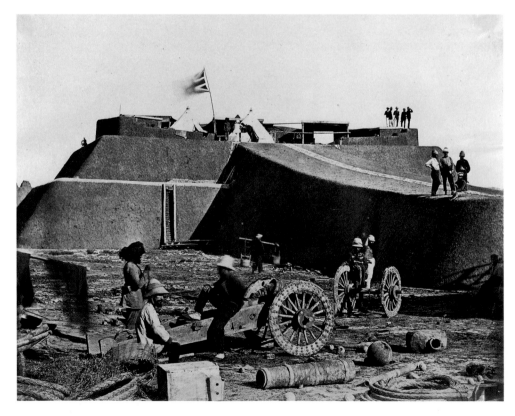

RIGHT: Felix Beato (attributed to). *Headquarter Staff, Pehtang Fort.* August 1, 1860. Albumen print, 9⁷/₁₆ x 11 ¹¹/₁₆". The Museum of Modern Art, New York. Purchased as the gift of Shirley C. Burden and the estate of Vera Louise Fraser. *This rammed-earth fort probably contributed to the collapse of the Taiping Rebellion (1850–64); after rebels seized Nanjing, Western powers, fearing the loss of foreign trade, sent their troops in to assist China's Qing, or Manchu, government.*

THE AMERICAS: THE MAYA AT WAR, A SPANISH MOAT IN FLORIDA

Earthwork fortifications in the Americas are relatively scarce. Between the second and fourth centuries B.C., the Maya occupants of Becán, now located in the Mexican state of Campeche, surrounded their settlement with massive defensive earthworks, consisting of a ditch and rampart with a combined height of 38 feet.[29] The Maya also constructed a notable late eighth-century fortress, Punta de Chimino, in Guatemala, where they sited it on the tip of a peninsula that juts into Lake Petexbatún. They maximized its defensive capabilities by digging three large moats into the limestone bedrock. The largest moat is 460 feet long, 100 feet wide, and 30 feet deep.[30] The series of moats effectively converted the tip of the peninsula into a fortified island. But intensive warfare may have forced the Maya to vacate the outpost by the early ninth century.

Florida's early Spanish settlers also believed in moats. When Pedro Menéndez de Avilés landed in St. Augustine in 1565, accompanied by 1,500 Spanish soldiers and settlers, he was welcomed by the chief of a Timucuan tribe and invited to occupy the Great House, a thatched domelike structure that could hold some 300 people. One of the Spaniards' first improvements was a circular moat, 14 feet wide, surrounding the house. Seven months after their initial meeting, the Indians tried to evict the Spanish by burning the house-fort. Menéndez and his company simply rebuilt a more substantial structure. Archaeologists found traces of both the fort and the moat in 1993. Soil stains indicated the long-ago presence of a row of wooden posts, presumably constituting part of a palisade.[31] The find is important because it establishes the precise location of the oldest permanent European settlement in North America. The St. Augustine fort was a going enterprise several decades before English settlers founded the Virginia Colony at Jamestown in 1607 and more than half a century before the Pilgrims landed at Plymouth Rock in 1620.

MODERN WARFARE: RAMPARTS AND TRENCHES VERSUS ARTILLERY

The introduction of gunpowder into 14th-century Europe increased the mobility and scope of military forces and by the late 15th century made cities newly vulnerable. Traditional stone-wall fortifications were no match for the new and powerful siege cannons, which were mounted on carriages and designed to fire iron cannonballs weighing between 25 and 50 pounds. Besieged Italians soon discovered, however, that loosely compacted earth could safely absorb cannon shot. When Florentines attacked Pisa in 1500, the defenders heaped up an earthen rampart *inside* their endangered city wall. Although cannonballs knocked down some of the stone fortifications, the Florentines were confronted by a formidable subsidiary barricade.[32]

In 19th-century Hamburg, the chief defense was a large mound of green turf. If an attacking force had approached the port city, they would have encountered a deep ditch and then a glacis. At first, the simple earthen embankments did not look at all intimidating. As a visiting English midshipman noted in the mid-1800s, the "precipitous enough" green mound was crowned with only a low parapet of masonry. But halfway up, the mound was "bristling with batteries" and "the muzzles of the guns were flush with the neighboring country beyond the ditch." The young Englishman concluded that assailing such a mound was virtually hopeless. "You might have plumped your shot into it until you had converted it into an iron mine," he wrote, "but no chasm could have been forced in it by all the artillery in Europe; so battering in breach was entirely out of the question, and this, in truth, constituted the great strength of the place."[33]

The technology of 20th-century war brought about dramatic changes in defensive strategies. What good was a hillfort like Maiden Castle or even the Great Wall when enemy aircraft could fly overhead? How useful was a rampart that could be traversed by the metal belts of a tank? Trenches were still crucial, however, enabling an army to secure the ground behind it until further advance in the field was possible.

OPPOSITE, ABOVE: George N. Barnard. *Rebel Works in Front of Atlanta, Georgia.* 1864–65. (From his *Photographic Views of Sherman's Campaign,* New York, 1866.) Albumen silver print from a wet-collodium glass negative, 10⅛ x 14⅛". The Museum of Modern Art, New York. Acquired by exchange with the Library of Congress. *During the U.S. Civil War, the Confederate army temporarily kept General Sherman out of Atlanta by ringing the city with earthworks. These Union soldiers enjoy a few moments of tranquility at a captured Confederate campsite outside Atlanta in 1864, but a sentry scans the horizon from his perch atop a timber-supported earthen bunker.*

During World War I, spades were as indispensable as rifles. Opposing armies entrenched themselves on both sides of the Western Front, which extended through Belgium and eastern France from the North Sea to Switzerland, a distance of less than 500 miles. The Allied side alone dug some 15,000 miles of trenches.[34] Many Europeans had enthusiastically endorsed the war, believing it would be over in a few weeks. They were doubtless surprised when 640,000 men were killed by magazine rifle and machine gun fire during the first five months. The Western Front became ensnared in a deadly stalemate: between 1914 and 1918, it moved scarcely more than 10 miles.[35]

Combatants on both sides employed a system with three successive trenches—a front line, a middle support line, and a reserve line in the rear. All were zigzag or wavy in plan to lessen the destructive effect of shell explosions and to deter enfilade firing, which would have enabled an enemy soldier with a machine gun to mow down everyone in the trench. British Intelligence credited the Germans with having the more elaborate and better-built trench system.

Commanding officers aimed their heaviest artillery on the enemy's reserve trenches, being reluctant to shell the foe's front line for fear of endangering their own men in the forefront. Shells from Germany's 49th Field Artillery Regiment fell short of their mark so regularly that their comrades dubbed it the 48th 1/2.[36] In addition to both enemy and "friendly" artillery fire, entrenched soldiers hoped to evade machine-gun and bayonet attacks, snipers, and shells containing fatal chlorine or mustard gas.

More than a mere entrenching tool, a sharpened spade was a handy and reliable weapon, according to novelist Erich Maria Remarque, who fought on the German side and wrote *All Quiet on the Western Front* (1929), probably the most harrowing, and certainly the most celebrated, novel of trench warfare during World War I. A spade's distribution of weight made it effective "for jabbing a man under the chin," he observed; "and if one hits between the neck and shoulder it easily cleaves as far down as the chest."[37]

The northernmost 50 miles of the Western Front was extremely flat and rarely more than a yard or two above sea level. Trench-diggers often hit water only two or three feet below the surface, making life in the trenches an endless struggle against mud. Heavy rainfall contributed to the soldiers' misery, causing the trench walls to subside. The mud stuck to boots like a gluey dough, turning short walks into arduous and dangerous journeys. During part of 1916, torrential rains filled the trenches with knee-high mud, virtually immobilizing combatants on both sides. An unknown number of men (perhaps several hundred) drowned in the mud.[38]

Still, the folds and hollows of the ground struck many men as a welcome protection. To quote Remarque again: "To no man does the earth mean so much as to the soldier. When he presses himself down upon her long and powerfully, when he buries his face and his limbs deep in her from the fear of death by shell-fire, then she is his only friend, his brother, his mother; he stifles his terror and his cries in her silence and her security; she shelters him and gives him a new lease of ten seconds of life, receives him again and often for ever."[39]

In the Pacific during World War II, both Allied and Japanese infantrymen hugged the ground as they battled their way across the Solomons, New Guinea, the Philippines, the Marianas, Okinawa, and Iwo Jima, advancing or retreating foxhole by foxhole, island by island. When the Japanese were driven out of Korea, which they had occupied since 1905, they left behind a honeycomb of caves, tunnels, and defensive bunkers on the island of Cheju, about 60 miles southwest of the Korean peninsula. In 1948 Korean guerrillas hid themselves in these subterranean positions and, using caches of small arms that the Japanese had abandoned, initiated uprisings that helped lead the way to an all-out war between North and South Korea.[40]

The United States contributed to the South Korean war effort by leveling with bombs most of northern and central Korea. Air raids on North Korea's capital, Pyongyang, helped plunge the population from 500,000 to about 50,000 and encouraged survivors to adopt a

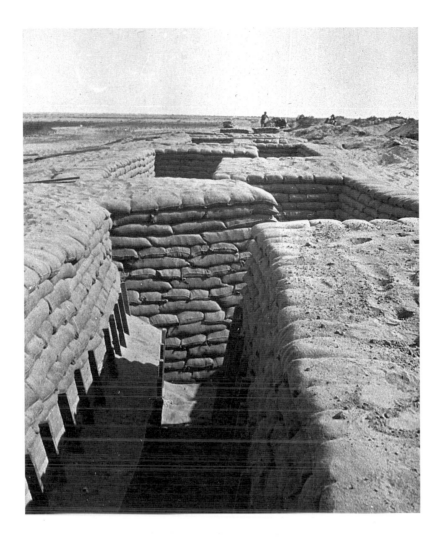

Sand-bagged trench in the Suez Canal defenses, spring 1916. The Imperial War Museum, London. *The trench zigzags to minimize the lethal consequences of enemy fire.*

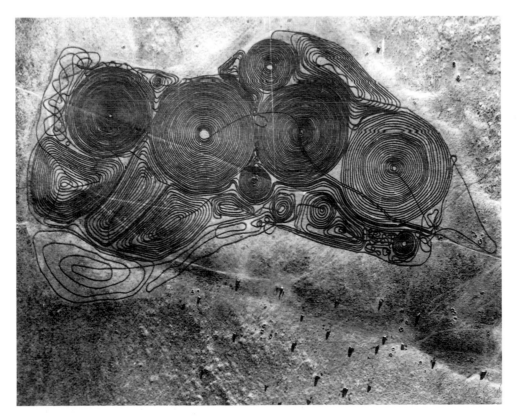

Plowed-up airfield, 1942. Ghindel, Libya. The Imperial War Museum, London. *Before German troops abandoned this airfield during World War II, they artfully plowed it up to render it unusable to enemy forces.*

troglodytic existence. North Korea's government and some of its factories operated from below-ground bunkers. By the time of the 1951 peace talks, the North Koreans had literally "dug in" all along the Front, building extensive underground fortifications that they referred to as "an underground Great Wall." They shifted 78 million cubic yards of rock and earth as they dug a total of 776 miles of tunnels and 3,427 miles of trenches.[41]

In the Vietnam War, the North Vietnamese army and their Viet Cong colleagues often created the impression of infiltrating entire mountain ranges in order to frustrate U.S. military might. For the grim battle at Khe Sanh in 1967, the Vietnamese entrenched themselves in foxholes and bunkers, remaining hidden until U.S. Marines were trapped in a position from which they could move neither forward nor backward. At Hill 881 South alone, Marines encountered 250 surprisingly durable bunkers. The smaller ones, suitable for two or three men, had roofs consisting of two layers of logs topped by five feet of dirt. Four-man bunkers offered more substantial overhead protection, and the largest bunkers of all (unquestionably the command posts) had roofs with four to eight layers of logs that were crowned by several feet of packed earth. Marines could rarely spot the bunkers until they were nearly on top of them.

United States air and artillery bombardment proved to be astonishingly ineffective. Napalm burned itself out in the trees, rockets detonated on the branches of the bunkers' overhead cover, and 20-millimeter cannon shells and machine-gun bullets failed to pierce the earth deep enough to cause damage. The bunkers were so rugged as to withstand almost anything but a direct hit by a 250- or 500-pound Snake-eye bomb. Eventually, U.S. bombers switched to 750-, 1,000-, and 2,000-pound bombs with delay fuses, enabling the bombs to penetrate the earth before exploding. These subterranean concussions created shock waves that collapsed many of the bunkers. When Marines finally seized the cratered wasteland of what had been Hill 881 South, they discovered 50 of the bunkers were still intact.[42]

Military technology has made tremendous advances, if we consider the contrast in destructiveness between ancient slings and modern intercontinental ballistic missiles. But human defensive capabilities have not developed to a comparable degree, if we compare the differences between Britain's prehistoric hillforts and Vietnam's bunkers. In today's violent world, we may still find occasion to seek sudden refuge behind a mound of earth or by throwing ourselves on the mercy of the ground.

OPPOSITE: Quemoy (Jinmen) foxholes with Nationalist Chinese soliders, 1954. Photograph by Howard Sochurek, *Life* Magazine © Time Warner. *During the 1950s, Nationalist China and the People's Republic of China battled for possession of a group of islands in Taiwan Strait, about 150 miles west of Taiwan. The People's Republic bombarded the islands for years, but Nationalist troops dug in and held their ground.*

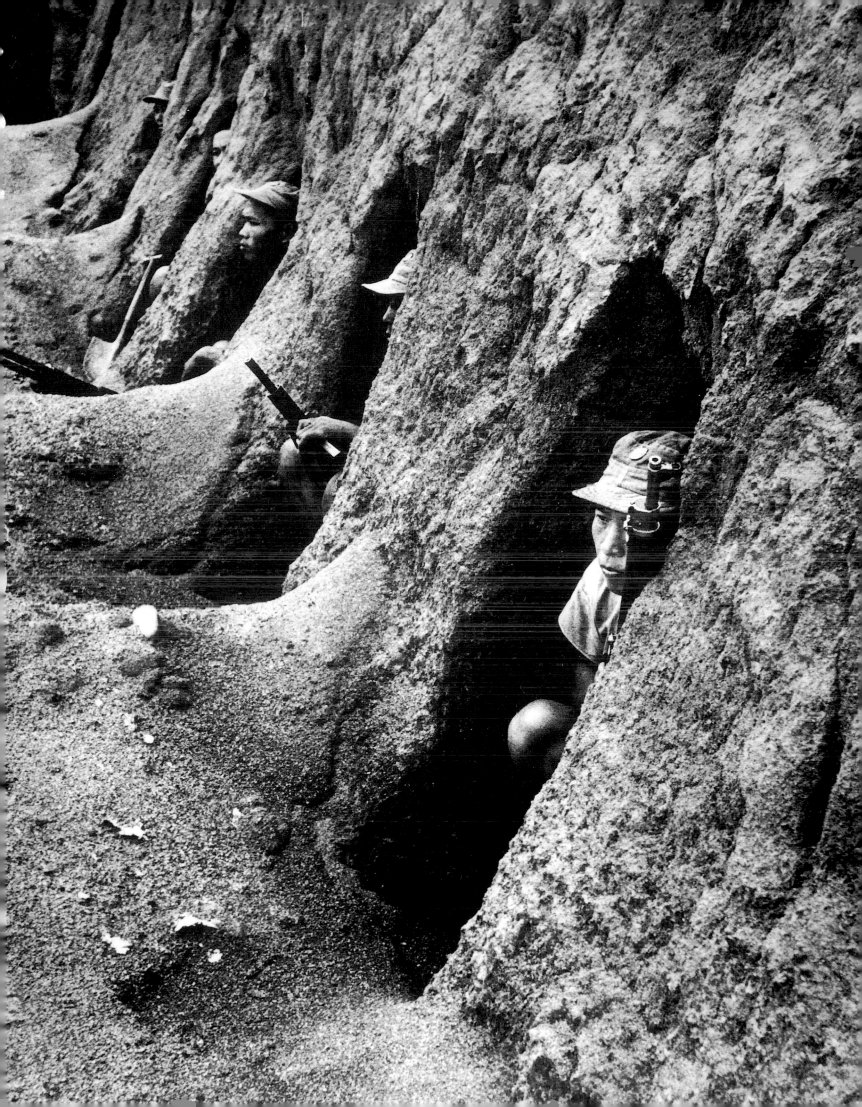

Tombs

*"Earth to earth, ashes to ashes, dust to dust": these bleak words
from the Book of Common Prayer, spoken at countless interments,
put mourners on the alert that their own "vile bodies" are destined
to disintegrate. But the nagging question of what to do with the cor-
poreal remains of loved ones persists. If, indeed, they are going to
decompose into an indistinct sediment of ashes and dust, it becomes
all the more crucial to mark the spot where they begin their
inevitable commingling with the earth.*

*Although nomadic tribespeople did not require a single year-
round residence, their deceased members necessarily had to occupy
fixed resting places. These had to be conspicuous enough so tribes
could revisit from time to time to tend the graves. "The dead,"
observed Lewis Mumford, "were the first to have a permanent
dwelling: a cavern, a mound marked by a cairn, a collective barrow.
These were landmarks to which the living probably returned at
intervals, to commune with or placate the ancestral spirits."[1]*

*Mortuary architecture and design assume many forms—from
cairn, barrow, and catacomb to crypt, cenotaph, and pyramid—but
the focus here shall be on the sepulchral arts as expressed in earthen
mounds and rock-cut tombs. Earthen burial mounds range in
height from a few feet to more than 70 yards and are often referred
to as "tumuli." (A solitary artificial hillock is a "tumulus"; the word
derives from the Latin verb meaning "to swell.")*

*Ancient and medieval civilizations are responsible for nearly all
the most spectacular earthen and rock-cut tombs. Our knowledge of
many long-ago societies is based mainly on the evidence supplied by
their tombs.*

OPPOSITE: Lycian tombs, c. 5th
century B.C. Demre, Turkey.
Photograph by Douglas Waugh.
*Lycian nobles were laid to rest in
these classically proportioned rock-
cut tombs in southwest Asia Minor
before their homeland was overpow-
ered by Persians, Seleucids, and
Romans.*

The first people who deliberately and regularly buried their dead were Neanderthals, whose efforts to conserve the memory of their dead date back at least 50,000 years. They usually excavated graves in the same caves that served as their homes, situating the deceased near hearths, probably in the belief that the fire's heat would maintain the warmth of existence. They also daubed or sprinkled their dead with red ocher, a pigment doubtless intended to restore the rosy blush of life.

Although no amount of rosy pigment could bring Neanderthal corpses back to life, their survivors evidently imagined that the dead experienced the same needs as the living. As a result, starting about 15,000 B.C., they initiated the custom of depositing prized or useful objects in the grave. In a number of their burials, they included practical or salutary items, such as stone tools or a joint of meat. On the basis of this kind of material evidence, some experts postulate that Neanderthal people believed in an afterlife.

The Neanderthalish practice of packing the grave with personal goods continued in many parts of the world. As the centuries rolled by, some civilizations became renowned for the opulence of their grave goods, which included lavish jewelry, exquisite housewares, fine weaponry, and, on occasion, a magnificent boat, all apparently intended to serve the deceased in an afterlife. The custom persisted until the Roman Catholic church put a stop to it in the Middle Ages.

FUNERARY MONUMENTS PRIOR TO 2001 B.C.

Around 7000 B.C. the inhabitants of Jericho buried their dead under the earthen floors of their homes. They sometimes interred the heads separately. Some human skulls had been modeled over with clay and decorated with shells.[2] Somewhat later, in Anatolia, the people of Çatal Hüyük also buried their relatives under the floors of their living quarters. They presumably first exposed the corpses outdoors (long enough to become defleshed), then interred the bones underneath the benches that were used for sitting or sleeping. Surviving family members possibly summoned the departed to daily offering meals.

Many of the earliest and most visible tumuli and barrows occurred in great numbers in southern England, northwestern France, and virtually all regions bordering on the North and Baltic seas. In both France and England, it became the custom among Neolithic people to construct megalithic chambered mounds—that is, crypts constructed of large stones that were subsequently heaped over with earth. They differ strikingly from earlier shaft graves, such as those in France's Marne Valley, where prehistoric peoples, using flint tools, excavated a network of underground radiating tunnels in which they laid out their dead on flat, bedlike stones.

Brittany is especially rich in ancient tumuli and barrows, some of which date to the fifth millennium B.C. The most renowned is the Tumulus St-Michel, near the town of Carnac (even more famous for its megalithic alignments). The artificial mound, which may be as old as 4300 B.C., is 400 feet long, 192 feet wide, and 32 feet high, a prodigious volume of earth to be moved by hand labor without even metal tools. Brittany's mounds were rich in burial goods, including ornamental axheads, necklaces, beads, and pottery.

Around certain parts of the Mediterranean, rock-cut tombs were more prevalent than megalithic mounds. Many of these hypogea (a Greek-derived word for subterranean burial chambers) were constructed in southern France (in the region of Arles) and in southern Italy. A startling number of them were carved on Mediterranean islands. A typical hypogeum consists of a circular burial chamber, preceded by a smaller antechamber, both accessible from the outside by a sloping passageway.

The islanders who settled in the Balearics by 4900 B.C. lived in caves and rock-shelters, and they initially buried their dead in natural caves or occasionally excavated artificial caves with one chamber. Until about 1500 B.C., the inhabitants of both Majorca and Menorca

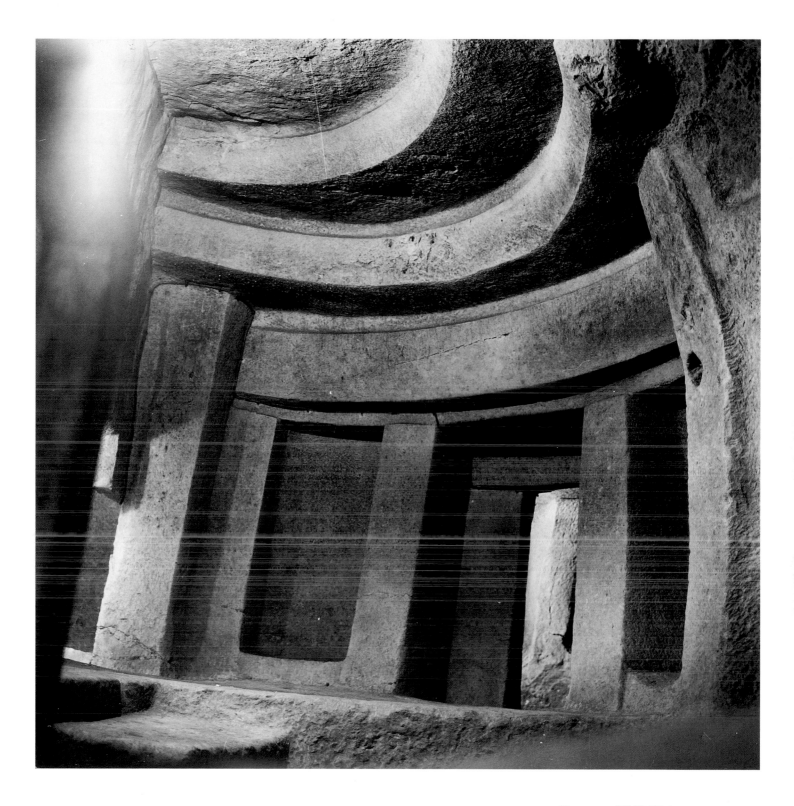

Hypogeum of Hal Safliéni, c. 3500–3000 B.C. Paola, Malta. Photograph by Roger-Viollet. *The main hall of this spectacular rock-cut tomb was carved in imitation of post-and-lintel construction.*

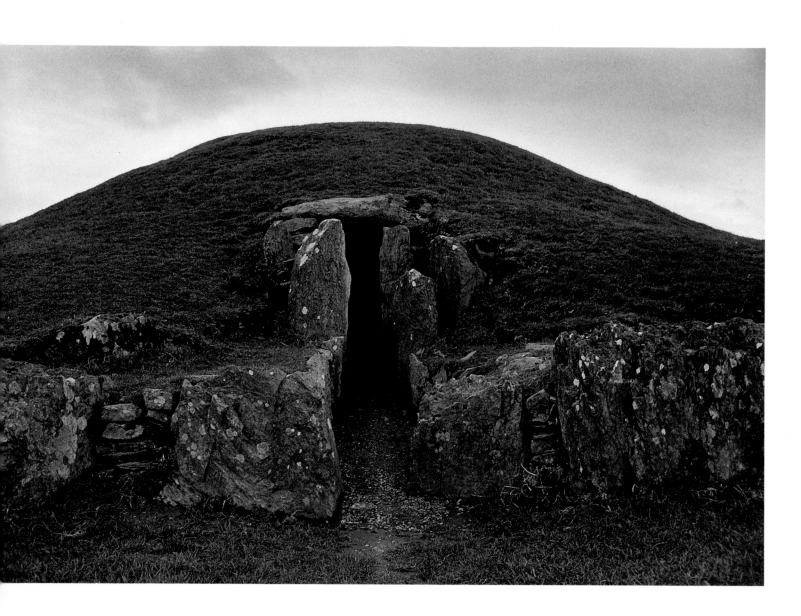

Bryn Celli Ddu tomb, third millennium B.C. Anglesey Island, Wales. Photograph by Janet & Colin Bord. *The earthen mound shrouds a burial chamber constructed of large stones.*

carved many rock-cut chambers that are shaped like upturned boats. Many of the vaults have side-chambers.

Sardinia's rock-cut vaults, many of which date back to the third millennium B.C., also had side-chambers. On Sicily, the prehistoric inhabitants converted many rocky hillsides into necropolises, carving out scores of crypts with rectangular entrances.

The Mediterranean's most spectacular hypogeum is Hal Saflièni, on Malta. This underground tomb, cut out of living stone, has an extraordinary main hall, designed in a seemingly classical style with post-and-lintel forms carved in the rock, and some 20 side chambers that contained the remains of 7,000 people. Although the stone is not subject to carbon 14 dating, experts believe that the carving of Hal Saflièni began in about 3500 B.C. and continued over the following 500 years. By the mid-third millennium the tomb was abandoned as the populace switched to other types of burial crypts that were less arduous to construct.[3]

Ancient barrows and tumuli were once so numerous in southern England, especially in Wiltshire, that as recently as a couple of centuries ago visitors could describe Salisbury plain as "one vast cemetery." Of the several hundred prehistoric barrows that still existed there, many had obviously been used for collective burials. The oldest are the "long barrows," presumably built by Windmill Hill people around 3000 B.C. They averaged about 49 yards in length, nearly 20 yards in width, and six and a half feet in height. Some long barrows could have been family vaults, which lengthened segment by segment over the years as families added newly deceased relatives. Being easily discernible protuberances on the terrain, the tumuli helped establish their makers' claim of territoriality. The long barrows and multichambered mounds qualified their localities as "family territories," which gradually merged to form larger "chiefdoms." Consequently, chambered mounds and barrows could have become cult monuments and ritual settings for seasonal gatherings.

Wiltshire's most elongated tomb is the West Kennet long barrow, whose origins appear to go back to about 3250 B.C. It is a multichambered megalithic tomb, covered by an earthen mound that is nearly 340 feet long, about 75 feet at its widest (the width tapers from one end to the other), and eight feet high. Its main passageway or corridor leads past a pair of chambers on either side to a large polygonal space at the far end, making five burial chambers in all. The barrow's makers covered their megalithic construction with earth and chalk rubble that they had excavated from two straight ditches that paralleled the structure. (These ditches have largely disappeared.) The mound was initially encircled by a curb of stones, but they vanished, probably in the distant past. The barrow is aligned along an east-west axis. Like other early chambered mounds, it may have been oriented toward the midwinter sunrise in the belief that the sun, even at its winter solstice, would shine its beneficent rays upon the deceased.

West Kennet was closed down about 2000 B.C. by a newly dominant population, the so-called Beaker people, who apparently filled the mound's chambers with chalk rubble and sealed off the forecourt with boulders. The Beaker people evidently did not believe in communal tombs, preferring to heap a round barrow of earth (and rubbled chalk) over an individual grave. Their barrows had no entrances or passageways and were rather large relative to the size of the lone occupant: the circular mounds were often 65 feet across and 10 to 12 feet high. The dead were sent to their graves accompanied by their prized personal possessions.

England's largest and most enigmatic tumulus is Silbury Hill, a 130-foot high, flat-topped conical monument sited in Wiltshire, some 16 miles north of Stonehenge. With a base diameter of 550 feet, it covers about five and a half acres. Silbury Hill's builders evidently began their work in about 2660 B.C., and they constructed the monument of earth, chalk, and gravel in four stages, probably over several decades. In its third stage, Silbury Hill was apparently a stepped cone, but in its final phase, all of the steps were filled in, except for the topmost one, some 15 feet below the summit, to create a smooth sloping profile. Although Silbury Hill is traditionally regarded as a gigantic tomb, certainly worthy

of an important chief or priest, several archaeological probes since the late 18th century have not turned up a single human bone.

While many of the tumulus- and hypogeum-building cultures of Europe and the Mediterranean were obviously concerned with the shelter and security of their deceased, few people were more dedicated to the material well-being of their afterlifes than the ancient Egyptians. Their kings, or pharaohs, seemed to spend most of their terrestrial existences planning for what they imagined to be an eternal continuation of their luxury-filled lives on earth. It evidently never occurred to them that life after death would be anything significantly different from what they had previously enjoyed. They believed that their immortality depended upon the duration of their name; the preservation of their body; and a provision of food, drink, and material comforts for the great beyond. Consequently, they developed the skill of mummification to ensure that the body remained intact.

The ancient Egyptians developed mortuary design to an unparalleled degree. Nearly all their funereal structures, however, feature one unifying element: a rock-cut burial pit.

The earliest royal tombs were typically oblong in shape, with sloping sides and a flat roof—and are commonly known to us, if not to the Egyptians, as "mastabas." Beneath their superstructures, however, was a burial chamber, hewn out of living rock. One of the first prototypes for later Egyptian pyramids was built near the village of Saqqâra, opposite Memphis: it is a stepped structure, rectangular in plan, possibly constructed during the First Dynasty, which would put its date somewhere between 3000 and 2800 B.C. (The history of ancient Egypt is traditionally divided into some 30 dynasties.) Its two stairways provided access to the rock-cut burial pit.

Toward the beginning of the Third Dynasty, about 2660 B.C., Djoser (Zoser) constructed a funerary complex at Saqqâra, which included a six-stepped pyramid made of limestone blocks, rising to a height of 200 feet. The monument is sited above a passage that led down to a burial chamber at the bottom of a rock-cut pit. Although the pyramid is huge, measuring 413 by 344 feet at the base, its rectangular burial chamber was just large enough to comfortably contain the pharaoh's body. The famous Bent Pyramid at Dahshur, near Saqqâra, probably built for Sneferu between 2680 and 2565 B.C., also has a lower chamber and anteroom carved out of bedrock.

During the Fourth Dynasty, the flat-topped stepped pyramid was transformed into the pointed, plane-sided pyramid with a pyramidion, or capstone, at the apex. The Fourth Dynasty pharaohs are responsible for Egypt's most celebrated pyramids, the three giant structures at Giza on the west bank of the Nile, upriver from Saqqâra. Giza's lofty trio represents the acme of pyramid construction, becoming the model for royal tombs over the next 1,000 years. They are the largest in a series of more than 45 pyramids, beginning with Djoser's stepped structure and continuing into the 13th Dynasty (c. 1750 B.C.). All three were initially planned to have subterranean burial crypts carved out of bedrock, though in each case the plans were altered during construction to enhance the security of the royal mummy.

The largest of Egypt's funerary monuments is the Great Pyramid at Giza, built for Khufu (Cheops), who ruled from c. 2551 to 2528 B.C. It stands about 450 feet high; when its limestone casing and pyramidion were still intact, it rose nearly 30 feet taller. Khufu's initial burial chamber was cut deep into the bedrock at the foot of a long passage descending from the north face of the pyramid, but he was presumably entombed in a crypt at a higher level. Like all Egyptian pyramids, Khufu's monument symbolized the primordial mountain upon which the sun god arose to cast his powerful, life-bestowing rays upon the land.

In 1954 archaeologists uncovered a rock-cut pit near the base of Khufu's pyramid and discovered the carefully disassembled components of a 142-foot-long royal bark, a sailing ship propelled by oars. The pit—102 feet long, over 11 feet deep, and eight and a half feet wide—had been so effectively sealed that it preserved the aroma of the cedar timbers, which had been imported from Lebanon some 4,600 years earlier. The papyriform boat (a vessel with a narrow beam and raised, tapered ends) is believed to be a "sacred vessel" that

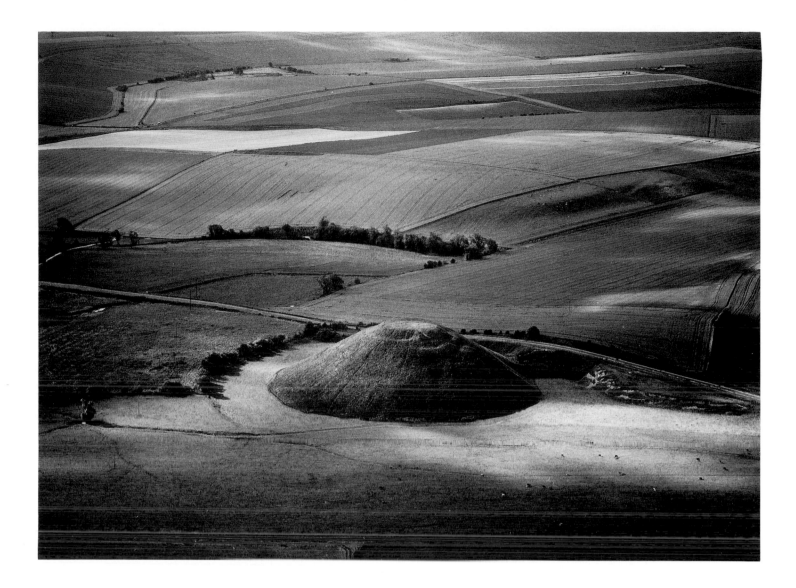

ABOVE: Silbury Hill, c. 2660 B.C. Wiltshire, England. Photograph by Marilyn Bridges. *England's largest man-made mound—generally regarded as a funerary monument—is 130 feet high and covers about five and a half acres.*

LEFT: Marlborough Mound, prior to A.D. 100. Wiltshire, England. Drawing by William Stukeley, 1721. The Bodleian Library, Oxford, England. *A junior counterpart to Silbury Hill, located five miles to the west, this monument was about 58 feet high. Its makers may have intended it as a territorial marker. By 1650 English gentry added terraces and installed a summerhouse on top.*

Khufu's son Djedefre buried alongside his father's tomb for use by the dead pharaoh in the hereafter. Experts removed and fitted together the 1,224 components of the boat, and it was ultimately put on display in a specially built museum near the Great Pyramid.[4]

The bark's discoverers became aware of a nearby second pit, also carved into the bedrock, and speculated that it, too, might contain a boat. In 1987 an international team of scientists devised a specially designed drilling system, which disclosed the presence of a second papyriform vessel, also disassembled. They probed the second underground chamber without disturbing either the boat or its environment, using a miniature 35-millimeter camera and a remote-control video system.[5]

Giza's so-called Second Pyramid contained the tomb of Khephren (or Khafre), a son of Khufu who reigned for 23 years, and the Third Pyramid housed the remains of his successor, Menkaure (Mycerinus). Many relatives of Khephren and Menkaure were buried in less elaborate tombs that were cut out of rock in nearby quarries.

About 2500 B.C. Khephren commissioned the sculpting of the Sphinx, which became an integral part of Giza's pyramid complex. His workmen supposedly had quarried a U-shaped pit to obtain blocks for his pyramid and nearby temples, leaving a knoll in the center that was subsequently sculptured into a leonine statue with a pharaonic head. Carved from limestone bedrock, the colossal, eastward-staring creature is 66 feet high and 240 feet long. The mysterious, crouching figure was known to the ancient Egyptians as Hu, and he apparently played a guardian's role, protecting sepulchral chambers and warding off intruders.[6] The face is presumably a portrait of Khephren himself in his royal headgear and false beard. (The creature's misnomer, "Sphinx," was supplied by the ancient Greeks, who evidently confused it with their notorious female monster who killed anyone who couldn't solve her riddles.)

Hu, alas, was an ineffectual watchcat, permitting all three of Giza's great pyramids to be robbed of their treasures. In fact, by the end of Egypt's Old Kingdom (c. 2134 B.C.), pyramids were on the way out because, like beacons, they attracted grave-robbers from miles around.

TOMBS IN THE ANCIENT WORLD BETWEEN 2000 AND 300 B.C.

In Egypt, with the beginning of the Middle Kingdom period (about 2040 B.C.), some 11th Dynasty pharaohs built rock-cut tombs at el-Tarif, near Thebes, by carving laterally into the cliffs. The royal preference for rock-cut tombs intensified through the 17th Dynasty. During the New Kingdom period (approximately 1550 to 1070 B.C.), the pharaohs completely abandoned the pyramid form. Tombs and mortuary temples, formerly coupled, were now separated by considerable distances. The New Kingdom pharaohs built their funerary temples on the edge of the Theban desert, making them as imposing and conspicuous as their resources permitted, but concealed their bodily remains in rock-cut tombs carved out of cliffs.

About 1500 B.C., Tuthmosis I, an 18th Dynasty ruler, was the first pharaoh to have his tomb cut in the cliffs of a desolate valley, now known as the Valley of the Kings (near present-day Deir el-Bahri). The valley would eventually contain more than 60 tombs. (One of them, "No. 62," discovered in 1922 with all its treasures intact, was that of King Tutankhamen, who died at age 18 or 19 about 1325 B.C.) All the royal New Kingdom tombs are similar in plan, consisting of a long rock-cut corridor that leads at a downward incline to one or more, sometimes pillared, halls and terminates in a crypt.

Tuthmosis was succeeded by a son, Tuthmosis II, who, in accordance with Egyptian custom, married his half sister, Hatshepsut (Tuthmosis I's daughter by another wife). Following the death of Tuthmosis II, the royal succession was supposed to pass to Tuthmosis III, his son by a "minor" wife. But Hatshepsut outmaneuvered her stepson/nephew, first by serving as regent, then by having herself crowned pharaoh. (She is frequently portrayed in artworks wearing the long false beard with which pharaohs

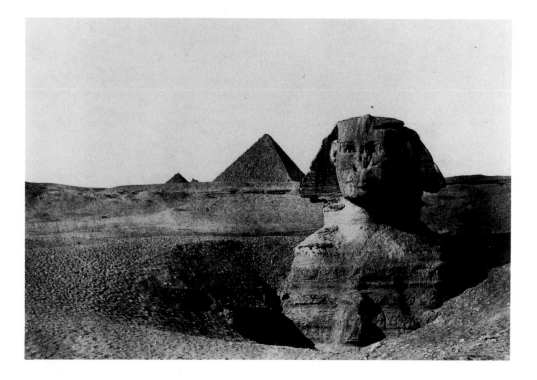

LEFT: *The Sphinx*, c. 2500 B.C. Giza, Egypt. Photograph by Maxime du Camp, 1849. George Eastman House, Rochester, New York. *The enigmatic creature, about 66 feet high and 240 feet long, was carved from a knoll of limestone.*

BELOW: Temple of Hatshepsut, c. 1470–1450 B.C. Deir el-Bahri, Egypt. Photograph by Wim Swaan. *Egypt's only female pharaoh commissioned this funerary temple. The top terrace leads into a sanctuary that was excavated from the cliff's living rock.*

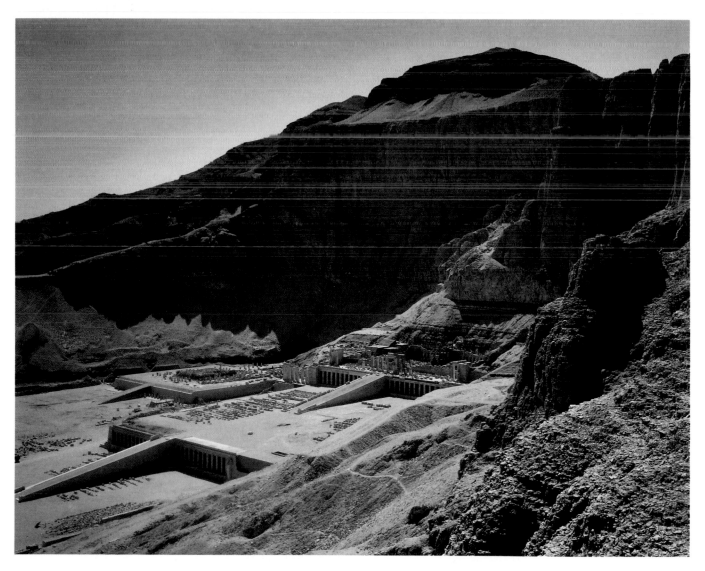

were typically represented.) Hatshepsut effectively governed the country for more than 20 years, until her death in 1458 B.C. She also built one of Egypt's most impressive mortuary temples, which is partly free-standing and partly rock-cut.

Hatshepsut's magnificent funerary temple was ingeniously designed with three wide terraces that seem to cascade from the towering cliffs at Deir el-Bahri. A processional way, lined with sphinxes, leads to the first terrace, which features reliefs that depict Hatshepsut's purportedly divine birth as a daughter of the god Amun. The top terrace leads to the main sanctuary, cut out of the solid rock of the hillside. Hatshepsut's mummy was entombed some distance away, in a more secretive rock-cut chamber.

Nearly 300 years after Hatshepsut's reign, Ramses II, a 19th Dynasty pharaoh who lived from about 1303 B.C. to 1224 B.C., commissioned rock-cut architecture on an even more ambitious scale. His reign was notable for his lavish building program: he commanded more buildings and giant statues (and more monuments to himself) than any other Egyptian king. In quest of a new building site he went farther upriver, into Nubia, and finally selected an area, known as Abu Simbel, where imposing sandstone cliffs flank the banks of the Nile. There, on the western bank, he established two huge rock-cut temples—the larger for himself, the smaller for his queen, Nefertari. Both structures, built between 1300 and 1233 B.C., were completely hewn out of living rock, all the interior spaces having been carved from the massive sandstone cliff.

Although Ramses's temple was not funerary in purpose, functioning more as a store-house for tribute exacted from Nubia, it contributed to his deification and therefore served a memorial use. Its facade featured four colossal seated statues of the pharaoh, each about 67 feet high. The figures face outward, their hands resting on their knees, their heads bearing the double crown of Upper and Lower Egypt. Between the king's massive calves are many smaller statues, some representing members of the royal family.

The interior of the temple extended nearly 200 feet into the cliff. Inside, the first of three main halls had eight rock-cut statues, each 30 feet high and representing Ramses in the guise of the god Osiris. The second hall had wall reliefs of Ramses and Nefertari. The third hallway was the sanctuary, with four giant seated figures, which represented three state gods of the New Kingdom (Ptah, Amon-Re', and Re'-Harakhty) and the deified pharaoh himself. Ramses's temple faced east and was sited in such a way that twice a year the rays of the rising sun penetrated the full length of the interior and illuminated the four statues at the rear.

Nefertari's temple was a somewhat reduced version of her husband's. The facade had six standing statues, each about 33 feet high, four of them representing the king and two portraying the queen, all flanked by smaller figures of their children.

For a millennium or so, Ramses's and Nefertari's temples were shrouded by drifting desert sands, unknown to the modern world until a Swiss traveler "discovered" them in 1813. As a mountain of sand blocked the facade of Ramses's temple, no one could gain access to it until 1817, when the intrepid Italian adventurer Giovanni Battista Belzoni and a crew of helpers worked for more than three weeks before they cleared an opening in the upper left corner of the entrance, slid through the small aperture, crawled over the mound of sand that filled the inside corridor, and finally made their way down the slope into the first main hall. There, by flickering torchlight, they were astonished to find the eight colossal statues of the pharaoh.

Less than 150 years later, both monuments were threatened with inundation by the construction of a new High Dam at Aswan. In the 1960s engineers devised an ambitious scheme to rescue the monuments by cutting the facades into large blocks and lifting them for reassembly nearly 70 yards higher, atop the cliff.[7]

In addition to carving crypts for the pharaonic first families, the ancient Egyptians also gouged rock-cut vaults for sacred animals. They worshiped a bull-god, Apis, for whom they excavated a sacred necropolis known as the Serapeum, located a couple of miles north of the Saqqâra pyramids. Only one carefully tended Apis bull could reign at any particular

time, and he apparently lived out all his days in pampered luxury. Upon his death, his body was meticulously mummified, a ritual process that required 70 days. The embalmed bull was then deposited within a granite sarcophagus and placed within a catacomb that had been carved out of bedrock, joining his sacred predecessors who had also been laid to rest there for eternity. When the Serapeum was discovered in 1851, only one or two sarcophagi remained inviolate: one contained, in addition to the mummified corpse, a four-foot-high gold statue of an Apis bull.[8]

Also at Saqqâra, not far from the Serapeum, the Egyptians entombed mummified primates and birds after gouging a rock-hewn shaft that led to a subterranean network of excavated galleries and passageways with niches cut into the walls. The niches in one area held hundreds of wooden boxes, each containing an embalmed body of a baboon. A nearby corridor was filled with elongated pottery jars, stacked on their sides like wine bottles, containing the linen-wrapped remains of some 4 million black-and-white ibis and 800,000 falcons.

In contrast to the Egyptians, the ancient Minoans, who flourished on the island of Crete prior to 1500 B.C., often buried their dead in collective tombs, sometimes in actual caves. But they occasionally excavated rock-cut chambers, such as the inner crypt of the so-called Temple Tomb. It was discovered about 650 yards south of the Palace of Minos at Knossos in 1931. Although it does not look anything like Hatshepsut's tomb in Egypt, it is similar insofar as it juxtaposes above-ground architecture with a rock-cut burial chamber carved out of a cliff.

On the Greek mainland, at Mycenae, between 1400 and 1200 B.C., important persons and members of ruling families were buried in round burial chambers, known as *tholoi*, which were excavated in hillsides. Nine of these cavelike tombs exist at Mycenae, suggesting the presence of a noble family with a long tradition and abundant assets. The large round chamber (the *tholos* proper) often has walls that taper inward toward the top to form a pointed dome, a shape that reminds some viewers of beehives or acorns. The interior of the *tholos* was typically faced with large dressed stones, each course overlapping the one below until the concentric layers of stone blocks met at the top, where they were crowned by a capstone. *Tholoi* were usually approached by a long, sloping passageway, also lined on both sides with massive blocks of stone.

The most impressive *tholos* at Mycenae is the Treasury of Atreus, probably constructed between 1300 and 1250 B.C. It received its fanciful name as a result of excavations by German archaeologist Heinrich Schliemann, who scoured the site in the 1870s and claimed he had uncovered the graves of Agamemnon (the son of Atreus) and his family, all legendary figures who predate the *Iliad*. The round chamber is 100 feet in diameter, 47 feet high at its apex, and lined with 35 rings of large squared-off stones. The deceased were apparently buried within a side chamber, connected to the main "beehive" hall. Now stripped, the still-imposing facade once had bronze-embellished wooden doors and marble half-columns.

The Greek warriors who fought and died at Troy were possibly buried under conventional mortuary mounds. (The Trojan War is surmised by many scholars to be based on actual events that took place at a city on the Anatolian side of the Aegean, just south of the Dardanelles, in the 13th century B.C.) In the *Iliad*, probably written several centuries later, Homer gives a detailed account of the elaborate funeral that Achilles devised for his favorite companion, Patroclus, a childhood friend from Thessaly and now a casualty in the siege of Troy. After making his friend's corpse the centerpiece of an enormous pyre and sacrificing many sheep, oxen, horses, and dogs, as well as 12 "valiant sons of great-hearted Trojans" (whom he personally slew), Achilles ignited the whole works, creating a roaring blaze that lasted throughout the night. Then Achilles and his Achaean comrades gathered up Patroclus's bones and deposited them in a golden urn, which they buried under a circular mound of earth. According to Homer, Achilles asked his companions not for a "huge barrow," but for "a seemly one, no more."[9] As to what size Achilles might have considered seemly, Homer leaves us in the dark.

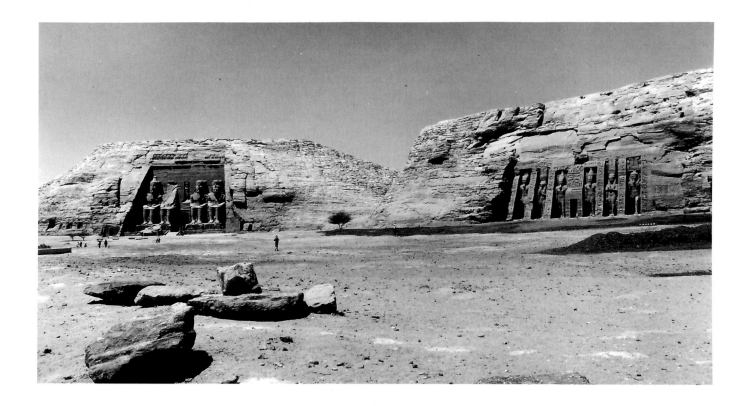

ABOVE: Temples of Ramses II and Nefertari, c. 1250 B.C. Rock-cut monuments at Abu Simbel, before relocation. Photograph by M. S. Hackforth-Jones. *To the right of his own temple, Ramses II dedicated a smaller one to his wife Nefertari. Its facade features alternating statues of the king and queen, each about 33 feet high. In the 1960s both monuments were moved to make way for the Aswan High Dam.*

RIGHT: Temple of Ramses II, Entrance Hall, c. 1250 B.C. Lithograph by David Roberts, c. 1836. *Ramses's temple, obscured by centuries of drifting sand, was not rediscovered until 1813. Scottish artist David Roberts visited the monument 23 years later. In order to gain access to its entrance, he had to slide down high mounds of sand that obstructed the approach. Inside, he found this scene of eight 30-foot-high statues of the pharaoh. Each holds a crook and scourge, symbols of kingly power.*

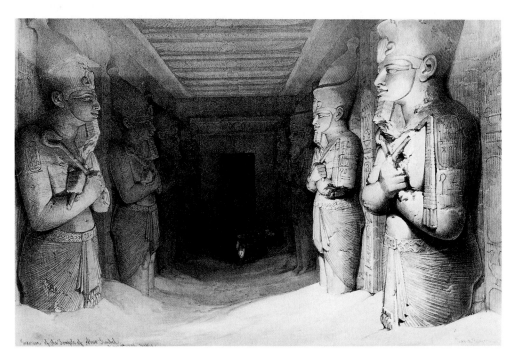

OPPOSITE: Temple of Ramses II, c. 1250 B.C. Abu Simbel, Egypt. Photograph by Maxime du Camp, 1850. George Eastman House, Rochester, New York. *Ramses II deified himself in this imposing monument, carved out of a sandstone cliff facing the Nile in Nubia. The facade features four giant statues of himself.*

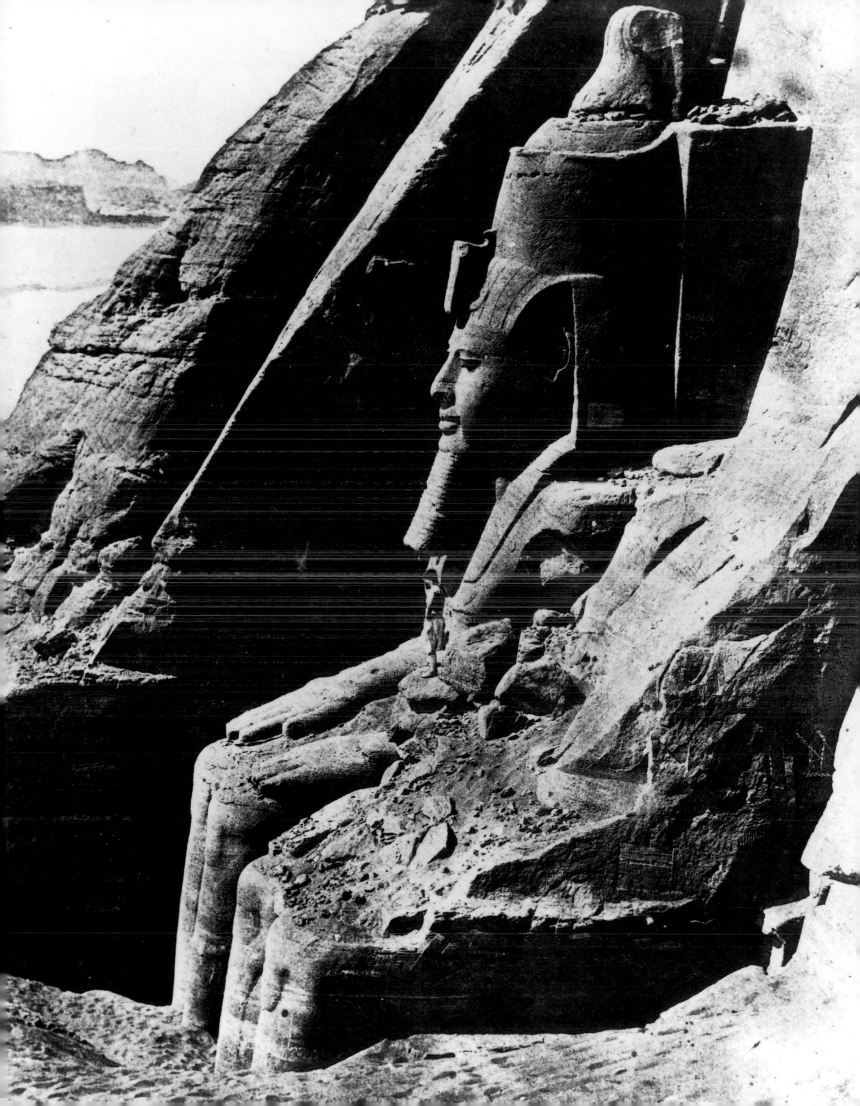

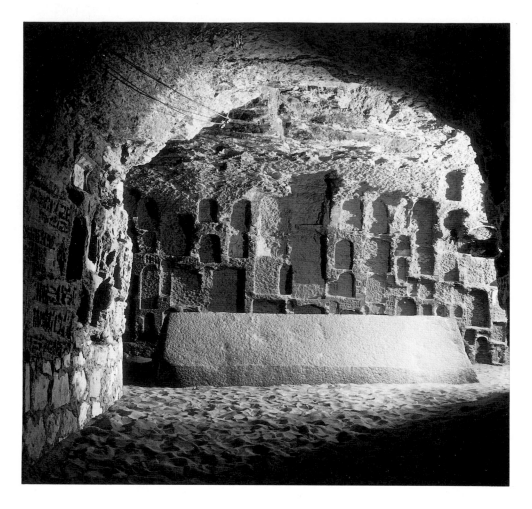

RIGHT: The Serapeum (Catacomb of the Apis Bull-Gods), c. 800–600 B.C. Saqqàra, Egypt. Photograph by Roger Wood. *Beginning about the 14th century B.C., the Egyptians worshiped a living embodiment of Apis, a bull-god. They created a vast rock-cut catacomb specifically for him by excavating a long central corridor that led past sunken burial vaults on either side. One of the mummified bulls was entombed in this granite sarcophagus. The carved niches held votive tokens of piety.*

BELOW: Treasury of Atreus, c. 1300–1250 B.C. Mycenae, Greece. Photograph by Giovanni Dagli-Orti. *Mycenaean royalty were entombed in circular vaults that were excavated out of hillsides. This tomb's main chamber is 100 feet in diameter and 47 feet high.*

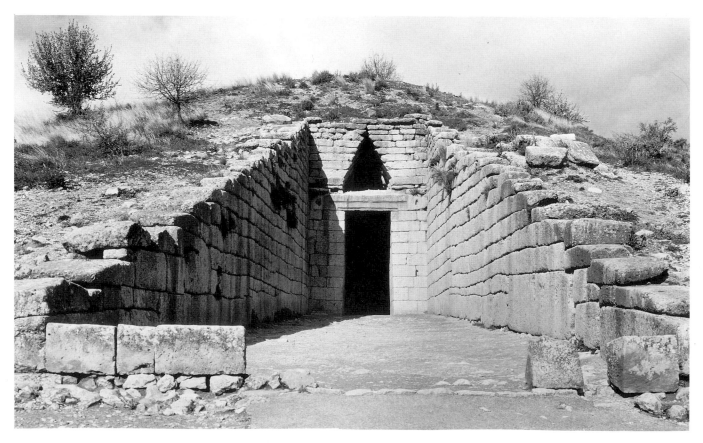

In 1984 German archaeologists in Turkey excavated a cone-shaped tumulus, rising nearly 50 feet high, several miles southwest of Hisarlik, a site that many scholars identify with Troy. The tumulus is perhaps the same mound that people in the ancient world regarded as the tomb of Achilles. When archaeologists dug into the base of the tumulus, they found more than 50 cremations and burials with Greek grave goods and pottery that appear to date from the 13th century B.C.

The rulers of many kingdoms around the eastern rim of the Mediterranean favored burial under large, imposing tumuli. The Phrygian kingdom, according to Greek tradition, had been settled by emigrants from Macedonia by the 12th century B.C. Within the next four centuries Phrygia became one of the most prosperous and politically powerful nations in the region. Under Midas, an eighth-century B.C. king who may or may not be related to the legendary potentate cursed with the golden touch, the Phrygian realm extended from the Aegean coast in the west to the Euphrates River in the east. The region is still marked by the large tumuli of long-dead Phrygians. The most imposing of them is the Great Tumulus, which rises nearly 175 feet high. Inside, within a wooden chamber, excavators found the remains of an elderly man—Midas himself?

About 685 B.C., after the collapse of the Phrygian kingdom, its neighbor to the east, Lydia, became the dominant power in Asia Minor. The Lydian necropolis, just north of its ancient capital, Sardis, contained enormous tumuli that marked the burial places of the nobility. The largest of them, according to Herodotus, was the tomb of Alyattes, a Lydian king who conquered many Ionian cities during his reign from about 609 B.C. until his death in 560 B.C. His tumulus is nearly 210 feet high. Herodotus noted that the breadth of the tomb was about 400 yards. More intriguingly, he added that the mound of earth was raised by the joint labor of tradesmen, craftsmen, and prostitutes. "On the top of it there survived to my own day," he wrote, "five stone pillars with inscriptions cut in them to show the amount of work done by each class. Calculation revealed that the prostitutes' share was the largest. Working-class girls in Lydia prostitute themselves without exception to collect money for their dowries, and continue the practice until they marry."[10] Alyattes's son, Croesus, was the last of the Lydian monarchs, losing his empire to the Persians and being taken prisoner by Cyrus the Great in 546 B.C.

The remains of four of Cyrus's successors were deposited in impressive rock-cut tombs in the cliffs at Naqsh-i-Rustum, near Persepolis, in what is now southwestern Iran. The earliest belonged to Darius the Great, who reigned from 521 to 486 B.C. His empire consisted of virtually all western Asia, as well as Egypt, and he was the key aggressor in the Persian wars with Greece. He initiated the construction of a magnificent new capital at Persepolis, but did not live to see it. Instead, he was interred in a cliffside tomb near the new city. The carved cruciform facade is embellished with a row of four columns that ostensibly supports the entablature.

On the Italian peninsula between the seventh and fifth centuries B.C., the Etruscans paid detailed and lavish attention to the housing of their dead, whom they buried in rock-cut tombs. They embellished their multichambered rock-cut crypts with terra-cotta reliefs, bronze votive figurines, and extraordinary wall paintings that portray the sensual pleasures of their social life, which included music, dancing, banquets, and other festivities.

Hundreds of Etruscan tombs were not only decorated with fine paintings but also furnished with many household necessities. A large necropolis near the Etruscan city of Caere (present-day Cerveteri) is noteworthy for the complexity of its mound tombs. Some of its tomb designs dramatically translate domestic interiors into sculptured stone. The most famous example is the large crypt in the Tomb of the Shields and Thrones, dating from the mid-sixth century B.C.

More than 6,000 tombs, some of them covered by massive mounds of earth, once existed in the Etruscan cemetery at Tarquinii. Vulci's cemeteries also had chamber tombs that were crowned with earthen mounds. One of them, the Cucumella, dating from about 550 B.C., is 70 yards in diameter, making it the largest of its kind in the Etruscan territory.[11]

OVERLEAF: Islamic necropolis. Beni Hasan el Shurûq, Egypt. Photograph by Marilyn Bridges, 1992. *After the ascent of Islam in seventh-century Egypt, many Muslims chose to be entombed in domed mud-brick structures. This cemetery of relatively recent sepulchers is in an area that was once known primarily as a Middle Kingdom necropolis, where dozens of 11th and 12th Dynasty monarchs were laid to rest in rock-cut tombs.*

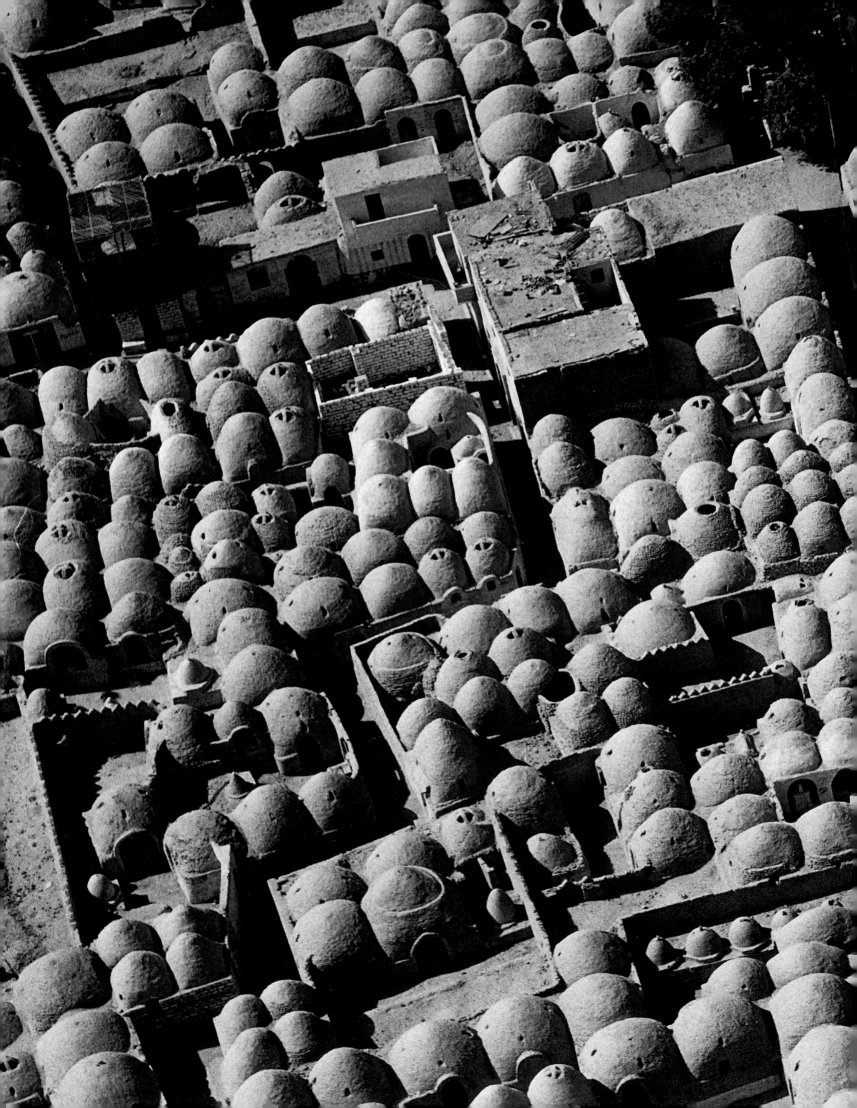

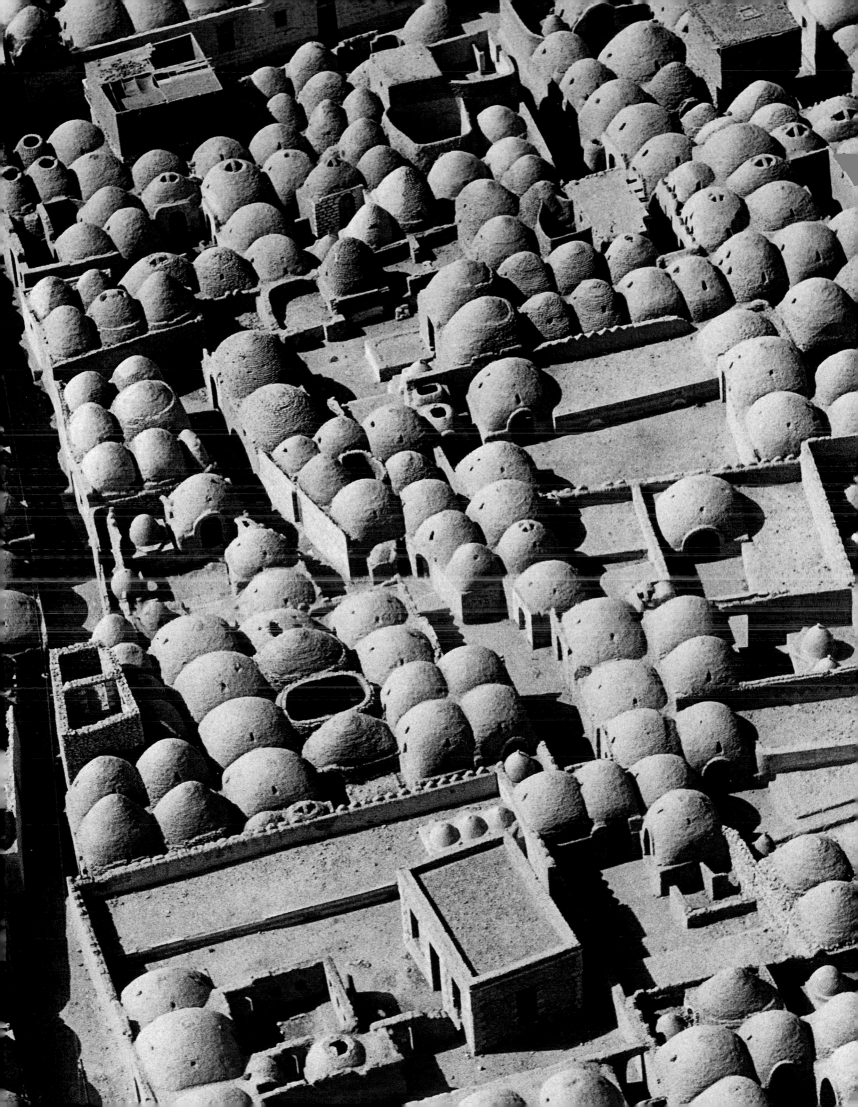

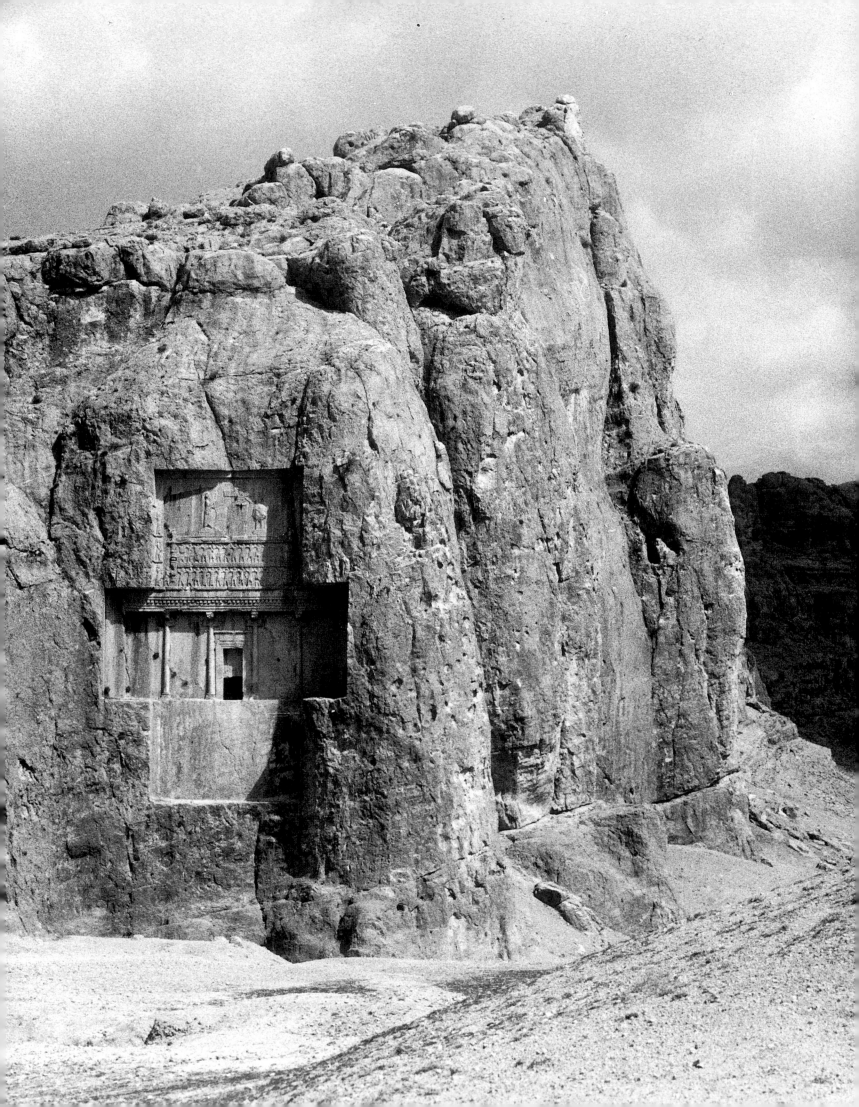

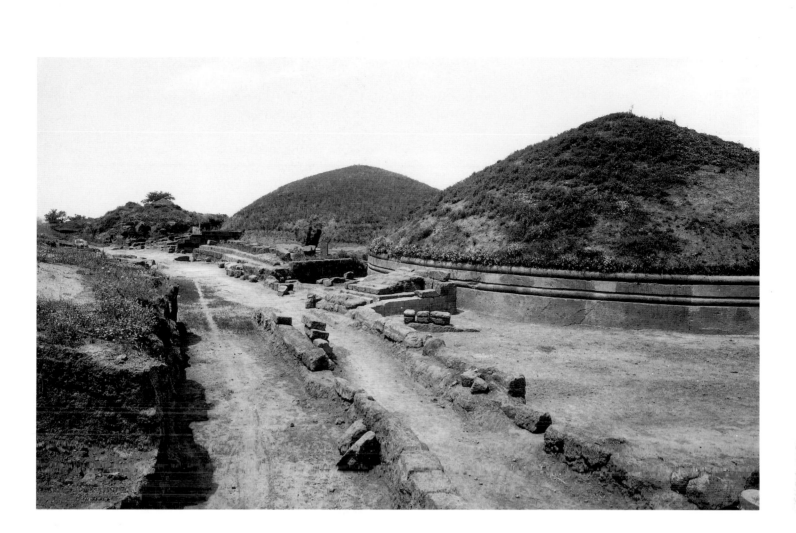

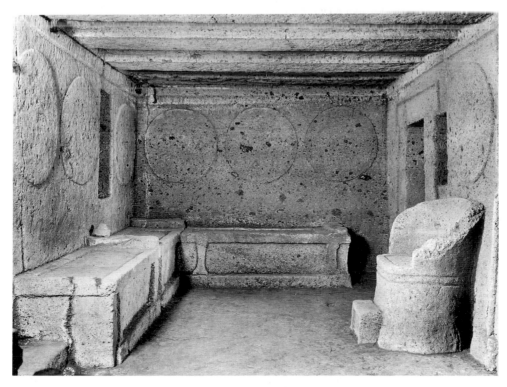

ABOVE: Banditaccia Necropolis, 7th–3rd century B.C. Cerveteri (Caere), Italy. *Etruscans who lived in the ancient city of Caere established this necropolis, where rock-cut chambered tombs are surmounted by massive rounded tumuli.*

LEFT: Tomb of the Shields and Thrones, mid 6th century B.C. Cerveteri (Caere), Italy. *This rock-cut crypt dramatically translates domestic interior design into sculptured stone. Armchairs, footstools, and a row of large round shields are all shaped out of living rock.*

OPPOSITE: Tomb of Darius II, late 5th century B.C. Naqsh-i-Rustam, Iran. Photograph by Wim Swaan. *Darius II, the great-grandson of Darius the Great and one of four Persian kings entombed in rock-cut crypts in the cliffs near Persepolis, presided over an unpopular regime, beset by revolts. He lost control of Egypt before he died in 404 B.C.*

The Etruscans deposited many of their deceased in crypts carved deep into hillsides. A rock-cut sepulcher at Vulci, known as the François tomb, was approached by a 90-foot-long corridor that penetrated into the depths of a hillside. At Clusium, the Etruscans converted a hill into a habitat for the dead, hollowing out no fewer than 40 sepulchral chambers on three levels, all interconnected by labyrinthine tunnels. Tomb builders in the Norchia Valley carved 100 or more crypts out of the cliff. Although the cliffs were sculpted into classical facades with columns and pediments, the actual entrances to the burial chambers were inclined tunnels that led into the mountain on either side of the facade.

In ancient Macedon, the Greeks favored relatively simple earthen burial mounds. The plains north of Thessaloníki are still dotted with many tumuli, often rising several feet in height and dating from 1000 to 700 B.C.

The most tantalizing of Greek Macedonia's ancient tumuli is the Great Tumulus, an artificial hillock that rose almost 40 feet above the surrounding terrain near the modern town of Vergina. The mound, which was about 325 feet in circumference, once covered three tombs. Two of the burial chambers were still intact in 1977, when one was opened by archaeologists, who instantly surmised that it was a royal tomb, possibly that of Philip II (382–336 B.C.), one of the greatest military leaders of the ancient world and the father of Alexander the Great.

The tomb that lay below the Great Tumulus had a Doric facade and large marble doors (which presumably closed on the deceased between 350 and 320 B.C.). Within, archaeologists found a white marble sarcophagus that contained a gold coffer with a hinged lid that was embossed with a stylized "exploding star," an emblem of Macedon's royal dynasty. The box contained an assortment of bones and teeth, wrapped in purple cloth, as well as an exquisitely crafted golden diadem of oak leaves and acorns. Although no names or inscriptions were found anywhere in the tomb, Philip II would seem to be the only monarch of that era for whom the Great Tumulus could have been built.

NATIVE AMERICAN BURIALS, 500 B.C. TO A.D. 400

The inscrutable Adena people constructed impressive burial mounds all over the Ohio River Valley between 500 B.C. and A.D. 400. (Modern historians named the culture "Adena" after an Ohio town.) Adena sites are concentrated mainly in the central part of the valley, but the experts have identified hundreds of related sites in the southern part of the state and adjacent portions of Pennsylvania, West Virginia, Kentucky, and Indiana. Unlike later mound-building societies of the Upper and Lower Mississippi, such as Cahokia (see Chapter 1), the Adena people apparently did not live among their mounds, which functioned primarily as mortuary sites.

Adena burial mounds were typically shaped like steep cones, usually circular or oval in plan and rarely more than 65 feet high. The largest known example is Grave Creek Mound in West Virginia, which was nearly 70 feet high and about 240 feet in diameter. Their burial mounds were often enclosed by relatively linear earthworks, usually in the form of geometric figures, such as circles, squares, and pentagons. These geometric figures averaged about 100 yards in diameter.

Like many tribal communities in the prehistoric Americas, Adena people probably had two classes of society, comparable to traditional nobility and commoners. The most elite members of Adena society—chiefs and other "upper-class" males—had their remains preferentially positioned within the mounds and were usually buried with grave goods such as hammered-copper ornaments, gorgets (ornamental collars), breastplates, stone axes, and carved-stone pipes for smoking. Commoners were routinely cremated, their ashes often deposited in the mounds.

Some of the Adena's neighbors and contemporaries, the Hopewell people, adopted and elaborated many traits of Adena culture. The Hopewell culture's name derived from Captain Mordecai C. Hopewell, the owner of a farm near Chillicothe, Ohio, where an

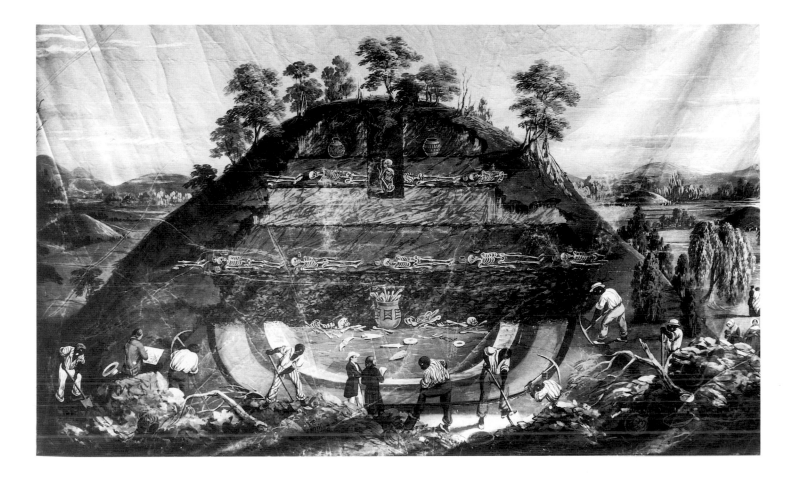

ABOVE: John J. Egan. *Panorama of the Monumental Grandeur of the Mississippi Valley* (detail), c. 1850. Tempera-like paint on muslin. St. Louis Art Museum Purchase, Eliza McMillan Fund. *This cutaway view of a Native American burial mound portrays the layered composition of such tumuli, as well as the class division in mid-19th century American archaeology—white scholars supervise black laborers digging up clues to a vanishing aboriginal culture.*

LEFT: Plan of Newark Earthworks, c. A.D. 200. Newark, Ohio. Drawing by William Morgan. *The circular earthen embankment was eight to 14 feet high and about 1,200 feet in diameter. The octagon, which enclosed nearly 45 acres, was composed of eight earthen walls with gaps, or entrances, between them. Facing the gaps were truncated pyramids. As shown here, the plan is superimposed on a 200 x 200-meter grid.*

extensive complex of 38 mounds was excavated in the early 1890s. The two cultures over-lapped both chronologically and geographically, making it difficult to sort out the distinc-tive characteristics of each society. The core area for the Hopewell people was also in Ohio, where they built their largest mounds, which also held the richest burial goods.

Hopewell earthworks appear to have functioned predominantly as mortuary and cere-monial centers. The people who constructed them often lived in nearby villages or hamlets. Their burial mounds were conical or domelike in form, occasionally flattened on top. The mounds were often 30 to 40 feet in height and about 100 feet in diameter at the base. Burial was reserved for the community's elite, cremation being adequate for the remainder of the population. The eminent dead were usually accompanied to the grave by their most valu-able personal goods, which in many cases included copper ornaments, carved-stone objects, silver nuggets, mica, quartz crystal, textiles, antlers, bear teeth, and conch shells.

The Hopewell seem to have built their mounds in two stages. They first laid their leaders to rest within charnel houses, then subsequently set the houses on fire and piled mounds of earth over the ruins.

The Hopewell people elaborated the Adena practice of positioning their burial mounds within seemingly sacred precincts, defined by enclosing earthworks. Hopewell enclosures were usually geometric—squares, circles, and octagons—and on a much grander scale than the Adena version: the ridges could be as high as 16 feet. For unknown reasons, the Hopewell had the curious custom of positioning burial mounds opposite the regularly spaced gaps in the surrounding embankments. This intriguing design element appeared at many Hopewell sites, including Newark, Marietta, Oldtown, High Bank, and Seal, all in the southern half of Ohio.

At Newark, one of Ohio's most famous Hopewell sites, probably constructed about A.D. 200, burial mounds were assembled within a complex of geometric embankments that once covered four square miles. Newark's earthen octagon, which was nearly 1,500 feet across, was composed of eight walls of nearly equal length (about 625 feet) with 17-foot-wide corner gaps that probably constituted entrances. A truncated pyramid, nearly five feet high and approximately 80 by 100 feet across at the base, was positioned inside each entry. Toward the southwest, two 100-yard-long berms, set nearly 60 feet apart, flanked an avenue that connected the octagon to a geometrically precise circle. The Great Circle consisted of an earthen embankment, eight to 14 feet high and about 1,200 feet in diameter. A bird effigy, the so-called Eagle Mound, stood at the center of the circle. Another long avenue, lined with earthen walls, now gone, once connected the Great Circle with a large square enclosure a quarter of a mile away. Only small sections of the square still remain.

The earthworks at Marietta, Ohio, occupied an area that was approximately 870 by 1,300 yards and consisted mainly of two large, slightly irregular squares, probably dating prior to A.D. 200. The larger square was defined by 16 ridge mounds; it enclosed nearly 45 acres and contained four rectangular, truncated pyramids, each more than five feet high. The other square, defined by 10 ridge mounds, contained eight small conical mounds. A nearby circular embankment with an inner moat (thought to be late Adena) surrounded a truncated elliptical mound that was nearly 30 feet high.

Circular and octagonal earthwork enclosures figured at three other Ohio Hopewell sites. At High Bank, near Chillicothe, the octagonal embankment, which measured about 11 feet high and 316 yards across, contained eight circular mounds and was connected to a circular earthen enclosure that was about 340 yards in diameter. At Frankfort, the earth-works group known as Oldtown consisted of one square and two circular earthen embank-ments. Finally, at Piketon, a site named Seal consisted of still another circle and square combination, the circular embankment being about 349 yards in diameter, the square having 272-yard-long sides. The two geometric figures were connected by a 158-yard-long avenue flanked by earthen walls.

What could have been the significance of the paired circles and squares? Frequently, the squares or octagons provided the only access to the circular enclosure. Perhaps

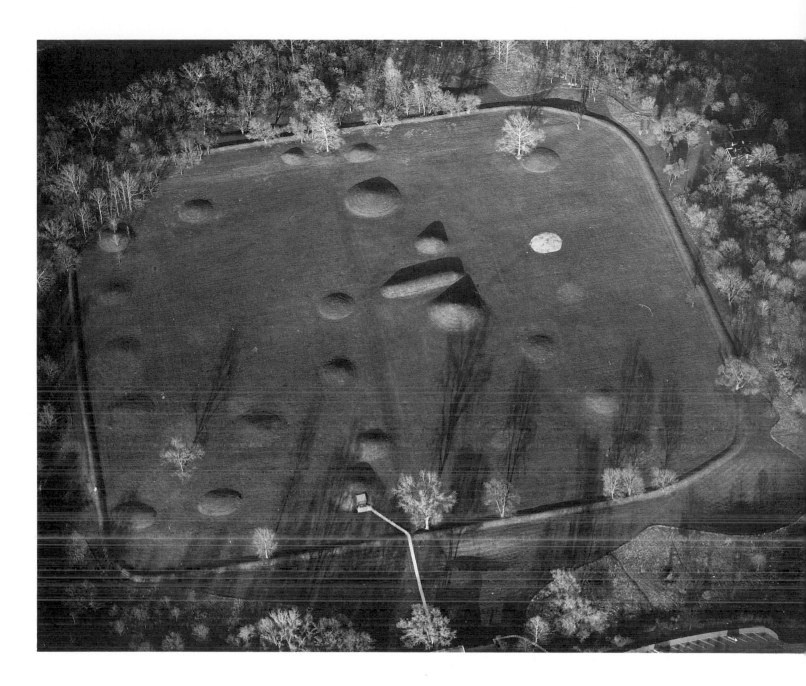

Mound City Earthworks, prior to
A.D. 400. Near Chillicothe, Ohio.
Photograph by Marilyn Bridges,
1988. *This Hopewell-related site
features a nearly square earthen
embankment containing more than
20 burial mounds.*

different kinds of rituals were performed within each type of enclosure.

Hopewell cultural traits spread westward and northward, reaching Illinois, Missouri, Michigan, and Wisconsin. The practice of constructing burial mounds extended northward through Minnesota, the eastern Dakotas, and southern Manitoba. The tribes who continued the mound-building tradition along the northeastern edge of the Great Plains were possibly ancestors of the Dakota, Assiniboin, and Cheyenne Indians.

Burial customs differed dramatically in South America, especially in Peru. There, on the Paracas Peninsula, about 150 miles south of Lima, archaeologists discovered three cemetery complexes of rock-cut shaft graves, the oldest of which—dubbed Cavernas—dated from 600 to 400 B.C. Their makers had dug deep shafts through the clay and granite and widened them at the bases to form large chambers, where they placed their mummified dead. Each grave contained the remains of between 30 and 40 individuals, bundled in an outer wrapping of coarse cotton that concealed and protected superbly embroidered textiles and elaborate ornaments and masks.

In northern Peru, the Mochica people also excavated shaft graves with enlarged chambers at the bottom, apparently dating from the third century A.D. The Loma Negra cemetery, discovered in 1969, is one of several ancient burial grounds with shaft graves located in Piura Valley. Its burial chambers contained many objects in precious metals, as well as gourd plates that once held corn, beans, and peanuts. Important noblemen were evidently accompanied to their graves by sacrificed women and servants.

ASIAN TUMULI AND ROCK-CUT CRYPTS FROM THE THIRD CENTURY B.C. TO THE SECOND CENTURY A.D.

The Chinese soul splits in two after death and travels in opposite directions, one part rising to heaven while the other part sinks into the earth. Eventually, they both dissolve into indiscriminate cosmic matter. But, until they do, the earthbound soul, if sufficiently irritated, can reappear as a capricious and malevolent ghost. Therefore, prudent Chinese are willing to go to extraordinary lengths to mollify whatever ancestral spirits may still lurk in their terrestrial environment. In choosing a grave, they often consult a geomancer, whose expertise in *feng shui* leads to the divination of which sites will assure that the deceased is not bedeviled by evil spirits.

One potentate who had many geomancers and fortune-tellers on his payroll was Qin Shi Huangdi (c. 258–210 B.C.), the first emperor of China. As befits a sovereign who initiated imperial highways and segments of the Great Wall (see Chapters 2 and 3), Qin Shi Huangdi inaugurated the largest tumulus in China's history, an artificial hill measuring 164 feet high and more than 4,500 feet in diameter.

The emperor began work on his tomb soon after he became king of Qin in 246 B.C. He chose a site in Shaanxi Province, about 25 miles east of the city of Xi'an (which overlays the ancient Qin capital of Xianyang), and conscripted 700,000 of his people from all parts of the country to labor for more than three decades on his monument. Like many tyrants, the emperor did not enjoy being the subject of negative gossip; in 212 B.C., convinced that Confucian scholars were spreading malicious rumors about him, he had 460 of them arrested and buried alive at Xianyang.[12] In 210 B.C., at about age 49, the emperor himself died and was readied for burial under his earthen mound.

According to Ssu-ma Ch'ien, a historian and archivist of the Han court (he died about 90 B.C.) who had access to many official records that no longer exist, Qin Shi Huangdi's tomb included a huge floor map of the empire, with the Yangtze and Yellow rivers simulated by circulating mercury. Ssu-ma Ch'ien also noted that automatic crossbows, intended to slay grave robbers, were positioned opposite the entranceway. The artisans responsible for the antilooting devices and other mechanical contraptions were sacrificed, along with the emperor's childless concubines. As soon as the emperor's body was installed within the burial chamber and sealed up with his treasures, the middle and outer gates were shut,

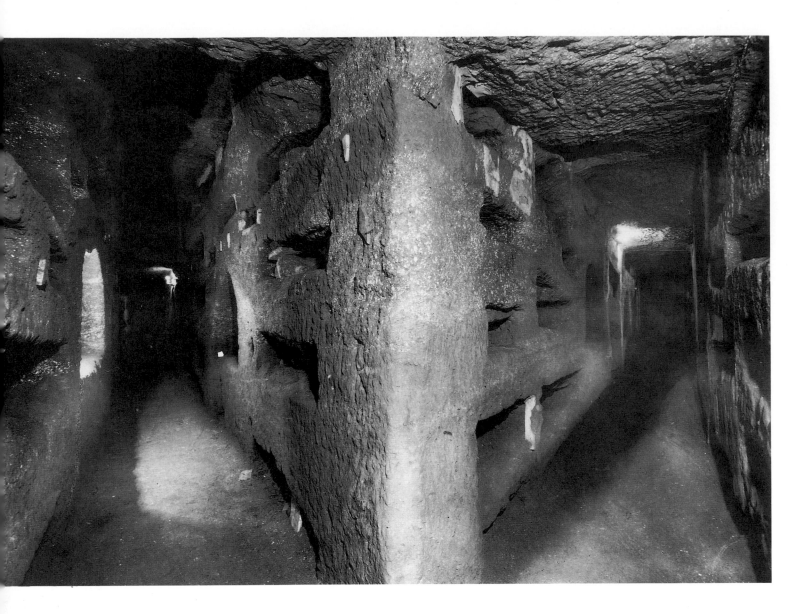

Catacombs of Domitilla, 2nd–4th
century A.D. Rome. Photograph
by Roger-Viollet. *Early Christians
excavated this multilevel subter-
ranean necropolis and deposited
their dead in niches and crypts
along mazelike passageways. It is
named after the martyred niece
of Domitian, a Roman emperor in
the first century A.D.*

imprisoning for eternity all those who had worked on the tomb. After trees took root on the earthen mound, it came to resemble a natural hill.

Although Qin Shi Huangdi's tumulus never disappeared from view, many people assumed—incorrectly, it now appears—that his tomb had been plundered soon after his death. Extensive digging in the vicinity indicates that the walls of the tomb are intact. In 1974 archaeologists made a spectacular find about three-quarters of a mile east of the tumulus, where they unearthed an "army" of nearly 7,000 life-size terra-cotta warriors, each distinctly detailed with an individual face and expression, and even different hairstyles that reveal their hierarchical positions. They were probably intended to wage the emperor's battles in the afterlife.

Following the demise of the Qin empire, rulers of the succeeding Han dynasty also chose to be buried under large tumuli. Many of these tumuli were sited on a plain about 12 miles from Xi'an, deployed in a line that approximately parallels the Wei River. One of the most impressive is the 100-foot-high tumulus of Jing Di, the fifth Han ruler, who reigned from 157 to 141 B.C. His crypt remains unopened, but in 1972 archaeologists uncovered the macabre graveyard of an estimated 10,000 enslaved laborers who apparently died during the construction of his tomb. Shackles were still attached to the necks and legs of many of the skeletons, and some of the captives had been chopped in half. In 1990 archaeologists, digging in a field alongside the emperor's tomb, unearthed hundreds of elegantly crafted clay soldiers—the second terra-cotta army from ancient China to come to light in the late 20th century. These clay warriors were only two feet tall and once possessed wooden arms and silk uniforms. According to legend, Jing Di suspected one of his generals of buying too many weapons for his own tomb; the emperor accused the general of planning an insurrection in the afterlife and had him imprisoned.[13]

On the opposite side of Asia, toward the southwestern edge of the continent, wealthy Nabataeans commissioned some of the world's most extraordinary rock-cut tombs, carved in red sandstone cliffs between 200 B.C. and A.D. 200. The Nabataean kingdom encompassed much of present-day Jordan, northwestern Saudi Arabia, and parts of Israel and Syria. Its capital was Petra (now in Jordan), which derived its prosperity from its strategic location along caravan routes between southern Arabia and Syria, enabling it to control traffic in frankincense, myrrh, and other aromatics and spices.

Elite Nabataeans merited splendid tombs with elaborate facades—complete with columns, triglyphs, and metopes—carved in deep relief. Nabataean tomb design went through distinct stages, the earliest dating from the fourth to the first centuries B.C. and featuring facades that suggest crenelated Egyptian pylons or a mixture of Egyptian and Perso-Mesopotamian forms. Later stages were Hellenistic or "classical" in style, surviving into the early second century A.D. Two of the principal rock-hewn monuments of this period are the mausoleums at el-Khazneh and Qasr Far'on, both dating approximately from 9 B.C. to A.D. 40. The Nabataeans' autonomy ended under Emperor Trajan, who annexed their territory as a Roman province in A.D. 106. Trade routes shifted to the Red Sea and Egypt, bringing an end to Nabataean prosperity.

BURIALS IN CHRISTIAN EUROPE AND ITS VIKING FRONTIERS

Rome's early Christians, persecuted in life, buried their dead inconspicuously in subterranean sepulchers, the famous rock-cut catacombs. They dug long, seemingly circuitous tunnels at various levels below ground and laid their dead in niches and crypts along the sides of the galleries. Some of the passages appear so devious that it is easy to imagine that adherents of the oppressed religion used them as hiding places. The Christians expanded their mazelike, subterranean passageways for several generations, tunneling warrens out of the soft tufa rock. After placing the shrouded remains in rock-cut recesses, they painted the walls of the chambers with Christian symbols such as the fish, the lamb, and the shepherd.

European burial customs changed dramatically with the spread of Christianity. The

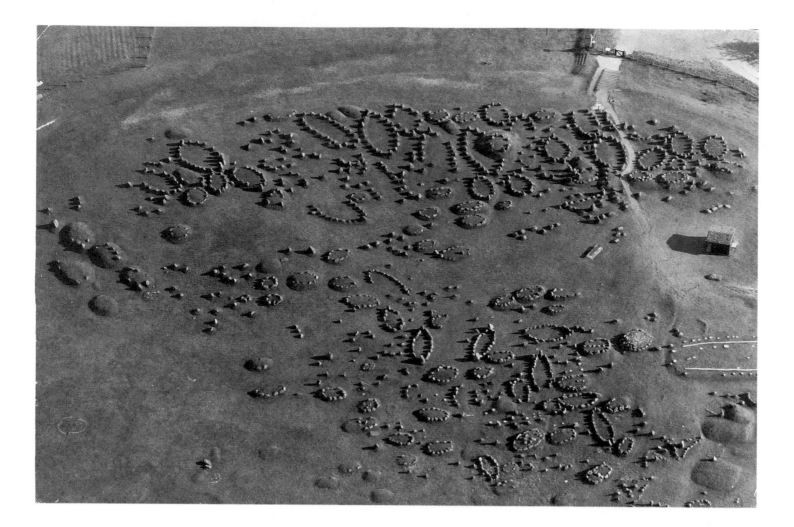

Viking necropolis, prior to 11th century. Lindholm Høje, northern Jutland, Denmark. Photographs by Georg Gerster (above) and Ken Gillham (right). *This cemetery contains the remains of hundreds of Vikings, many of them interred in stone-bordered boat-shaped graves.*

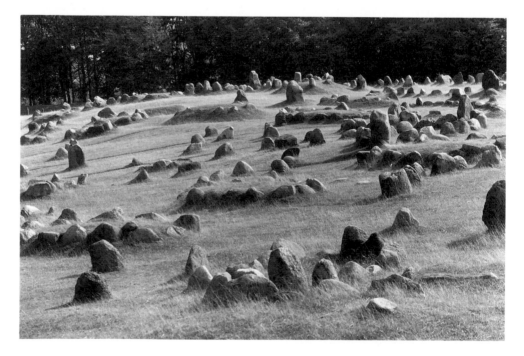

Roman Catholic Church banned cremation, which had been a commonplace practice from England to Greece. Moreover, the church forbade the faithful to inter the deceased with their earthly goods because those who merited an afterlife in the Christian scheme of things would need only their persons, not their material possessions.

Although the church discouraged the inclusion of grave goods in interments, people on the outskirts of Christendom perpetuated the practice. In the late 1930s, excavators at Sutton Hoo on the coast of Suffolk, England, uncovered the remains of a seventh-century royal burial ship, apparently dating from about 625 and possibly belonging to Raedwald, king of the East Angles. Raedwald was a baptized Christian but apparently did not want to take any chances and therefore worshiped at both Christian and pagan altars. He and his ship were buried under a large mound, and he was accompanied by his armor, weapons, and a mass of golden and bejeweled treasures from many countries, including silver spoons from Byzantium, Frankish gold coins, and a Scandinavian-made helmet and shield. His burial goods constituted the finest ever found in a North European grave. All that remained of the wooden boat, however, were its iron nails. Its timber had decomposed during its 1,300-year interment but left an impression in the sand that revealed details of its form and construction, enabling experts to determine that it had been an open vessel, some 75 feet in length.[14]

In Scandinavia, where Christianity arrived rather tardily, Raedwald's Viking counterparts were occasionally interred in their vessels under imposing tumuli. When important Vikings were buried in a boat, it perhaps reflected their mundane status as captains and owners. But the buried ships also suggest that Vikings may have perceived death as a journey to a new realm of existence.

In Norway, Viking ships accompanied their owners to the grave at least as early as the ninth century, as evidenced by a group of burial mounds with ships found at Oseberg and Gokstad, both on the west side of Oslo Fjord. In 1880 archaeologists opened a mound at Gokstad and unearthed a well-preserved 10th-century ship, outfitted for sailing and rowing. The boat was more than 76 feet long and probably had required a crew of at least 34. The burial goods of the deceased male included six beds, kitchen equipment, a sledge, and three rowboats. The mound also contained the sacrificial remains of 12 horses, six dogs, and a peacock. A ninth-century burial mound at Oseberg, excavated in the early 1900s, yielded a 70-foot-long ship containing the remains of a well-to-do woman, speculatively identified as Queen Asa, grandmother of Harald Fairhair. She had been provided with a wagon, four sledges, a saddle, two tents, and a travel bed, and was accompanied by the remains of 10 horses, two oxen, and an elderly woman, possibly a maidservant.[15]

Viking tumuli in Denmark were often shaped like vessels with bowed sides and tapered ends, their now-ghostly contours indicated by rows of curbstones deployed on the ground. Traces of hundreds of these boatlike burial mounds exist at Lindholm Høje on the Danish mainland.

In Jelling, also on the Danish mainland, two flat-topped burial mounds were possibly constructed by King Harald Bluetooth in the mid-10th century. Both mounds contained timber frameworks, probably intended to hold the deceased. Harald presumably built the massive mound to the north to safeguard the remains of his parents, Gorm the Old (who reigned from about 936 to about 950) and his queen, Thyri.[16] The south mound, conceivably built for Harald himself, was evidently never occupied. Harald may have changed his mind about the mounds after accepting the Christian faith in about 960. According to this view, he built a timber church alongside the mounds and transferred his parents' bodies from their "pagan" tumulus to a new grave under the church.

MEDIEVAL MEMORIALS IN ASIA, THE AMERICAS, AND AFRICA

A tumulus of monumental proportions became the tomb of choice for many Chinese, Korean, and Japanese kings during much of the Middle Ages. Starting in the third century

A.D., Japanese emperors were laid to rest under earthen mounds that are known as *kofuns*; the monuments often combined a circular hillock with an angular earthen platform mound in front. Emperor Nintoku, a fourth-century monarch who lived in the Osaka area, built the largest *kofun*: it is about 520 yards long, 38 yards high, and is surrounded by a water-filled moat. Beneath the mound is a burial chamber of megalithic masonry containing the sarcophagus. *Kofun* construction ended in the late seventh century, when cremation became the accepted burial practice.

Korean kings of the Silla dynasty took it for granted that they would be interred under imposing mounds of earth. Some 200 tumuli, both large and small (for the lesser nobility), are situated in and around the city of Kyongju, the capital of the Silla dynasty from 57 B.C. to A.D. 935. Kyongju's Tumuli Park holds 23 of the larger royal tombs. One of them—the so-called Heavenly Horse Tomb—was excavated in 1973; under 15 feet of earth, archaeologists uncovered an elaborate burial site, possibly dating from the eighth century, containing some 11,500 artifacts, including a gold crown, golden bracelets and earrings, a gold-plated harness, glass cups, and seven eggs.[17]

In China monarchs continued to choose tumuli for their funerary monuments—as they had done for more than 1,000 years. At least nine of the Xixia sovereigns, who ruled what is now the Ningxia Autonomous Region in northern China from the 11th to the 13th century, had themselves buried in massive conical mounds between Yinchuan and the Helan mountains. In 1420 the Ming emperor Chengzu (Yung-lo) chose a funeral site north of Beijing, where he and 12 of his successors would be buried in chambers under circular earthen mounds. That necropolis is known as the Thirteen Tombs (Shisanling). Of the royal Ming tumuli, only one has been excavated. It belonged to Wan-li, who ruled from 1572 to 1620. When Chinese officials opened his crypt in 1956, they found his corpse in a wooden coffin. Nearby coffins contained the remains of his empress and chief concubine. Exposed to the air, the three corpses and their coffins rapidly disintegrated. Chinese archaeologists are understandably reluctant to open additional Ming tombs.[18]

In the Americas archaeologists who specialize in the Maya civilization are finding that at least some of the temple-pyramids built between A.D. 300 and 900 were actually sepulchral monuments, intended to perpetuate the worship of deceased kings. At Kaminaljuyú, in southern Guatemala, the Maya constructed (possibly prior to A.D. 300) a mortuary mound that consisted of several superimposed temple platforms, mostly built from clay and basketloads of earth. Its makers apparently placed the remains of their leaders in successively higher stages of the structure; from the top, they cut downward into the earlier temple platform, scooping out a series of stepped rectangles of decreasing size until they were able to lower the corpse into the tomb, which they then covered over with a new floor of clay.[19]

At Palenque, in Chiapas, Mexico, a seventh-century Maya king, Pacal, was interred in a subterranean crypt below the base of a 65-foot-high stepped pyramid known as the Temple of the Inscriptions. His crypt was not discovered until 1952, when an archaeologist removed a curious-looking stone slab from the floor of the temple on top of the pyramid and saw a vaulted stairway leading downward into the interior of the structure. It led to an antechamber that contained skeletons of five or six sacrificed young adults, then to a large crypt, 30 feet long and 23 feet high, that contained the undisturbed stone sarcophagus of Pacal himself, surrounded by jade and mother-of-pearl ornaments.[20]

Between about 1260 and 1380, the Mogollon people, pueblo dwellers who occupied a 15-acre settlement near what is now Springerville, Arizona, entombed some of their dead in subterranean crypts. They may have deliberately sited their pueblo on a parcel of land that had natural underground fissures, which they could enter through obscure entrances. They exploited the existing fissures and excavated additional spaces to create a vast network of subterranean galleries—some as large as 50 feet high and 100 feet long—which they used for burials and ritual ceremonies. The Mogollon catacombs contained the graves of several hundred individuals whose remains had been deposited under the floors, in wall niches, or

LEFT: Burial mound of a Xixia king, c. 11th–13th century. Ningxia Autonomous Region, northern China.

BELOW: Muslim necropolis. Ürümqi, Xinjiang Uygar Autonomous Region, north western China. Photograph by Georg Gerster.

within stone cairns. Since the Mogollon burial ground was rediscovered in 1990, an archaeological team has explored several acres of the subterranean cemetery.

In West Africa, where people traditionally constructed buildings out of earth because of the scarcity of native timber, many families buried their deceased under earthen mounds. More than 6,000 tumuli exist in Senegal and Gambia, some dating to the eighth century A.D. For centuries kings in Ghana were buried beneath massive tumuli. The most compelling tomb in Mali, from a design point of view, is Gao's mud mausoleum of Askia Muhammad, who ruled the Songhai empire from about 1493 to 1528. His mausoleum is a four-sided, three-stepped pyramid, with projecting wooden pickets (*toron*) that both strengthen the structure and function as scaffolding for periodic touch-ups of the mud surface.

The universality of earthen and stone sepulchers underscores the fact that all flesh is destined to merge with Earth. The 19th-century American poet William Cullen Bryant referred to Earth as "one mighty sepulcher" in his renowned poem, *Thanatopsis*, part of which goes:

> Earth, that nourished thee, shall claim
> Thy growth, to be resolved to earth again,
> . . .
> To mix for ever with the elements,
> To be a brother to the insensible rock
> And to the sluggish clod. . . .

The remains of most folks have to blend in, alas, with insensitive clods and rocks. But the high and mighty can always attract posthumous recognition, at least in theory, with a colossal barrow or a spectacular rock-cut crypt.

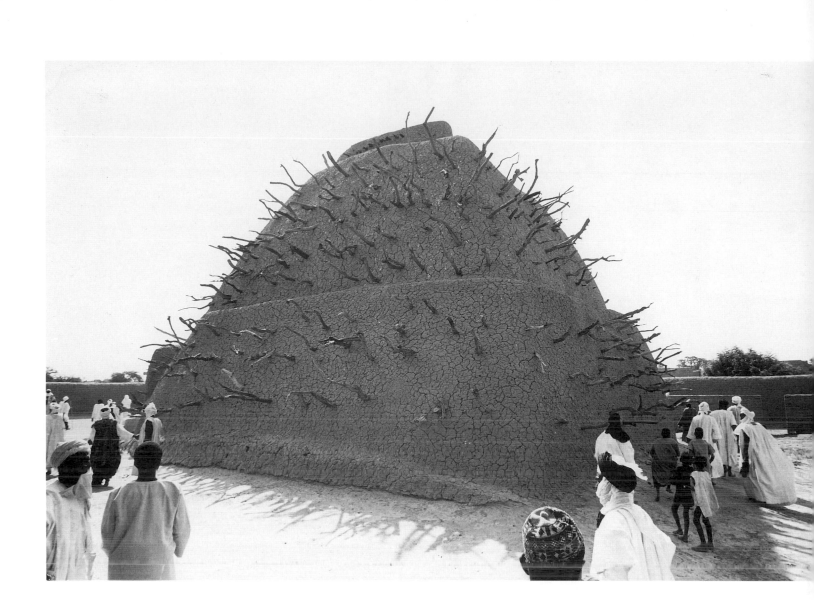

Mausoleum of Askia Muhammad,
16th century. Gao, Mali. Photo-
graph by Georg Gerster. *Following
the death of Askia Muhammad,
ruler of the Songhai empire, in
1528, his subjects constructed this
imposing earthen monument. The
projecting pieces of wood function
as scaffolding for periodic mud
maintenance.*

Sacred Places

Mud-brick Mountains, Rock-cut Caves

Who hasn't been spooked by natural phenomena—ghostly faces that loom out of fleecy clouds, wailing voices that slice through wintry winds, or monstrous creatures who suddenly materialize from an eerie configuration of rock or tree? If we can be startled by such apparitions today, imagine how readily people in the distant past must have attributed conscious life to virtually every aspect of nature. Because our early ancestors had little notion of causality, they could detect prophetic significance in almost any natural phenomenon, discovering omens in the tumultuous fury of thunder, the trembling reflections on ponds, and the ominous eclipse of the sun. Spirits and gods spoke to them, sometimes through the beaks of birds, other times through echoes that magically leaped out at them from across canyons or the recesses of caves.

Mountains and caves were especially sacred. Lofty peaks suggest spiritual places, mediating between land and sky and offering the closest access to the sun, moon, and other heavenly bodies. Mountaintops were often perceived as the departure points from which human souls flew off into a celestial afterlife. Caves, leading into the deepest, womb-like interior of the earth, were typically identified with the origins of life.

Peoples of different faiths in many parts of the world carved cave-temples out of solid rock or constructed artificial mountains in order to gain closer access to their gods. The spiritual significance of their monumental works often eludes us, but the lengths to which they went in expressing their devotion can still excite our wonder.

OPPOSITE: El Pital, A.D. 100–600. Veracruz State, Mexico. Photograph by David Hiser. *A pyramid-studded settlement situated near Mexico's Gulf Coast came to light in 1994. The long-lost city is now known as El Pital, named after a nearby village.*

Impressively high mud-brick ziggurats were the pride of many ancient Mesopotamian cities in the period between 2100 and 500 B.C. These artificial mountains were actually stepped, multistoried towers, usually surmounted by shrines. The populace was encouraged to believe that the ziggurats had been designed by the gods themselves (who revealed the plans to the priesthood in dreams). It is quite likely that priests and their backers occasionally tried to exaggerate their own importance—and outclass their counterparts in rival cities—by building ever-higher towers. One of their more grandiose structures may have been a historical antecedent for the legendary Tower of Babel, described so sketchily in Genesis: 11:3–4.

Ur-Nammu, a king who founded the Third Dynasty of Ur and reigned from 2112 to 2095 B.C., constructed several mud-brick temples, the most imposing of his monuments being Ur's ziggurat. Like some of his other structures, it was made of mud-bricks that bore stamped inscriptions, identifying the name of the temple, the name of the god who was worshiped there, the name of the city, and, of course, his own name.[1] For durability, many ziggurats were surfaced with a water-resistant outer layer of fired mud-brick.

The greatest of Babylon's ziggurats was Etemenanki, which may have had its origins in the second millennium B.C. Although it was demolished in 689 B.C. by the city's Assyrian nemesis, Sennacherib, Etemenanki was subsequently rebuilt by the city's Chaldaean kings. One of them, Nebuchadnezzar II, constructed Etemenanki's "high" temple, the shrine on its uppermost stage. Several experts maintain it was the only Mesopotamian ziggurat whose height equaled the width of the base—about 292 feet. Some scholars believe the first stage was about 106 feet high; the second nearly 58 feet high; and the third, fourth, fifth, and sixth stories each slightly more than 19 feet high. The lower two stories were reached by a huge outdoor staircase. On top of it all stood the 48-foot-high temple dedicated to Marduk, the supreme Babylonian god. The temple walls were said to be gold-plated and decorated with blue-enameled bricks that gleamed in the sun.[2]

According to Herodotus, the temple—"still in existence in my time"—could be "climbed by a spiral way running round the outside, and about half-way up there are seats for those who make the ascent to rest on. On the summit of the topmost tower stands a great temple with a fine large couch in it, richly covered, and a golden table beside it. The shrine contains no image and no one spends the night there except (if we may believe the Chaldaeans who are the priests of Bel [Baal]) one Assyrian woman, all alone, whoever it may be that the god has chosen. The Chaldaeans also say—though I do not believe them—that the god enters the temple in person and takes his rest upon the bed."[3]

When the Persian king Cyrus the Great conquered Babylon, he spared the great ziggurat. His son, Xerxes, however, was not so benign: he toppled the tower in the fifth century B.C.

Several ancient American civilizations engaged in their own ambitious mountain-building projects. The clustering of pyramids in several parts of the Americas—particularly in Peru, Mexico, and the Mississippi Valley—perennially tantalize inquisitive minds trying to establish cross-cultural connections. Nowadays, however, the experts are more inclined to accept the possibility that various civilizations around the globe may have developed their architectural vocabularies individually. The appearance of pyramidal forms in different cultures may be due primarily to commonplace engineering solutions, discovered through trial and error. There are not so many ways, after all, to build a high earthen structure *without* angling the walls inward to prevent collapse.

Mexico's pyramids are especially impressive for their superb and varied design, their dramatic siting, and, not least of all, their durability. The Olmec people constructed what appears to be Mexico's oldest pyramid (c. 900 B.C.), a 110-foot-high earthen mound in the shape of a fluted cone, measuring about 420 feet across at the base. Some experts speculate that it may contain the tomb of an Olmec leader, while one archaeologist suggested that

Ziggurat of Ur, c. 2100 B.C. Southern
Iraq. Photograph by Georg Gerster.
*Ur-Nammu, a king of ancient
Babylonia, constructed this stepped
tower dedicated to the moon god-
dess, Nannar. Only the ziggurat's
lower levels remain today (partially
restored). Although its core consists
of sun-dried mud-brick, the struc-
ture was faced with fired brick for
more durable resistance to water.*

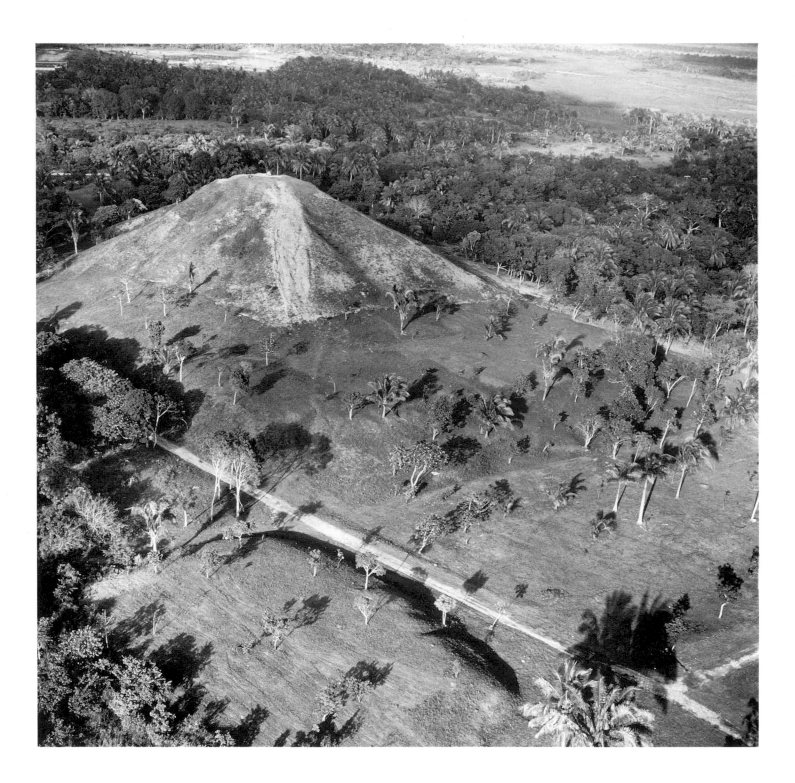

Olmec Pyramid, c. 900 B.C. La
Venta, near the border of Veracruz
and Tabasco states, Mexico. Photo-
graph courtesy The Metropolitan
Museum of Art, New York. *This
110-foot-high earthen mound is
apparently Mexico's oldest pyramid.*

the mound imitates similarly shaped volcanic cones that occur in mountains 60 miles west of its La Venta site.[4]

Between 300 B.C. and A.D. 500, more than 100 pyramids and shrines arose at Teotihua-cán, the vast urban center in the Valley of Mexico, some 30 miles northeast of present-day Mexico City. Teotihuacán covered an area of about eight square miles and included some 2,000 apartment compounds and numerous plazas, all laid out on a grid plan. Between A.D. 450 and 600, Teotihuacán was the largest and most important economic, political, and religious center in Mesoamerica.

The most sacred edifice at Teotihuacán was the Pyramid of the Sun, a 210-foot-high monument constructed between 50 B.C. and A.D. 250. Measuring 650 feet square at the base, the structure has a core of sun-dried mud-bricks, earth, and rubble fill, surfaced on the exterior with cut stone. The pyramid initially rose in four stages (erroneously reconstructed with five), each accessible by an immense central staircase on the side facing the so-called Avenue of the Dead. A wooden temple with a thatched-roof probably stood on top. (It is not known if the monument was actually devoted to worship of the sun, as the Aztecs later maintained; Teotihuacán was burned and abandoned about A.D. 700, long before the Aztecs appeared on the scene.)

In 1971 archaeologists discovered a natural cave directly beneath the Pyramid of the Sun. Its presence suggests that the location may have been a center for shamanistic rituals long before the area developed into a city. The building's planners obviously chose the site because they perceived the cave as a sacred place with a connection to underworld deities. Possibly, they regarded the cave as a supernatural "place of emergence," a metaphysical womb from which their tribal ancestors had originated.[5] They apparently enlarged the cav-ity into a clover-leaf-shaped chamber, made accessible by a tunnel that ran under the center of the pyramid. When archaeologists entered the cave some 1,700 years later, they discov-ered the undisturbed remains of offerings made in its four chambers.

The Maya seem to have conceived at least some of their temples as sacred mountains. In keeping with this metaphorical view, the door of the temple symbolized the cave entrance leading into the heart of the mountain, which in turn led to the supernatural world. Several kings had themselves buried within sacred mountain-tombs (see Chapter 4). Of the many platform temples at Chichén Itzá, near the northern tip of the Yucatán Peninsula, the pyra-midal Tomb of the High Priest, dating from the mid-ninth century, was built over a cave, which perhaps signified the passageway to another world of existence.

In 1994 archaeologists announced the discovery of still more artificial mountains in a long-lost city that had existed between A.D. 100 and 600 near Mexico's Gulf Coast, almost equidistant from Tampico and Veracruz. They named the settlement El Pital after a nearby village. The city was contemporary with the Classic period of the Maya, who lived several hundred miles to the southeast, and apparently it also had powerful cultural and trade ties with Teotihuacán. The newly refound city had more than 100 earth-and-stone pyramids, temple mounds, ball courts, and other structures, some as high as 130 feet. The metropolis spread over 40 square miles and may have been occupied by 20,000 people.[6] For centuries the site was obscured by dense rain forest vegetation. In the 1930s the land around El Pital was cleared for orange and banana plantations, but the people who went to work there assumed that the geometrized, softly contoured hills were natural.

Like Mexico, Peru abounds with prehistoric pyramids that indicate the monumental spiritual aspirations of earlier civilizations. The oldest Peruvian pyramid, built by the Chavín culture whose origins may go as far back as 2000 B.C., is the Huaca de los Idolos at El Aspero on the central coast.

The Mochica people, who flourished along Peru's northern coast from A.D. 200 to 700, also created colossal pyramids. Their homeland was a 250-mile-long strip of coast, running from the valley of Lambayeque in the north to Nepeña in the south and extending as far as 50 miles inland. The capital was near the present-day town of Moche, some 300 miles north of Lima, where they built two stepped adobe-brick mountains, the Huaca del Sol (Pyramid

of the Sun) and the Huaca del Luna (Pyramid of the Moon). Huaca del Sol, probably built prior to A.D. 500, is the largest pyramid in South America, rising 135 feet high and covering over 12 acres. Ramps led to the summit, which served as the base for various buildings, probably including temples and residences of high-ranking officials. The pyramid was progressively enlarged, assembled in eight stages of construction. Mochica leaders evidently apportioned labor on the project, assigning tasks to each clan or community group. More than 100 such groups contributed their share, each stamping its symbol into the mud-bricks while they were still malleable. Although the pyramid was not primarily a tomb, some human burials were incorporated in the structure.

What remains of Huaca del Sol today is only a third of the original structure, which has endured serious erosion over the centuries. Heavy rainfalls have furrowed the once-smooth sides, leaving deep rifts, but the worst destruction was caused by Spanish colonists during the 17th century. In their unrelenting lust for gold, they diverted the Moche River, channeling its flow to wash away two-thirds of the mound, which enabled them to plunder the gold ornaments that the Mochica had buried with their dead.

Modern excavators found 31 graves at the foot of Moche's other pyramid, Huaca de la Luna, which was terraced and had three mud-brick mounds atop the summit of its 76-foot-high platform. Both structures were abandoned when the Mochica population deserted their capital and moved north to Pampa Grande in the Lambayeque Valley, where, about 550, they built another multilevel pyramid, 125 feet high.

Even earlier, the Lambayeque Valley was a center of pyramid-building activity. About A.D. 200, the Mochica constructed a huge adobe-brick pyramid at Sipán, situated to the west of Pampa Grande. To one side of it, they built an adobe platform that was 230 feet long, 165 feet wide, and 33 feet high. In 1987 archaeologists discovered that one end of the platform contained the sepulcher of a man in his early 30s, perhaps a high-ranking warrior-priest and evidently laid to rest in about A.D. 290; he was retroactively dubbed "The Lord of Sipán." Amazingly, the royal burial was still intact, making it one of the most spectacular tomb finds ever uncovered in the Americas. The "lord" was outfitted with golden ornaments that covered his eyes, nose, cheeks, and chin, and his accessories included turquoise bracelets, a copper knife, and a gold rattle. He was accompanied to the grave by two young women, possibly wives or concubines; two older men; and a dog. A couple of years later, archaeologists uncovered an even earlier and richer grave, immediately named for the "Old Lord of Sipán."[8]

Near Peru's southern coast, the Nazca people, who flourished at approximately the same time as the Mochica society, built their own version of a mountain—a 70-foot-high stepped pyramid at Cahuachi, about 10 miles from the town of Nazca. The mud-brick structure was part of a complex of raised platforms and pyramid-like mounds, all built similarly and laid out to enclose an impressive array of plazas and terraces.

The Incas, who dominated 15th-century Peru, venerated both mountains and caves and made offerings and sacrifices to them at certain times of the year. They regarded almost anything with supernatural associations as a *huaca*, worthy of worship. A *huaca* could be virtually any odd or unusual object, place, or person. As the Andean territory is abundantly supplied with dramatic mountains, caves, boulders, and springs, it was easy to find candidates for such sacred designation. More than 300 *huacas* existed in the environs of Cuzco. The people pilgrimaged to their favorite sacred places and made offerings such as cloth, maize liquor, and coca. Occasionally, perhaps in hard times, they sacrificed a healthy llama or nice-looking child.

In establishing the mountaintop village of Machu Picchu in the last half of the 15th century, the Incas carved a steep and rocky summit, dressing the stone to create a plaza, flanked by terraced banks. The spectacular site is surrounded on three sides by a deep canyon. The town planners obviously recognized that the isolated peak could be hewn into an elaborate series of steps and platforms. Two stone walls, situated about 800 feet apart, protected the town to the south, the only side that was conceivably open to attack. The

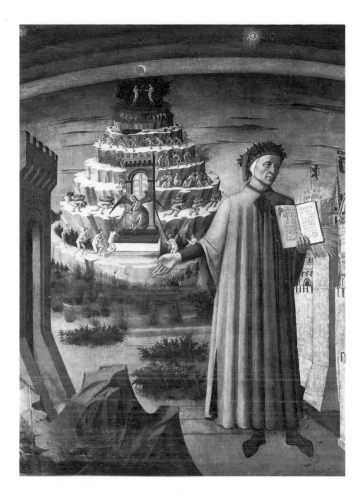

LEFT: Domenico di Michelino. *Dante Explaining the Divine Comedy* (detail of panel painting), 1465. Cathedral of Florence. *Ascent to a mountaintop symbolizes spiritual cleansing in this image of purgatory, inspired by Dante's epic poem. Purgatory, unknown to the ancient world, was conceived during the Middle Ages as an intermediate "other world" where certain sins could be redeemed posthumously. Purgation began on earth, but penitent souls who struggled to the summit could hope for eternal salvation.*

BELOW: Pyramid of the Sun (Huaca del Sol), prior to A.D. 500. Moche Valley, Peru. Photograph by Shippee-Johnson. Courtesy American Museum of Natural History, New York. *The Mochica people, who lived along Peru's northern coast, created this stepped adobe-brick structure, the largest of South America's pyramids, 135 feet high and 12½ acres in area. Only a third of the original structure remains today.*

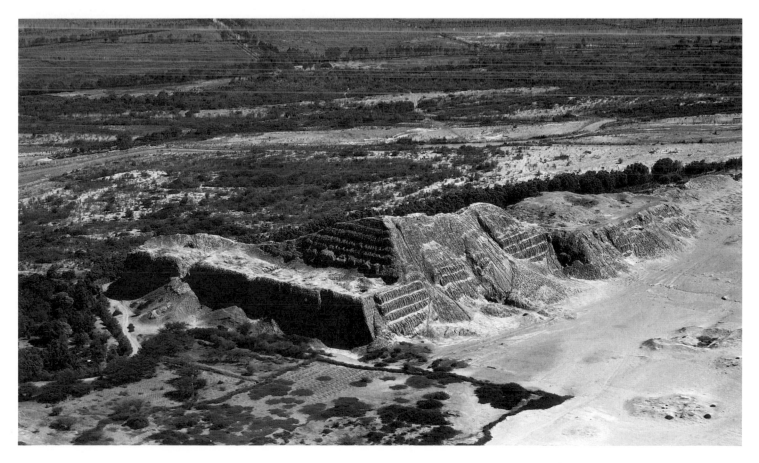

RIGHT: Machu Picchu, second half of 15th century. Cuzco Department, Peru. Photograph by Wim Swaan. *The Incas lived in close proximity to their sky gods at this multiterraced mountaintop village in the Andes. Although its existence was overlooked by the conquistadors during their looting of Peru in the 1530s, Machu Picchu was abandoned by the end of the century, remaining unknown until rediscovered as the "lost city of the Incas" in 1911.*

BELOW: Hitching Post of the Sun (Intihuatana). Machu Picchu. Photograph by Klaus D. Franke. *Machu Picchu's inhabitants worshiped a sun-god, Inti, considered to be a divine ancestor of the ruling Inca dynasty. To prevent the sun from disappearing, they symbolically tied it to a pillar atop an altar-like base, the whole meticulously hewn from a natural rock.*

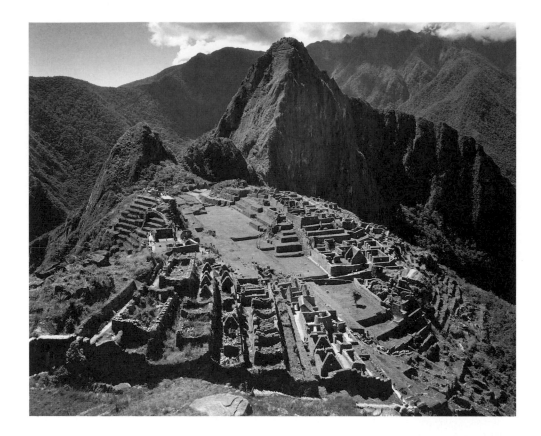

village may have been home to as few as 1,200 people. Amazingly, its existence was not known to the conquistadors, which is probably why it survived intact. Its rediscovery in 1911 caused a sensation. Given its superb vantage point, it is not surprising that Machu Picchu's inhabitants worshipped the Inca sun-god, Inti, a divine ancestor of the ruling dynasty, and his moon-god wife, Killa.

CAVES: THE SANCTITY OF EARTHEN RECESSES

Caves at Altamira, in Spain, and Lascaux, in France, contain humankind's earliest surviving artworks, astonishingly vivid paintings of animals dating back some 35,000 years. Intriguingly, none of the animal imagery appears near the caves' openings, existing, instead, as far back as possible from the entrance, in deep recesses that are sometimes reachable only by an arduous crawl on hands and knees. These sequestered images probably served in some form of fertility ritual, which their makers conducted in the bowels of the earth, imagining themselves in accord with the cyclical rhythms of birth and regeneration.

Tens of thousands of years later, on the island of Crete, the ancient Minoans descended into the gloom of natural caves to honor their deities. The brightest light in their pantheon was Zeus, who had the very best credentials for a Greek divinity, being identified with both caves and mountains. According to some versions of the myth, his mother, Rhea, secretly gave birth to him in a mountain cave on the island of Crete, so as to save him from his father, Cronus, who, following the cautionary advice of an oracle, developed the nasty habit of devouring his infants in order to deprive them of the opportunity of dethroning him. Zeus, being unconsumed, went on to preside over heaven from the top of Mount Olympus in Thessaly, on the Greek mainland.

Speculation about Zeus's "actual" birthplace on Crete intensified in the 1880s, following the discovery of the Idaean Cave, on Mount Ida, and the Psychró Cave, near the highest peaks of Mount Dhíkti, both obviously used for sacred rituals in antiquity. The Idaean Cave's main sanctuary, accessible via a labyrinthine passageway, was a roomy 114 by 129 feet, with a ceiling that soared as high as 196 feet. The cave contained a stone altar and numerous objects that dated to the ninth century B.C. The Psychró Cave contained even earlier objects, dating from 1550 to 1250 B.C. Its main cavern was about 130 by 278 feet, with a ceiling approximately 65 feet high. A winding passageway leads to a lower grotto, where explorers found a "forest" of stalactites overhanging a subterranean lake. They also discovered an altar and what appeared to be libation tables and cups. At almost every turn in the lower grotto, they came upon votive offerings wedged into crevices—hundreds of objects, including double axes, daggers, ornaments, and statuettes, made of bronze, lead, gold, terra-cotta, and precious stones. It was enough to make almost anyone believe in Zeus.

As for Rome, it might never have come into being without the natural cave that sheltered the city's legendary founders, Romulus and Remus. The twin infants, having been orphaned or deliberately exposed, were supposedly saved from starvation by a she-wolf who suckled them. The cavern in which this occurred is known as the Lupercal, or Wolf's Grotto, situated on the northwestern side of the Palatine hill, where in Julius Caesar's time the rites of Lupercalia were performed. The priests sacrificed a goat, cut its hide into strips, and apparently looked on with approval as naked youths ran about, flicking the strips at women who welcomed this treatment in the belief that it would ward off infertility.

One of the Roman Empire's dominant religions during the second century A.D. was Mithraism, whose bloody rituals were performed in subterranean shrines. Originating in Persia, Mithraism was a mystery cult exclusively for men, appealing particularly to Roman legionaries, who spread it from the frontier provinces to the center of Rome. Mithras was a god of light, supposedly born in a cave. As a man, he encountered a wild bull whom he lured into his cave and killed by stabbing it in the throat. The bull's blood gushed onto the ground and spawned all the creatures of the earth. Mithras's followers perpetuated this slaughter of hapless bulls in thousands of ritual ceremonies, all of which took place in

underground sanctuaries designed to simulate the original cave. The remains of one of these Mithraic dungeons exists beneath the medieval basilica of San Clemente in Rome, a few blocks east of the Colosseum.

Caves—both natural and artificial—provided major settings for the spiritual customs of many tribal societies in the Americas. The Maya believed in a living universe in which mountains, rivers, sky, and earth were animated with sacred powers. They conceived their universe as a three-tiered structure, consisting of an ethereal Upperworld, a Middleworld of everyday life, and an Underworld named Xibalba, a place of death that was sometimes enterable through a cave or lake. At Dos Pilas, founded in 645 in the rainforest of northern Guatemala, the Maya performed rituals to honor their gods in many caves, the most frequented being the so-called Cave of Blood. There, an immense amount of trade goods and possibly much of the tribute that had been paid to the reigning lords ended up as offerings, including incense-filled pots, jade axes, obsidian blades, bone awls, and mirrors made of polished iron pyrite. The presence of numerous skeletons and a pile of skulls suggests human sacrifice.[8]

According to Inca legend, their earliest ancestors emerged from a cavern near the Andean village of Pacariqtambo. The founder of the Inca dynasty, Manco Capac, led his brothers and sisters out of the cave and across the mountains, eventually reaching a sacred peak that overlooks the city of Cuzco. Among the Incas' sacred sites near Cuzco were natural caves (perceived as entrances to the underworld and therefore useful for funeral rites), where they carved altar-like blocks and slabs out of the cavern walls.

The Pueblo Indians in the southwestern United States invented (prior to A.D. 300) a highly distinctive form of counterfeit cave—the kiva. Although kivas were not always underground, they derived their circular, "sunken" form from earlier pit houses and were intended to simulate subterranean cavities. Kivas symbolize the Earth Mother, and their builders typically outfitted them with a hole in the floor, representing the *sipapu*, or "place of emergence," through which persons metaphorically ascended from a primordial underworld. The cavelike chambers ranged in size from 10 to 80 feet in diameter and were entered by ladders that poked through hatchways in timbered roofs. Many kivas were solidly constructed of stone masonry, but others had walls of clay or mud-plastered earth.

Kivas served as council chambers, meeting rooms, weaving workshops, and lounges for the male members of a tribe. Smaller chambers served the men of individual clans, while the largest kiva in the village was utilized by the entire male community. All Pueblo communities seem to have had them; they were particularly plentiful at Chaco Canyon in New Mexico and Mesa Verde in Colorado. Kivas still play a ceremonial role in today's pueblos.

Cavelike sanctuaries, artificial grottoes, rock-cut temples—such structures seemed ideally suited to sacred rites, possessing an almost universal appeal that inspired many religious societies to burrow holy spaces into the earth. Among the many types of architectural spaces that humankind devised for the celebration of religion, none required as much laborious dedication as the temples and churches that were excavated—sometimes over a period of several decades—from solid rock. And of those rock-cut structures, none surpass the astonishing complexity of the temples of ancient India, where crews of designers and carvers displayed infinite attention to intricate and exquisite ornamentation, creating works of exceptional splendor that reveal the depth of their commitment. India has more than 1,000 cave-temples, most of them scooped out of hilly or mountainous terrain between the third century B.C. and the 10th century A.D. Many of the most impressive examples are clustered in the west, within a 200-mile radius from Bombay.

India's rock-cut temples exemplify a basic architectural—and perhaps spiritual—concept of space: the void. Negative space, "subtracted" from a mass of living rock, becomes a place where the religious can intensively concentrate their spiritual energies and identify with the life-giving essence of the earth itself. By tunneling elaborately carved, artificial caves into living rock, the holy men virtually penetrated the womb of the earth. The Hindus gave the penetration an explicitly sexual connotation by enshrining a linga—a

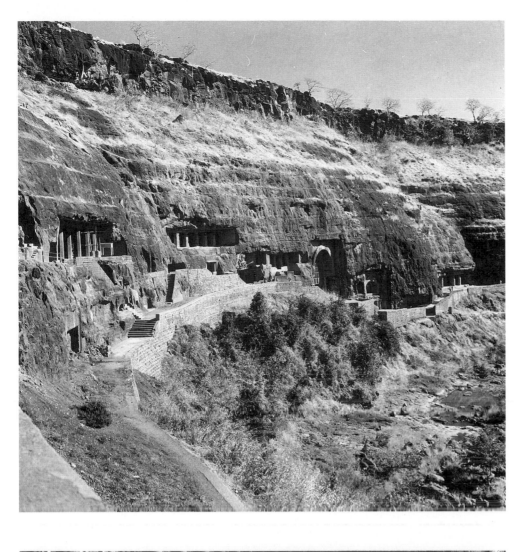

Rock cut temple caves, 2nd century B.C.–7th century A.D. Ajanta, Maharashtra State, India. Photograph by Roger-Viollet. *Buddhist monks carved more than two dozen monasteries and several sanctuaries out of this curved cliff.*

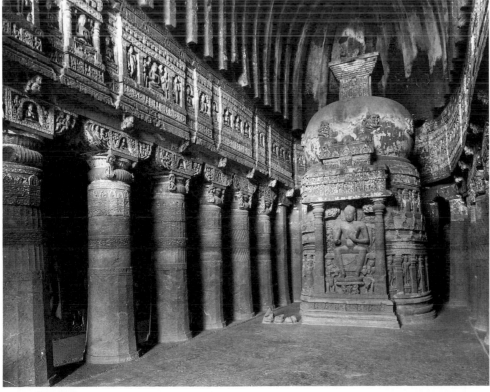

Rock-cut *chaitya*-hall (Cave No 26), 6th–7th century A.D. Ajanta, Maharashtra State, India. Photograph by Eliot Elisofon. *This Buddhist sanctuary, or chaitya, has a typically elongated central hall, flanked by a row of pillars and side aisles, permitting perambulation around the main shrine, or stupa, at the far end. The ceiling is carved in imitation of a ribbed barrel vault.*

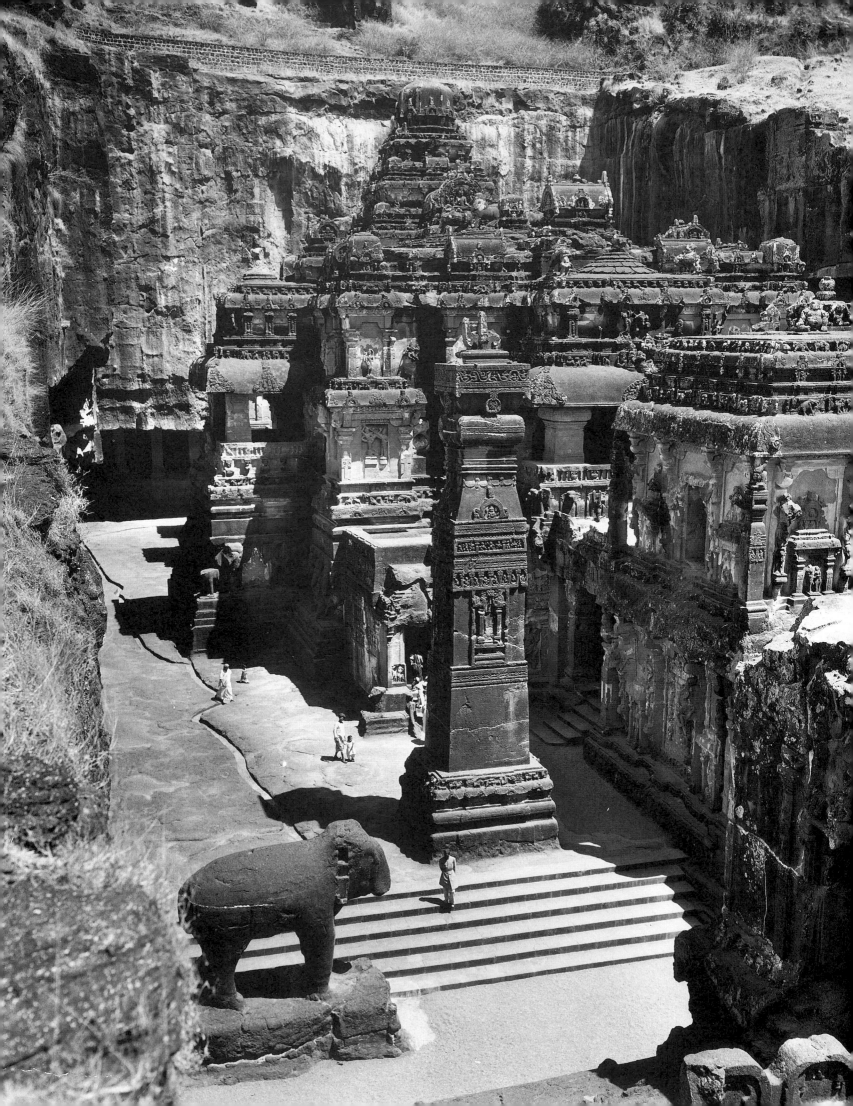

usually cylindrical stone post symbolizing the male organ—in the temples' innermost sanctuaries, suggesting a fecund encounter between religion's potent seed and the actual substance of the earth.

Some of the earliest of India's artificial caves are the Buddhist monasteries and temples built near the village of Ajanta, in the state of Maharashtra. Constructed (or should we say deconstructed?) between the second century B.C. and the seventh century A.D., they are essentially interior spaces that were diligently carved out of one side of a horseshoe-shaped cliff.

The first Buddhist monks who settled at Ajanta may have been attracted by the cliff's naturally eroded niches, which offered shelter. They entrenched themselves there by excavating more than two dozen *viharas* (monasteries with individual cells, scarcely large enough to contain a low, narrow stone slab bed) and several *chaityas* (sanctuaries or halls of worship). A typical *chaitya* has an arched entrance that leads into an elongated hall with a row of pillars on each side—anticipating the central nave and side aisles of later Christian basilicas. The pillars can be round, square, or fluted. The ceiling is shaped like a ribbed barrel vault, and the far end of the hall features a stupa, or domed shrine, similar to an apse.

To reduce their need for scaffolding, the builders began their excavations at the ceiling and worked downward. As the carvers, equipped with pickaxes, hammers, and chisels, finished their work, other craftsmen followed, smoothing the rough stone surfaces by applying coats of plaster. Afterward, the muralists took over to paint scenes from Buddha's life and imaginative representations of his various incarnations. Much of the most ambitious excavation and painting at Ajanta occurred during and after the fifth century A.D.

Other early Buddhist cave-temples, possibly dating from the second century B.C., were carved into the hillsides near the village of Karli, also in Maharashtra. The largest and most famous of the Karli temples is a Buddhist *chaitya*, 124 feet in length. The basilica-like design has two rows of 15 pillars that define side aisles, which lead to the semicircular (or "apsidal") far end, which has eight pillars. Collectively, the pillared perimeter spaces permit the circumambulation of the entire temple.

Like the sanctuaries at Karli and Ajanta, the cave-temples near the village of Ellora, also in the state of Maharashtra, are nestled in a rocky landscape, but these are even more strikingly designed. All of Ellora's 34 temples and monasteries were excavated along a horizontal line that extends for more than a mile along an irregularly shaped hill. They represent three different religions—Buddhism, Brahmanism (or Hinduism), and Jainism—and were built between the fifth and 13th centuries. The most elaborate of the Ellora excavations are the Hindu and Jain shrines, dating from the period between the eighth and 10th centuries, when both faiths experienced a dramatic renewal, while Buddhism declined. Every element of their architectural interiors, including the pillars that theoretically support the ceiling, is carved from a solid piece of living rock. Some of the rock-cut temples at Ellora are deeper than 100 feet and two or three stories high, with carved columns and balustrades on each level. The columns may be square or round, but are invariably fluted and topped by scrupulously carved capitals.

Ellora's most spectacular temple, Kailasa, is a completely freestanding edifice with a roofline exposed to the sky—because the uppermost part of the mountain has been entirely removed. The multistoried temple was carved from a single mass of living rock in the eighth century. To achieve this extraordinary temple complex, carvers had to subtract much of the existing hill, excavating an immense courtyard, while leaving within it a standing mass of stone, which they then carved and hollowed out to fashion the temple itself, a building 164 feet long, 109 feet wide, and 96 feet high. The courtyard features obelisks and groups of sculpted elephants. The temple is dedicated to Shiva, the Hindu god of destruction and regeneration. Nearly every surface throughout the complex is aswarm with vigorous relief carvings of mythological and fantastic figures.

Kailasa is a magnificent example of the Hindu temple in its most idealized form, but it must have taken a tremendous toll on its makers, who apparently spent nearly a century

OPPOSITE: Kailasa Temple, late 8th century. Ellora, Maharashtra State, India. Photograph by Eliot Elisofon. *Hindu carvers spent nearly a century subtracting the surrounding mountain of rock from this temple, which is dedicated to the god Shiva. The result is a freestanding, multistoried structure that is 96 feet high, 109 feet wide, and 164 feet long, all carved from a massive chunk of living rock.*

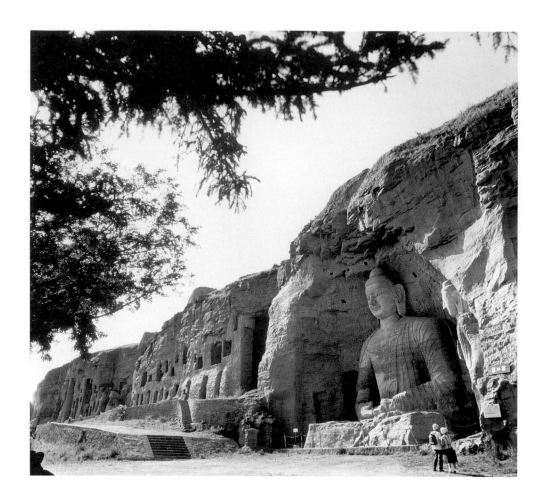

Rock-cut Yungang temple-caves, c. 460–525. Near Datong, Shanxi Province, China. *Buddhist monks carved more than 50 cave-shrines in the face of this sandstone cliff. Cave No. 20, carved in 470, has a 45-foot-high seated Buddha.*

Fengxian grotto with Vairocana Buddha and standing bodhisattvas, 672–75. Longmen, Henan Province, China. *From a carved niche over-looking the Yi River, a 44-foot-high Buddha sits on a thousand-petaled lotus that symbolizes the universe. The cliff's numerous cave-shrines contain an abundance of smaller statues.*

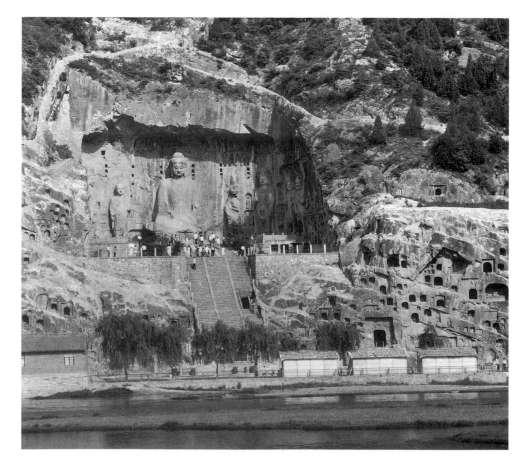

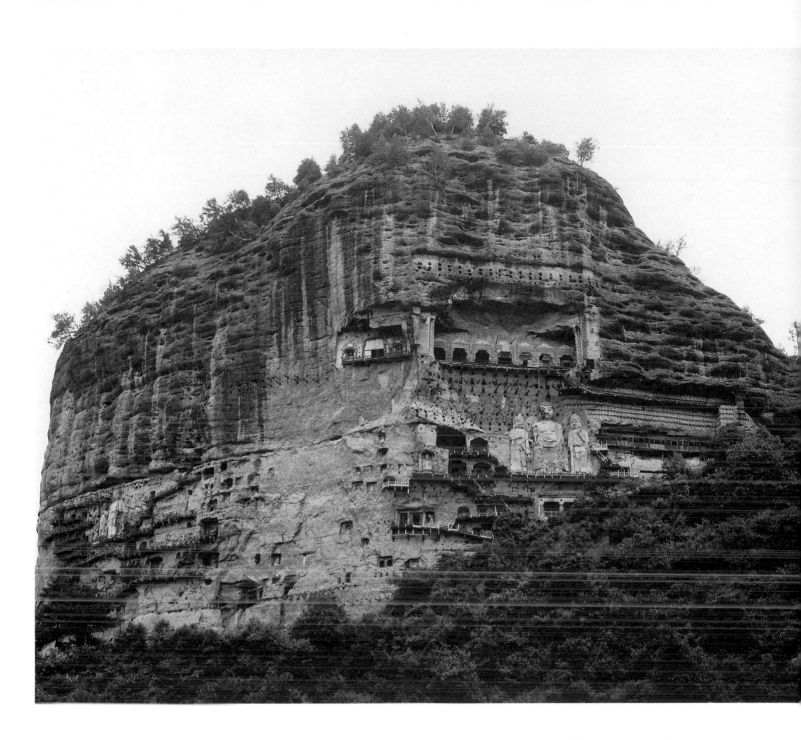

Rock-cut Buddhist temple-caves,
6th century. Gansu Province,
China. *After Buddhism spread to
China in the first century* A.D., *its
adherents began to excavate temple-
caves there as well. This impressive
mountain is pocked with 194 man-
made caves and niches and embell-
ished with more than 1,000 carved
representations of Buddha.*

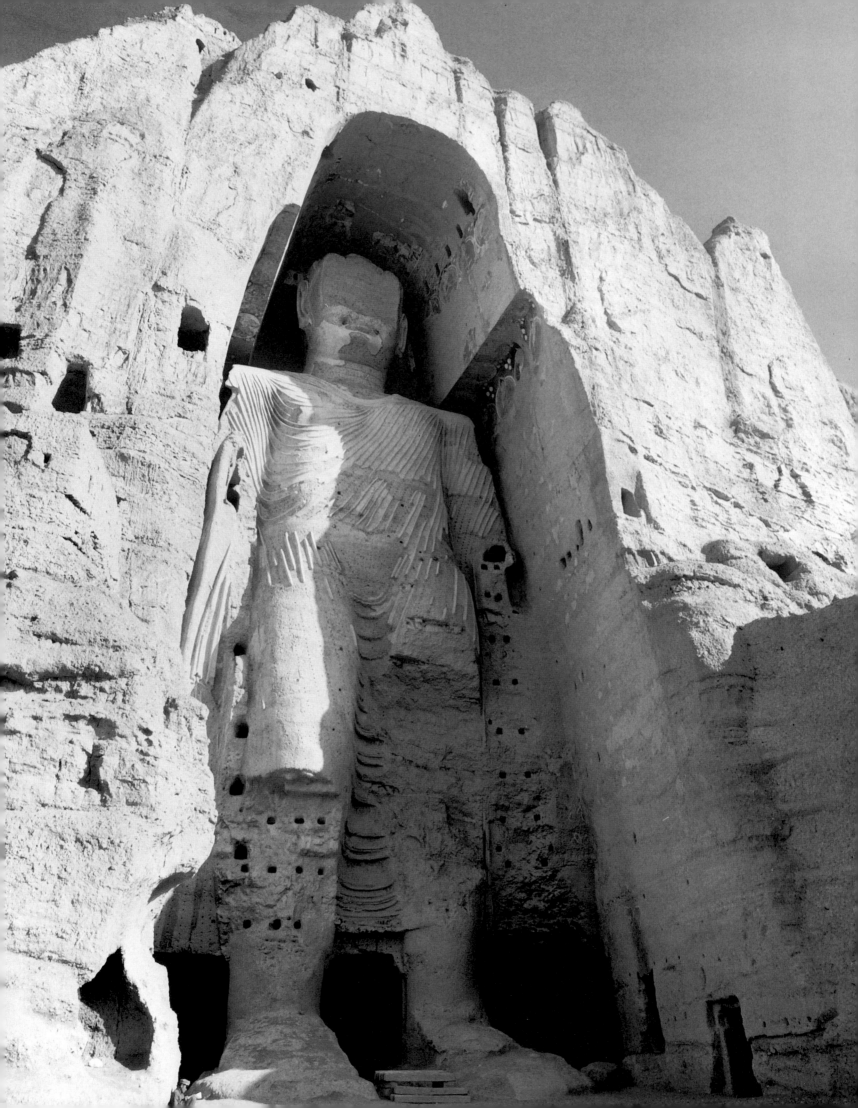

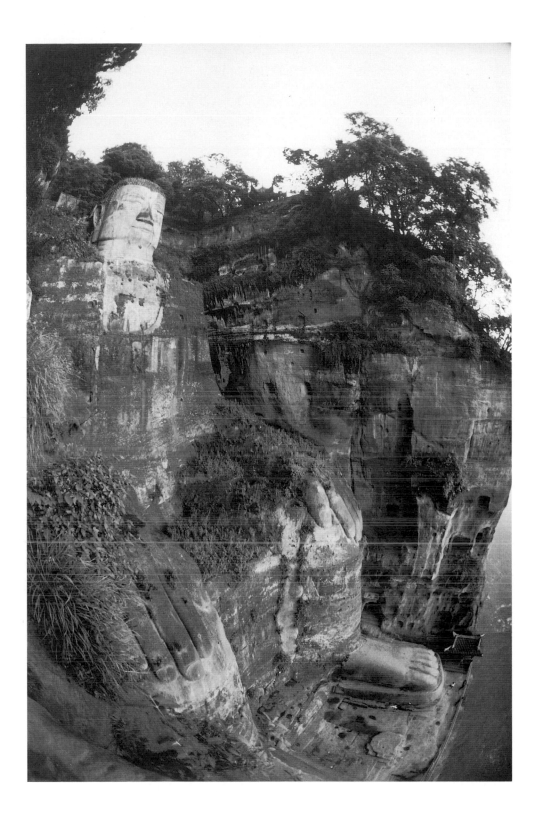

LEFT: Great Buddha, 8th century. Leshan, Sichuan Province, China. Photograph by Courtney Milne. *Carved out of living rock, this is the world's largest seated Buddha— 234 feet high.*

OPPOSITE: Colossal Buddha, 4th or 5th century A.D. Bamian, Afghanistan. Photograph by Ian Griffith. *Carved out of a mountain-side west of Kabul, this is the world's largest standing Buddha— 175 feet high.*

subtracting the surrounding mountain of rock. After its realization, none of India's monks—Brahman or otherwise—ever attempted to equal it. Future houses of worship would be built more efficiently and cheaply in brick or dressed stone *above* ground.

Without leaving Maharashtra State, pilgrims can make their way to one of the most renowned cave-temples dedicated to Shiva by visiting Elephanta, an island near Bombay. The island actually holds six Brahmanic cave-temples, all carved from solid rock, but the largest (130 feet long) is a sixth-century structure, the Great Cave, which features impressive pillars and statuary, including a huge three-headed bust of Shiva. The temple's innermost sanctuary contains, not surprisingly, a linga. Like other Shiva cave-temples, the one on Elephanta can be considered a colossal sculpture, carved out of the mountain.

After Buddhism spread to China, its adherents excavated cave-temples there as well. Buddhist monks arrived in China, probably via the Silk Route, as early as A.D. 65. By the end of the second century, Buddhist communities were scattered over much of northern China, including Luoyang, the Han capital. By the beginning of the fourth century, Buddhism was firmly established even in southern parts of the country.

Among the earliest of China's Buddhist cave-shrines are the Dunhuang grottoes—also known as the Caves of the Thousand Buddhas (Qianfodong)—gouged out of a line of cliffs in the northwestern province of Gansu, about 15 miles southeast of the town of Dunhuang. The first of them dates to A.D. 366, but the majority were excavated from the seventh century onward. By the end of the Tang dynasty, in 907, more than 1,000 caves had been completed.

In the fifth century Buddhist monks began work on the Yungang cave-shrines, which they carved out of a sandstone cliff in a mountain pass in northern Shanxi Province, about 10 miles west of the present-day city of Datong. Most of the monuments date from 460 to 525, when monks excavated more than 20 large shrines—often containing immense statues of Buddha—and dozens of smaller ones. Some of the sculptures are carved in high relief within niches, while others are virtually freestanding. Cave No. 20, dating from 470, is particularly famous for its 45-foot-high seated Buddha; unfortunately, some of its roof and front walls have collapsed, exposing the statuary to the elements.

The Yungang caves and sculptures were apparently commissioned by people of Mongol and Turkic descent, which would help explain why their colossal Buddhas display facial features and clothing that resemble those of the nomadic tribesmen to China's north. Work on the Yungang caves slowed down considerably after 495, when the Northern Wei dynasty moved its capital southward to Luoyang.

Between 640 and 720 in Henan Province, Buddhist monks carved the Longmen cave-temples in cliffs alongside the Yi River, south of Luoyang. One cave-temple features a giant Buddha, carved in high relief, wearing a garment with dramatically swagged folds and sitting on a thousand-petaled lotus that symbolizes the universe. Longmen's statuary is on a smaller scale than those at Yungang but more detailed.

To the southwest of the Longmen caves, eighth-century monks carved up a mountainside at Leshan, a river town in Sichuan Province, to create the world's most colossal seated Buddha, the 234-foot-high Great Buddha. His impassive, squarish face gazes out over the intersection of the Min, Qingyi, and Dadu rivers. As a toe-level view from the water provides a somewhat distorted impression, viewers who want to take in the entire sculpture are almost obliged to climb nearby terrain.

Between 841 and 845, the Tang emperor undertook a devastating persecution of Buddhists. Thousands of monks and nuns were killed, and some 4,600 monasteries and 40,000 temples and shrines were ravaged: the Longmen cave-temples were among the severely vandalized. Buddhism was so thoroughly crushed that it would never recover its economic and social importance in China. For most of the next 1,000 years, the nation's Buddhist cave-temples languished in obscurity.

Curiously, just as the era of great cave-temples was concluding in both China and India, an extraordinary case of cliff-carving fever was about to strike southwestern France. An

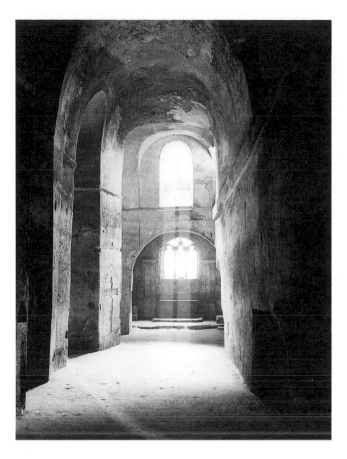

LEFT: Monolithic Church (*Église Monolithe*), late 9th–early 12th century. Saint-Emilion, France. Photograph by Roger-Viollet. *A Benedictine monk established a hermitage in a natural grotto here during the eighth century. His followers excavated out of the base of a massive cliff the largest rock-cut sanctuary in Europe—about 124 feet long and 65 feet wide.*

BELOW: Rock-cut church of Saint Barbara, c. 1020–1130. Göreme, Cappadocia, Turkey. Photograph by Wim Swaan. *Cappadocia's Byzantine monks carved hundreds of churches and chapels out of the area's volcanic stone, shaping pillars, arches, and domed ceilings that they subsequently painted. Some of the geometric blazonry in this church apparently derives from military standards.*

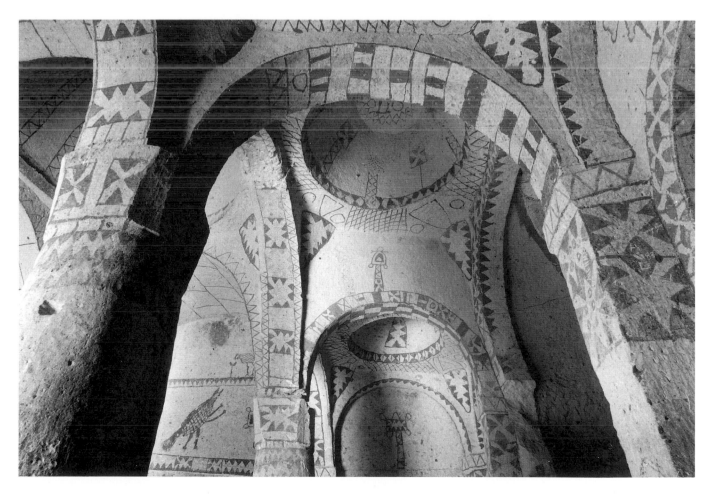

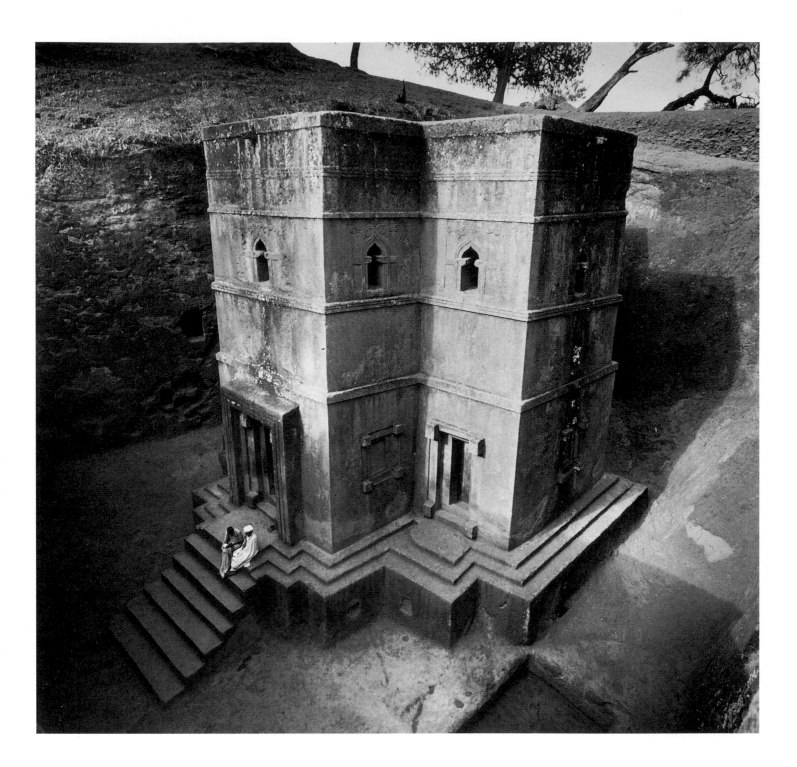

ABOVE AND OPPOSITE: Church of
Saint George, 13th century. Lalibela,
Ethiopia. Photographs by Georg
Gerster (opposite) and Roger
Wood (above). *King Lalibela com-
missioned several rock-cut churches,
the most extraordinary of which is
the Church of Saint George, excavat-
ed from a huge subterranean stone.
The rock church is of rigorous sym-
metry, 35 feet high and 41 feet in
width and depth.*

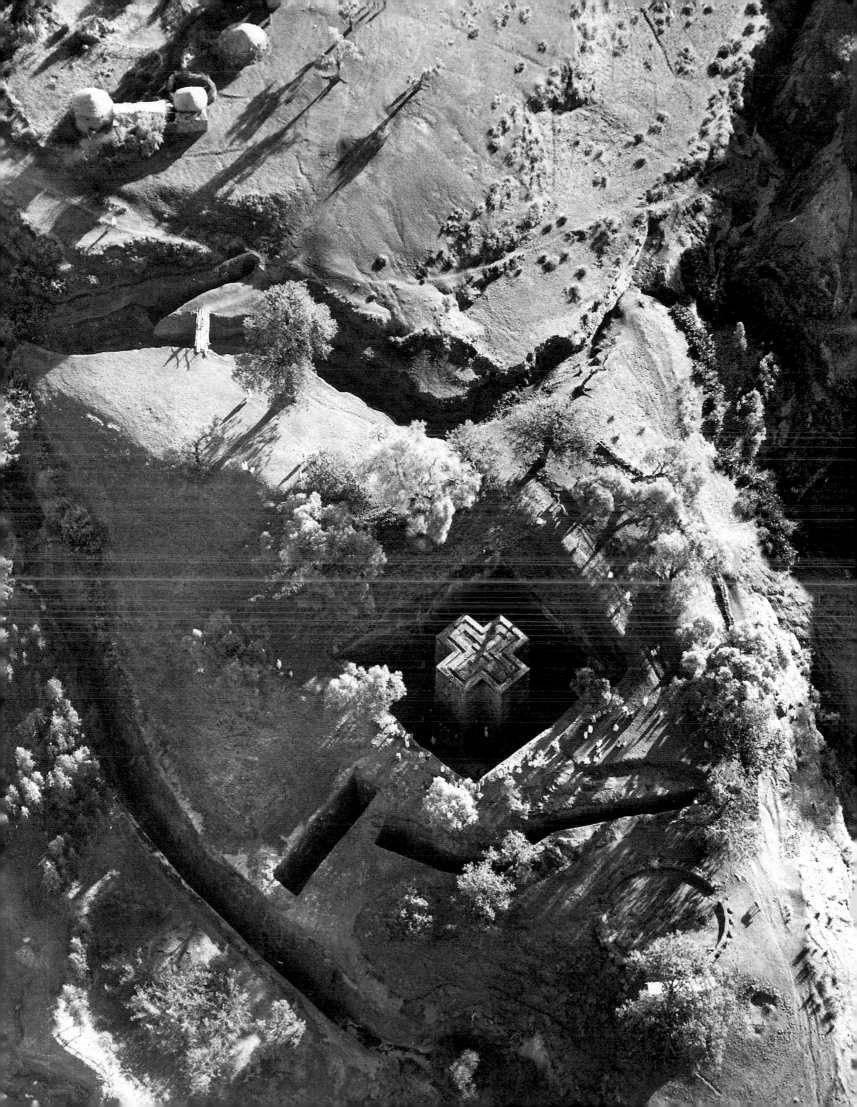

eighth-century Benedictine monk named Emilian set up a hermitage in a natural grotto on a northern slope of the Dordogne Valley, near an old Gallo-Roman site (and about 25 miles northeast of Bordeaux). According to tradition, Emilian lived there for 17 years, attracting so many religious followers that the place eventually became a lively medieval town— known now as Saint-Emilion. From the end of the ninth century to the first quarter of the 12th century, his followers demonstrated the depth of their devotion by excavating a church out of the base of a massive calcareous cliff. Their handiwork, called the Monolithic Church (*Église monolithe*), is the largest rock-cut sanctuary in Europe—about 124 feet long and 65 feet wide, with a 36-foot-high nave. The interior is a rustic sort of basilica with two rows of five squarish pillars, all of irregular thickness and rather casually aligned. Six windows admit daylight. By the end of the 12th century, the interior was decorated with wall-paintings and bas-reliefs of angels, of which only traces remain today. Like so many other religious monuments, the Monolithic Church was plundered during the French Revolution.

Compared to Saint-Emilion's house of worship, the rock-cut churches and monasteries of Cappadocia (see Chapter 1) are far more sophisticated and complex in plan, and often display a superior level of workmanship. Byzantine churches and retreats were carved out of the rocky landscape in such quantity that, even today, their exact number is not known. "By some current reckonings," according to architectural historian Spiro Kostof, "there may be as many as 600 rock-cut churches and chapels in the landscape, as well as hundreds, perhaps thousands, of monastic and secular rooms."9

Hundreds of rock-cut Christian sanctuaries also exist in the rugged terrain of Ethiopia, many dating from the 10th through the 15th century. The most splendid of them were built in the town of Lalibela between 1137 and 1270. (Lalibela, named after an early-13th-century Zagwe king, was then the capital of the country, later replaced by Addis Ababa, 250 miles to the south.) According to Ethiopian tradition, King Lalibela built the structures—10 churches and one chapel—to mark his conversion to Christianity. All were carved from red volcanic rock, and many are still in use today for Ethiopian Orthodox services.

Four of Lalibela's rock-cut churches were excavated from huge subterranean stones. The buildings are virtually freestanding, being connected only by their base to the surrounding rock. Their makers first had to isolate the enormous stones by cutting deep trenches around them. The trenches enabled carvers, working downward from the top, to sculpt the rock into the shape of a church. Obviously, the builders also had to hollow out the rock into an architectural interior. In plan the churches typically resemble traditional basilicas, but they display a more "orthodox" Byzantine style in their use of three entrances and a domed sanctuary. Lalibela's church carvers may have derived some of their excavation techniques from the rock-cut temples and tombs of ancient Egypt.

The largest of Lalibela's monolithic sanctuaries is the church of Mekina Medahane Alem: it is 110 feet long, 77 feet wide, and 37 feet high. But the most famous is the Church of Saint George, a subterranean edifice that is isolated from its "mother rock" by a 40-foot-deep trench. The building is cruciform in plan, like a Greek cross, measuring 41 feet square and 35 feet high. As viewers approach, the first thing they see is the structure's patterned roof with three nested Greek crosses in boldly carved relief.

BRITAIN'S PREHISTORIC SACRED RINGS

Concentric ditches and earthen embankments, often enclosing an inner ring of very large stones, or megaliths, began to appear in southern England during the second half of the fourth millennium B.C. In plan these circular open-air zones resemble ancient Britain's causewayed camps (see Chapter 3), with which they are roughly contemporary. More than 900 stone circles exist in the British Isles. They range in size from relatively compact circles of waist-high boulders to large majestic rings of tall "standing" megaliths. Megalithic monuments probably served as communal centers for ritual activities. Some ringed enclosures

may have begun as settings for funeral rites and then evolved over the years to become general meeting places, used for seasonal gatherings and festivals. Others may have been built to indicate a sacred cosmological connection between the movements of the sun (and other heavenly bodies) and terrestrial cycles of life and death.

Britain's largest megalithic monument is Avebury, which covered more than 28 acres in Wiltshire and dates from the third millennium B.C. Its paired focal points were a few large stones, centered within megalithic rings that were more than 50 yards in diameter; each of the two "inner rings" was encircled by an "outer" megalithic ring that was more than 100 yards in diameter. These twin (if irregular) sets of double rings were jointly encircled by a single exterior ring (about 367 yards in diameter) of giant stones. The entire complex of concentric stone circles was in turn encompassed by a deep ditch (about 383 yards in diameter) and an outer earthen embankment that was between 14 and 18 feet high. Most of the stones are long gone (deliberately destroyed by pious Christians in the 13th and 14th centuries), but much of the ditch and rampart are still intact. The current consensus of opinion is that Avebury functioned as a religious center, serving as a mortuary enclosure for rituals involving the dead and as a center for fertility cults linked with the earth.[10]

The most celebrated of Britain's megalithic monuments is, of course, Stonehenge, also in Wiltshire and about 18 miles south of Avebury. For many people, the name "Stonehenge" instantly brings to mind an imposing circle of standing stones, some supporting massive lintels. (The so-called Sarsen Circle, 97 feet in diameter, was originally made up of 30 upright stones, 17 of which still stand today.) But this colonnade was a relatively "late" development in the monument's history, occurring after 2000 B.C. Stonehenge was constructed in six stages, starting around 2800 B.C. and continuing over an 1,800-year period. The earliest structure may have been considerably more modest—possibly a timber hut in which corpses were left to rot.

About 2200 B.C., Stonehenge's makers began to excavate a circular perimeter ditch, 380 feet in diameter, using the upcast soil and chalk to build both an inner and outer bank. A single causewayed entrance passed through both banks and above the ditch on the northeast arc. The entrance was approached via a 35 foot wide "avenue," flanked by its own banks and ditches. The ditch's depth varied from between four and seven feet and its width ranged from about 10 to 20 feet. The outer earthen embankment, now mostly obliterated, was about eight feet wide and two or three feet high and formed a nearly perfect circle; the inner embankment was about 20 feet wide and at least six feet high. Individual families or clans may have been assigned work on specific segments of the ditches and banks, which would help account for the irregularities in their dimensions.

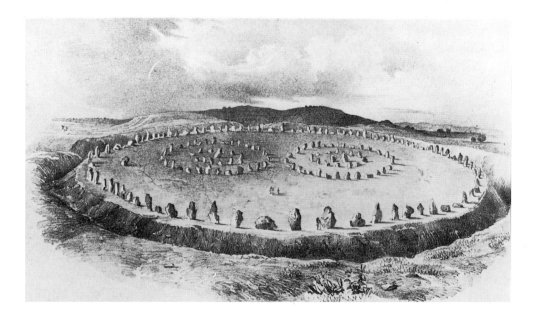

Avebury, c. 2500–2200 B.C. Wiltshire, England. Drawing of the stone circles as they may have appeared on completion, after Godfrey Higgins, *The Celtic Druids.* London, 1829. *Avebury, Britain's largest megalithic monument (about 28½ acres), was encircled by a deep ditch about 383 yards in diameter as well as an outer earthen embankment. Its most significant components, however, were its concentric stone circles.*

The earlier cultures that contributed to Stonehenge's design in the centuries prior to 2000 B.C. appear to be the same ones that constructed the dozens of massive funeral mounds in the neighboring environs, including the West Kennet long barrow. (The deceased, it is thought, were first taken to Stonehenge for funeral rites and their defleshed bones were later interred in barrows.) Intriguingly, most of the long barrows near Stonehenge have an east-west orientation that suggests their alignments were correlated to the movements of the sun.

The cultures that occupied the area after 2000 B.C. followed very different burial customs. One of those inscrutable groups dug a set of 56 regularly spaced holes, comprising a 288-foot-diameter ring, sited just inside the large inner embankment. The pits are known as the Aubrey holes, named after John Aubrey, a Wiltshire-born antiquarian who came upon them in the 17th century. The Aubrey holes varied from two and a half to almost six feet in width and from two to four feet in depth. What is particularly cryptic about these 56 excavations is that, soon after they were dug, they were deliberately filled with chalk rubble. Later, the holes were again dug out and refilled with a mixture of chalk rubble and remains of human cremations. Sometimes the holes were dug out for a third time and refilled with new additions of cremated remains. One bone fragment was dated by carbon 14 to about 1850 B.C.[11]

Stonehenge's astronomical connections have tantalized the modern world since the 18th century, when the antiquarian Dr. William Stukeley concluded that key elements of the complex were built on an axis with the summer solstice. A few decades later, Dr. John Smith, who practiced medicine in a nearby village, also emphasized the monument's alignment with the midsummer sunrise and deduced that the stone circle was "an Astronomical Temple."[12] By 1906 the noted scientist Sir Thomas Lockyer was able to determine that the "sun temple" was the handiwork of "astronomer-priests."[13] Is it any wonder that starry-eyed people began to form mental pictures of Stonehenge's builders as ascetic men in white laboratory smocks with crosiers that doubled as surveyors' levels?

In stressing the "sun-temple" aspect, Lockyer and his predecessors laid the groundwork for an interdisciplinary science that combines the methodologies of archaeology and astronomy. This relatively recent field of study is known as astroarchaeology in Britain and as archaeoastronomy in the United States. Despite their confusing nomenclature, archaeoastronomers and astroarchaeologists have one common goal: the scrutiny of megalithic sites in order to deduce their makers' astronomical knowledge.

By the early 1960s, Stonehenge's role as a sun temple was widely accepted. Then, in 1963, Gerald S. Hawkins, a British-born American astronomer, suspecting that Stonehenge might possess further astronomical significance, plotted various directional lines among the stones and fed the information into a computer, matching the lines against the movements of the sun and moon. The results enabled Hawkins to advance the startling theory that Stonehenge was also a lunar observatory, capable of following the moon's motions—far more complex than those of the sun—through a complete cycle, which takes nearly 19 years. "There can be no doubt," Hawkins wrote, "that Stonehenge was an observatory; the impartial mathematics of probability and the celestial sphere are on my side. In form the monument is an ingenious computing machine. . . ."[14]

Hawkins's book *Stonehenge Decoded* (1966) created a sensation in the popular press, where computers were still considered a novelty. Among specialists, however, the responses were considerably cooler. Aubrey Burl, a prehistorian who assisted in the excavation of many stone circles in Britain, cautioned against astronomical overstatements: "Care has to be taken not to distort the people into copies of ourselves, turning medicine-men, shamans or witch-doctors into astronomer-priests just because the latter fit more comfortably in our modern, technological minds."[15] Other scholars thought it "condescending" to refer to Stonehenge as either an observatory or computer because that presumed its main significance was its anticipation of our own observations and calculations.

About a half mile north of Stonehenge, a most intriguing earthwork, the Cursus, was

built along an east-west axis that may have had some solar import. The Cursus, probably built prior to 2000 B.C., consists of two parallel earthen banks, 100 yards apart and nearly two miles long. Its twin ridges do not appear to have been intended as funeral barrows, although several dozen grave mounds once existed in the immediate vicinity. The Cursus is the most famous—and second largest—of 20 similar constructions in the British Isles. (The longest "cursus"—six miles long—is sited in Dorset county.) Dr. Stukeley, who "discovered" the Cursus in 1723, thought it might have served as an ancient racecourse—hence its name, which derives from the Latin word for "course."

In recent decades archaeoastronomers have advanced imaginative (if not intentionally fanciful) theories about the cursus constructions, which were intended, they maintain, to direct viewers' attention to various astronomical events. Two experts noted, for instance, that skywatchers in 2500 B.C. could have lit a bonfire at one end of a particular cursus, moved to the opposite end, and found themselves in a perfect position to witness a moonset declination. Thanks to archaeoastronomy, many once-enigmatic ancient structures have been assigned new and equally obscure identities, converted from the mystifying temples and ceremonial centers of yesteryear to crypto-utilitarian ocular devices appropriate to today's aerospace era.

NATIVE AMERICAN EFFIGY MOUNDS AND GROUND DRAWINGS

The tribal societies that inhabited the woodlands to the south of the Great Lakes and along the upper stretches of the Mississippi River amassed hundreds of large earthen mounds in the form of native animals. Other earthen bas-reliefs of animals were made as far north as the province of Ontario (serpent mounds to the north of Lake Ontario) and as far south as Louisiana (a bird effigy at Poverty Point). Many of the effigies in the upper Midwest were probably built by post Hopewellian tribes between A.D. 650 and 1300.

The animal effigies are frequently sited on high bluffs alongside rivers. The subjects are almost always recognizable local species, which probably figured in native folklore. To whom were the effigies addressed—to airborne spirits of the animals incarnated in the swelling earth or to other heavenly gods? Were the mound builders hoping to increase their food supply or to access the perceived strengths of the sculpted animals?

The most famous animal effigy in the United States is Serpent Mound, a grass-covered earthwork north of the town of Peebles in southern Ohio. It is one of the largest serpent effigies anywhere in the world; if fully stretched out, its length would measure 1,254 feet. (Because snakes frequently shed their skin, many cultures viewed them as models of renewal.) The snake's body rises four to five feet above ground level and has an average width of 20 feet. The giant reptile appears to slither along a rocky plateau 100 feet above Ohio Brush Creek, its body undulating in seven curves before terminating in a coiled tail. Its open mouth envelops an egglike form that suggests the cyclical forces of nature. Serpent Mound contains no burials or artifacts, so its makers and date of origin remain unknown. It may have been the work of the Adena people; several conical burial mounds built by the Adena between 800 B.C. and A.D. 1 are only 400 feet away. Threatened by plowing in the late 19th century, the effigy is now protected as the main attraction of Serpent Mound State Memorial, a public park with its own museum.

Southern Wisconsin was virtually a zoological park between A.D. 600 and 1000, when woodland clans built thousands of effigy mounds. It is said that 98 percent of all North American effigies are in that state.[16] The represented species range from bear and buffalo to eagle, waterfowl, and turtle. One bird effigy near Madison is noted for its tremendous wingspan—207 yards. A 133-foot-long mound in Wyalusing resembles an elephant in profile, but the animal lacks both tusks and tail, and its proboscis is too short; more likely, it was a bear until flood waters caused its metamorphosis. Lizard Mound County Park, northeast of West Bend, has a group of 31 effigy mounds, few higher than a yard, representing panthers, birds, and, of course, a lizard. Although most effigies are made of banked

RIGHT: Serpent Mound, c. 800 B.C.–
A.D. 1. Peebles, Ohio. Photograph
by Tony Linck. *Ohio's Serpent
Mound is one of the world's largest
snake effigies; if fully stretched out, it
would be 1,254 feet long. The Adena
people may have built the mound,
which was partially excavated and
reconstructed in the 1880s.*

BELOW: Giant ground figures,
c. 890. Near Blythe, California.
Photograph by Marilyn Bridges.
*Ancestors of the Mohave or Quechan
peoples may have created these
drawings—one of three sets made by
scraping away the dark, gravelly sur-
face to reveal the lighter soil beneath.
The 94-foot-long human figure and
the 36-foot-high animal possibly
refer to creation myths. The ruinous
imprint of contemporary vehicles
has necessitated the fences around
both figures.*

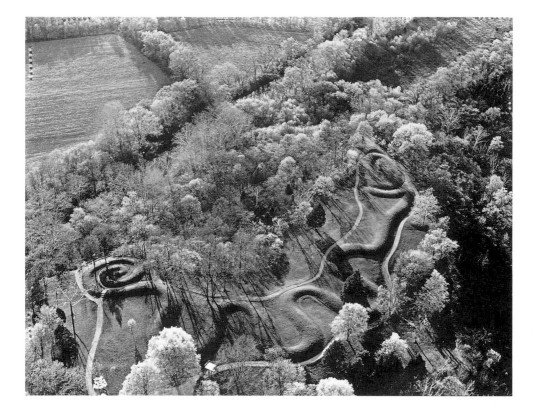

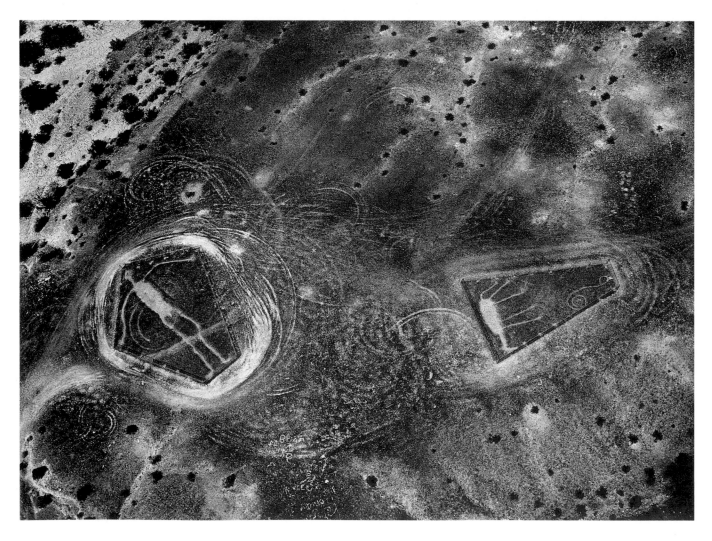

earth, some were excavated below ground level, such as the "intaglio" panther, nearly 12 inches deep and 190 yards long, at Buffalo Lake, near Fort Atkinson.

In Iowa, where several hundred mounds were leveled during the last century to make room for agricultural fields, preservation efforts are finally paying off. In 1949 a 1,500-acre park, Effigy Mounds National Monument, was established near Marquette to protect 191 mounds, including nearly 30 effigies of mammals and birds, some of which may date from 500 B.C. or earlier. The most celebrated creatures here are the Marching Bears—10 ursine effigies, each about 90 feet long, presented in profile as if walking in line. They may have been made by a post-Hopewellian tribe between A.D. 650 and 1200.

While mounded effigies obviously appealed to several cultures in the upper Midwest, line drawings—less laboriously scratched out of the earth—seemed more appropriate to early societies in arid regions, such as the American southwest. At Blythe, in southeastern California near the Arizona border, unknown draftsmen drew a primitive silhouette of a standing human figure with outstretched, sticklike arms, measuring 170 feet from head to feet. The tall, skinny person is in close proximity to a feline animal, perhaps a mountain lion or puma. Both figures were made by scraping away the dark brown gravelly surface to reveal the lighter tan-and-gray soil beneath. In 1990 scientists applied radiocarbon-dating techniques to organic matter that had grown on the gravel and concluded that the drawings were created about A.D. 890. The figures may have been made by ancestors of the Mohave or Quechan peoples, who lived along the Colorado River, and possibly refer to creation myths.[17]

Earlier and far more extensive ground drawings, popularly known as the Nazca lines, exist over some 300 square miles along the arid southern coast of Peru. They were made between 100 B.C. and A.D. 700 by the society known to us as the Nazca culture. The bleak, infertile terrain is 1,500 feet above sea level, receives virtually no rainfall, and is covered with sand and pebbles. An accretion of oxides over the centuries caused the dry, gravelly surface to darken to a reddish-brown hue, a process that some geologists call "desert varnish." By carefully sweeping aside the surface gravel to reveal the lighter-colored soil below, the Nazca people managed to create vast ground drawings, or "geoglyphs."

The most broadly appealing of them are contour drawings of animals, but they are so extensive in size as to be virtually illegible except from an airplane. Because no one standing on the ground can perceive the images in their entirety—in proper perspective, that is—modern-day viewers are inclined to believe that the Nazca animal effigies were intended for heavenly eyes. Among the delineated creatures are 18 birds, including stylish hummingbirds with extravagantly outstretched wings and elongated beaks. One of the more extraordinary creatures is a lithe, agile monkey with a preposterously coiled tail. Curiously, its right paw has four splayed digits while its left paw, which measures more than 40 feet across, has five digits. The simian charmer may represent either a woolly spider monkey or a capuchin monkey, both indigenous to the forested eastern slopes of the Andes. Other ground drawings represent a killer whale, a fox (or dog), a lizard, and a spider.

Nazca's animal designs are greatly outnumbered, however, by hundreds of long straight lines as well as geometric figures, such as elongated trapezoids (which suggest landing fields), concentric rings, and spirals. The lines are frequently several hundred yards in length; the longest extend for several miles. Collectively, they add up to some 800 miles of lines. Many cut right across figurative images and other abstract drawings, almost as if the line-makers were claiming a right of way. In numerous places clusters of crisscrossing straight lines seem deliberately to converge on a single point, or "ray center."

The intended purpose of the Nazca lines remains inscrutable. If they were merely utilitarian, functioning as ceremonial pathways leading to sacred mountain sites, why would the people have needed so many of them? Could the lines somehow be associated with rainmaking or fertility rituals? Not surprisingly, several experts stepped forward to examine the lines for possible astronomical significance.

Gerald S. Hawkins, fresh from his triumphant "decoding" of Stonehenge, conducted an

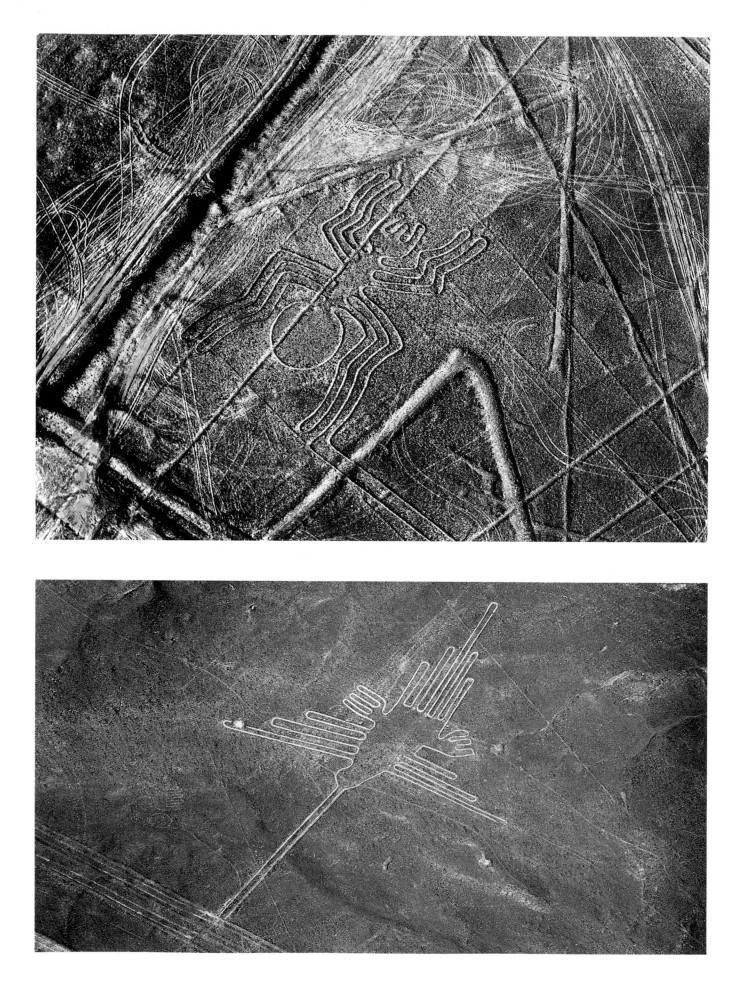

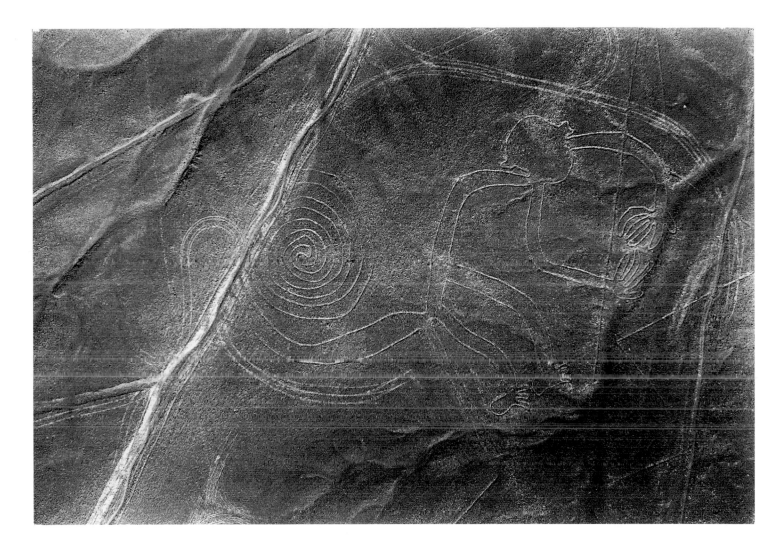

OPPOSITE, ABOVE: Spider ground drawing, 100 B.C.–A.D. 700. Nazca, Ica Department, Peru. Photograph by Marilyn Bridges, 1979. *This elegant spider, 150 feet in length, is one of many large images of animals that were drawn on a coastal desert of southern Peru. An obscure society, known to us as the Nazca culture, created the drawings by sweeping aside dark surface gravel to expose the lighter-colored soil below. They may have been intended as symbolic offerings to gods who controlled the arid region's water supply.*

OPPOSITE, BELOW: Hummingbird ground drawing, 100 B.C.–A.D. 700. Nazca, Peru. Photograph by Georg Gerster. *The Nazca drawings include 18 representations of birds, one being this exceptional hummingbird with a wingspan of more than 200 feet. Its perceived association with the sun gave the hummingbird a mythic significance in Andean myth.*

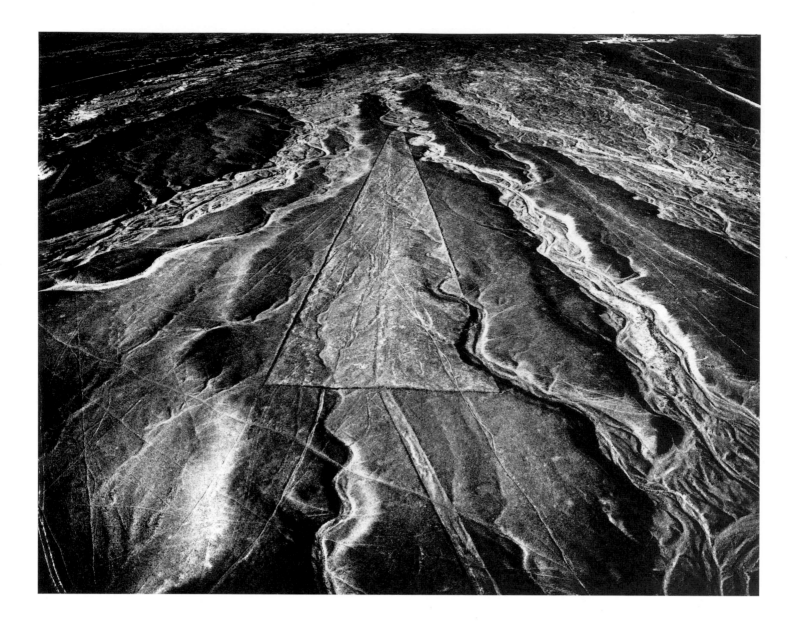

ABOVE: Great Triangle, c. 600–900. Nazca, Peru. Photograph by Marilyn Bridges, 1979. *The Nazca drawings include this elongated— and enigmatic—trapezoid, as well as hundreds of straight lines, concentric rings, and spirals. Some may have been intended to direct the eye to specific points on the horizon.*

RIGHT: Trident. Paracas Peninsula, Ica Department, Peru. Photograph by Marilyn Bridges, 1979. *This symbolic composition is more than 600 feet from top to bottom. Because it faces the sea, some people believe it was intended as a landmark for sailors. Others interpret it as a sprouting plant, intended to lure rain clouds inland.*

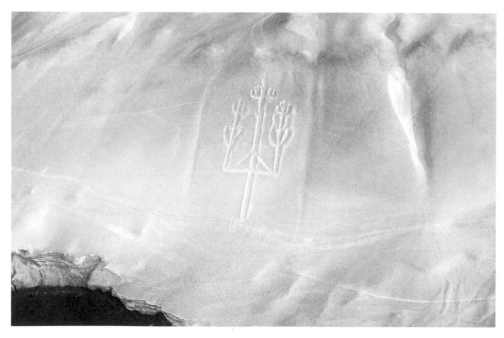

investigation of the Nazca lines in 1968. After feeding information on the directions of nearly 200 lines into a computer program designed to compare their individual alignments with the movements of heavenly bodies along the horizon, he concluded that solar and lunar movements did not account for the deployment of the Nazca lines.[18] In the early 1980s archaeoastronomer Anthony Aveni and anthropologist Gary Urton also attempted to discover whether the Nazca lines possessed any astronomical significance. They compiled data on 62 ray centers, about 80 percent of the total, involving more than 500 lines. They, too, decided that the lines do not coordinate in any meaningful way with the movements of heavenly bodies.

About 100 miles north of Nazca, an enigmatic ground drawing faces the sea from a sloping dune on the coast of Paracas Peninsula. The trident-like design, which is more than 600 feet from top to bottom and nearly 200 feet across, is said to date back several centuries. Its makers dug the figure about three feet deep into the crust of the dune. Some viewers advance the theory that the drawing is a landmark for sailors: on a clear day the "trident" is visible from as far out to sea as 15 miles. If it is a navigational sign, perhaps it represents one of the most noticeable constellations in the southern sky—the Crux, or Southern Cross (four stars deployed in the form of a Latin cross), traditionally an important guide for Peruvian fishermen. Others see the figure as a vegetable form, albeit with a candelabra-like formality. Its trunk or stem arises from a triangular base, while its right-angled branches are outfitted with petal-like motifs. If the design was indeed intended as a sprouting plant, perhaps its makers placed it there to attract rain clouds inland.

MUD MOSQUES, ADOBE MISSIONS

Mud-brick architecture, which had been so prominent throughout the ancient Near East, attained a new degree of excellence during the medieval age. Instead of skyscraping ziggurats dedicated to Babylonian and Assyrian gods, the new shrines assumed the forms of domed mosques and soaring minarets and were dedicated to Allah. Of these Islamic structures, few are as distinctive as the 164-foot-high minaret of Samarra, built in ninth-century Iraq by Caliph al-Mutawakkil. Samarra, north of present-day Baghdad, was home to the Abbassid monarchs from 836 until 892, and Caliph al-Mutawakkil, who reigned from 847 to 861, was the city's preeminent builder, responsible also for the Great Mosque, a massive structure of fired mud-brick, now in ruins. Its celebrated minaret, however, evokes the scale and splendor of the city's Islamic architecture. The top of the mud brick tower is accessible by a spiraling staircase that coils around the freestanding conical structure.

A century or so later, Arab traders, in quest of gold and slaves, introduced the Islamic faith to West Africa, where the ruling classes readily accepted it and commissioned local versions of mosques and minarets, which began to arise almost literally out of the earth. Many of Mali's early mosques, even when reconstructed in the 16th and 17th centuries, were built of clay with a minimum of wood scaffolding. The mosque at Sakora was constructed of mud-brick and rubble and surfaced with clay. It was probably founded by Mansa Musa, who ruled Mali from about 1312 to 1337, making his domain one of the world's foremost suppliers of gold.

Mali's mud mosques are typically distinguished by conical or four-sided towers that necessarily taper inward toward the top for structural reasons. The buildings characteristically feature the projecting ends of wooden scaffolding, which result in decorative, if prickly-looking, surface patterns. The scaffolding, shrewdly incorporated in the design of the mosques, offers useful footholds to the people who annually replaster the exterior clay surface. The outer walls are often regularly punctuated by gracefully shaped pilasters, also made of mud (although they may contain a wooden core), which impose an attractive vertical pattern.

Elsewhere in Mali, an agricultural people known as the Dogon worship their traditional gods in sanctuaries that are frequently modeled in clay in a highly sculptural manner,

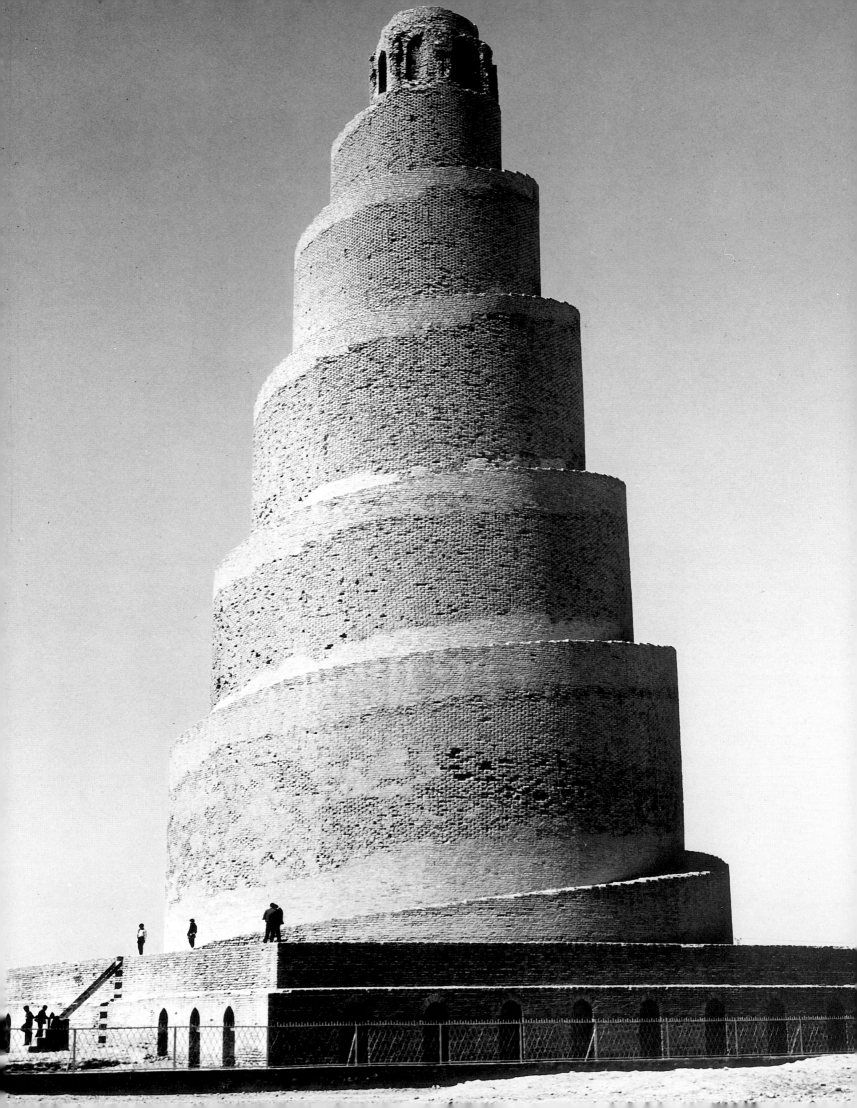

suggesting the work of master potters who have kneaded, squeezed, and patted their structures into shape. Their religious buildings, like their clay dwellings and granaries, possess a pleasingly organic quality in which various surfaces flow together expressively with a seamless continuity.

In the mid-16th century, as Islam's earthen mosques multiplied in West and North Africa, Catholic missionaries from Spain began to infiltrate the American Southwest. Often backed up by military might, Franciscan friars became the predominant proselytizers in the Southwest. Not the least of the Franciscans' achievements was the introduction of missionary architecture in adobe brick.

Although the Pueblo Indians had constructed housing by slathering successive layers of mud, often over a core of stone masonry, they were ignorant of adobe-brick construction until Spanish colonists introduced them to the process. This is a very curious omission in Pueblo Indian knowledge, suggesting an enormous cultural divide between Native Americans in the Southwest and their earlier counterparts in Mesoamerica and South America. Ironically, the Spaniards acquired their knowledge of adobe from the Moors, Arab Muslims whose origins were in North Africa. In the evolution of building materials and processes, Tangiers and Taos share a bit of common ground.

Adobe brick, as introduced by the Spanish, became one of the most prevalent building materials in the Southwest. The bricks were made from a mixture of clay, sand, straw, and water. The ideal formula was about three parts sandy soil to one part clay soil: too much sand made the bricks dissolve, while too much clay caused them to split. Brickmakers combined wet mud with straw, then poured the concoction into wooden molds and left it outdoors to dry in the desert sun.

Father Junípero Serra headed a group of Spanish Franciscans who built 16 adobe-brick missions in California, from San Diego to Sonoma, between 1769 and 1823. One of his most grandiose achievements was the mission at San Juan Capistrano, south of Los Angeles. Its initial structure, an adobe chapel dating from 1777, is still intact. The church that followed, built between 1797 and 1806, was relatively elaborate, with a vaulted ceiling and seven domes as well as a 120-foot-high bell tower. During a morning service in 1812, however, an earthquake caused the ceiling to collapse, crushing 40 Indian worshipers. Until the 1980s, when the remaining structure was earthquake proofed with repellent scaffolding, the mission's most loyal parishioners were the thousands of cliff swallows who regularly flew in each March to build their mud nests along the upper areas of the adobe walls and arches.

At the time of his death in 1784, Father Serra was living at the mission he founded in Carmel-by-the-Sea. His successors, notably Father Fermín Lasuén, continued the Franciscans' efforts to make California a safe haven for Catholicism and the Spanish monarchy. Santa Barbara, founded in 1786, ultimately became known as the "Queen of the Missions," prized for its beauty as well as its relative authenticity—it is the only mission to have been constantly occupied by Franciscans.

If Saint Francis of Assisi, the ascetic founder of the Franciscan order of mendicant friars, is a bit discomforted that the West Coast's most sybaritic city is named after him, he perhaps takes solace that so many of his order's missions and churches are still functioning as places of worship. One of the most revered is San Francisco de Asís (1772) in Ranchos de Taos; the adobe church is especially famous among art lovers because it is the subject of two notable artworks of 1930, a painting by Georgia O'Keeffe and a photograph by Paul Strand.

Earlier, in 1718, the Franciscans founded a mission in south-central Texas, which they named San Antonio de Valero. They built an adobe chapel there sometime after 1744. Nearly a century later, the chapel, functioning more as a garrison than a place of worship, became a flash point in the Texas Revolution against Mexico. An army of several thousand Mexican troops besieged the structure, terminating in a famous bloodbath on March 6, 1836. Mission San Antonio's adobe chapel is remembered, of course, as the Alamo.

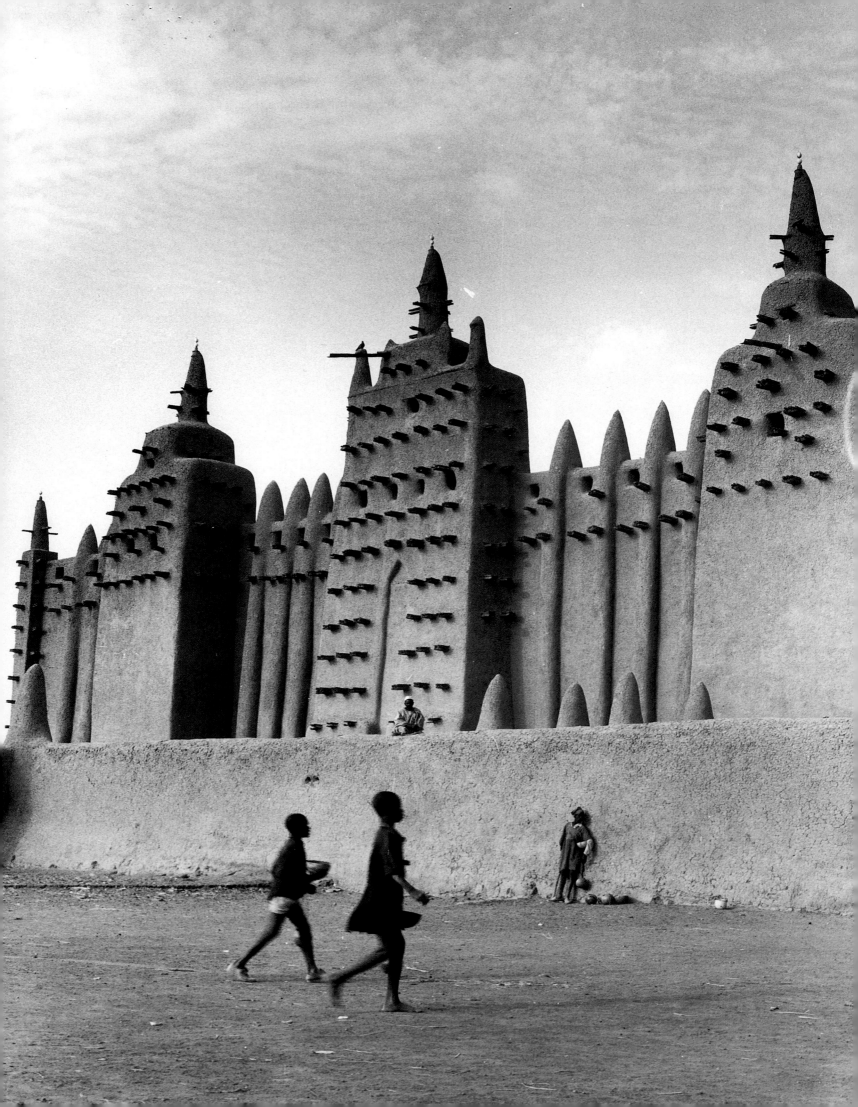

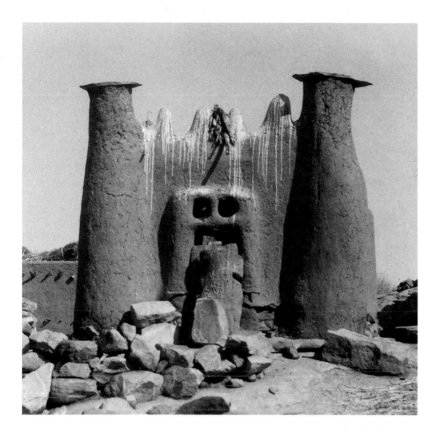

OPPOSITE: Great Mosque (reconstructed c. 1905). Djenné, Mali. Photograph by Roger-Viollet. *Since the initial Islamization of West Africa in the 10th century, the region's Muslims have built and rebuilt hundreds of clay mosques and minarets. Mali's mosques typically have tapered towers and conical forms that rise above the roofline. The projecting ends of wooden scaffolding produce a surface pattern that is both functional and decorative.*

LEFT: Dogon sanctuary. Clay. Ogol, Mali.

BELOW: The Old Church at Pueblo of San Ildefonso. Adobe-brick. Near Los Alamos, New Mexico. Photograph by Adam Clark Vroman, 1900. Courtesy Bureau of American Ethnology, Smithsonian Institution, Washington, D.C.

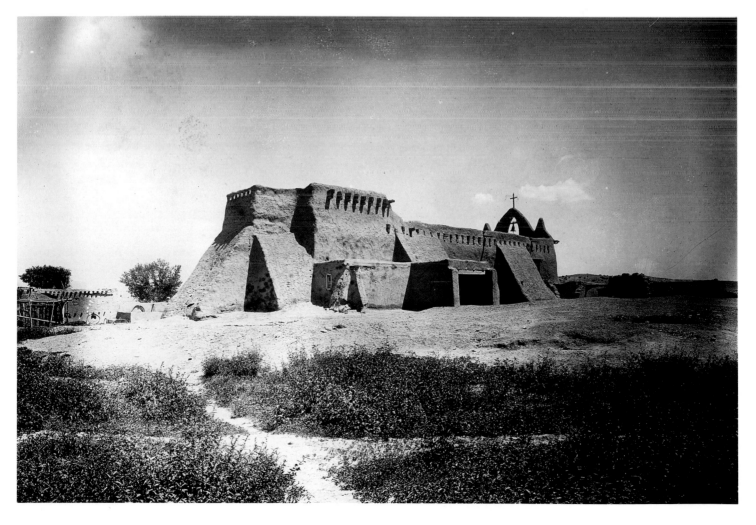

Many religious structures in modern times are completely dissociated from any identification with the earth. Instead of excavating temples and churches into living rock or constructing them of earth, contemporary architects and their patrons frequently emulate the sleek, expensive structures of industrial materials that are more appropriate to the headquarters of multinational corporations.

One of the most intriguingly designed of recent rock-cut religious structures is Helsinki's Temppeliaukio Church, completed in 1969. Designed by Finnish architects Timo Suomalainen and Tuomo Suomalainen, the church is excavated into a vast rock near the city center. Its builders determined to hollow the building out of stone not for reasons of spiritual identification with the earth but, instead, to placate nearby apartment dwellers and other citizens who wanted to preserve the open spaces of the "square," an irregularly shaped parcel of land dominated by an outcrop that rises some 25 to 40 feet above street level. Consequently, the architects designed a tunnel that leads from the street-level facade into the main church, which was quarried out of the rock. The most attractive feature of Temppeliaukio is its circular roof, consisting of 180 reinforced concrete beams supporting a 78-foot-diameter glass-paneled dome. The lower portion of the interior walls consists of bedrock, but the upper register is composed of stacked stones.

Among recent mud-brick mosques, one is particularly noteworthy, if only for its unexpected location—Abiquiu, New Mexico. While New Mexico offers one of the world's highest concentrations of adobe architecture, it is seldom perceived as an oasis of Islam. But that began to change in 1980, when Egyptian architect Hassan Fathy (1900–1989) arrived in Abiquiu to oversee the construction of Dar al-Islam, a mosque that he had designed to serve as the religious focal point of a new Islamic community. For a couple of weeks, as turbaned workmen molded and laid adobe bricks, Fathy roamed the site coaching the workers in how to build typical Middle Eastern vaults, domes, and cupolas. His mosque, for instance, features "Nubian vaults," barrel vaults that are slanted at one end.

Since the late 1960s, many people, dissatisfied with traditional faiths, have sought alternate routes to religious consciousness through a wide spectrum of cross-cultural or countercultural sources. In its more faddish manifestations the "New Age" movement is a quixotic blend of Western and Asian spiritual traditions, consciousness-raising research, Jungian psychology, cultural anthropology, and archaeoastronomy. This last discipline, combined with New Age mysticism, prompts some geomancers to survey ancient megalithic sites in search of centers of terrestrial magnetism, or "earth energies." Not surprisingly, New Age studies seem to appeal particularly to those of an eco-feminist persuasion who look for evidence of earth goddesses in caves and find much to admire in the presumed spirituality of certain ancient, non-Western, non-patriarchal cultures.

In our search for a more gratifying spiritual life, are we really that different from the ancient Peruvians who found supernatural associations, worthy of worship, in every *huaca*? Our earliest ancestors lived in what New Age folk call a "conscious interactive environment," in which rocks displayed emotion, had memories, and communicated with humans. Then, for several recent centuries, people considered the mineral kingdom to be inanimate matter. Now, thanks to a newly perceived kinship with a sensate environment, many individuals are reawakened to the ability of quartz crystals to transform energy and to "store consciousness." In the early 1970s English scientist James Lovelock advanced the Gaia hypothesis, which considers the entire earth as a living organism. In 1988 he wrote, "There is no clear distinction anywhere on Earth's surface between living and non-living matter. There is merely a hierarchy of intensity going from the 'material' environment of the rocks and the atmosphere to the living cells."[19]

Spiritual life may have to be radically redefined if we consider the possibility that all matter may have some form of soul. But where to look for evidence of this spiritual consciousness? Try mountains and caves.

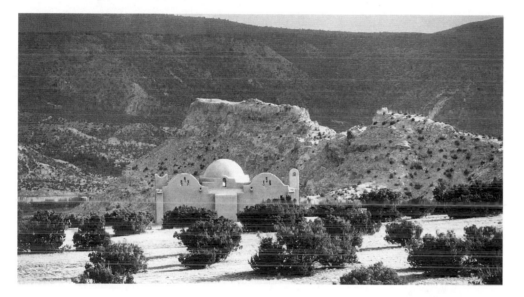

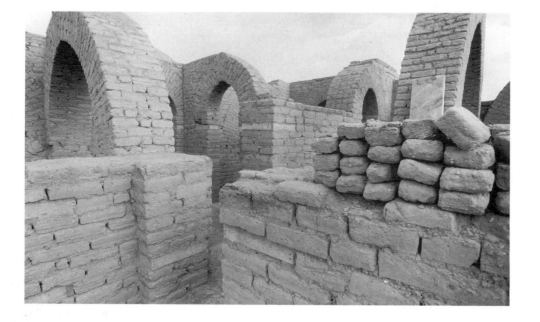

LEFT: Timo Suomalainen and Tuomo Suomalainen. Temppeliaukio church, 1969. Helsinki. Photograph by Ä. Fethulla. *Temppeliaukio Square's semisubterranean church was quarried into a massive outcrop that exists near the city center. The lower portion of the interior wall is bedrock, while the upper section was assembled from the large stones that were displaced during the quarrying.*

MIDDLE AND BELOW LEFT: Hassan Fathy. Dar al-Islam mosque, 1980–81. Abiquiu, New Mexico. Photographs by Cradoc Bagshaw. *The Egyptian architect designed the adobe-brick mosque with Middle Eastern–style vaults and cupola. The loaflike adobe bricks were made locally.*

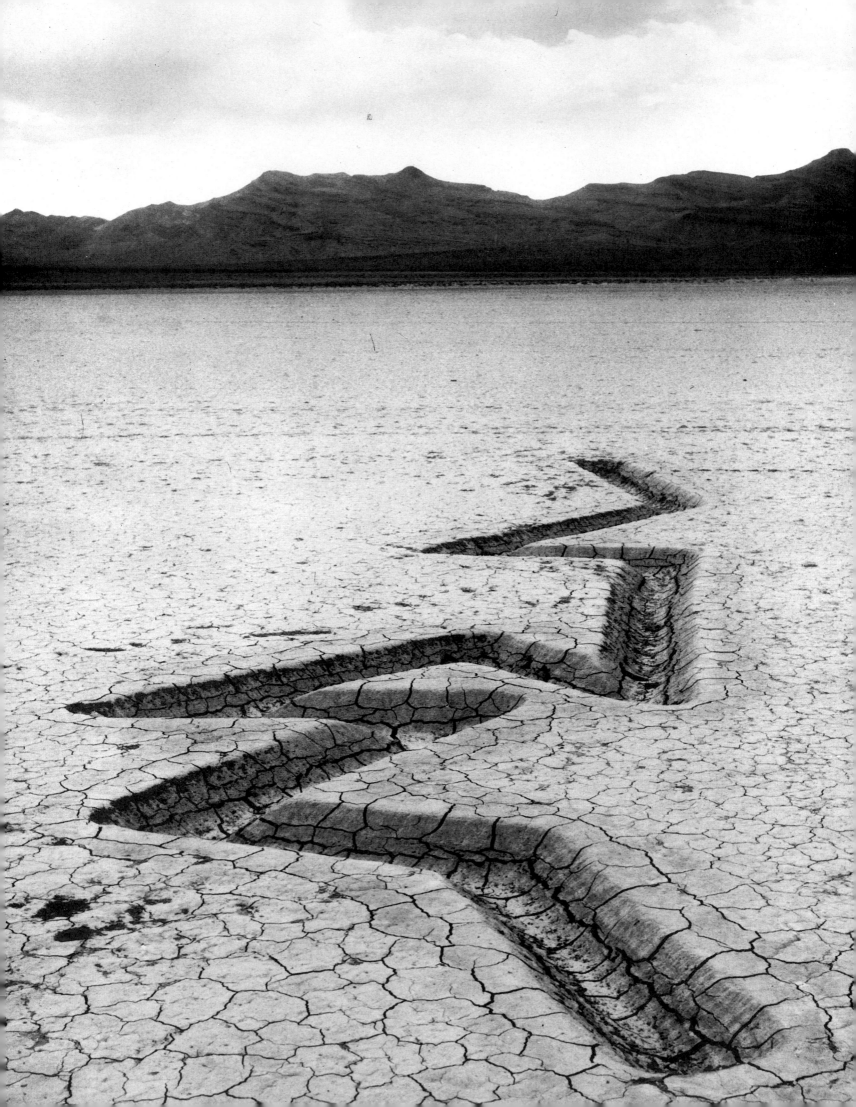

Land Art

Paradise Gardens, Provocative Earthworks

The road from Eden to the present has been long and bumpy, but all along the way individual men and women have tried to re-create a portion of earthly paradise by reworking the terrain around them. The urge to create a private world that is both immediately sensual and peaceful is nowhere better expressed than in a garden. The ancient Egyptians, as we know from their tomb paintings, placed a high priority on lush gardens, whose irrigation canals brought luxuriant life to plants and trees and helped keep alive the idea of eternal renewal. Over the centuries garden design acquired national characteristics, which enable us to speak of Italian, French, English, Persian, and Japanese gardens.

In contrast to Edenic gardens, which coax us to look inward for tranquillity, contemporary Land or Earth art prods us to look anew at the world around us—and possibly raises our anxiety level. The artworks range from monumental, relatively permanent impositions in uninhabited desert environments to deliberately transient interventions in natural landscapes. Some modern earthworks are decidedly aesthetic but arouse our apprehensions because they seem to be insolent assaults upon otherwise pristine terrains, while other examples may consort in harmony with nature but offend our sense of artistic significance. The artists' intentions are as diverse as their end results, but all of them contribute to the spirit of our time by enabling us to perceive, as if with newly opened eyes, the scope of humankind's past and potential imprint upon the world.

OPPOSITE: Michael Heizer. *Rift*, 1968. Excavation in playa surface, 52 x 1'6" x 1'. Impermanent installation at Jean Dry Lake, Nevada. Commissioned by Robert C. Scull. Photograph by Michael Heizer. *This was the first in a series of nine Nevada Depressions, site-specific "negative" sculptures that Heizer created in several of Nevada's dry lake beds between July and September 1968.*

The authors of the Old Testament were too preoccupied with humankind's fall from grace to provide us with any concrete information about the design of the Garden of Eden or, with the exception of two trees (both metaphorical), any of its plants. As for the garden's irrigation, they do inform us that an unnamed river ran through it, which subsequently branched into four separate streams, including the Hiddekel (or Tigris) and the Euphrates. Although evidence is scanty, there is no reason to disagree with traditional assumptions that the Garden of Eden was situated somewhere between the rivers Tigris and Euphrates. But we might also take note that for many writers of the biblical epoch the words for "garden," "park," and "paradise" were synonymous.

Ancient kings of Assyria and Babylon spared no effort or expense in diverting water to their paradise gardens. Assyrian king Sennacherib boasted of his extensive canalization of the streams north of Nineveh, his capital, enabling his gardens to flourish with fruits, vines, spices, and trees. So that his gardens might prosper, Sennacherib claimed to have "cut down and leveled mountain and field."

While some kings razed mountains, others raised them. If we make a great leap forward to Kublai Khan's capital, the core of present-day Beijing, we discover that he created an artificial hill within view of his palace. The earth for the mound came from the excavations of two lakes, one used for watering cattle, the other stocked with food fish. Marco Polo visited the Great Khan in about 1275 and later recalled that the mountain's height was "fully a hundred paces and the circuit at the base about a mile. It is covered with the most beautiful evergreen trees; for whenever his Majesty hears of a handsome tree growing in any place, he causes it to be dug up with all its roots and the earth around it, and however massive it may be, he has it transported by means of elephants to this mound and adds it to the verdant collection."[1] Because of both its evergreens and a green pavilion on its summit, the hill acquired the name of the Green Mount.

In Kyoto, whose splendid dry gardens (*karesansui*) are the most famous in Japan, mountainous forms are subtly evoked by an artfully placed rock or a stylized pile of sand (the coarse consistency of which approaches gravel). One of the most beautiful garden "mountains" is the truncated cone of white sand at the Silver Pavilion (Ginkakuji), initially built as a princely retreat in 1482. According to legend, the prince happened upon the pile of sand, which had been left behind by his workmen, and was so impressed by its beauty in the moonlight that he gave orders for it to be preserved just as he found it, but with flakes of mica added to make it sparkle.[2]

Kyoto's *karesansui* are typically designed to be viewed from a specific vantage point, usually the residence of a scholar, noble, or monastery superior. Perhaps the most renowned of these "contemplation" gardens is the Ryoan-ji, which adjoins a sanctuary and dates from the late 15th century. Its artfully deployed stones suggest cliffs arising from water, the latter evoked by sand raked into linear patterns. A Zen priest designed the dry garden of the Daisen monastery in the temple of Daitokuji, built between 1509 and 1513. There, a balcony overlooks a rectangular plot of raked sand with two conical "hills" of sand. Even the Imperial Palace at Kyoto, as rebuilt in 1855, maintains a traditional sand garden, raked daily for a seascape effect.

WESTERN GARDENS: ITALIAN GROTTOES, ENGLISH HA-HAS

Renaissance gardens brought about a new emphasis upon caves and mountains, those traditionally favored places for sacred shrines. Owners of Italian villas typically sited gardens upon a slope, which they then terraced to provide a multitiered setting for lush greenery. Each terrace was often individualized, with its own pattern of parterres, or ornamental plant beds divided by orderly pathways.

Italian garden-makers especially prized artificial grottoes, which they hollowed into

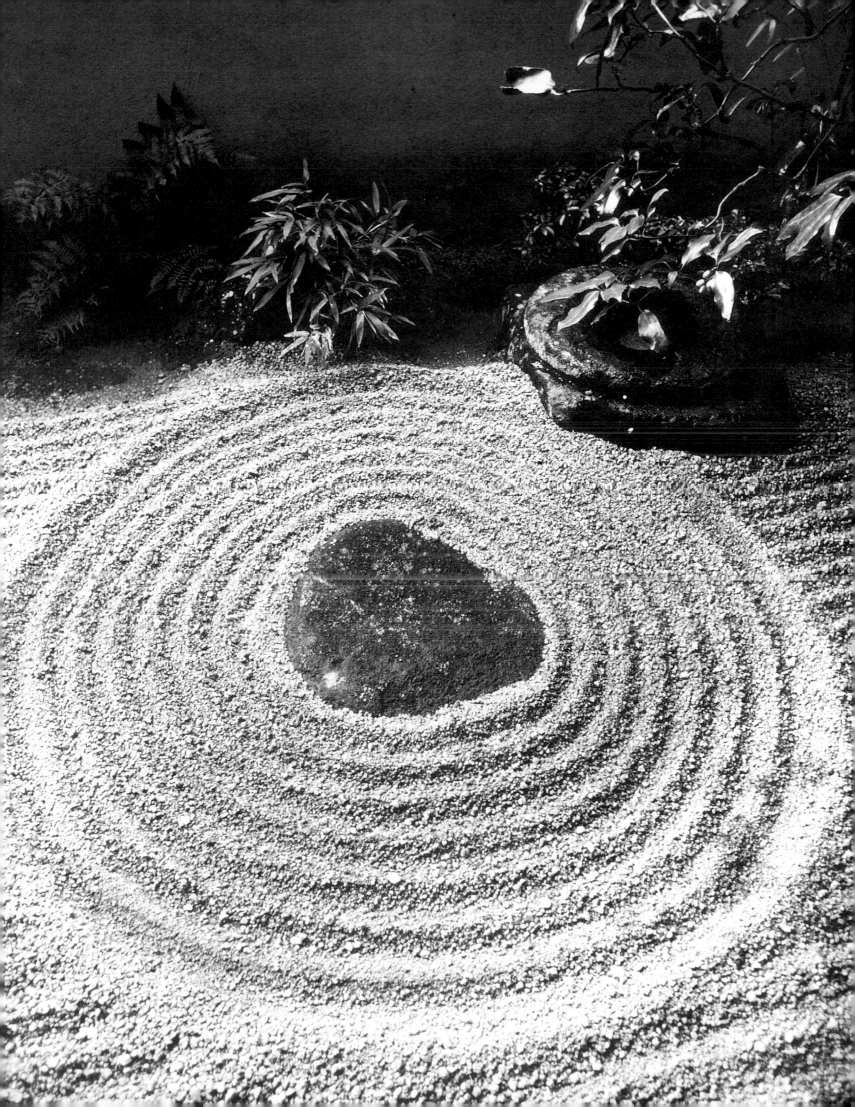

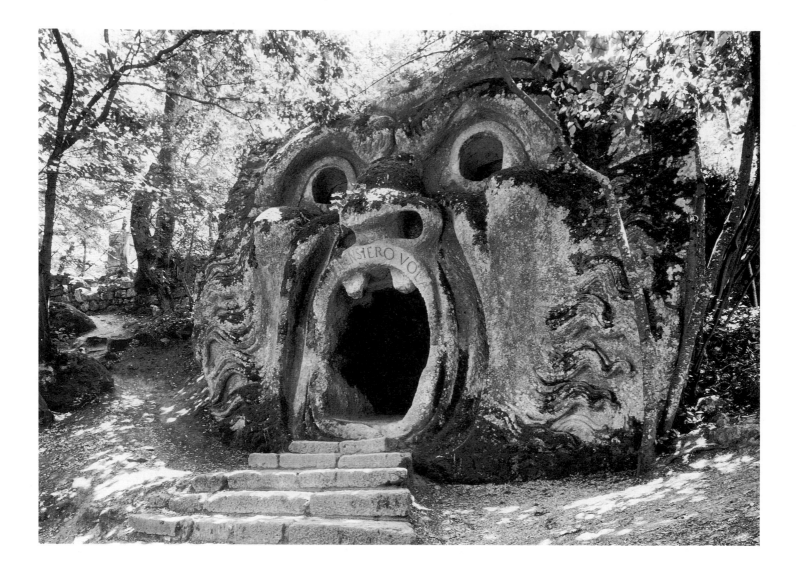

ABOVE: Hell-Mouth (rock-cut grotto), c. 1550–84. Bomarzo, Italy. *Italian garden-makers delighted in artificial grottoes. One clever duke commissioned artisans to carve a large outcrop into an ogre-like face. The inscription cut into the lips invokes the Gate of Hell described by Dante in his* Inferno.

RIGHT: Pieter Brueghel the Elder. *Spring*, 1565. Pen and bister ink, 8⁵⁄₁₆ x 11³⁄₈". Graphische Sammlung Albertina, Vienna. *In much of 16th-century Europe, fashion dictated parterre garden designs, symmetrical arrangements of plant beds with pathways in between. Brueghel was living in Brussels when he portrayed this bustling scene of spring planting. A Flemish lady, standing to the left, supervises her gardeners, who prepare the soil with shovels and rakes.*

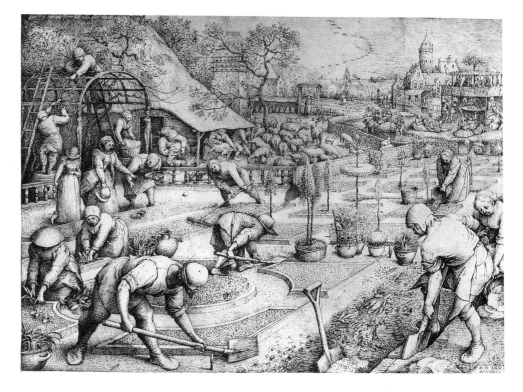

actual hillsides or built above ground in such a way as to suggest natural cavities pene-
trating the earth. Some Renaissance grottoes imitate "wild and primitive" caves and were
intended to serve as retreats or sanctuaries for their owners when they needed to escape the
cares of the world. The fashion for grottoes, which can be traced back to ancient Rome,
persisted into the 18th and 19th centuries. No matter how bizarre its form and decorations,
the artificial grotto presumably established a link to a primordial and obscurely mysterious
realm, the subterranean cave, a place apart from otherwise sunnier terrain.

One of the most bizarre of all Italian grottoes is at the Parco dei Mostri, at Bomarzo
(some 70 miles north of Rome). From 1550 to about 1580, Duke Pierfrancesco "Vicino"
Orsini created a spectacular garden of almost demonic ingenuity, apparently to amuse him-
self and to impress his contemporaries with his cleverness. Bomarzo's grotto was carved
into the living rock of the hillside and shaped on the exterior as a monstrous, ogre-like
mascherone, or mask, with wrinkled brow, round eyes (that functioned as windows), pudgy
nose, and a wide-open, fanged mouth, large enough for a standing person to enter the
room within. A carved inscription on the lips of the hell-mouth deliberately invokes the
Gate of Hell that Dante described in Canto III of his *Inferno*.

Bomarzo's garden contained many large outcrops that the cultivated aristocrat had
carved into fanciful statues of animals, including a bear, an elephant, a giant tortoise,
dolphins, a dragon, a three-headed dog, and a chimera or two. The duke challenged his
visitors to determine whether his garden's "marvels" were "made by deceit or by art." In
fact, his sculptures expressed a double conceit, because they looked like artworks that were
subsequently reshaped by nature. Some of Bomarzo's outcrops, for instance, had been
carved to suggest architectural fragments that then subsided into the earth. A "fallen pedi-
ment" appears to have tumbled onto its side and to lie half buried in the ground, evoking
the destructive power of time, when, in fact, it is a trompe l'oeil piece of carving that had
never been in an upright position. Similarly, the lower story of a "leaning" house derives
from the existing form of the large boulder from which it was cut.[3]

Bomarzo's eccentric rock-cut sculptures contrast dramatically with the serene geome-
tries that prevailed elsewhere in 16th-century Europe, where the trend was for a formal type
of garden with parterres. The typically geometrized parterres that characterized a 16th-
century Flemish garden are displayed in Pieter Brueghel the Elder's pen-and-ink drawing
Spring (1565), showing the woman of the house supervising a team of gardeners who
prepare the plant beds for shrubs and flowers.

Formalist garden design became even more emphatic in France. But the French
shunned the Italian taste for multiple terraces ranked along a slope. French sensibility
seemed more comfortable with gardens laid out on level ground, where rigidly ordered
geometric parterres could suggest an idealized model for the rational arrangement of the
entire universe. The more elaborate French gardens featured an element that was beyond
the means of most citizenry—an ornamental canal, appropriate for a nation of great
rivers. No embellishment was more prestigious than a perfectly straight canal, especially
if it could run on for nearly 3,900 feet, like the one that Henri IV commissioned at
Fontainebleau.

In contrast to the French taste for symmetry and order, the English favored rustic
and natural-looking scenery. By the early 1700s, they abandoned their passion for parterres
in favor of arcadian views because they had begun to look at landscape through eyes that
had been educated by painters. This taste for romantic, pastoral scenery came about
through exposure to 17th-century landscapes by, among others, Salvator Rosa, Claude
Lorraine, Nicolas Poussin, Meindert Hobbema, and Jacob van Ruisdael. English enthusiasm
for paintings by such masters helped bring about dramatic changes in the aesthetics of
gardening.

The new aesthetic in English landscape was also shaped by some of England's most
eloquent literary figures and devotees of "natural" gardens. The poet Alexander Pope
(1688–1744) summed up his aesthetic in the following couplets:

Let not each beauty everywhere be spied
When half the skill is decently to hide.
He gains all points who pleasingly confounds,
Surprises, varies, and conceals the bounds.[4]

England's booming economy enabled a rising class of newly wealthy Englishmen to establish themselves in grandiose country houses on large parcels of real estate. A few of these gentlemen threatened to turn into mini-Sennacheribs, moving mountains to satisfy their needs. At Harewood House in Yorkshire, for instance, Lord Harewood ordered the removal of a large hill, which had been inoffensive so long as it stood behind the old house but would have interrupted the descending sweep of land below the new one. His mountain-razing project employed between 10 and 45 men over a 10-year period.[5]

Much of what we now regard as "classic" 18th-century English landscape conforms to Pope's rules, advocating a varied sequence of vistas with extensive mowed lawns, serpentine rivers, informal clumps of trees, and winding paths and drives, all of it looking as artless and unadorned as possible. A surprisingly large number of these "natural" settings, however, were cleverly conceived by landscape gardener Lancelot Brown (1716–1783), better known to his clients and to history as "Capability." He earned the nickname through his habit of referring to the "capabilities" of the places on which he worked.

Born into a farm family in the village of Kirkharle, in Northumberland, Brown was about 16 years old when he found a gardening job on a nearby estate. His horticultural skills and flair for landscape design caught the attention of his employer's friends and neighbors, who hired him to replan their own grounds. One recommendation led to another, and Brown was soon reshaping the terrain of country estates for titled gentlemen all over England. His list of clients peaked in 1764, when George III appointed him chief gardener at two royal estates, Hampton Court and Richmond.

Brown excelled at creating informal parklike landscapes with rolling, gently contoured grounds, generally sloping downward to a placid lake or winding river. He could inspect an existing landscape and determine to liberate its innate "genius" by creating a body of water over here and planting a clump of trees over there, always tearing up any parterres in his path. He did not hesitate to reconfigure the terrain of the estates with which he was entrusted. At Bowood, in Wiltshire, Brown lowered a hill between the woods and the house. At Moor Park, in Hertfordshire, after he determined that the grounds were insufficiently varied, he heaped up artificial hillocks on either side of the house to help "undulate" the horizon.

One of Brown's standard design components was a gently winding river, situated in the middle distance as viewed from the house. But a natural river with suitable proportions was seldom available to him, so he frequently had to divert or dam an existing stream or reconfigure a lake in order to create a serenely curved body of water. For Croome, in Worcestershire, in the 1750s, Brown converted a spring-fed pool into a sinuous "river" that narrowed as it wound past the west front of the house, then widened in an eastward turn as it flowed into view of the garden front, before making a southward turn that channeled it to the edge of the park. He typically contrived to make lakes extend beyond an ideal vantage point so that they would appear to be rivers. In 1760 at Charlecote, near Stratford, he reconfigured the existing banks of the river Avon to give them a more "natural" look.

To maintain long, uninterrupted vistas, Brown often employed a sunken fence, similar to a fosse or dry moat and known as a ha-ha. (The name derives not from the sound of laughter but, instead, from cries of startled surprise, as in "Aha!") The ha-ha was widely used in 18th-century England as a substitute for boundary walls, providing an invisible (from the house) barrier between the lawns and gardens and the rural countryside beyond. Moreover, it was a practical means for keeping an estate's grazing animals from the immediate vicinity of the house, while enabling the people of the house to enjoy panoramic landscapes. Constructing a ha-ha involved digging a fairly deep trench that was sloped on

OPPOSITE, BELOW: Saffron Walden Maze, prior to 1699. Turf-cut maze, dia.: 114'. Essex, England. Photograph by Georg Gerster. *Although its exact date of origin is not known, documentary evidence indicates that this maze's turf was recut as early as 1699. Since then, it has been recut six times. The path that winds to the center is nearly a mile long. During the 18th century, young men gathered at the maze for racing contests, wagering gallons of beer on who could sprint to the center in the fastest time.*

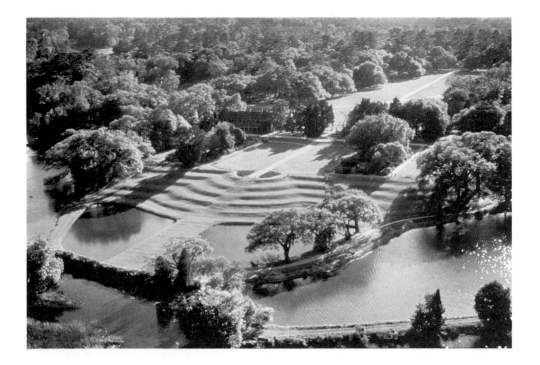

LEFT: Terraced grounds at Middleton Place, c. 1755. Near Charleston, South Carolina. *Henry Middleton acquired the rice plantation by marriage in 1741. Because visitors frequently arrived by boat, traveling up the Ashley River from Charleston, he decided to create a more impressive waterfront approach to his property. Putting slaves to the task for some 10 years, he recontoured the riverfront bluff into curved terraces that descend to symmetrical lakes shaped like butterfly wings. The grounds are believed to be the nation's earliest still-extant landscape design.*

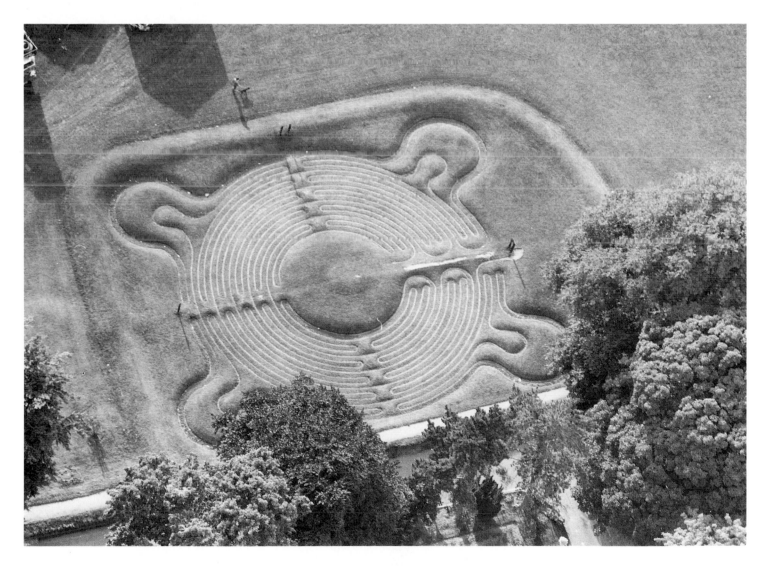

RIGHT, ABOVE: The White Horse at Uffington, 100 B.C.–A.D. 100. Turf-cut chalk silhouette, length: 365'. Berkshire, England. Photograph by Georg Gerster. *Its makers created the sleek animal by scraping away grassy topsoil on a steep hillside to reveal the white chalk below. It may be Celtic in origin.*

OPPOSITE: The White Horse and Rider, 1815. Turf-cut chalk silhouette, 323 x 260'. Osmington, Dorset County, England. Photograph by Georg Gerster. *An early tradition maintained that this rider represents George III, who vacationed at nearby Weymouth.*

RIGHT, BELOW: Cerne Abbas Giant, 100 B.C.–A.D. 200. Turf-cut drawing, length: 180'. Dorset County, England. Photograph by Georg Gerster. *This herculean figure, positioned on a slope below an ancient banked enclosure, is possibly of Celtic or Roman origin. Barren women who wished to conceive allegedly passed the night within the outlined tumescence.*

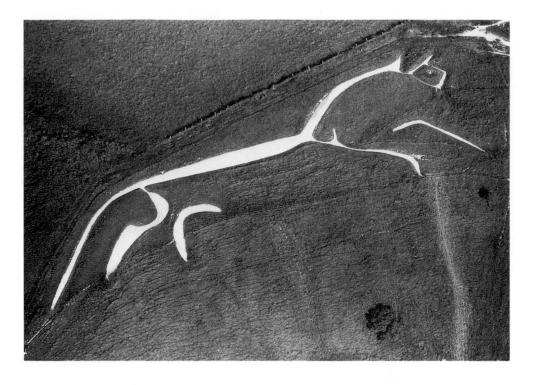

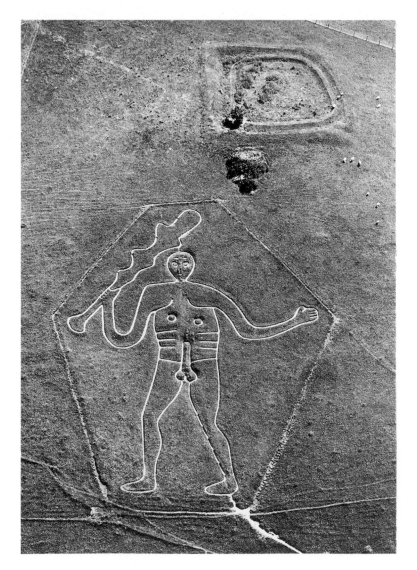

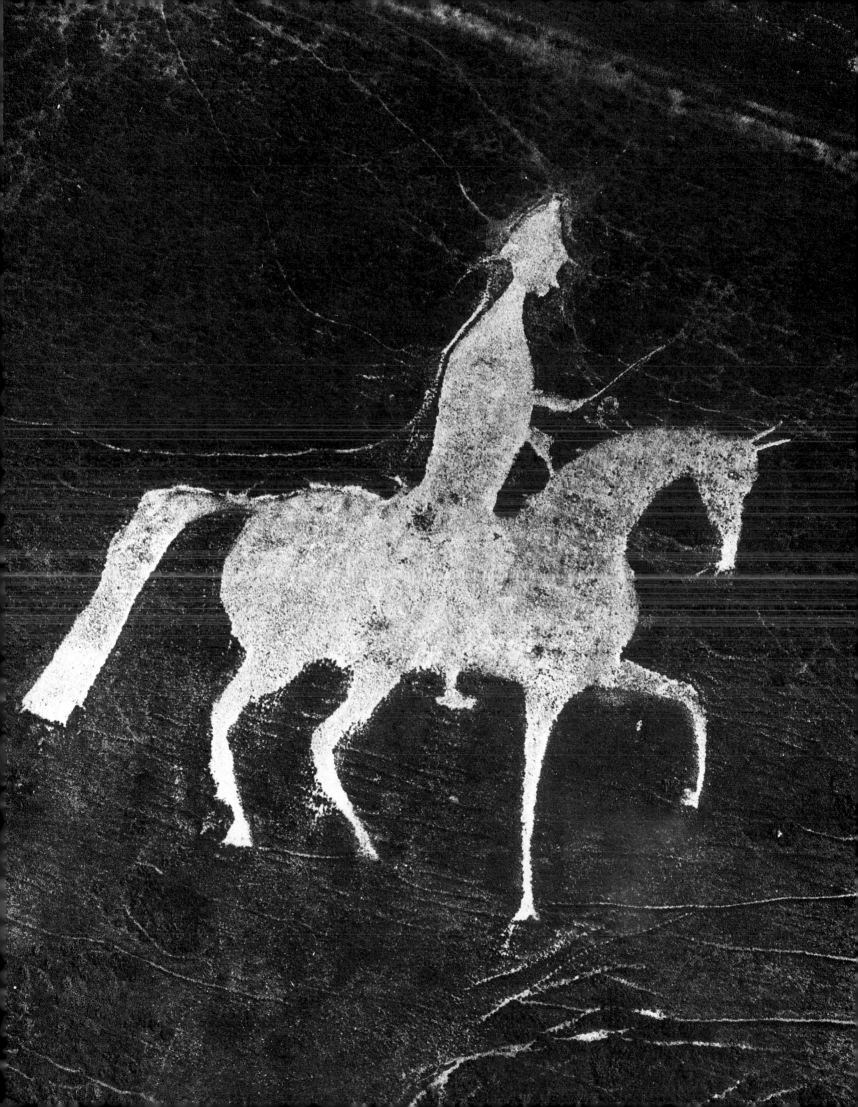

one side and, on the other, sharply vertical and sufficiently high to serve as a barrier for foraging animals.

After Brown's death, at age 67, one of his admirers, politician-author Horace Walpole, could not resist writing a Miltonian epitaph:

> With one Lost Paradise the name
> Of our first ancestor is stained;
> Brown shall enjoy unsullied fame
> For many a Paradise he regained.[6]

In fact, Capability Brown's fame plummeted almost immediately after his death, because he had succeeded all too well in creating landscapes that looked so natural that future generations assumed they were completely indigenous. Moreover, landscape design is one of the least durable of art forms, being dependent not only on the caprices of nature but also on the whims of subsequent landowners, who often remodeled or obliterated Brown's plans. Changing tastes brought back parterres, while financial pressures prompted some owners to subdivide their properties. But several of Brown's landscapes—including Alnwick Castle in Northumberland, Ashburnham Place in Sussex, and Longleat in Wiltshire—look much as they did in the 18th century.

In the concluding years of Capability Brown's career, a folkloric type of Land art began emerging on the hills of England. For many of the nation's gentry, terrestrial paradise was unimaginable without a horse or two of estimable blood lines. This was a golden era for equine art, when the most enlightened and affluent Englishmen commissioned George Stubbs (1724–1806) to paint portraits of their favorite mounts. The most impassioned of these horsemen were so proud of their equine champions that they even had their silhouettes deployed on hilltops. This was usually accomplished by removing the turf to expose the underlying white chalk, which seldom supports a very thick soil cover. The chalky white silhouettes are especially conspicuous in the summer, when they contrast most dramatically with the surrounding greenery.

Landowners in Wiltshire created a veritable herd of white horses, many of them dating from the late 18th and early 19th centuries. One of the most imposing of the equine hill figures is the Westbury White Horse, cut in 1778. Some of the later Wiltshire horses are at Cherhill (1780), Marlborough (1804), Pewsey (1812), and Hackpen Hill (1838).[7]

A distant ancestor of these equine hill figures is the White Horse of Uffington, whose silhouette bounds across a steep chalk hillside in Berkshire, about 17 miles southwest of Oxford. It, too, was achieved by scraping away grassy topsoil to reveal the solid white chalk beneath it. The sleek animal, with its elongated neck and body, and skinny forelegs, measures about 365 feet from its nose to the tip of its long tail, and it may be Celtic in origin, dating to pre-Roman Britain. It appears to conform to the stylized conventions of Celtic art, and its outline is characteristic of representations of horses on Celtic metalwork.

Like the Uffington horse, the Cerne Abbas Giant, on a chalk slope in Dorsetshire, may be of considerable antiquity. The 180-foot-long stalwart figure may date from the first or second century A.D. and be of either Celtic or Roman origin. Those who argue for the Celtic source point out that both feet are in profile, a supposedly Celtic trait. Because the giant brandishes a club, however, some viewers believe he may be related to the Roman Hercules, which would date him to the Roman Britain era. Others, determined to find an archaeoastronomical significance, point out that the giant's robustly tumescent penis constitutes a 30-foot-long sight line to the rising sun on May Day, since antiquity the day to celebrate fertility.

While Britain's hill figures engendered few artistic offspring beyond its shores, the English passion for picturesque landscape design was transplanted with great success to North America by Frederick Law Olmsted (1822–1903), whose most majestic achievement is New York City's Central Park. Many visitors assume that Central Park is an entirely natural

terrain, a piece of virgin landscape that the city merely walled in. In fact, Olmsted shrewdly designed the park's topography and supervised the rearrangement of many tons of earth and rock.

Olmsted was the proprietor of a farm and tree nursery on Staten Island, when, in 1850, he decided to go on a walking tour of England. During his tour, he had the opportunity to visit a great new public park in Birkenhead, across the river Mersey from Liverpool. Birkenhead's park had opened to the public in 1847, when municipal parks were still a novelty, and its design, by Joseph Paxton, included undulating terrain and winding paths. Olmsted was greatly impressed by "the manner in which art had been employed to obtain from nature so much beauty," and the experience made him a fervent advocate for public parks, which he firmly believed could enhance the amenities of urban life.[8]

Back in New York, influential citizens such as William Cullen Bryant, editor of the *Evening Post*, had been crusading for a major city park for many years. The campaign ultimately resulted in legislation in 1853 that authorized the creation of a "central park." The final site, an 843-acre rectangular plot, extended up the middle of upper Manhattan Island, from 59th to 110th Streets. At the time, the location was quite desolate, encompassing many swampy areas and barren flats, and almost devoid of trees. Then as now, homelessness and gentrification were set on a collision course. Thousands of squatters occupied the rubbish-filled site, many of them living in shacks, some of them keeping menageries of poultry, pigs, and goats—the last devouring every bit of greenery within reach.

Olmsted campaigned to get himself appointed as park superintendent, even though the park did not yet exist, then, in April 1858, entered the public competition for the design of the park. He collaborated with a young English architect, Calvert Vaux, who designed all the architectural elements, from the bridges and pergolas to Belvedere Castle, while Olmsted concentrated on the overall landscaping. Their entry won the design competition and they immediately set to work to implement their plan.

Like English proponents of the picturesque, Olmsted regarded an ideal landscape as one with a sequence of progressively unfolding views, offering walkers a variety of surprises and vistas. His plan called for extensive tree planting that would screen out any suggestion of the city beyond the park's perimeter.

Olmsted and Vaux drained swamps and marshes; they left many of the schist outcrops

G. Hayward. *View in Central Park, Promenade, June 1858*. Lithograph, from D. T. Valentine's Manual, 1859. Museum of the City of New York. *Central Park's existing topography was dramatically altered by landscape architects Frederick Law Olmsted and Calvert Vaux. Several million cartloads of earth were conveyed into and out of the park during its construction.*

RIGHT: Bruno Taut. *Der Fels Matterhorn*. Drawing from his publication *Alpine Architektur*, 1919. *Taut thought it a good idea to make the Matterhorn sparkle by embedding immense blades of glass in its gnarled peak.*

BELOW: Gutzon Borglum. Mount Rushmore National Memorial (carving in progress), c. 1935. Near Keystone, South Dakota. *Borglum's most prominent achievement is the quartet of American presidential heads that he and his crew jackhammered and dynamited out of Mount Rushmore in the 1930s. Workmen, suspended by cables from overhead winches, converted this portion of living stone into a living likeness of Thomas Jefferson.*

DER 'FELS MATTERHORN < < <

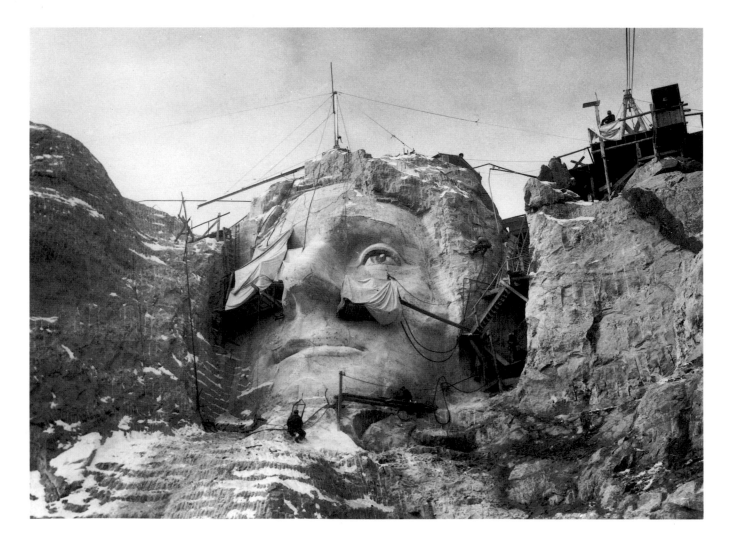

in place but blasted away unwanted rock with gunpowder, using some of the rock rubble to fill bogs or as foundations for the perimeter walls. They hauled out of the park thousands of cart loads of rocks and glacial till and hauled into the park hundreds of thousands of cubic yards of topsoil from Long Island and New Jersey. All the earthmoving, to Olmsted's way of thinking, was like the priming of an artist's canvas, functioning as the support upon which the painter would create his landscape.

In 1866 the team of Olmsted and Vaux was appointed the landscape architects of Prospect Park in Brooklyn. As Olmsted was away from New York during much of this period, Vaux became the park's primary designer. Once again, platoons of carters and shovelers went to work, dramatically regrading the site. Olmsted and Vaux dissolved their partnership in 1872, but continued on occasion to work together. On his own or with other partners, Olmsted designed urban parks for many cities, including Chicago, Boston, Detroit, and Montreal. He also laid out the grounds of the New York State Capitol at Albany and the terraced grounds along the west front of the Capitol in Washington, D.C. Although he is often called the preeminent North American landscape architect of his era, Olmsted considered himself neither a gardener nor an architect. He rejected the term "landscape architect," preferring to think of himself as a practitioner of "sylvan art."

SCULPTURED MOUNTAINS, CONTOURED PLAINS

Among the world's mountain chains, the Alps are perhaps least in need of tampering for purely aesthetic purposes. With the coming of World War I, however, Berlin architect Bruno Taut (1880–1938) began to think otherwise. Taut, a member of the Expressionist movement in German architecture, was inspired by the forms of mountains and caves. In the final years of World War I, when commissions were scarce, Taut let his imagination run wild, conceiving flamboyant schemes for the Alps. He sketched a series of visionary proposals, which he published in a book, *Alpine Architektur*, in 1919. He wished to brighten up the Matterhorn by studding its gnarled peak with immense blades of jagged glass. (An advocate of glass architecture, Taut had earlier designed a noteworthy Glass Pavilion for the 1914 Werkbund Exhibition in Cologne.) The shards of glass, wedged into the mountains like glittery shrapnel, were intended to refract the rays of the sun in all directions. As if in anticipation of New Age crystalmania, he sought to recut other Alpine peaks to emphasize their faceted crystallinity. He also proposed to embellish mountain lakes by floating huge, convoluted glass ornaments that, viewed from overhead, would suggest extravagant waterlilies. Taut's fanciful proposals may strike present-day environmentalists as megalomaniacal and symptomatic of architects' notorious disdain for nature when it stands in the way of a designer "statement." As a visionary and idea man, however, Taut remains a significant figure.

In contrast to Taut, American sculptor Gutzon Borglum (1867–1941) was indefatigable in his efforts to convert mountainscapes into monumental artworks. His most durable achievement is the set of four presidential heads that he jackhammered and dynamited out of a mountainside at Mount Rushmore, near Keystone, South Dakota. The Idaho-born sculptor received his first monumental commission in 1916, when the United Daughters of the Confederacy invited him to carve a colossal figure of General Robert E. Lee, the preeminent hero of the Old South, on the 825-foot-high granite face of Stone Mountain, about 15 miles from Atlanta. The project was to memorialize the 11 slave states that attempted to secede from the United States in the early 1860s, triggering the Civil War. In 1917 Borglum's crew constructed scaffolding over the face of the mountain and the sculptor set to work with blasting materials and rock-drilling tools. He had planned to marshal some 1,200 Confederate soldiers across the cliff, but in 1925, he became entrenched in a dispute over the scope and budget of the project and his sponsors dismissed him. Another sculptor was hired to take over. He blasted away most of Borglum's contribution until funds ran out.

Meanwhile, Borglum was commissioned to carve Mount Rushmore. The project was

initiated by a South Dakota state historian, but Borglum himself chose not only the site but also the four presidents whose faces would be set in stone for posterity. The nation was enjoying a burst of postwar prosperity, and the temper of the times seemed to demand a tribute to American leadership in the form of presidential visages on a 400-foot-high cliff atop the highest mountain in the United States east of the Rockies.

Borglum and his crew set up a camp at the base of the mountain, ran a tram on a 1,300-foot-long cable to the top, and purchased enough electric power from a nearby mine to operate 20 jackhammers simultaneously. Workmen blasted away a half million tons of rock before they arrived at 60-foot-high gray-granite faces. On July 4, 1930, the first relief portrait—that of George Washington—was unveiled. Thomas Jefferson's head was completed in 1936, Abraham Lincoln's in 1937, and Theodore Roosevelt's in 1939.

Borglum's Mount Rushmore sculpture is extraordinary not only because of its immense size, but also because it is an unusually successful example of public art. The composition is well suited to the site. By situating the heads at the top of the mountain, Borglum implied that the four presidents represent the pinnacle of American leadership. All the faces are on the same level but at different depths in the mountainside. They gaze soberly into the distance, each in a different direction, suggesting the heroic, farsighted nature of their vision. Their ideas, values, and character are made to seem as durable as stone. It is a majestic, emotionally rousing sculpture that ably withstands the test of time. Borglum's work does not present itself as an aggrandized expression of artistic ego; if anything, it embodies the collective self-confidence of an earlier and seemingly more innocent and idealistic era in American life.

Meanwhile, loyal supporters of the Confederacy still had designs on Stone Mountain. In 1958 the State of Georgia bought the rock and, in 1963, hired a new sculptor, Walker Kirtland Hancock (b. 1901), a noted maker of statues of military heroes, to complete the piece. Hancock and his assistants worked on the mountain face from 1963 to 1972, creating one of the world's largest (190 by 305 feet) sculptures and bringing to fruition a project that had spanned more than half a century. When the work was unveiled in 1970, the mountainside bore relief carvings of three Confederate leaders: the generals Robert E. Lee and Stonewall Jackson along with the president of the Confederate states, Jefferson Davis, all represented on horseback, piously holding their hats over their hearts. Unfortunately, the composition is routine and the portraits are lifeless and without character. Even worse, the monument perpetuates an image of the purported gallantry of the Southern patriarchy and as such is an epic affront to all African-Americans.

One of Borglum's students for a brief period in the 1920s was a Japanese-American, Isamu Noguchi (1904–1988). Borglum was underwhelmed by the young man's talent, however, and told him he would never be a sculptor. Undiscouraged by that bleak prognosis, Noguchi went on to Paris and a six-month apprenticeship with the modernist sculptor Constantin Brancusi. Eventually, Noguchi achieved enormous international success as one of the most gifted and versatile artists of his generation, noted for his dramatic abstract sculptures in carved stone and cast metal, as well as his imaginative stage and costume designs and his Japanese-inspired paper-lantern lamps.

Noguchi anticipated the earthworks-as-art movement by more than 30 years, although none of his early proposals was realized. His first major earthwork would have been *Monument to the Plow*, a 1933 design that he proposed to the Public Works of Art Project, a federal program. The monument was to be a three-sided pyramid of packed earth, positioned in the geographical center of the United States. Each side of the pyramid was to be 12,000 feet long at the base. One side would have been tilled soil, radiating in great furrows from one of the corners. The second side would have been half barren, uncultivated soil, the other half tilled with furrows that radiated from the apex. The third side would have been entirely planted in wheat. The pyramid was to be crowned with an oversized stainless-steel plow. Noguchi submitted a model and drawings and as a result was dropped from the government payroll for refusing to do work of a "purely sculptural character."9

OPPOSITE, BELOW: Isamu Noguchi. Model for *Sculpture To Be Seen from Mars*, 1947. Sand on board, 12 x 12". Photograph by Soichi Sunami. Courtesy The Isamu Noguchi Foundation, Long Island City, New York. *Noguchi's pessimism about the prospects of the human race in the post–atomic bomb world is stunningly expressed in this model for a colossal earthwork, which he initially titled* Memorial to Man. *The pyramidal nose would have risen one mile high.*

Two of Noguchi's most intriguing projects, both unrealized, were influenced by World War II. One of these was *This Tortured Earth*, a 1943 proposal for a parcel of land with a slashed and scarred surface, suggesting frightful flesh wounds. It is not entirely clear whether Noguchi actually intended to model the earth with a technique novel to sculpture: aerial bombardment. Regarding *This Tortured Earth*, he observed: "After all, you can make a sculpture by bombing it from the air. It's a form of carving. But just to bomb is not the intention."[10]

The other war-inspired project is *Sculpture To Be Seen from Mars*, a 1947 proposal for a colossal earthwork to be built in an "unwanted area," such as a desert, in the form of a stylized human face. An oblong mound with flattened top signifies the forehead; conical forms represent the eyes; a ringlike mound suggests lips; and the pyramidal nose rises one mile high. In contrast to Borglum's Mount Rushmore portrait busts, Noguchi's face is abstract rather than specific, universal rather than individual, and obviously designed to be seen from the air rather than from the ground. Conceived two years after the end of World War II, in which 45 million people lost their lives, Noguchi's monument is a powerful and provocative memorial to the futility of war.

Like Noguchi, artist-designer Herbert Bayer (1900–1985) was a precursor of the Land art of the late 1960s and early 1970s. In 1955 the Netherlands-born, Bauhaus-trained artist created *Earth Mound*, a large earthen ring for the grounds of the Aspen Institute for Humanistic Studies in Colorado. A single pathway leads into the ring, which contains a standing stone, a mound of earth, and a bowl-like depression, the totality apparently referring to the stone circles of Britain. Although the piece compels attention because of its early date, Bayer would produce a more captivating earthwork a couple of decades afterward.

THE NEW GROUND-BREAKERS

The earthworks-as-art movement was initiated by a small group of mainly New York sculptors who attained prominence in the 1960s. The decade witnessed a flurry of styles and tendencies; among these crisscrossing currents, minimalism was clearly the predominant style in the domain of sculpture.

Minimalist sculptures are reductive, almost oversimplified, so dedicated to being irreducible objects that they often seem confrontational and perversely inexpressive. Donald Judd fabricated floor-to-ceiling wall-sculptures that consist of several identical units of metal-and-Plexiglas boxes that cantilever from the wall at regular intervals. Robert Morris constructed plywood boxes in elementary shapes, painted an anonymous-looking battleship gray. Sol LeWitt specialized in see-through modular constructions that resemble jungle gyms. None of the above sculptors had any use for pedestals, deploying their works directly on the floor (unless, of course, they were designed to hang on the wall). Of the three, Morris, who had an astonishingly timely knack for recognizing new artistic issues, became an early initiator of earthworks.

But another minimalist sculptor, Carl Andre, may have had a more pervasive influence on earthworks because, more than anyone else, he suppressed the vertical orientation of sculpture, leveling it to the floor and making an issue of flatness. In 1966 he began attracting widespread attention with his provocative floorpieces, consisting of commercially manufactured products, such as bricks, which he laid down side by side like floor tiles in simple linear and rectangular formats. Instead of viewing sculpture as "structure," Andre redefined it as "place," alerting other artists to the possibilities of the ground plane as a field for sculptural activity. He even remarked in passing that his "ideal piece of sculpture is a road."[11]

Andre, Morris, and other artists of their generation wanted to create artworks that were so thoroughly integrated with their setting as to be inseparable from it—what eventually came to be known as site-specific art. Gradually, an idea began to crystallize: artists could expand the scale of their sculptures by "rooting" them to the ground and identifying them with the landscape itself. Sculpture would no longer be an alien object plopped *onto* the

terrain, but instead a fully integrated element *of* the overall landscape.

Earthworks became a certifiable art movement in 1968. During the course of that year, three of the movement's leading practitioners—Michael Heizer, Robert Smithson, and Walter De Maria—made exploratory visits to the desert regions that extend across the Southern California–Nevada border. Heizer created his Nine Nevada Depressions. De Maria proceeded to Germany, where he spread a two-foot-deep layer of wall-to-wall earth over the floor of a Munich art gallery. Smithson, a prolific essayist, published a tantalizing article, "A Sedimentation of the Mind: Earth Projects," in the September issue of *Artforum* (then New York's most avant-garde magazine). Carl Andre created a short-lived work, *Joint*, aligning 183 bales of hay to extend in a straight line for hundreds of feet across a Vermont field and into the woods. Robert Morris proposed an unrealized "earth project" for Evanston, Illinois, that would have assumed the form of an extremely long, sodded barrow that made four hairpin turns. In England, Richard Long designed "negative" ground patterns by removing linear sections of turf, digging out several inches of the underlying earth, then replacing the turf to define sunken volumes. In Japan Nobuo Sekine undertook a similar tactic: for an outdoor sculpture exhibition in Kobe's Suma Rikyu Park, he dug a cylindrical hole in the earth—nearly nine feet deep and slightly more than seven feet in diameter—then molded the displaced soil into an equivalent cylindrical volume that stood alongside the corresponding void. New York's Dwan Gallery presented (in October) a timely survey titled "Earthworks," which contained works by several key artists, including Andre, De Maria, Heizer, Morris, Smithson—and Herbert Bayer, who was represented by a photograph of his 1955 *Earth Mound*. Several of the younger artists were also represented by photographs of existing pieces or by drawings for contemplated projects. By year's end, the earthworks movement had definitely hit pay dirt.

THE PRIME MOVERS: ROBERT SMITHSON AND MICHAEL HEIZER

The individual who intellectually dominated the Dwan stable of artists was Robert Smithson (1938–1973), who possessed an uncommon gift for articulating many of the issues and concerns that preoccupied him and his colleagues. Born in Rutherford, New Jersey, he was exceptionally well read, with an eclectic range of interests that included geology, dinosaurs, crystallography, industrial wastelands, and science fiction. In the essays he published in art magazines, he usually argued against purity, idealism, and craftsmanship, preferring to side with flux, decay, and collapse. But he also wrote a spirited tribute to Frederick Law Olmsted, calling him "America's first 'earthwork artist.'"[12]

Smithson initially attracted attention in the mid-1960s with painted-steel minimalist sculptures whose planar surfaces and modular units often suggest the faceting of crystal formations. At the time, he was making frequent field trips to desolate areas in New Jersey, revealing a seemingly morbid fascination with despoiled sites, such as abandoned quarries. In 1968 he began exhibiting his series of Nonsites, one of which—*Nonsite, Franklin, New Jersey*—was included in the Dwan Earthworks show. These were essentially metal bins with slatted sides, devised to contain rocks, earth, chunks of broken cement, or other material evidence taken from a specific place; the exact location of the "find" was represented on a complementary map that he customarily displayed on a nearby wall.

"One cannot avoid muddy thinking when it comes to earth projects, or what I will call 'abstract geology,'" Smithson wrote in his 1968 "Sedimentation of the Mind" essay.[13] "One's mind and the earth are in a constant state of erosion, mental rivers wear away abstract banks, brain waves undermine cliffs of thought, ideas decompose into stones of unknowing, and conceptual crystallizations break apart into deposits of gritty reason. . . . This slow flowage makes one conscious of the turbidity of thinking. Slump, debris slides, avalanches all take place within the cracking limits of the brain."[14] The article revealed his awareness of "antiformative" processes newly relevant to sculpture, specifically dumping and pouring.

Pursuing the concept of "slow flowage" and intrigued by viscous materials, which

OVERLEAF: Robert Smithson. *Spiral Jetty*, 1970. Black basalt, limestone, and earth, length: 1,500', width of jetty: 15'. Northeastern shore of Great Salt Lake, Utah. Photograph by Gianfranco Gorgoni. *Smithson's most celebrated earthwork makes two and a half counterclockwise turns as it curls in on itself before coming enigmatically to a dead end.*

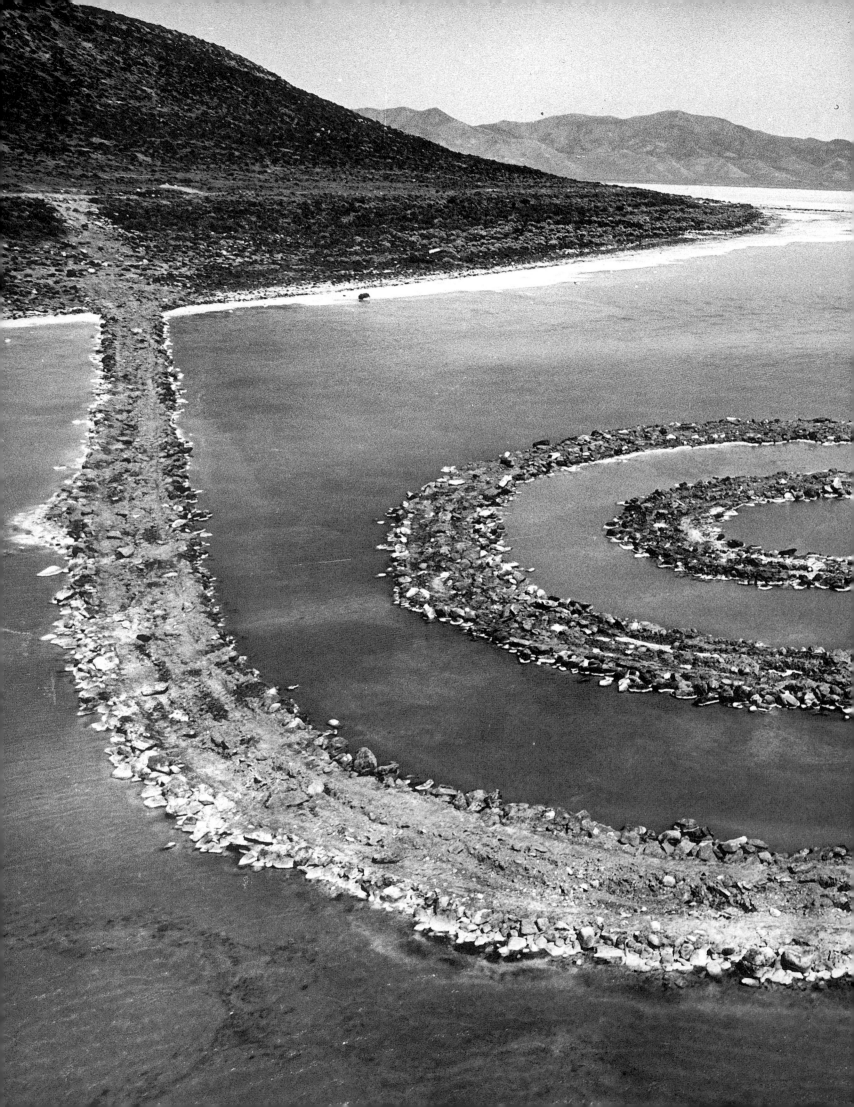

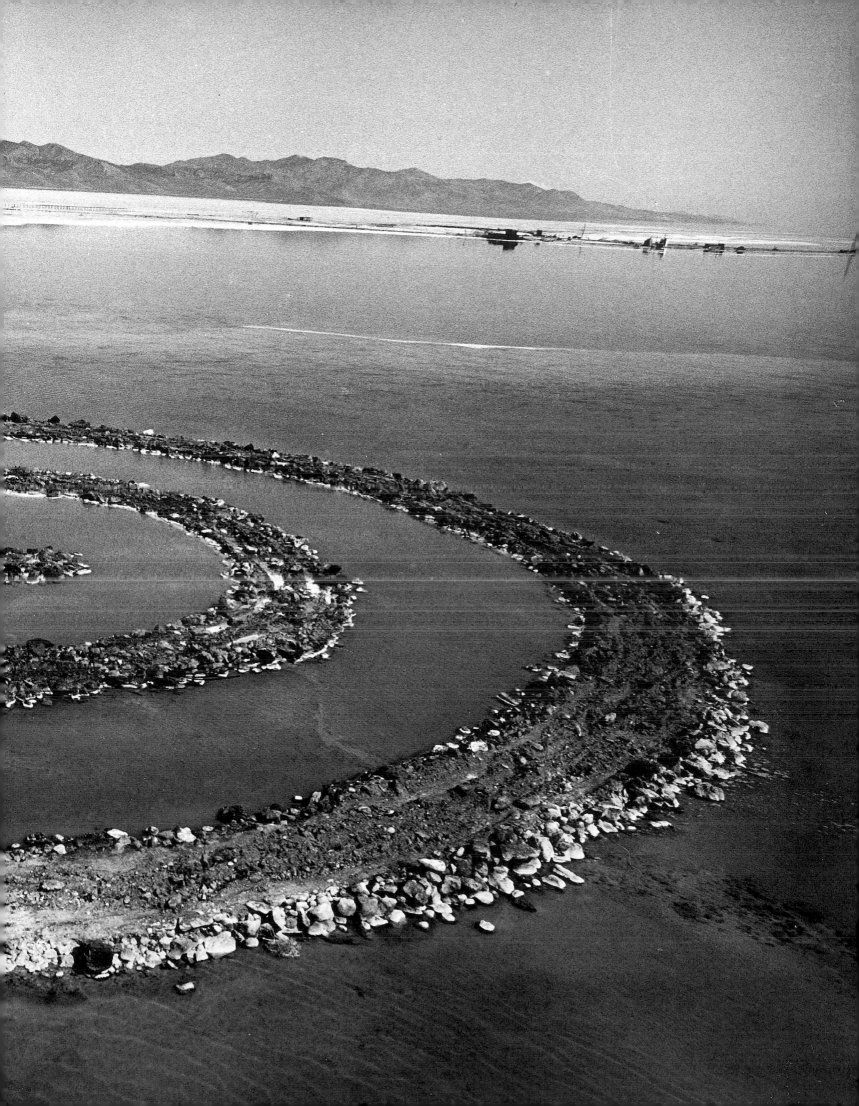

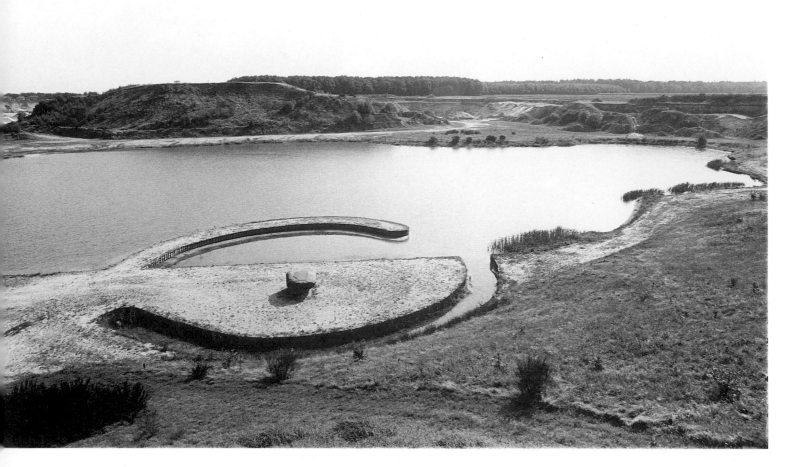

ABOVE: Robert Smithson. *Broken Circle*, 1971. Earthen fill, dia.: 140'. Emmen, The Netherlands. Photograph by Pieter Boersma. *Smithson combined a curved jetty with a correspondingly curved canal to create a circular work in a disused sand quarry.*

RIGHT: Robert Smithson. *Amarillo Ramp*, 1973. Red shale and earth, length: 396', height: 14'. Tecovas Lake, near Amarillo, Texas. Photograph by Gianfranco Gorgoni. *Smithson designed his last earthwork to arise from a man-made irrigation pond on a Texas ranch. The ramp curves to create a ringlike form about 150 feet in diameter.*

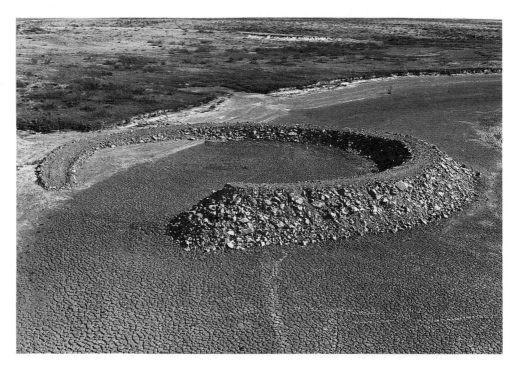

respond with a natural flux to the force of gravity, Smithson began pondering the sculptural potential of materials such as asphalt, mud, and glue. For his 1969 piece *Asphalt Rundown*, a truckload of asphalt was poured down the side of a quarry near Rome. Gravity and the viscosity of the asphalt determined the final shape of the spill.

In April 1970 Smithson constructed what would become his most celebrated earthwork, the majestic *Spiral Jetty*, on the bleak northeastern shore of Great Salt Lake in Utah. The "jetty" is a stone-and-earth causeway, 15 feet wide and 1,500 feet long, spiraling from the shore and making two and a half turns in a counterclockwise direction. The spiral form, so prevalent in nature and rich in referential overtones, was one of Smithson's favorites. For both practical and economic reasons, he utilized the materials of the site itself—a mixture of black basalt, limestone, and earth. He waded into the water to lay out his stakes, using a central stake and string to establish the spiraling arcs. Contractors and earthmoving equipment were hired to excavate the rocks and soil. Drivers of the dump trucks had to cautiously back out along the coil to deposit their loads.

Spiral Jetty is a rough, rock-strewn course that winds in on itself and comes to a dead end. Visitors who walked its length found themselves simultaneously at the jetty's terminus and in the center of the overall piece. Many people sensed that the work referred to the primordial origins of life along the shore.

Spiral Jetty turned out to be surprisingly responsive to seasonal and climatic variations. The water changed color, depending on the amount of algae, and the rocks were subject to shifting levels of salt incrustation. During the summer of 1971, the lake rose and completely submerged the jetty under a few inches of water. As the water level dropped through evaporation, *Spiral Jetty* reappeared. The surrounding algae-glutted water was unusually reddish, and, to quote the artist, "the entire *Jetty* looked like a kind of archipelago of white islands because of heavy salt concentrations."[15]

Smithson approved of nature's shifting temperament. "The main objective is to make something massive and physical enough so that it can interact with those things and go through all kinds of modifications," he said. "If the work has sufficient physicality, any kind of natural change would tend to enhance the work."[16] Before long, however, *Spiral Jetty* was inundated again—and possibly for a very long time. The level of the Great Salt Lake continues to rise, submerging nearby roads and railroad tracks.

Smithson continued his variations on spirals and jetties in a pair of works that he created for the 1971 version of Sonsbeek, an international art exhibition held in Holland. The show's organizers initially had planned to display the works in a park, but Smithson rejected the idea because he believed that a park was already a work of art. Through contacts, he found an almost exhausted sand quarry with a body of water in it in Emmen, in northeastern Holland. When he first saw the site, he was impressed by its suitability to an idea that had been "lurking" in his mind—a circular piece, combining a jetty and canal.

As realized, *Broken Circle* incorporates both land and water to define a large round shape (140 feet in diameter), bisected by the shoreline. A curved jetty arcs into the water and a similarly curved canal cuts into the land to define the two halves of a full circle. The work tantalizes with its dramatic symmetry of corresponding shapes, the semicircles of water and earth, the curving borders of jetty and canal. The interlocking halves suggest an almost yin/yangish union. A large glacial boulder, discovered on the site during construction and too difficult to remove, stands on the half-circle of land, anchoring the piece—like a navel—to its geological past. At first, Smithson believed the boulder contributed an objectionable focal point to the work, but he resigned himself to its presence once he recognized its contemporaneity with nearby prehistoric megaliths.

On a bank adjacent to *Broken Circle*, Smithson created a corresponding earthwork, *Spiral Hill*, a conical form whose base is 75 feet in diameter. It has a path of white sand that winds counterclockwise to the top. Less astounding than *Spiral Jetty*, *Spiral Hill* suffers by comparison because of its more predictable form and somewhat nonchalant construction.

Smithson's last major earthwork would be *Amarillo Ramp*, which he initiated in 1973 on

a private ranch northwest of Amarillo, Texas. He planned the piece as still another variation on a spiraling curve, this time a ramp that gradually rises as it extends from the bank of an irrigation pond into the water. The ramp is composed of red shale and earth and forms an incomplete circle about 150 feet in diameter. When the pond is full, the ramp curves away from the shore into several feet of water.

As he did with *Spiral Jetty*, Smithson waded into the lake to stake out the piece. On July 20, 1973, Smithson and a professional photographer boarded a small chartered plane to survey and document the site. The pilot flew them over the area and, afterward, Smithson rewalked the site and staked out the piece more precisely. Then he and the photographer returned to the airplane for another aerial survey. This time they were flying low over the site when the plane's engine stalled. The aircraft slammed to earth and killed all three men on board. As the 35-year-old artist had been virtually teeming with ideas for future projects, his swift and tragic demise left a chilling void in the art world. Smithson's widow, artist Nancy Holt, assisted by friends, completed *Amarillo Ramp* a couple of months later.

In contrast to Smithson and his brooding references to prehistoric epochs, Michael Heizer (b. 1944) aspired to make clean-cut geometric abstractions that were devoid of referential overtones. Whereas an appetite for erosion and flux informed Smithson's aesthetic, durability and precision were what counted for Heizer. As a child in Berkeley, California, he became acquainted with ancient petroglyphs and prehistoric architectural structures through his father, Robert F. Heizer, a prominent archaeologist who headed the anthropology department of the University of California. The youngster frequently accompanied his father on field trips to desert sites in California and Nevada to study rock carvings.

In 1966 Heizer headed for New York, where he painted geometric abstractions on eccentrically shaped canvases until he convinced himself that painting was no longer "relevant." Feeling somewhat alienated from the city's art scene, he withdrew in December 1967 to the desert alongside the Sierra Nevada mountain range in eastern California, where he made a series of "negative sculptures," digging geometric figures in the ground. The pieces were impermanent—and on public land—but he methodically documented them in photographs.

Heizer's intention was to invent an "American art" that owed nothing to European sources. (References to the designs of Native Americans and Mesoamericans were permissible.) He maintained that he could express himself satisfactorily through the basic mediums of soil and rock: "I think earth is the material with the most potential because it is the original source material."[17]

In 1968 Heizer traveled westward again, going to California's Mojave Desert to create a group of sculptures, ground paintings, and drawings. He also worked in Nevada, making *Nine Nevada Depressions*, a series of shallow, linear cuts in several dry lake beds, spaced out along a 520-mile-long extent. He chartered a small plane to scout potential desert sites and then, having chosen some from the air, rented a pickup truck to drive the 100 or so miles to his designated spots. Once there, he used a pickax, shovel, and wheelbarrow to remove portions of the crusty, fissured surface of the mud flats. One of the Nevada Depressions was *Isolated Mass/Circumflex #2*, a 120-foot-long trench with a loop in the center, trailing across Massacre Dry Lake. Another work, *Dissipate*, consisted of a cluster of five 12-foot-long trenches, their random orientation based on the fall of match sticks, carved out of Black Rock Desert. Abandoned to the desert's natural processes of erosion, these early works have largely disappeared.

The fact that Heizer's negative sculptures existed in remote areas at a forbidding distance from most of the art audience did not prevent him from making his photographs of them available to galleries, collectors, and the art press. From the very beginning, earthworks shared a common ground with conceptual art: both rely on documentation to supply an informational and commercial framework for the artists' aesthetic activities.

Heizer achieved his most famous work, *Double Negative*, in 1970, the same year as Smithson's *Spiral Jetty*. In 1969 Heizer purchased 60 acres of Mormon Mesa, near Overton,

OPPOSITE, BELOW: Michael Heizer. *Complex One*, 1972–74. Concrete, steel, and compacted earth, 110 x 140 x 23½'. Garden Valley, Nevada. Collection of the artist and Virginia Dwan. Photograph by Michael Heizer. *The "front" of Heizer's mastaba-like sculpture is sloped at a 45-degree angle and framed by a discontinuous band of concrete beams. When viewed straight-on from a distance, the beams appear to form a continuous rectilinear border.*

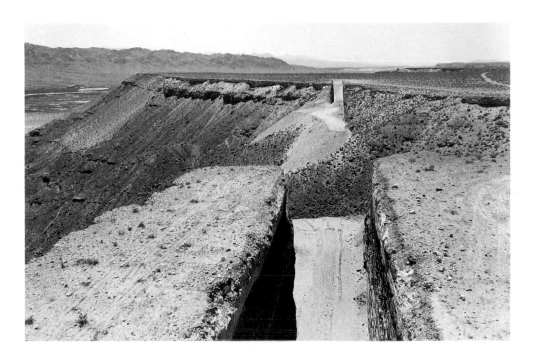

LEFT: Michael Heizer. *Double Negative*, 1969–70. Rhyolite and sandstone, 1,500 x 30 x 50'. Mormon Mesa, Overton, Nevada. The Museum of Contemporary Art, Los Angeles. Gift of Virginia Dwan. Photograph by Michael Heizer. *The artist excavated facing grooves—each 30 feet wide, 50 feet deep, and 100 feet long—on opposite sides of a curved mesa. The cuts are aligned to constitute a continuous 1,500-foot-long rectilinear void.*

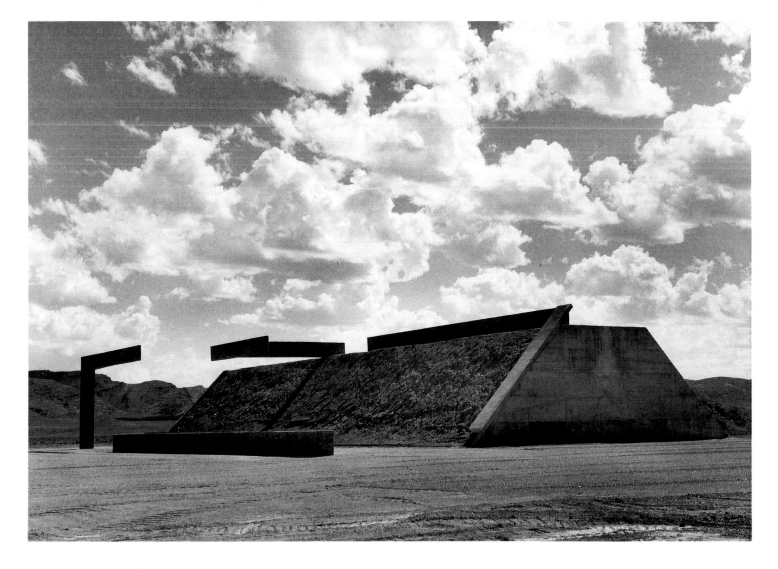

Nevada. There he excavated two facing slots, each 30 feet wide, 50 feet deep, and 100 feet long on opposite sides of a curved mesa. He blasted and bulldozed 240,000 tons of earth and rock to carve out two matching rectangular grooves, which are aligned to suggest they are the terminal points of a continuous 1,500-foot-long line. "All it really is, is absence," Heizer said. "Obviously the open space between the two cuts is implicated. This combination creates the double negative. If you can visualize the voids combining, then you understand the work. What's interesting is that the center, almost a third of the sculpture, is an implied volume."[18]

In 1972 Heizer bought an 1,800-acre property in Garden Valley, Nevada, about 180 miles north of Las Vegas, where he began constructing a kind of earthworks "city" composed of massive earth-and-concrete forms. The first element, *Complex One*, completed in 1974, resembles a mastaba, being a 20-foot-high, flat-topped rectilinear mound of earth, with its 140-foot-wide western or "front" side sloped at a 45-degree angle. This front is framed on all four edges by a band of concrete beams, each about three and a half feet wide, bringing the total height of *Complex One* to 23½ feet. As seen from a distance, the concrete beams appear to constitute a continuous rectilinear border. But viewed from a closer, more angular vantage point, the border proves to be discontinuous, segmented into six different columns, two of which are cantilevered. Of the two cantilevered sections, one is T-shaped and juts out 30 feet, while the other, positioned at the extreme left, is an inverted L-shaped column. Heizer relates the concrete banding to a serpent motif that he saw on the walls of a Maya structure at Chichén Itzá in Mexico. "The head of the snake sticks out at one end of the wall, the body runs along the edge, and the tail protrudes at the other end. The body of the snake is a lineal element upon the wall. I used this basic idea from a drawing I made there."[19] The two shorter sides of the mastaba are faced with concrete walls. The rear of the piece is left unfinished.

Since 1980 Heizer has been working on the "city's" *Complex Two*, *Complex Three*, and *Complex Four*. *Complex Two* is more than a quarter of a mile long and sited half above ground and half below ground.[20]

Heizer's *Double Negative* and Smithson's *Spiral Jetty* were undoubtedly the most impressive and talked-about of the early earthworks, becoming instant classics of contemporary art. But there were many other contributors to what became a mini-boom in Land art.

VARIETIES OF LAND ART, 1968–79

Robert Morris (b. 1931) and Richard Long (b. 1945), minimalist sculptors on opposite sides of the Atlantic, played key roles in the early phase of Land art. Each had a knack for taking extreme positions, which promptly established some horizons of the new movement.

Morris has demonstrated a consistent interest in shaping earth into sculptural forms. For the 1971 Sonsbeek exhibition in Holland (the same show that included Smithson's *Broken Circle*), Morris devised one of his most ambitious earthworks, *Observatory*. The work consisted of an earthen ring that was eight feet high and 60 feet across, encircled by additional earthwork structures. *Observatory* was razed at the conclusion of the exhibition but later (1971–77) reconstructed in an enlarged form and permanently installed at Oostelijk in Flevoland Province on land reclaimed from the vast IJsselmeer or Zuider Zee. The piece now consists of two concentric earthen rings with an outer diameter of nearly 300 feet. The inner ring, which is nine feet high and 79 feet in diameter, was formed by piling up earth against a wooden palisade. Visitors enter the work by a triangular passageway in the outer earthen embankment. From there, they follow a path that leads into the central ring. Inside that space, they find other openings in the inner ring that offer views of V-shaped notches in the outer ring. The sightlines are oriented to the two solstitial and the two equinoctial sunrises.

Observatory's obvious allusions to ancient megalithic monuments such as Stonehenge and Avebury seem somewhat heavy-handed and pedantic. At the same time, Morris

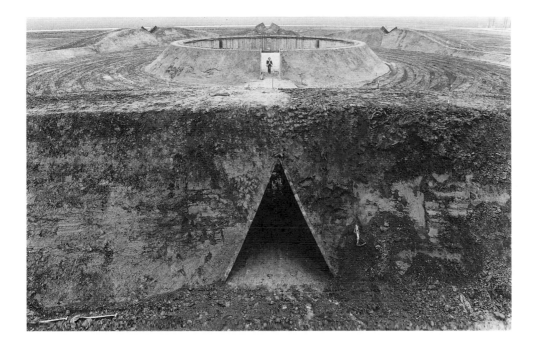

LEFT: Robert Morris. *Observatory,* 1971–77. Earth, wood, and granite, dia.: 298½', height: 9'. Oostelijk, Flevoland Province, The Netherlands. Photograph by Pieter Boersma. *The inner ring, 79 feet in diameter, consists of earth piled up against a wooden palisade. The V-shaped sightlines in the outer earthen embankment are oriented to seasonal sunrises.*

BELOW: Richard Long. *Mirage: A Line in the Sahara,* 1988. Displaced rocks. Ahaggar Plateau, southern Algeria. Courtesy of the artist. *Long creates minimalist compositions in uninhabited terrain, often by rearranging natural materials—in this case, rocks.*

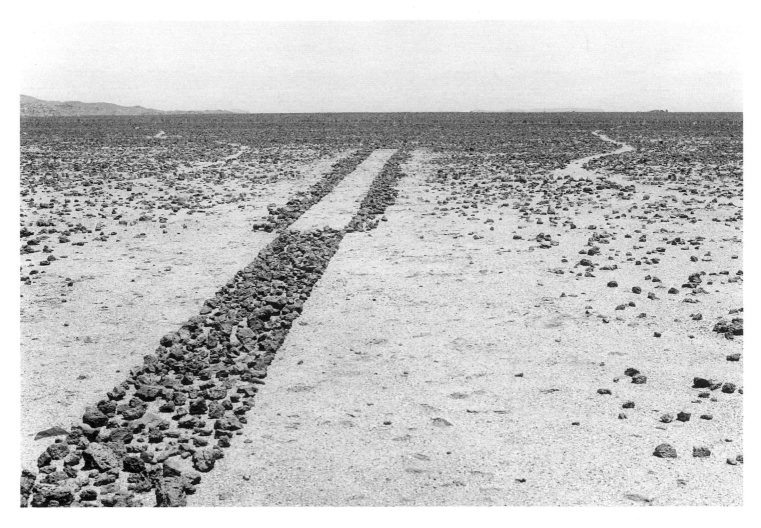

appears to be uncritical in his facile adaptation of ideas derived from the unproven theories of contemporary archaeoastronomers. His *Observatory*, unlike its prehistoric antecedents, is devoid of religious or ceremonial overtones, although its pretensions are indeed astronomical.

References to Britain's ancient earthworks make a recurrent but subtle appearance in the work of Richard Long, who grew up in Bristol, England, not far from Salisbury Plain. Long creates deliberately ephemeral outdoor works of natural "found" materials, typically in uninhabited sites that are devoid of any trace of human activity. He imposes himself on the landscape in a gentle, respectful manner, usually by organizing the materials (most often, stones and sticks) into elementary geometric forms. His figure-ground compositions are essentially two-dimensional designs deployed on the ground. For a 1967 "path piece," he walked a straight line back and forth across a grassy field until his shoeprints merged to yield a uniform linear mark on the turf. Most of his work seems ascetic, meditative, and even spiritual, not unlike the sparse stone arrangements in Japanese dry gardens.

Long is an itinerant artist who improvises works during his journeys. He considers walking and camping to be an idyllic sort of life and believes walking is an ideal way to generate sculptures. So, equipped with a backpack and cooking and sleeping gear, he tramps about the globe for at least a few months each year. He has walked across Scottish moors and North African deserts, and he has scaled the Himalayas and the Andes. In 1975 he walked every road and lane within a six-mile radius of the Cerne Abbas Giant, the prehistoric hill figure in Dorset. He also has made two pieces "about" Silbury Hill and several of his stone groups deliberately evoke ancient British megaliths.

Long's intentionally short-lived pieces seldom leave much of a physical trace. For one 300-mile walk, he left as the only record of his passage five piles of stones. Often, after he has documented his stone compositions in black-and-white photographs, he scatters the rocks and restores the site to the condition in which he came upon it. (The photographic documentation becomes the surrogate public work of art.

Many artists who made outdoor installations—especially those who created large-scale, impermanent pieces—found themselves categorized under the Land art rubric during the late 1960s and early 1970s. Among them, four of the New York art world's most startling talents were Dennis Oppenheim (b. 1938), Christo (b. 1935), Peter Hutchinson (b. 1932), and Walter De Maria (b. 1935). All four displayed a flair for flamboyant theatrics in rugged parts of the world.

Oppenheim employed a dizzying variety of mediums, including an icy, snow-banked river. For his *Annual Rings* of 1968, he superimposed a schemata of tree rings upon a frozen portion of the Saint John River, which separates the northern border of Maine from New Brunswick. He shoveled and chopped away snow to reveal six concentric half-circles of ice on either side of the river. The ground pattern was approximately 150 by 175 feet overall. The fact that the piece spanned the U.S.-Canadian border apparently held significance for the artist, who stated, "Seeing these rings brutally disconnected by a political boundary should at least hint at the latent content of the project."[21]

Christo, the Bulgarian-American entrepreneur who typically employs acres of plastic fabric to dramatically (but temporarily) transform large stretches of terrain, draped a mile-long section of cliff-edged coast near Sydney, Australia, in white woven polypropylene and rope in 1969. By swathing the rocky topography in smoothly unifying fabric, he converted it into a surrealistic setting that was almost hallucinatory in its scale and eeriness.

While his colleagues incorporated rivers and oceanfront cliffs in their work, Hutchinson took on an active volcano. In 1970, he traveled to Paricutín, about 360 miles northwest of Mexico City, and distributed some 500 loaves of crumbled bread in the faults alongside the rim of the volcano's crater. The aim of his *Paricutín Project* was to juxtapose living microorganisms (bread mold) with a sterile macrocosmic landscape (volcano). During the six-day project, the bread crumbs turned from white to orange, all scrupulously documented in photographs.

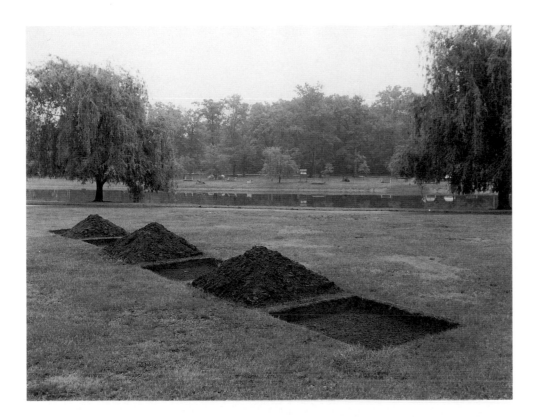

Cecile Abish. *4 into 3*, 1974.
Excavated earth, overall 45 x 5';
excavations, 5' x 5' x 7"; heaps
5' x 5' x 30". Impermanent installa-
tion at Van Saun Park, Paramus,
New Jersey. Courtesy of the artist.
*The New York artist's unitary com-
position involved the transference
of earth from four shallow pits to
three interposing mounds.*

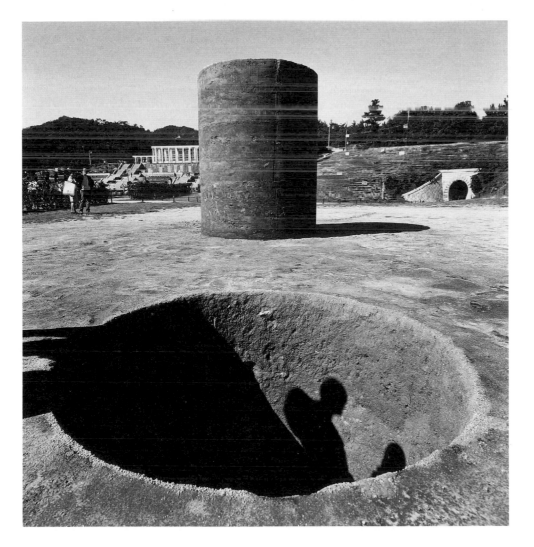

Nobuo Sekine. *Phase-Mother
Earth*, 1968. Earthen column,
height: 106⅜", dia.: 86⅝".
Impermanent installation at
Suma Rikyu Park, Kobe, Japan.
Photograph by Osamu Murai. *As
his contribution to an outdoor
sculpture exhibition, Sekine dug a
cylindrical hole in the ground, then
molded the displaced earth into an
equivalent cylindrical volume.*

RIGHT: James Turrell. *Roden Crater Site Plan with Projected Cross Section*, 1990. Wax pencil drawing on vellum paper, 40¼ x 58¾". Courtesy Barbara Gladstone Gallery, New York. *Turrell plans to reshape and standardize the bowl and rim of the Roden Crater, an extinct volcano in Arizona, to create an ideal vantage point for sky-watching. Tunnels will provide access to the bottom of the crater. This study combines an aerial photographic view of the crater with an elevation drawing of the silhouetted mountain, showing the location of the tunnels.*

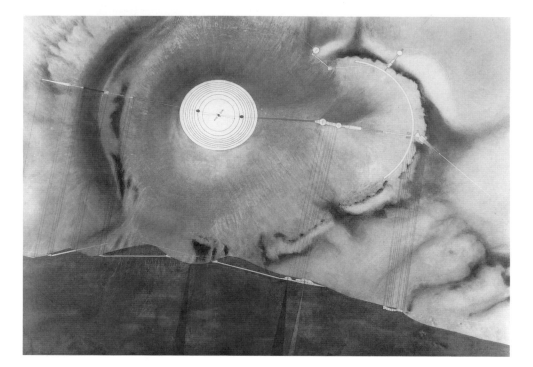

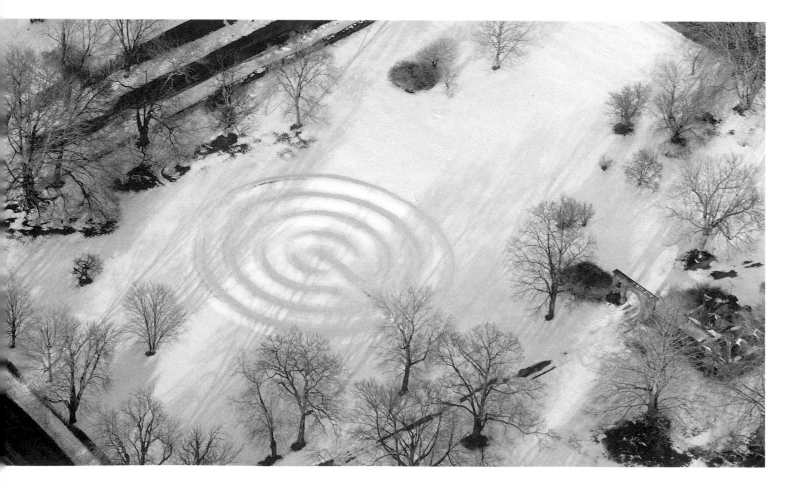

De Maria, one of the most eccentric and cryptic artists of his generation, numbers among his famous achievements an outdoor grid sculpture, *Lightning Field*, dating from 1976–77 (but evolving from a "test" version made on a reduced scale in another location in 1974). In its final form *Lightning Field* consists of 400 stainless-steel poles deployed in the desert near Quemado, New Mexico. The poles are spaced 220 feet apart, defining a rectangular area that measures one mile by one kilometer. They range in height from 15 to more than 26 feet, depending on the varying elevation of the terrain, but their pointed tips are aligned to create a level upper plane that is approximately 20 feet above the ground, which the artist left unaltered.[22]

A second wave of earth artists also explored new aesthetic terrain. Like Hutchinson, James Turrell (b. 1943) saw design possibilities in volcanoes, and he has pursued an extraordinarily ambitious project for more than 20 years. His main medium is light, both natural and artificial, which he concentrates in a sculptural manner to redefine a given space. Through his resourceful manipulations, light attains an almost palpably physical presence. Around 1972 Turrell was struck by the idea that a bowl-shaped volcanic crater would be an ideal "focusing device" for sky-watching. As the Los Angeles-born artist is also a pilot, he took to the air to scout for a suitable volcano. His search intensified during 1974–75 as he aerially surveyed the western United States from Canada to Mexico. Finally, he zeroed in on the Roden Crater, about 50 miles north of Flagstaff, Arizona.

The Roden Crater, which has an elevation of 5,415 feet, is one of more than 400 craters that make up a volcanic field that runs through northern Arizona. Its form was almost perfectly conelike, with a truncated top whose rim was nearly regular. Turrell purchased the 1,100-acre site in 1977 and initiated construction two years later. (The scheduled completion of the project has been repeatedly delayed.) He plans to move more than 100,000 cubic yards of volcanic cinder to even out the crater's rim. He also plans to construct a tunnel, running nearly 330 yards long through the base of the volcano, that will lead visitors to the bottom center of the crater. After making the underground passage, viewers will perceive the sky as if it were a three-dimensional inverted bowl that had alighted on the perfectly round rim of the crater. In this way, Turrell will focus viewers' attention on the phenomenon of "celestial vaulting."

In contrast to Turrell, Richard Fleischner (b. 1944) is a more systematic sculptor with a great many outdoor designs to his credit. The Rhode Island artist is particularly intrigued by mazes, which he has devised in a variety of materials. In 1974, he constructed *Sod Maze* on an estate lawn in Newport, Rhode Island. The composition, which is 142 feet in diameter, has four concentric rings, all intersected by a radial line. A single pathway leads visitors in alternately clockwise and counterclockwise directions before reaching the center.

LAND ART AND ENVIRONMENTAL RECLAMATION

The first Earth Day was organized in 1970—the same year as *Spiral Jetty* and *Double Negative*—to promote the public's awareness of ecology and the need to conserve the globe's natural resources. (Earth Day is now observed on April 22 in 140 nations.) While Land art certainly contributed to citizens' interest in ecology, few of its makers would have qualified as environmental activists. Indeed, some artists displayed a chilling insensitivity to nature, regarding the great outdoors as nothing more than a colossal sketch pad on which to impose their artistic egos. But, as museum curator Michael Auping points out, "Insofar as earth art physically interacts with the landscape, it cannot be ecologically neutral. Ecological politics is thus an inherent aspect of earth art."[23]

Robert Smithson complained that "the ecology thing" had become "like the official religion now," and he insisted that he was "totally concerned with making art."[24] His experience in building *Broken Circle* in a quarry, however, awakened him to the possibilities of making art on disused industrial sites. That year, he began contacting corporations, particularly mining companies, offering to "reclaim" their devastated properties with his earth-

OPPOSITE, BELOW: Richard Fleischner. *Sod Maze*, 1974. Sod over earth, dia.: 142', height: 18". Château-sur-Mer, Newport, Rhode Island. Photograph by Gene Dwiggins. *The four concentric rings of this sod maze (snow-covered in this view) are intersected by a single radial line. The pathway alternates in clockwise and counterclockwise directions as it leads to the center.*

RIGHT: Robert Smithson. *Wandering Canal with Mounds M3,* 1971. Pencil, 19 x 24". Courtesy John Weber Gallery, New York. *Smithson contacted several mining companies, offering to create earthworks on their disused excavation sites. This sketch presents his scheme for a serpentine canal that winds around many rounded mounds of tailings.*

BELOW: Robert Morris. *Untitled (Johnson Pit #30),* 1979. Terraced and grassed gravel quarry, tree stumps preserved with tar, 3½ acres. Sea Tac, Washington. Commissioned by King County Arts Commission. Photograph by Colleen Chartier. *Morris transformed a disused gravel pit into a multileveled sculpture by regrading the excavation into an irregularly shaped bowl with concentric terraces.*

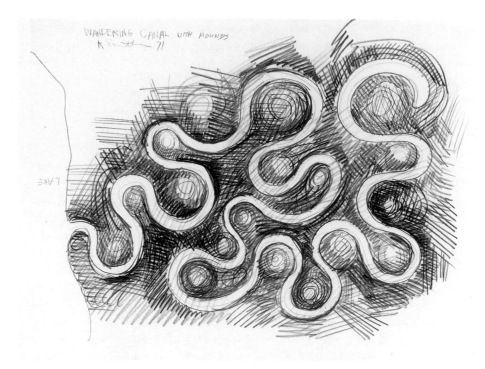

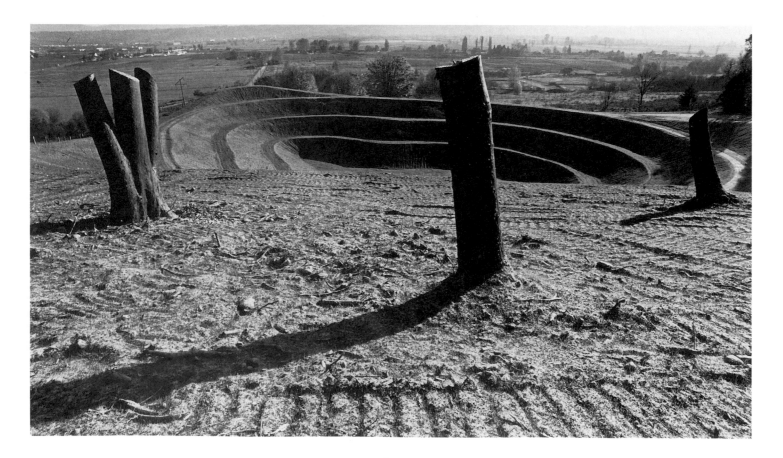

works. He advised his colleagues that "the best sites for 'earth art'" were those "that have been disrupted by industry, reckless urbanization, or nature's own devastation."[25] He maintained, "Art can become a resource that mediates between the ecologist and the industrialist."[26] It is difficult to assess the level of Smithson's commitment: did he really believe that artworks could rectify otherwise despoiled and polluted landscapes?

In 1972 Smithson submitted reclamation proposals to Hanna Coal, which was considering the restoration of a 1,000-acre strip-mined site in southeastern Ohio. The piece he wanted to build, *Lake Edge Crescents*, would have related to *Broken Circle*, featuring another curved jetty along the shore of a lake. In 1973 the artist contacted Minerals Engineering, a Denver mining company, and sent in sketches of several proposed *Projects for Tailings*. Smithson would have used the tailings (the solid waste that remains after ore is extracted from rock) to build several terraced earthworks. Executives of both companies were tantalized by Smithson's ideas, but nothing came of the proposals.

One of the first and most ambitious attempts to link land reclamation with public art works occurred in King County, Washington. In 1979 the King County Arts Commission sponsored a project titled "Earthworks: Land Reclamation as Sculpture," and invited several artists, including Herbert Bayer and Robert Morris, to submit designs to help restore environmentally problematic areas, including quarries, a landfill, and an abandoned airstrip, in various parts of the county. The arts commission was sufficiently impressed by Morris's proposal to engage him to implement his scheme for an abandoned gravel pit, which the county intended to convert into a park. Morris altered the gravel pit by regrading its bowl like concavity into an irregularly shaped, concentrically terraced form. His aesthetic transformation of the pit was so subtle that some area residents complained he had merely parodied a strip mine. He further antagonized some people by cutting down a group of fir trees that had been growing along the rim, leaving only their stumps in place, which he had treated with wood preservative and coated with bitumen. The lopped-and-tarred tree stumps were intended perhaps as sardonic commentary on the site's previous exploitation.

Morris seemed to feel that artists face a moral dilemma in agreeing to "beautify" disturbed sites. Expressing his reservations about artist-doctors of sick sites, he said (in 1979): "The most significant implication of art as land reclamation is that art can and should be used to wipe away technological guilt. Will it be a little easier in the future to rip up the landscape for one last shovelful of a nonrenewable energy source if an artist can be found—cheap, mind you—to transform the devastation into an inspiring and modern work of art?"[27]

Elsewhere in King County, the city of Kent engaged Herbert Bayer to help restore a creek area in a badly eroded canyon. Land development along the creek had resulted in an excessive flow of water during periods of heavy rain, and the city wanted to find a way to contain the runoff and allow it to recede slowly. Bayer designed a group of grass-covered earthworks which check further erosion by functioning as part of a drainage system. The *Mill Creek Canyon Earthworks*, built in 1979–82, are the centerpiece of a large park that also includes a play area and a canyon trail.

The most ambitious reclamation project of the 1980s is undoubtedly Michael Heizer's *Effigy Tumuli*, a group of five earthen mounds in the form of animals near Ottawa, Illinois, about 75 miles southwest of Chicago. The effigies were designed for a former mining site that runs along the top of a sandstone bluff overlooking the Illinois River. The property had been disfigured by surface mining for coal during the 1930s, becoming an environmental wasteland that the state of Illinois had identified as a high-priority area for reclamation because it was adjacent to Buffalo Rock State Park. The barren spoil—the soil and rock overburden that was removed to expose the coal—had been left in ridges more than 20 feet high. Acidic shale and pyrite had been deposited over the topsoil, making the land so toxic that, even 50 years later, it was virtually incapable of sustaining vegetation. The rain water that collected on it acidified before flowing into the Illinois River and a nearby lake, polluting both.

The Ottawa Silica Company, which owned the property, donated nearly 200 acres of land to the state of Illinois, and the federal Office of Surface Mining provided nearly $1 million in reclamation funds. Illinois's Abandoned Mined Lands Reclamation Council coordinated the effort and oversaw the engineering and construction of what came to be the Buffalo Rock Reclamation Project.

In 1983 the project was offered to Heizer. He was quick to point out that he was not an artist who cared about restoring degraded environments. He insisted that "reclamation sculpture" held no interest for him: "I'm not for hire to go patch up mining sites. The strip-mine aspect of it is of no interest to me. I don't support reclamation art sculpture projects. This is strictly art. I love mining sites. My whole family has been in the mining business." (His paternal grandfather was a mining engineer and his maternal grandfather was chief of California's Division of Mines.)

Heizer visited the site and eventually decided to devise animal forms reminiscent of the effigies that prehistoric peoples had constructed nearby and throughout much of the upper Midwest. "The native American tradition of mound building absolutely pervades the whole place," he observed, "mystically and historically and in every sense."[28]

For practical purposes, Heizer let the existing topography suggest to him certain animal forms that he could translate into geometric configurations, thus minimizing the need for extensive earth moving. He finally settled on five animals—snake, turtle, catfish, frog, and water strider—all of which are both associated with water and indigenous to the region. The project was completed in 1988.

Three of the effigies are deployed in a curving line that roughly parallels the edge of the bluff. Of this trio, the most successful are *Water Strider* and *Catfish*, both strikingly articulated. The insect rises to a maximum height of 14 feet and is 685 feet long. The fish is even longer—770 feet. The drastically compacted frog effigy measures 340 feet from nose to tail. Both the snake and the turtle are situated as if descending the bluff and are intended to be visible to Illinois River boaters. Heizer incorporated preexisting masses of earth for most of the turtle, designing only the rear limbs and tail. The angular snake is segmented into seven parts and, if stretched out in a straight line, would measure 2,070 feet. While the effigies are large, they are not aggressively monumental but, instead, blend subtly into the terrain. They hug the ground and are scarcely discernible until the visitor is practically upon them.

LAND ART SINCE 1980

Earth art continues to challenge the imaginations of artists, many of whom are sought after by governmental agencies and private foundations to create pieces for public spaces. Canadian Bill Vazan (b. 1933), for instance, has created a substantial body of Land art since the late 1960s, working consistently in natural materials, such as soil, sand, rocks, chalk, and snow. Many of his forms are derived from archaeological or more recent historical sources, which he translates into relief patterns on the surface of the ground. He made *Tire Track* (1987) for a park in Sherbrooke, Québec, by removing turf from a circle of earth, about 50 feet in diameter, to reveal a witty, Pop-oriented design of colossal tire treads. As a tire is a metaphorical extension of a human foot, the piece cleverly refers to humankind's imprint on the earth's surface.

The people's quest for justice came to mind when California artist Lloyd Hamrol (b. 1937) was commissioned to design an outdoor sculpture for the law school campus at the University of New Mexico in Albuquerque. He became "preoccupied with thoughts about the scales of justice," which led him to design *Highground* (1980), a concrete-and-sod sculpture that is 60 by 45 feet across and wedged at an angle into the surrounding lawn. The work suggests a grass-covered saucer or pan trying—judiciously, of course—to find its correct balance.

In Britain, Andy Goldsworthy (b. 1956) fashions mainly ephemeral outdoor works of natural materials, such as snow, ice, leaves, bark, sand, and stones. Some of the pieces are so

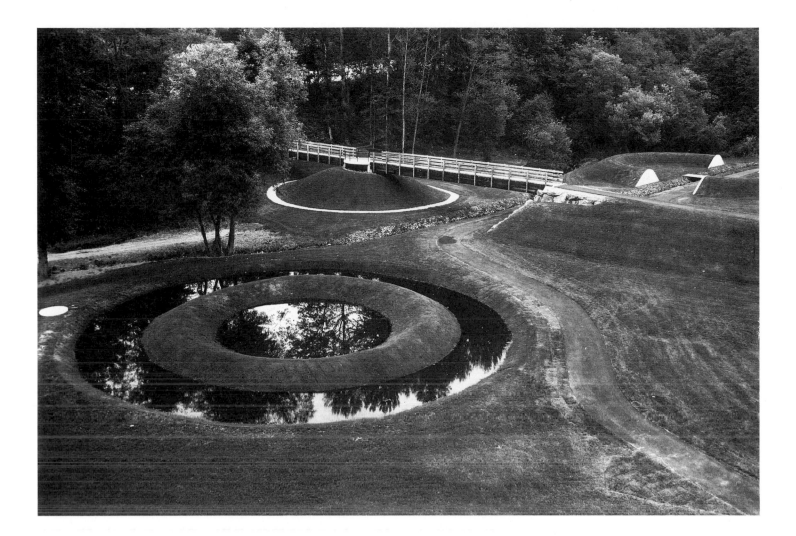

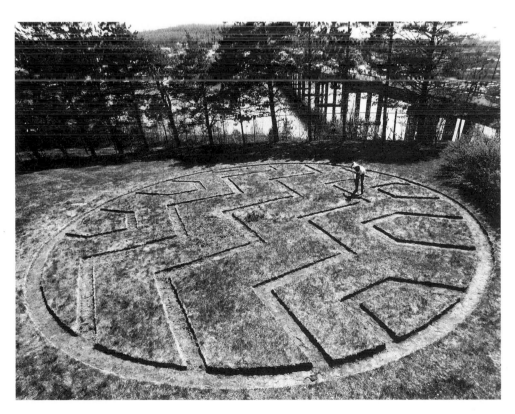

LEFT: Bill Vazan. *Tire Track*, 1987. Turf removal, dia.: 50', depth: 6". Impermanent installation at Parc Jacques-Cartier, Sherbrooke, Québec. Photograph by Bill Vazan. *The giant tire treads may refer to humankind's continuing imprint on the earth.*

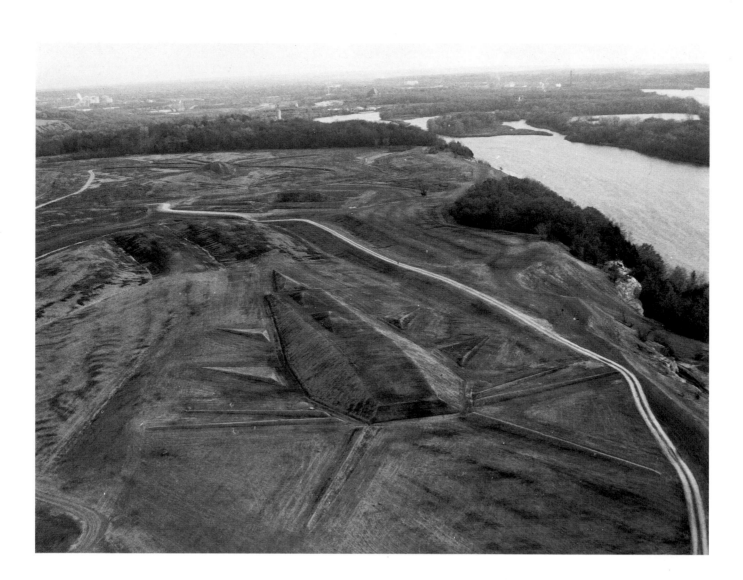

ABOVE: Michael Heizer. *Catfish* (from Effigy Tumuli), 1983–85. Compacted earth, 770 x 280 x 16'. Buffalo Rock State Park, Ottawa, Illinois. Commissioned by the Ottawa Silica Company Foundation for the State of Illinois. Photograph by Michael Heizer. *All five of the animal effigy mounds Heizer designed for a former surface mining site along the Illinois River are indigenous to the region and associated with water. The whisker-like barbels of the* Catfish *are 170 feet long.*

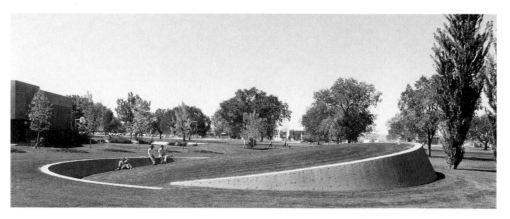

ABOVE: Lloyd Hamrol. *Highground*, 1980. Concrete and sod, 60 x 45 x 5'. School of Law, University of New Mexico, Albuquerque. Photograph by Mike Mouchette. *Commissioned to design a sculpture for a law school campus, Hamrol decided on a disk of banked earth to suggest the scales of justice.*

Andy Goldsworthy. *Lambton
Earthwork*, 1988. Earthen serpen-
tine mound, length: ¼ mile.
Durham County, England. Photo-
graph by Andy Goldsworthy.
*Challenged to make a sculpture on a
narrow portion of disused railway
line, the artist devised a wavy barrow
that is narrower at one end and wider
at the other, conveying an impres-
sion of flowing, "a river of earth."*

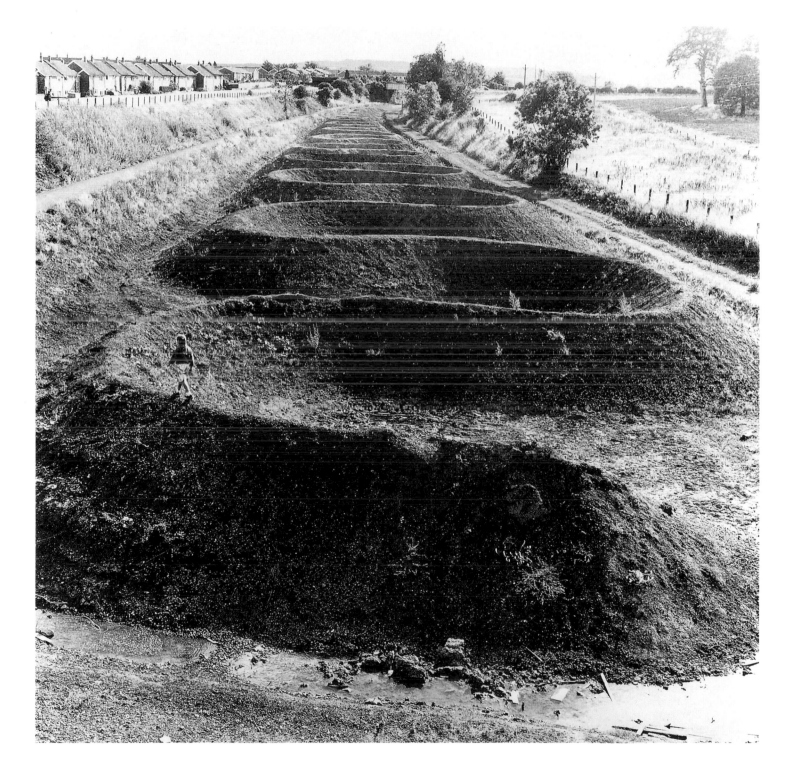

fragile that they endure only a few hours, scarcely long enough for him to document them in color photographs. On a 1989 visit to Arizona, the English-born, Scotland-based artist created some impermanent ground sculptures in the ruddy desert sand: one piece was a line of 13 low cratered mounds, while another consisted of several parallel, swirling ridges. In contrast to works of such fleeting duration, Goldsworthy has designed two large and relatively permanent earthworks for Durham County in northern England, both commissioned to "reclaim" abandoned railway lines. The first of them, *Lambton Earthwork*, built in 1988, is a wavy or serpentine ridge, measuring a quarter of a mile from end to end. It met with such success that he was asked the following year to construct an even larger piece, resulting in *Leadgate Maze*, a handsome arrangement of concentric rings and arcs that suggests the spreading ripples from a stone thrown into a pond.

Ripples of a more evocative nature were aroused by a recent example of Land art sited in the Netherlands. There, New York artist Vito Acconci (b. 1940) created a poetic installation piece, *Personal Island* (1992), which contributed an element of dreamlike logic to an outdoor sculpture exhibition in the Floriade park in the town of Zoetermeer. The work incorporated a matching pair of metal rowboats; the bow of each had been filled with soil and planted with a sapling. One craft was completely ashore, but immobilized by being buried up to its rim in the ground. The other boat, wedged into a circular plane of grass, constituted what the artist called, "a portable island." When "docked," the island fitted into a semi-circular section of the shore. "You can step out onto the grass," said the artist, "and into the boat, and row the island; the shore pulls out from itself and floats on the water."[29] The work is richly metaphorical, brimming with associations about isolation, separation, and aspiration. It brings to mind the great entombed boats of Khufu in Old Kingdom Egypt and Raedwald in medieval England, as well as the Viking practice of placing the dead in funeral boats to sail off into the next life. Perhaps Acconci's landlocked boats signify the plight of the human condition: our imaginations float away toward fancied realms, but our bodies are moored to earth. We aspire to move on to more idealized and spiritual planes of existence, but we remain earthbound.

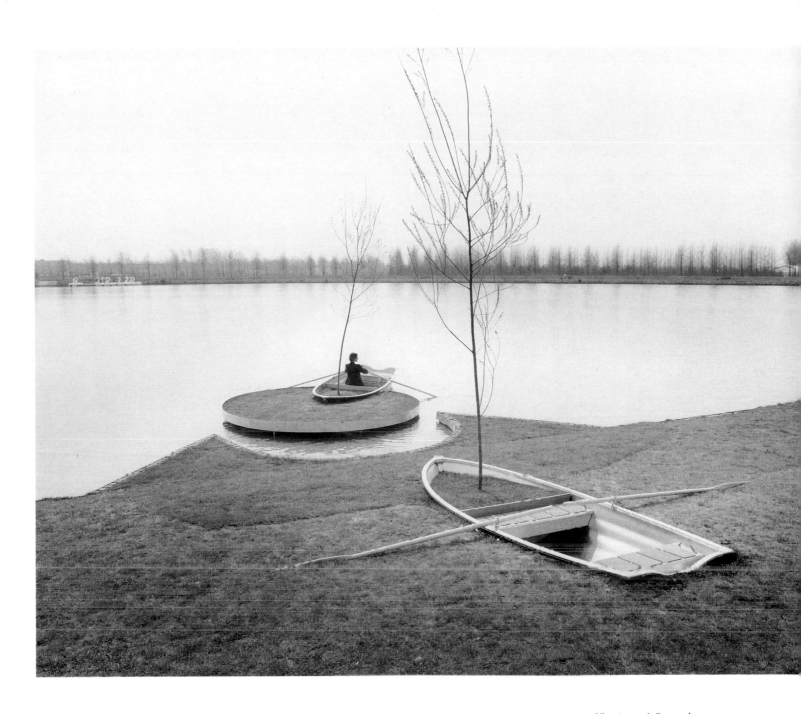

Notes

CHAPTER 1

1. Stuart J. Fiedel, *Prehistory of the Americas*, 2nd ed., rev. (New York: Cambridge University Press, 1992), p. 50.
2. Andrew Sherratt, ed., *The Cambridge Encyclopedia of Archaeology* (New York: Crown and Cambridge University Press, 1980), pp. 156–57.
3. Kwang-Chih Chang, *Shang Civilization* (New Haven: Yale University Press, 1980), p. 78.
4. Chang, *Shang*, pp. 90–95, 194.
5. Chang, *Shang*, p. 273.
6. William N. Morgan, *Prehistoric Architecture in the Eastern United States* (Cambridge, Mass.: MIT Press, 1980), pp. 3, 6; Fiedel, *Prehistory*, pp. 235–36, 354.
7. Brian M. Fagan, *Kingdoms of Gold, Kingdoms of Jade* (New York: Thames and Hudson, 1975), pp. 144–45.
8. Spiro Kostof, *Caves of God* (New York and Oxford: Oxford University Press, 1989), pp. 23, 27.
9. Richard Muir, *Riddles in the British Landscape* (New York: Thames and Hudson, 1981), p. 113.
10. James Graham-Campbell, *The Viking World* (New Haven and New York: Ticknor & Fields, 1980), pp. 80–81; James Graham-Campbell and Dafydd Kidd, *The Vikings* (London: British Museum, and New York: Metropolitan Museum of Art, 1980), pp. 77–79.
11. Graham-Campbell, *Viking World*, p. 190; Graham-Campbell and Kidd, *Vikings*, p. 183.
12. Graham-Campbell, *Viking World*, p. 83.
13. Morgan, *Prehistoric Architecture*, pp. 114–15.
14. Dorothy Seiberling, "Horizons of a Pioneer," *Life*, Vol. 64 (Mar. 1, 1968), p. 45.

CHAPTER 2

1. Hans J. Nissen, *The Early History of the Ancient Near East, 9000–2000 B.C.* (Chicago: University of Chicago Press, 1988), pp. 129–30.
2. Arthur Cotterell, ed., *The Encyclopedia of Ancient Civilizations* (New York: Mayflower Books, 1980), p. 244.
3. Michael Grant, *The Etruscans* (New York: Scribner's, 1980), pp. 224–25.
4. Larry Kohl, "Above China," *National Geographic*, Vol. 175, No. 3 (Mar. 1989), pp. 284, 287, 298.
5. Stuart J. Fiedel, *Prehistory of the Americas*, 2nd ed., rev. (New York: Cambridge University Press, 1992), p. 286; Michael D. Coe, *The Maya*, 5th ed., rev. (New York: Thames and Hudson, 1993), p. 93.
6. Inga Clendinnen, *Aztecs: An Interpretation* (New York: Cambridge University Press, 1991), p. 18.
7. Fiedel, *Prehistory*, pp. 309–10.
8. Fiedel, *Prehistory*, pp. 309–10.
9. Anthony DePalma, "Mexico City Restoring Area Tilled by Aztecs," *New York Times*, Sept. 14, 1993.
10. Christopher B. Donnan, "Masterworks of Art Reveal a Remarkable Pre-Inca World," *National Geographic*, Vol. 177, No. 6 (June 1990), pp. 17, 26, 33.
11. Evan Hadingham, *Lines to the Mountain Gods: Nazca and the Mysteries of Peru* (New York: Random House, 1987), pp. 189–92.
12. Hadingham, *Lines to the Mountain Gods*, pp. 44–50.
13. Charles Hadfield, *World Canals* (New York: Facts on File, 1986), pp. 16–17.
14. Herodotus (trans. by Aubrey de Sélincourt), *The Histories*, rev. ed. (New York: Penguin Books, 1972), p. 193. Other historians dispute Herodotus on this point, asserting that the canal was completed and operational; see Donald B. Redford, *Egypt, Canaan, and Israel in Ancient Times* (Princeton: Princeton University Press, 1992), pp. 434, 451–52.
15. Hadfield, *World Canals*, pp. 17–18.
16. Marco Polo, *The Travels of Marco Polo* (New York: New American Library, 1961), p. 209.
17. For a dramatic fictional account of junk-hauling on the Yangtze, see John Hersey's 1956 novel, *A Single Pebble* (New York: Random House [Vintage Books]), pp. 81–83, 136–40.
18. Hadfield, *World Canals*, pp. 47–53.
19. Lewis Mumford, *The City in History* (New York: Harcourt, Brace & World, 1961), pp. 440–43.
20. Hadfield, *World Canals*, pp. 314–15.
21. David Attenborough, *The First Eden* (Boston and Toronto: Little, Brown, 1987), p. 179.
22. Attenborough, *First Eden*, p. 179.
23. Hadfield, *World Canals*, p. 173.
24. Hadfield, *World Canals*, pp. 171–73.
25. Hadfield, *World Canals*, p. 159.
26. Bill Bryson, "Main-Danube Canal Linking Europe's Waterways," *National Geographic*, Vol. 182, No. 2 (Aug. 1992), pp. 3–31.
27. Arthur Cotterell, *The First Emperor of China* (New York: Holt, Rinehart and Winston, 1981), p. 58.
28. Cotterell, *First Emperor*, pp. 152–53, 171–72.
29. Hadingham, *Lines to the Mountain Gods*, p. 226.
30. Brian M. Fagan, *Kingdoms of Gold, Kingdoms of Jade* (London and New York: Thames and Hudson, 1991), p. 50.
31. Donald Dale Jackson, "The Ins and Outs of a Dangerous and Boring Subject," *Smithsonian*, May 1986, p. 72.
32. Jonathan P. Hicks, "Air-Conditioning a 32-Mile Tunnel," *New York Times*, May 1, 1991.
33. James Sterngold, "Huge Airport Has Its Wings Clipped," *New York Times*, July 3, 1991; James Sterngold, "Pride and (Ouch!) Price: The $14 Billion Airport," *New York Times*, Dec. 16, 1993.
34. Michael Grant, ed., *Readings in the Classical Historians* (New York: Scribner's, 1992), pp. 254–55.
35. Joseph Lelyveld, "De Beers Steps Up Gem Search," *New York Times*, Jan. 7, 1981.
36. Marlise Simons, "Dutch Do the Unthinkable: Sea Is Let In," *New York Times*, Mar. 7, 1993.
37. Joel Greenberg, "Israel Restoring Drained Wetland, Reversing Pioneers' Feat," *New York Times*, Dec. 5, 1993.
38. Attenborough, *First Eden*, pp. 203–5.
39. Chris Hedges, "In a Remote Southern Marsh, Iraq Is Strangling the Shiites," *New York Times*, Nov. 16, 1993; Hedges, "Iraqi Regime Fights To Kill a Way of Life," *New York Times*, Nov. 28, 1993.

CHAPTER 3

1. Andrew Sherratt, ed., *The Cambridge Encyclopedia of Archaeology* (New York: Crown and Cambridge University Press, 1980), pp. 105, 107; Robin Lane Fox, *The Unauthorized Version: Truth and Fiction in the Bible* (New York: Knopf, 1991), p. 227.
2. John Keegan, *A History of Warfare* (New York: Knopf, 1993), pp. 124–25, 141.
3. James G. Macqueen, *The Hittites and Their Contemporaries in Asia Minor* (Boulder, Col.: Westview Press, 1975), pp. 72, 104, 106–8.
4. David Hume, *The History of England* [1754–57], Chap. 65.
5. Arthur Ferrill, *The Origins of War* (London: Thames and Hudson, 1975), p. 68.
6. Herodotus (trans. by Aubrey de Sélincourt), *The Histories*, rev. ed. (New York: Penguin Books, 1972), p. 113.
7. Michael Grant, *The Etruscans* (New York: Scribner's, 1980), p. 166.
8. Robin Lane Fox, *Alexander the Great* (New York: Dial Press, 1974), pp. 187–91; Robin Lane Fox, *The Search for Alexander* (Boston and Toronto: Little, Brown, 1980), pp. 185–91; Ferrill, *Origins*, pp. 204–5.
9. Lane Fox, *Search*, p. 191; Lane Fox, *Alexander*, p. 193.
10. Michael Grant, *The Army of the Caesars* (New York: Scribner's, 1974), p. xxi.
11. Keegan, *A History of Warfare*, p. 303.
12. Grant, *Army*, pp. 299–300.
13. Grant, *Army*, p. 300.
14. Kenneth G. Holum and Robert L. Hohlfelder, eds., *King Herod's Dream: Caesarea on the Sea* (New York and London: Norton, 1988), pp. 67, 69.
15. Stephen Johnson, *Hadrian's Wall* (London: B. T. Batsford/English Heritage, 1989), p. 42.
16. Johnson, *Hadrian's Wall*, pp. 30–31; H. H. Scullard, *Roman Britain* (London: Thames and Hudson, 1979), pp. 59–60.
17. Johnson, *Hadrian's Wall*, pp. 69–70.
18. Scullard, *Roman Britain*, p. 62.
19. Philippe Contamine, *War in the Middle Ages* (New York: Basil Blackwell, 1984), p. 183.
20. George Holmes, ed., *The Oxford Illustrated History of Medieval Europe* (New York: Oxford University Press, 1988), pp. 107–8.
21. James Graham-Campbell, *The Viking World* (New Haven and New York: Ticknor & Fields, 1980), p. 209.
22. Graham-Campbell, *Viking World*, pp. 92–95.
23. Graham-Campbell, *Viking World*, pp. 202–6; William N. Morgan, *Prehistoric Architecture in the Eastern United States* (Cambridge, Mass.: MIT Press, 1980), p. 141.
24. Kenneth O. Morgan, ed., *The Oxford Illustrated History of Britain* (New York: Oxford University Press, 1984), p. 99.
25. Contamine, *War*, p. 45.
26. Contamine, *War*, pp. 114–15.
27. Luo Zewen, Dick Wilson, Jean-Pierre Drege, and Hubert Delahaye, *The Great Wall* (New York: McGraw-Hill, 1981), p. 92.
28. Zewen et al., *Great Wall*, p. 145.
29. Michael D. Coe, *The Maya*, 5th ed., rev. (New York: Thames and Hudson, 1993), p. 89.
30. Arthur A. Demarest, "The Violent Saga of a Maya Kingdom," *National Geographic*, Vol. 183, No. 2 (Feb. 1993), pp. 106, 109.
31. John Noble Wilford, "Long-Lost Spanish Fort Found in St. Augustine," *New York Times*, July 27, 1993.
32. William H. McNeill, *The Pursuit of Power* (Chicago: University of Chicago Press, 1982), p. 90.
33. Tom Cringle, *Tom Cringle's Log* (Paris: Baudry's European Library, 1854), p. 24.
34. John Ellis, *Eye-deep in Hell: Trench Warfare in World War I* (Baltimore: Johns Hopkins, 1977), p. 25.
35. Keith Mallory and Arvid Ottar, *The Architecture of War* (New York: Pantheon, 1973), p. 37.
36. Ellis, *Eye-deep*, p. 62.
37. Erich Maria Remarque, *All Quiet on the Western Front* (Boston: Little, Brown, 1929), p. 103.
38. Ellis, *Eye-deep*, p. 45.
39. Remarque, *All Quiet*, p. 54.
40. Jon Halliday and Bruce Cumings, *Korea: The Unknown War* (New York: Pantheon, 1988), p. 36.
41. Halliday and Cumings, *Korea*, pp. 165–66, 171–72.
42. Neil Sheehan, *A Bright Shining Lie* (New York: Random House, 1988), pp. 646, 648.

CHAPTER 4

1. Lewis Mumford, *The City in History: Its Origins, Its Transformations, and Its Prospects* (New York: Harcourt, Brace & World, 1961), p. 7.
2. Hans J. Nissen, *The Early History of the Ancient Near East, 9000–2000 B.C.* (Chicago and London: University of Chicago Press, 1988), p. 35.
3. Jean-Pierre Mohen, *The World of Megaliths* (New York: Facts on File, 1990), pp. 132–33.
4. Farouk El-Baz, "Finding a Pharaoh's Funeral Bark," *National Geographic*, Vol. 173, No. 4 (Apr. 1988), pp. 513–33.
5. El-Baz, "Finding a Pharaoh's Funeral Bark," pp. 513–33.
6. Mark Lehner, "Computer Rebuilds the Ancient Sphinx," *National Geographic*, Vol. 179, No. 4 (Apr. 1991), pp. 32–39.

7. John Baines and Jaromír Málek, *Atlas of Ancient Egypt* (New York: Facts on File, 1980), pp. 184–85.

8. David Attenborough, *The First Eden* (Boston and Toronto: Little, Brown, 1987), pp. 77–78.

9. Homer, *The Complete Works of Homer, The Iliad* trans. by Andrew Lang, Walter Leaf, and Ernest Myers (New York: Modern Library, 1950), pp. 421–23.

10. Herodotus (trans. by Aubrey de Sélincourt), *The Histories*, rev. ed. (New York: Penguin Books, 1972), p. 80.

11. Michael Grant, *The Etruscans* (New York: Scribner's, 1980), p. 162.

12. Arthur Cotterell, *The First Emperor of China* (New York: Holt, Rinehart and Winston, 1981), p. 154.

13. O. Louis Mazzatenta, "A Chinese Emperor's Army for Eternity," *National Geographic*, Vol. 182, No. 2 (Aug. 1992), p. 120.

14. James Graham-Campbell, *The Viking World* (New Haven and New York: Ticknor & Fields, 1980), p. 42.

15. Graham-Campbell, *Viking World*, p. 129; James Graham-Campbell and Dafydd Kidd, *The Vikings* (London: British Museum, and New York: Metropolitan Museum of Art, 1980), pp. 27–29.

16. Graham-Campbell, *Viking World*, p. 200.

17. Cathy Newman, "Kyongju, Where Korea Began," *National Geographic*, Vol. 174, No. 2 (Aug. 1988), pp. 261–68.

18. Larry Kohl, "Above China," *National Geographic*, Vol. 175, No. 3 (Mar. 1989), p. 310.

19. Michael D. Coe, *The Maya*, 5th ed., rev. (New York: Thames and Hudson, 1993), pp. 55–56.

20. Coe, *Maya*, pp. 112, 115; Stuart J. Fiedel, *Prehistory of the Americas*, 2nd ed., rev. (New York: Cambridge University Press, 1992), p. 295.

CHAPTER 5

1. Hans J. Nissen, *The Early History of the Ancient Near East, 9000–2000 B.C.* (Chicago: University of Chicago Press, 1988), p. 190.

2. C. W. Ceram, *Gods, Graves, and Scholars* (New York: Knopf, 1951), pp. 290–91.

3. Herodotus (trans. by Aubrey de Sélincourt), *The Histories*, rev. ed. (New York: Penguin Books, 1972), p. 114.

4. Stuart J. Fiedel, *Prehistory of the Americas*, 2nd ed., rev. (New York: Cambridge University Press, 1992), pp. 268–70.

5. Michael Coe, Dean Snow, and Elizabeth Benson, *Atlas of Ancient America* (New York and Oxford: Facts on File, 1986), p. 106.

6. John Noble Wilford, "An Ancient 'Lost City' Is Uncovered in Mexico," *New York Times*, Feb. 4, 1994.

7. Walter Alva, "Richest Unlooted Tomb of a Moche Lord," *National Geographic*, Vol. 174, No. 4 (Oct. 1988), pp. 510–48; Walter Alva, "New Royal Tomb Unearthed," *National Geographic*, Vol. 177, No. 6 (June 1990), pp. 2–16.

8. Arthur A. Demarest, "The Violent Saga of a Maya Kingdom," *National Geographic*, Vol. 183, No. 2 (Feb. 1993), pp. 104–5.

9. Spiro Kostof, *Caves of God* (New York and Oxford: Oxford University Press, 1989), p. viii.

10. Aubrey Burl, *Prehistoric Avebury* (New Haven: Yale University Press, 1979), p. 202.

11. Gerald S. Hawkins, *Stonehenge Decoded* (New York: Doubleday, 1965), p. 45.

12. Michael Balfour, *Stonehenge and Its Mysteries* (New York: Scribner's, 1980), p. 30.

13. Balfour, *Stonehenge*, p. 33.

14. Hawkins, *Stonehenge*, p. vii.

15. Burl, *Prehistoric Avebury*, p. 202.

16. William N. Morgan, *Prehistoric Architecture in the Eastern United States* (Cambridge, Mass.: MIT Press, 1980), p. 22.

17. "Geographica," *National Geographic*, Vol. 179, No. 4 (Apr. 1991), n.p.; Evan Hadingham, *Lines to the Mountain Gods: Nazca and the Mysteries of Peru* (New York: Random House, 1987), pp. 268–70.

18. Hadingham, *Lines to the Mountain Gods*, pp. 97–100.

19. Paul Devereux, John Steele, and David Kubrin, *Earthmind* (London and New York: Harper & Row, 1989), p. 148.

CHAPTER 6

1. Marco Polo, *The Travels of Marco Polo* (New York: New American Library, 1961), p. 133.

2. Germain Bazin, *Paradeisos* (Boston and Toronto: Little, Brown, 1990), p. 245.

3. Esther Gordon Dotson, "Shapes of Earth and Time in European Gardens," *Art Journal*, Vol. 42, No. 3 (Fall 1982), pp. 210–16.

4. Nikolaus Pevsner, *The Englishness of English Art* (New York: Frederick A. Praeger, 1956), p. 164.

5. Thomas Hinde, *Capability Brown* (London and New York: W. W. Norton, 1987), p. 160.

6. Dorothy Stroud, *Capability Brown* (London: Faber and Faber, 1975), p. 202.

7. Richard Muir, *Riddles in the British Landscape* (New York: Thames and Hudson, 1981), pp. 118–21.

8. Elizabeth Barlow, *Frederick Law Olmsted's New York* (New York: Praeger, 1972), p. 13.

9. Nancy Grove, "Isamu Noguchi, Shaper of Space," *Arts Magazine*, Vol. 59 (Dec. 1984), pp. 111–15.

10. Robert Tracy, "Artist's Dialogue: Isamu Noguchi," *Architectural Digest*, Vol. 44 (Oct. 1987), p. 83.

11. David Bourdon, "The Razed Sites of Carl Andre," *Artforum*, Vol. 5, No. 2 (Oct. 1966), p. 17.

12. Robert Smithson, "Frederick Law Olmsted and the Dialectical Landscape," *Artforum*, Vol. 11, No. 6 (Feb. 1973), p. 65.

13. Robert Smithson, "A Sedimentation of the Mind: Earth Projects," *Artforum*, Vol. 7, No. 1 (Sept. 1968), p. 46.

14. Smithson, "Sedimentation," p. 45.

15. Robert Smithson and Gregoire Muller, ". . . The Earth, Subject to Cataclysms, Is a Cruel Master," *Arts Magazine*, Vol. 46 (Nov. 1971), p. 41.

16. Smithson and Muller, " . . . The Earth," p. 40.

17. Julia Brown, ed., *Michael Heizer Sculpture in Reverse* (Los Angeles: Museum of Contemporary Art, 1984), p. 14.

18. Brown, *Heizer*, p. 36.

19. Brown, *Heizer*, p. 34.

20. Brown, *Heizer*, p. 17.

21. Dennis Oppenheim, postcard to author, Feb. 1969.

22. Walter De Maria, "The Lightning Field," *Artforum*, Vol. 18, No. 8 (Apr. 1980), pp. 52–59.

23. Alan Sonfist, ed., *Art in the Land* (New York: Dutton, 1983), p. 94.

24. Sonfist, *Art in the Land*, p. 97.

25. Smithson, "Olmsted," p. 65.

26. Nancy Holt, ed., *The Writings of Robert Smithson* (New York: New York University Press, 1979), p. 220.

27. Judith L. Dunham, "Artists Reclaim the Land," *Artweek*, Vol. 10, No. 29 (Sep. 15, 1979), p. 1.

28. Douglas C. McGill, *Michael Heizer: Effigy Tumuli* (New York: Abrams, 1990), p. 22.

29. Artist's information sheet, 1992.

Selected Bibliography

For works that have been translated or printed in more than one edition, the original publication dates are given in brackets at the end of a listing.

Albertazzi, Liliana, ed. *Différentes Natures: Visions de l'art contemporain*. Catalogue to exhibition at La Défense, Paris. Turin: Lindau, 1993

Albright, William Foxwell. *The Archaeology of Palestine*, rev. ed. Baltimore: Penguin Books [Pelican Books], 1960 [1949]

Altshuler, Bruce. *Noguchi*. New York: Abbeville, 1994

Attenborough, David. *The First Eden*. Boston and Toronto: Little, Brown, 1987

Aveni, Anthony. *Conversing with the Planets: How Science and Myth Invented the Cosmos*. New York: Random House, Times Books, 1992

Baines, John, and Málek, Jaromir. *Atlas of Ancient Egypt*. New York: Facts on File, 1980

Balfour, Michael. *Stonehenge and Its Mysteries*. New York: Scribner's, 1980

Barlow, Elizabeth. *Frederick Law Olmsted's New York*. New York: Praeger, 1972

Bazin, Germain. *Paradeisos*. Translation of *Paradeisos, ou, L'art du jardin*. Boston: Little, Brown [Bullfinch], 1990 [1988]

Beardsley, John. *Earthworks and Beyond*. New York: Abbeville, 1989
———. *Probing the Earth: Contemporary Land Projects*. Exhibition catalogue. Washington, D.C.: Smithsonian Institution Press, 1977

Bierbrier, Morris. *The Tomb-Builders of the Pharaohs*. New York: Scribner's, 1984

Brown, Julia. *Michael Heizer, Sculpture in Reverse*. Los Angeles: Museum of Contemporary Art, 1984

Brown, Julia, ed. *Occluded Front James Turrell*. Larkspur Landing, Calif.: Lapis Press, 1985

Burl, Aubrey. *Prehistoric Avebury*. New Haven: Yale University Press, 1979
———. *Rings of Stone: The Prehistoric Stone Circles of Britain and Ireland*. New York: Ticknor & Fields, 1979

Ceram, C. W. *Gods, Graves, and Scholars*. Translated from the German by E. B. Garside. New York: Knopf, 1951 [1949]

Chadwick, John. *The Mycenaean World*. Cambridge, London, and New York: Cambridge University Press, 1976

Chang, Kwang-Chih. *Shang Civilization*. New Haven: Yale University Press, 1980

Childe, Gordon. *What Happened in History*. Baltimore: Penguin Books [Pelican Books], 1957 [1942]

Clendinnen, Inga. *Aztecs: An Interpretation*. New York: Cambridge University Press, 1991

Coe, Michael D. *The Maya*, 5th ed., rev. New York: Thames and

Hudson, 1993 [1966]

Coe, Michael; Snow, Dean; and Benson, Elizabeth. *Atlas of Ancient America.* New York and Oxford: Facts on File, 1986

Contamine, Philippe. *War in the Middle Ages.* Translated from the French by Michael Jones. New York: Basil Blackwell, 1984 [1980]

Cornell, James. *The First Stargazers.* New York: Scribner's, 1981

Cornell, Tim, and Matthews, John. *Atlas of the Roman World.* New York: Facts on File, 1982

Cotterell, Arthur, ed. *The Encyclopedia of Ancient Civilizations.* New York: Mayflower Books, 1980

Cotterell, Arthur. *The First Emperor of China.* New York: Holt, Rinehart and Winston, 1981

————. *The Minoan World.* New York: Scribner's, 1979

De Camp, L. Sprague. *The Ancient Engineers.* New York: Dorset Press, 1990

Dethier, Jean. *Architectures de Terre,* rev. ed. Paris: Editions du Centre Pompidou, 1986 [1981]

Devereux, Paul; Steele, John; and Kubrin, David. *Earthmind.* London and New York: Harper & Row, 1989

Ellis, John. *Eye-deep in Hell: Trench Warfare in World War I.* Baltimore: Johns Hopkins University Press, 1977

Fagan, Brian M. *Kingdoms of Gold, Kingdoms of Jade.* London and New York: Thames and Hudson, 1991

Ferrill, Arthur. *The Origins of War.* London: Thames and Hudson, 1975

Fiedel, Stuart J. *Prehistory of the Americas,* 2nd ed., rev. New York: Cambridge University Press, 1992 [1987]

Frankfort, H. and H. A.; Wilson, John A.; and Jacobsen, Thorkild. *Before Philosophy: The Intellectual Adventure of Ancient Man.* Baltimore: Penguin Books [Pelican Books], 1959 [1946]

Friedman, Martin. *Noguchi's Imaginary Landscapes.* Exhibition catalogue. Minneapolis: Walker Art Center, 1978

Friedman, Terry, and Goldsworthy, Andy. *Hand to Earth: Andy Goldsworthy Sculptures, 1976-1990.* New York: Abrams, 1993

Gerster, Georg. *Flights of Discovery.* London and New York: Paddington Press, 1978

Goldsworthy, Andy. *Andy Goldsworthy: A Collaboration with Nature.* New York: Abrams, 1990

Graham-Campbell, James. *The Viking World.* New Haven and New York: Ticknor & Fields, 1980

Graham-Campbell, James, and Kidd, Dafydd. *The Vikings.* Exhibition catalogue. London: British Museum, and New York: Metropolitan Museum of Art, 1980

Grant, Michael. *The Army of the Caesars.* New York: Scribner's, 1974

————. *The Etruscans.* New York: Scribner's, 1980

————. *Readings in the Classical Historians.* New York: Scribner's, 1992

Guidoni, Enrico. *Primitive*

Architecture. Translated by Robert Erich Wolf. New York: Rizzoli, 1987 [1975]

Guilaine, Jean, ed. *Prehistory: The World of Early Man.* Translation of *La Préhistoire.* New York: Facts on File, 1991 [1986]

Hadfield, Charles. *World Canals.* New York: Facts on File, 1986

Hadingham, Evan. *Lines to the Mountain Gods: Nazca and the Mysteries of Peru.* New York: Random House, 1987

Harney, Andy Leon, ed. *Art in Public Places.* Introduction and text by John Beardsley. Washington, D.C.: Partners for Livable Places, 1981

Hatzopoulos, Miltiades B., and Loukopoulos, Louisa D. *Philip of Macedon.* Athens: Ekdotike Athenon, 1980

Hawkins, Gerald S. *Stonehenge Decoded.* New York: Doubleday, 1965

Henderson, John S. *The World of the Ancient Maya.* Ithaca, New York: Cornell University Press, 1981

Herm, Gerhard. *The Celts.* New York: St. Martin's Press, 1976

Herodotus. *The Histories* (translated by Aubrey de Sélincourt), rev. ed. New York: Penguin Books, 1972

Hibbert, Christopher. *Rome, the Biography of a City.* London and New York: W. W. Norton, 1985

Hinde, Thomas. *Capability Brown.* London and New York: W. W. Norton, 1987

Hoag, John D. *Western Islamic Architecture.* New York: Braziller, 1963

Hobbs, Robert, ed. "Earthworks: Past and Present." Special issue of *Art Journal,* Vol. 42, No. 3 (Fall 1982)

Holmes, George, ed. *The Oxford Illustrated History of Medieval Europe.* Oxford and New York: Oxford University Press, 1988

Holt, Nancy, ed. *The Writings of Robert Smithson.* New York: New York University Press, 1979

Holum, Kenneth G., and Hohlfelder, Robert L., eds. *King Herod's Dream: Caesarea on the Sea.* New York and London: W. W. Norton, 1988

Hopper, R. J. *The Early Greeks.* New York: Harper & Row, Barnes & Noble Import Division, 1977

Hucker, Charles O. *China's Imperial Past.* Stanford, Calif.: Stanford University Press, 1975

Johnson, Stephen. *Hadrian's Wall.* London: B. T. Batsford/English Heritage, 1989

Keegan, John. *A History of Warfare.* New York: Knopf, 1993

Kostof, Spiro. *Caves of God.* New York and Oxford: Oxford University Press, 1989 [1972]

Kramrisch, Stella. *Manifestations of Shiva.* Philadelphia: Philadelphia Museum of Art, 1981

Lane Fox, Robin. *Alexander the Great.* New York: Dial Press, 1974 [1973]

————. *The Search for Alexander.* Boston and Toronto: Little, Brown, 1980

Lippard, Lucy. *Overlay: Contemporary Art and the Art of Prehistory.* New York: Pantheon Books, 1983

Macqueen, James G. *The Hittites and Their Contemporaries in Asia Minor.* Boulder, Col.: Westview Press, 1975

Mango, Cyril A. *Byzantium, the Empire of New Rome.* New York: Scribner's, 1980

Martindale, David. *Earth Shelters.* New York: E. P. Dutton, 1981

McGill, Douglas C. *Michael Heizer: Effigy Tumuli.* New York: Abrams, 1990

McNeill, William H. *The Pursuit of Power.* Chicago: University of Chicago Press, 1982

Mohen, Jean-Pierre. *The World of Megaliths.* New York: Facts on File, 1990

Morgan, Kenneth O., ed. *The Oxford Illustrated History of Britain.* Oxford and New York: Oxford University Press, 1984

Morgan, William N. *Prehistoric Architecture in the Eastern United States.* Cambridge, Mass.: MIT Press, 1980

Muir, Richard. *Riddles in the British Landscape.* New York: Thames and Hudson, 1981

Mumford, Lewis. *The City in History: Its Origins, Its Transformations, and Its Prospects.* New York: Harcourt, Brace & World, 1961

Nissen, Hans J. *The Early History of the Ancient Near East, 9000–2000 B.C.* Chicago and London: University of Chicago Press, 1988

Oates, Joan. *Babylon.* London: Thames and Hudson, 1979

Pehnt, Wolfgang. *Expressionist Architecture.* New York: Praeger, 1973

Pevsner, Nikolaus. *The Englishness of English Art.* New York: Frederick A. Praeger, 1956.

Pirenne, Henri. *Medieval Cities.* Translated from the French by Frank D. Halsey. Garden City, New York: Doubleday Anchor Books, 1956 [1925]

Platt, Colin. *Medieval England, A Social History and Archaeology from the Conquest to 1600 A.D.* New York: Scribner's, 1978

Polo, Marco. *The Travels of Marco Polo.* Edited and with an introduction by Milton Rugoff. New York and Toronto: Signet Classic [New American Library], 1961 [c. 1298]

Redford, Donald B. *Egypt, Canaan, and Israel in Ancient Times.* Princeton: Princeton University Press, 1992

Remarque, Erich Maria. *All Quiet on the Western Front.* Translated from the German by A. W. Wheen. Boston: Little, Brown, 1929

Robinson, Roxana. *Georgia O'Keeffe: A Life.* New York: Harper & Row, 1989

Rudofsky, Bernard. *Architecture Without Architects.* Garden City, New York: Doubleday, 1964

Schele, Linda, and Freidel, David. *A Forest of Kings: The Untold Story of the Ancient Maya.* New York: Morrow, 1990

Schele, Linda, and Miller, Mary Ellen. *The Blood of Kings: Dynasty and Ritual in Maya Art.* Exhibition catalogue. Fort Worth, Texas: Kimbell

Art Museum, 1986

Scullard, H. H. *Roman Britain.* London: Thames and Hudson, 1979

Service, Alastair, and Bradbery, Jean. *Megaliths and Their Mysteries.* New York: Macmillan, 1979

Sherratt, Andrew, ed. *The Cambridge Encyclopedia of Archaeology.* New York: Crown and Cambridge University Press, 1980

Silverberg, Robert. *Mound Builders of Ancient America: The Archaeology of a Myth.* New York: New York Graphic Society, 1968

Smith, Rex Alan. *The Carving of Mount Rushmore.* New York: Abbeville, 1985

Smith, W. Stevenson. *The Art and Architecture of Ancient Egypt.* Baltimore: Penguin Books, 1965 [1958]

Smithson, Robert: Drawings. Exhibition catalogue. New York: New York Cultural Center, 1974

Sonfist, Alan, ed. *Art in the Land.* New York: E. P. Dutton, 1983

Stroud, Dorothy. *Capability Brown.* London: Faber and Faber, 1975 [1950]

Taylor, Colin F., ed. consultant, and Sturtevant, William C., tech. consultant. *The Native Americans, The Indigenous People of North America.* New York: Smithmark, 1991

Thomas, Hugh. *A History of the World.* New York: Harper & Row, 1979

Tomkins, Calvin. *The Scene: Reports on Post-Modern Art.* New York: Viking Press, 1976

Twentieth Century Engineering. Exhibition catalogue. New York: Museum of Modern Art, 1964

Underground Space Center, University of Minnesota. *Earth Sheltered Housing Design.* New York: Van Nostrand Reinhold, 1979

Waldron, Arthur. *The Great Wall of China: From History to Myth.* Cambridge, England: Cambridge University Press, 1990

Walker, Charles. *Wonders of the Ancient World.* London: Popular Press, 1988 [1980]

Wellard, James. *The Search for the Etruscans.* New York: Saturday Review Press, 1973

Willett, Frank. *African Art.* New York: Praeger, 1971

Wood, Michael. *In Search of the Trojan War.* New York: Facts on File, 1985

Wu, Nelson I. *Chinese and Indian Architecture.* New York: Braziller, 1963

Yadin, Yigael. *Masada: Herod's Fortress and the Zealots' Last Stand.* London: Weidenfeld and Nicolson, 1966

Zewen, Luo; Wilson, Dick; Drege, Jean-Pierre; and Delahaye, Hubert. *The Great Wall.* New York: McGraw-Hill, 1981

Index

All references are to page numbers. *Italic* numbers refer to illustrations; **boldface** numbers, to captions. Insofar as possible, ancient sites are identified by the present-day polity in or near which they are located. Entries for continents and inclusive areas provide general references only; specific sites, cultures, and polities within the area are indexed separately.

Photograph Credits

The author and publishers wish to thank the photographers, galleries, and institutions who kindly loaned their photographs and/or their consent to the publication of their works. Whenever the attribution is not included in the caption, the listing follows below. All references are to page numbers.